Digital Stock Photography
How to Shoot and Sell

Michal Heron

ALLWORTH
PRESS
NEW YORK

Dedication: To My Family

Acknowledgments: My great appreciation goes to the generous professionals who were interviewed for the "Tips from the Experts" segments in this book.

The Allworth staff, as always, performed with extraordinary skill, understanding, and patience. Thanks to Nicole Potter-Talling, Derek Bacchus, Michael Madole, Cynthia Rivelli, Katie Ellison, and Tad Crawford.

11 10 09 08 5 4 3 2

Published by Allworth Press
An imprint of Allworth Communications, Inc.
10 East 23rd Street, New York, NY 10010

Cover design by Derek Bacchus
Interior design by Robin Black, www.blackbirdcreative.biz
Page composition/typography by Integra Software Services, Pvt., Ltd., Pondicherry, India
Cover photo by Michal Heron

All photographs copyright © Michal Heron unless otherwise credited under the photograph.

Library of Congress Cataloging-in-Publication Data

Heron, Michal.
 Digital stock photography : how to shoot and sell / Michal Heron.
 p. cm.
 Includes index.
 ISBN-13: 978-1-58115-484-9 (pbk.)
 ISBN-10: 1-58115-484-4 (pbk.)
1. Stock photography. 2. Photographs—Marketing. 3. Photography—Digital techniques.
I. Title.

TR690.6.H45 2007
770.68'8—dc22

 2007014807

CONTENTS

Introduction: Stock in the Digital Age..v

1. The Business of Digital Stock...1

2. How to Shoot for Stock—Style and Concept13

3. Equipment for Capturing and Scanning Images33

4. Shooting What's Needed ..57

5. Twenty-Five Stock Assignments You Can Shoot71

6. Preparing the Shoot ...103

7. On the Shoot ...141

8. Editing and Post-Production in the Digital Work Flow..........149

9. Running a Stock Photography Business171

10. Marketing Your Stock ...195

11. Finding a Stock Agency or Portal217

12. Negotiating Prices ...231

13. Copyright—What Do We Own? ...247

14. Model Releases and Business Forms253

Appendix 1: Bibliography ..269

Appendix 2: Organizations ...271

Appendix 3: Workshops..272

Appendix 4: Promotion/Source Books273

Appendix 5: Manufacturers..274

Index...275

This book is based on the Third Edition of *How To Shoot Stock Photos That Sell,* published by Allworth Press. Some materials from that book have been revised and adapted for this first edition of *Digital Stock Photography*. Other sections are completely new to this title and reflect the sea of change brought about by the complete transformation of every aspect of stock photography to the digital mode.

Throughout this book, what has been maintained is the principle that fine photography, shot with joy and marketed with skill, is a means of building a rewarding career in stock photography.

Stock in the Digital Age

Where do all those photos come from? The ones used in advertising, annual reports, magazines, books and newspapers; you know, the ones that decorate, illustrate, inform, and explain? Many of them are stock photos found in photographers' or stock-agency Web sites. You'll learn in this book that stock photography has been around for quite a while, and that it is an important aspect of a photographer's business strategy, even as the industry is continually transformed.

To veteran photographers, stock photography may seem like a new breed now that it's digital, but the underlying principles remain the same. This book is built on the bedrock idea that for success in stock, the photography must be excellent quality, in touch with the style of the times, and well marketed. The digital environment doesn't alter that. In this book we have adapted the basic principles for creating saleable stock to the digital arena.

DIGITAL ENVIRONMENT

Just a few years ago photographers were proclaiming the merits of film relative to digital capture. Now there is hardly a murmur—the discussion centers merely on what type of digital capture you choose.

Whether you are new to stock or a veteran shooter, today's message can be boiled down to the guidance that one should shoot digitally, edit, and then enhance digitally, market digitally, deliver digitally, and invoice digitally. Scanning film images from your archive may be part of the process for the time being, but as you move forward, digital capture will become the mainstay of your stock business. Digital is the norm.

Changes Brought by Digital

Insight and vision are still the photographer's most valuable tools. The brain of a photographer is needed to understand what goes into creating a good digital stock photograph, just as when stock photographs were shot with film. But the

means for the creation and technical handling of digital images has changed completely in the past few years.

Digital tools, which allow us to make creative improvements to an image or to create a never-before-seen-in-reality image are powerful and exciting. They are also handy when used to change or remove annoying details in a scene. This ability to enhance, alter, and combine elements in photographs is known to photographers and probably to most amateurs.

But what is a less heralded, though an equally big change, is the need to use an entirely new bundle of software when working digitally. There are a wide range of programs available—and essential—to shooting and operating a stock business. Mastering these programs, and keeping up with the changes that seem to come almost monthly, is a critical part of staying afloat in the current stock environment. We must review all this software, choose which works best for us—then buy it and learn it.

Work Flow

The physical activities connected with film photography—shooting, processing, editing, labeling, captioning, and filing—are replicated in the digital world. These tasks are organized in a group of steps designed to create an efficient method of handling digital images. This organization, termed "work flow," and the process of storage and management of images are critically important to success in the digital world of stock photography.

Style

Style is often determined by what the buyers want. Each decade brings shifts in the style of stock requested by clients. Sometimes innovative photographers can influence style by putting out dramatic new approaches that catch the imagination of buyers.

Later we'll be exploring the trends and offering guidelines for being in style and creating style.

Economy and the Business of Stock

The success and proliferation of stock could be its downfall unless photographers understand the delicate balance needed between investment and skillful marketing.

There is greater use of stock than ever before, but downward pressure on pricing has created narrower profit margins. The economic realities today cannot justify huge investments in lavish production shoots, such as those used successfully by photographers in the 1990s and early 2000s. The chapters on business and negotiating offer advice on how to plan frugal but innovative shoots and the need to market widely and aggressively.

If you haven't had experience with stock photography, it's important to be familiar with the opportunities available to you and the realities of this part of the business. In many ways, stock photography is a microcosm of the larger world of photography. Many of the same career possibilities available in the wider world of photography exist in stock. For a start, there are photographers who shoot specifically for stock, whereas others make stock an adjunct to their assignment careers. And a few of the larger stock-photo agencies have photographers on staff.

The successful stock photographer today will have to be vigilant, alert, and ready for new developments. The most creative will anticipate and be responsive to change. Clinging to what once worked won't bring successful results. But through all these changes there are certain constants—quality, imagination, and perseverance—which will win out.

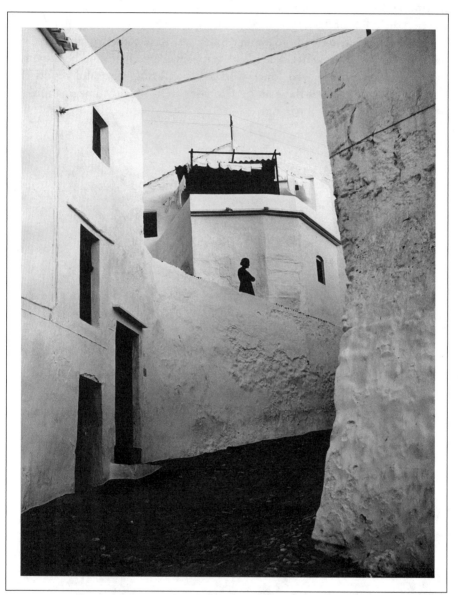

Frigiliana, Spain

The Business of Digital Stock

N ot long ago I got an email from a long-time client requesting a stock photo of a Hispanic family having a picnic. The client hadn't found anything on my Web site but knew me well enough to ask if there were some new photos I hadn't posted yet. I didn't happen to have it, but it didn't seem like a tough request. I emailed back, "Sorry, I can't provide that picture but surely you can find it easily. The only alternative I can offer is this photo from my Web site but it shows a white family on a picnic." To my surprise, they chose my photo.

Some weeks later, I saw that client at an industry meeting and asked about her difficulty in finding the right photo of the Hispanic family, and why they'd settled for a white family. She sighed and explained that there hadn't been time to shoot an assignment, so she had counted on finding it in stock. "I looked everywhere, on dozens of agency Web sites, but nothing worked for our concept." They had wanted to target the Hispanic market and appeal to a mainstream middle class audience. It seemed very odd.

Were there other pictures of family picnics in stock agencies files?

Yes.

Why didn't they work?

As the client explained it, most everything she saw was one stylistic extreme or another. Some photos were in the style of gritty photojournalism. Others were too far on the other end of the spectrum, showing the current taste for oblique angles, extreme soft focus, or moody color. There were none that presented a Hispanic family in a well-executed photo with an approachable, authentic warmth in the family interaction—and at a picnic.

This anecdote is not an isolated occurrence. I have heard many variations of it from stock clients who can't find exactly what they need. It may seem as if virtually everything in the world has been photographed somewhere by some-body. But that doesn't mean the photographs are a suitable style for all stock users. Or that they fit all concepts. I admit being constantly surprised that even with the seeming glut of images being produced by eager photographers, there are still so many holes in agency files.

The holes are there because either photographers haven't thought to shoot the concept or the agencies have edited down, showing only a limited selection of styles that matched current taste—often concentrating on the most fashionable, faddish approach.

Later in this book you will learn more about the technological, stylistic, and economic reasons for the gaps. We'll also explore the way you can fill the gaps by tailoring your techniques for the stock industry.

WHAT IS A STOCK PHOTOGRAPH?

The definition is straightforward: a stock photograph is an existing photograph that is available in the files of a photographer (or photo agency) to be loaned (licensed) for reproduction use to a wide variety of clients. Stock photographs are different from assignment photographs, which a photographer is commissioned by a client to create specifically for its needs. Stock exists, whereas assignment is potential or proposed photography. Ownership is the key issue. A photograph can't be your stock if you don't own it. You do automatically, under law, own the rights to a photograph at the moment you click the shutter and the image is fixed on film or on a memory card, unless you have a contract that gives those rights to somebody else, such as an assignment client. One should avoid contracts that take away your rights to a photograph. You will learn more about ownership later in the copyright chapter.

WHY THE WORD "STOCK"?

The word can cause confusion, especially for those searching the Web because "stock" to the general public refers to company shares traded on a stock exchange. Proof of this comes through reports from photographer friends who use the word *stock* in the name of their Web sites; they get hits from people seeking financial information. But the term stock, with reference to photography, means it's available—it's "stock on the shelf." In the early years of stock there was a lingering taint attached to the word for some photographers and clients, who regarded stock as lesser form of photography, below the quality of assignment photography. But that pejorative disappeared as stock evolved to where it is now—a valued type of image, a mainstay for clients. Today's stock photographs can be every bit as creative as the most artistic of personal or assignment photography.

WHERE DOES STOCK COME FROM?

Essentially, stock comes from five sources:
1. From a photographer's personal shooting, that is, work derived from independent projects, such as those taken while traveling or simply when shooting for the sheer joy of it. These are the pictures you've been taking all along, photographs on which you hold the copyright.

2. From photographs created specifically with stock in mind—that is, photographs based on the photographer's sense of market needs or at the suggestion of a stock agent: pragmatic but creative photographs. (More later about the costs of this type of photo production versus the projected income it might generate.)

3. From assignment outtakes—these are photographs available after an assignment has been completed and after any time restriction has expired. When negotiating with assignment clients, a photographer should grant nonexclusive rights and try to negotiate a time limit that is reasonably short so that their good stock is available soon for marketing.

4. From stock productions done with agency participation—joint ventures. Though still not the norm, cooperation between photographers and agencies in financing the production of stock is steadily increasing. Cooperation between photographers and agencies in financing the production of stock is available to a select group of photographers who have proven their value to an agency.

5. From royalty-free (R-F) shooting. Royalty-free shooting occurs when the photographer accepts a fee and turns over all rights to the company producing and or selling the R-F images. There can be a variety of financial arrangements when shooting for a royalty-free company, but generally the process provides immediate cash—but because the photographs are often sold outright to the company, there are usually no residual licensing fees. In other words, there is nothing to add to the photographers long-term income flow. This form of stock was called by the derogatory term "clip art" when it first appeared about twenty years ago. The relationships between royalty-free shooters and royalty-free companies continues to grow and change. And some major stock photographers have begun to participate in royalty-free production. (In chapter 9, Running a Stock Photography Business, there will be a greater discussion on this segment of the stock photography market, which has grown beyond what veteran stock shooters could have imagined.)

LICENSING RIGHTS

We speak casually of "selling" stock, but, except for some royalty-free arrangements, nothing is "sold"—no product actually changes hands. It's important to reinforce the idea that you are *not* "selling" photos, though that's the easy term and commonly in use. The client doesn't buy or own an object after the stock transaction is completed. In correct terminology, stock use is the licensing of reproduction rights. By way of the license, the client receives permission to reproduce a photograph for the usage specified on the photographer's invoice. The usages that are licensed might be as diverse as an illustration for a magazine article, a consumer ad, a calendar, or a menu cover. If the photograph happens to be physical, tangible property, such as a print or transparency, it is on loan for reproduction purposes only and is returned after use. As is more likely today, you are granting permission to use the digital file of an image provided for reproduction. Photos you value should never be sold outright; with proper vigilance in licensing stock, your photographs can have a long, fruitful earning life.

WHERE STOCK IS USED

The major markets for stock break down into the broad categories of advertising, corporate, and editorial.

- ADVERTISING AGENCIES use photographs for a wide range of client products or services in many types of ads. The best known are national consumer ads, which appear in publications circulated to the general public, and trade ads, which appear in publications directed to a particular industry, such as hospital-equipment manufacturers or the metal-refining industry. Stock photos sold to the advertising market command the highest prices.
- CORPORATIONS use photographs for corporate annual reports—(often to extol their productivity to stockholders)—for brochures, and in internal magazines. They use photographs ranging from executive portraits (usually shot on assignment) to gritty scenes—often turned into stunning graphic symbols—of workers on an assembly line, in food processing plants, or in a textile mill. The prices paid for corporate use can be on par with advertising, but are usually somewhat less.
- THE EDITORIAL MARKET for stock, primarily magazines, trade books, textbooks, and newspapers, has a high volume of "sales" but historically the lowest fees in the stock industry.
- AUXILIARY MARKETS include a wide variety of uses, from calendars and greeting cards to bank checks and T-shirts. In fact, these markets extend to every conceivable use a photograph can have.

Not so many decades ago, in the 1970s and 1980s, stock photography was thought of as a cottage industry. Now stock has blossomed into a billion-dollar business with very specific and fast-growing needs, and complex problems for photographers to handle.

WHO SELLS STOCK?

Some photographers market their own work to stock buyers, but many leave that aspect of the business to one or more of the many stock-photo agencies in the United States and abroad. Originally thought of as picture archives, today's stock agencies are much more than mere repositories of photographic images. In addition to handling scanning, keywording, filing, billing, and licensing of reproduction rights to clients for a percentage of the reproduction fee, agencies spend large amounts of time and money maintaining and upgrading complex electronic marketing systems through a series of Web sites. In addition, they are constantly researching and opening new markets for the use of stock photography.

In the United States, the Picture Agency Council of America (PACA) is a trade association that represents the interests of member photo agencies. Its Web site is *www.pacaoffice.org*. The British Association of Picture Libraries and Agencies (BAPLA) does the same in the United Kingdom. Its Web site is *www.pbf.org.uk*.

TAKING A LOOK BACK

Where did it all start and why does it matter? An understanding of the shifts in the attitudes and economics of stock over the years can inform today's stock photographers. It is helpful when negotiating to have a keen sense of past realities and prejudices because the ploys used by clients over the years cannot be countered if not understood. For those who want to understand the history of the business, here's an overview.

In the late 1880s, the invention of the half-tone printing process made it possible for newspapers and magazines, such as *Harper's Weekly* and *Frank Leslie's Illustrated News,* to reproduce photographs instead of the line drawings that had been their only illustrations for almost a half century. Since then, the market for photographs has grown from an enthusiastic need into an insatiable demand for exciting images.

Ways of getting paid for photography have varied over the years. At first, providing these images was the job of photographers working on salary for these nineteenth-century publications. There were also photography studios that sold prints, mostly of portraits commissioned by the customer. Later there were the emerging freelancers (before that term was used)—these photographers often sold prints of images outright rather than through the process of licensing we know today. The emergence of photojournalists and the modern magazine brought the concept of licensing to the fore in the late 1930s and 1940s. This trend was aided by the efforts of photography trade organizations like the American Society of Media Photographers (ASMP) and cooperatives like Magnum Photos, which endorsed the practice of licensing rights and protecting copyright. (For those interested in the origins and development of magazines, consult Art Kleiner's excellent article *The History of Magazines on a Timeline* at his web site *www.well.com/~art/index.hrml.*)

Early in the twentieth century, the first photo libraries were set up, licensing rights to stock images (all in black-and-white, of course) of such predictable subjects as babies, animals, and staged photographs of people.

The next development was the emergence of assignment agencies in both Europe and America designed to produce photo stories for magazine syndication. After World War II, the advent of color photography influenced the agencies of the period, leading, in the mid-1950s, to the establishment of photo researchers, the first modern photo agency, to make available assignment outtakes for stock. To satisfy a burgeoning demand for stock photos, inspired mostly by the post-Sputnik needs of the sciences and the TV-generation's craving for visual images, new agencies sprang up all over the map. These agencies, like their predecessors, were still based on whatever photographers chose to contribute—personal work or assignment outtakes—and their market was primarily editorial.

A significant change occurred when The Image Bank, the first agency to serve the advertising market was founded. Assaulting the bastion of big-money assignment photography, this agency introduced aggressive sales techniques and,

new to the stock industry, the concept of worldwide franchise agencies. With this opening of the previously untapped advertising market and the introduction of tough and sometimes glitzy marketing approaches, the 1970s saw the rapid and irreversible move away from the small-business mentality that had prevailed in stock in the past. As a result, stock photography changed more in one decade than in the previous six. What was once a mom-and-pop handshake business became irrevocably altered for the better—in financial terms—but the informal atmosphere that had appealed to many photographers and agents alike was fast waning. However, the changes opened up exciting new opportunities for photographers who wanted to concentrate their efforts on stock.

A bonanza in stock opportunities was under way. Like the Forty-Niners sweeping into California during the gold rush, every photographer who had heard the word "stock" rushed into the arena, some lured by the illusion of easy money.

New agencies stretched the accepted boundaries of the industry and prospered. Others overreached and failed. By the end of the twentieth century, as we'll see later, merger mania had swept through the business. The result was that giant agencies now control most of the business. Veteran agencies either struggled to survive or were swallowed in mergers; regional or specialty agencies created their own niches in the hectic shuffling for position in the new marketplace. For photographers, there were success stories, a few horror stories, and a lot of questions about the future of stock and their place in it.

During the same period, digital technology created a definitive and global shift in the way all photography, including stock, was produced and marketed.

CHANGING PERCEPTIONS OF STOCK

During the 1980s, certain preconceptions were changed or put to rest. For many years there had been the underlying sense, held by photographers as well as clients, that stock was the "poor relation" of assignment photography. Stock was thought of as second-rate photography, commonly described by such negative words as "cliché," "mundane," "trite," "hackneyed," "ordinary," and "predictable." A popular phrase summed up the prevailing opinion: "Stock is schlock."

Another widely held notion was that stock is gravy, easy money. Photographers contributed to this fallacy by eagerly taking whatever sum was offered, in order to clinch the occasional stock sale. The idea that stock photography was "found" money was not easily dispelled. What many photographers didn't realize was that the value of a photograph doesn't diminish simply because the work has already been done, whether last week or last year. The fact that the photograph exists—and does not have to be created anew—does not mean the photographer should license it at a low fee.

The irony in under-pricing stock photography is that, for many years, few people in the industry realized or acknowledged that stock has the value of being risk-free photography. Stock has none of the weather problems, technical difficulties, or

schedule delays sometimes associated with assignments. The photograph is there, finished and ready to be examined by an art director and wend its way through a client's approval process. An early ad from a stock-photography agency called on photographers to "dust off those old yellow boxes—there's a gold mine in your closet." The attitude that there was stock value attached to any old picture someone had hanging around gave amateurs and even some professionals false expectations. It reinforced the disdain of many buyers who dismissed stock, and it discouraged top photographers, who held their profession in higher esteem, from taking the stock business seriously.

The problem of winning respect for stock was not easily solved. Even photographers involved directly with stock sometimes gave short shrift to their stock agents by sending only outtakes, also called seconds or brackets, to agencies. When shooting for stock, these photographers often failed to give the same care and attention they gave to assignment work. "After all, it's just for stock," was their attitude.

With the entry of first-rate photojournalists and magazine photographers into the stock field, these old and largely negative perceptions began to fade. This shift became complete in the 1980s, after the advertising and commercial players had joined the game. As the quality of available stock increased, and with the rise of digital imaging in the 1990s, there was a movement by clients from assignment to stock, giving an advantage to photographers who had embraced the new technology.

CURRENT TRENDS

Some aspects of stock have not changed. Photographers still shoot universal subjects and concepts, but the look of the images changes with the style of the era. Stock is no longer a poor relation to assignment photography: it is a very competitive field and mediocre images don't stand a chance. Successful stock today sends more than just a clear message; it stands as an icon that communicates concepts directly to the viewer. The new stock is executed with finesse and meticulous craftsmanship—and often in the most contemporary or strikingly new style, influenced by everything from YouTube to the nightly news.

Stock-photo agencies have changed too. Some have bolstered the new image of stock by promoting professional service to buyers by including cutting edge electronic delivery of images and by demanding consistent quality from their photographers over a wide range of concepts. Agencies have also made major investments in new technology.

Agencies are acutely aware of the need for a constant supply of fresh, exciting new photographs. They actively encourage photographers to produce stock—in some cases, they participate in the process themselves through financial support for set-up production photography which is otherwise produced at the photographer's expense. In the competitive arena of today, photographers must go to the limits to meet market expectations and retain a piece of the pie.

In addition to traditional stock agencies there are new marketing entities called "portals." A portal is a place that connects you to other locations where stock photography is marketed, such as very small agencies or individual photographer's web sites. Portals offer innovative ways to get your photographs in front of buyers; these will be covered in chapter 9.

WHERE DOES THE BEST STOCK COME FROM?

During the evolving process of stock in the 1980s, there was a debate about whether assignment outtakes or stock production provided the best stock. Photographers pondered how to reconcile the demand from stock agencies for saleable images with their own desire to shoot creative, innovative, personally satisfying photographs. Reduced to simple terms, the agency wanted product, while you, the photographer, wanted to make creative photography.

The dilemma is a familiar one. The issue of creativity versus someone else's needs has always plagued photographers. Photographers asked themselves these questions: Where is spontaneity in seeing, in personal vision, in the excitement of experimentation? How does pressure to create saleable product affect our creative satisfaction? At what point do creativity and innovation become deadened by production of a predictable image?

Today that question doesn't "obtain," as the Brits would say. Not only are the two goals not mutually exclusive, the good news is that agencies and clients now demand the highest level in creativity and innovation. Competition has brought that about. Agencies hold their photo editors and photographers to the same high standards set by their clients. To that degree, we are on the same page. You'll see in chapter 9 that changes in the economics of the industry make it more urgent than ever for photographers to produce superior work and to follow their aesthetic vision.

MERGERS AND ECONOMICS

The trend that began in the 1990s toward fewer and more powerful agencies has become a shift of tidal wave proportions. Corbis (owned by Bill Gates) and Getty Images have between them acquired many significant photo agencies, thus creating the twenty-first century's mega-agencies. We now have two monster corporations dominating what only a few decades ago were mainly family enterprises. There are some alarming aspects to this trend. One is the difficulty of gaining representation in these mega-agencies. Overall, there are more photographers competing for representation in fewer agencies. Also, there has been a rise in the use of in-house photographers—those who work on staff for the agency. Photos created in-house can cut into the potential for sales by the agency's contributing freelance photographers. Finally, the fewer the agencies, the more firmly they can control pricing. As the big agencies compete for market share, they offer volume discounts to clients. This contributes to a downward movement in pricing. In addition, photographer/agency contracts are being dictated by the agencies.

Now more than ever, contracts will require your keen business eye and the help of your lawyer to get the most favorable deal you can.

On the plus side, these corporations have unparalleled electronic capabilities, which can work to your benefit. It's useful to remember the marketing power they can represent on your behalf—if you can get representation. The reality check is to understand that getting accepted by these mega-agencies is extremely competitive. And the economics of investing money in your own production shoots must be carefully considered. (You'll find more about these trends in Chapter 9: Running A Stock Business.)

EXPECTATIONS

There is a niche in stock for the talented and truly dedicated person. Whether you are an assignment photographer who hasn't yet made the transition to stock, an entry level professional who wants to build a career in which stock plays an integral part, or an avid photographer from another profession who wants to understand and participate in stock, you can search for a place.

Where Do You Belong in the World of Stock?

One school of thought says that it's wrong to encourage any photographer to consider stock as a viable profession. Their argument is that the dwindling of midsize agencies, the power of the mega-agencies negotiating for a bigger market share by lowering prices, and the further downward spiral of prices due to availability of cheap photographs on the Internet all combine to create a discouraging climate.

Certainly, realistic expectations are important because each year there is more competition. However, I decry the doomsayers. There will always be a need for images. Somebody must produce and market these images. It's not as easy as it once was, but as old photographers drift away, new ones enter bringing new vision and energy. Even during the Great Depression, new businesses were created as old ones foundered.

It helps to find your place in stock if you do what you do best. However, some photographers go astray when trying to shoot exactly what a stock photo agency wants or what they think the market needs. This happens if the concept or style requested doesn't appeal to you, or doesn't match your skills. Then the results can be sterile, mechanical, lifeless photography. By all means, experiment and try different styles. But don't force what is foreign to your own sense of style or vision. You can't achieve if you don't believe. As you'll hear throughout this book, whether marketing through an agency or on your own, your approach must be the same, which is to create the best, most vital images possible.

Producing successful stock lies in finding a balance, a harmonious relationship between salability and fine photography. The creative challenge for you, the photographer, is to find a way to breathe life into your own work, making it grow and bloom. The most effective approach is to view everything you shoot for stock

as a portfolio piece. Choose the stock concepts that most appeal to you and give them the same care and love as you would give your portfolio samples or an assignment from your most demanding client. This theme will be repeated throughout this book.

How Will You Succeed?

Start with a belief in the value of your photography. Approach stock with the conviction that you will produce and market your work on as high a professional level as anyone in the business—and that you will develop your style of photography to its fullest. Then arm yourself with technology, your greatest ally in today's competitive market. Total immersion in digital imaging and a full understanding of electronic marketing are key.

The economics of stock have changed dramatically in recent years, so a good business sense is an invaluable asset. Even if it's not your strong point or even an area of interest, you can learn (through this book and elsewhere) how to handle business and negotiation. Don't give up on it. Though photographers have had the value of business skills preached at them for years, these days it's not crying wolf to say that sound business management of your stock-photography profession is essential. In practical terms, finding ways to finance your own stock production without spending huge amounts on lavish productions is a new challenge. It has always been tough to finance stock productions, but now that stock prices are being pushed downward by the mega agencies, it is critical to find innovative ways to control costs on your stock productions. We will look at that in later chapters.

The fervor and imagination that you bring to photography can be channeled into building a strong stock file. There is satisfaction and profit to be found in stock photography, but only if you bring time, energy, commitment, and a keen eye for business to the profession.

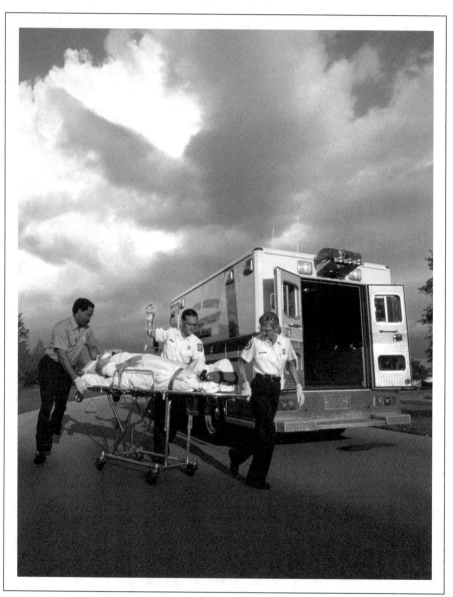

Paramedics. Sarasota, Florida

How to Shoot for Stock—Style and Concept

P olonius was not thinking of photographers when he advised, "To thine own self be true." But as a guide for shooting stock, he couldn't have been more apt.

STYLE

In photographic terms, style is your point of view, that distinctive, characteristic way of seeing that distinguishes your work from others—your personal vision. It is the expression of an idea. It is the form rather than the content of a photograph. Style is *how* you shoot rather than *what* you shoot. As true in stock as it is in assignment work, developing your own style is central to success and joy in photography. It is important to understand, define, and refine your style, and know where it fits in the market. In the same way, it's important to be aware of changing trends in the style of photography buyers want, as we'll cover later.

Over the years, certain markets for stock have been characterized by specific styles, and this led to the following assumptions:

- Advertising requires photographs that are close-ups, evocative, having a sense of immediacy and clear, simple messages.
- Both advertising and corporate markets require photographs featuring strong graphic statements that reduce the subject to design elements.
- Both advertising and fashion markets look for photographs that contain surreal, inventive fantasies.
- Editorial markets prefer photographs that are literal, detailed, spontaneous, authentic, and informative.

Today, many of these stylistic assumptions have been shattered. In the client's urgent search for new approaches, preconceived notions have been turned upside down. Clients are using any and every photographic style in an effort to break the old molds. In the 1990s, we saw that advertising adopted a style of grainy, gritty reality

once seen only in photojournalism, while many magazine photographs were stage-managed productions using the slick lighting style previously associated only with advertising. These trends started with assignments, and the influence spread to stock.

Today, you may see stock images with extreme soft focus, or scenes with unexpected cropping such as body parts emerging into the frame at oblique angles, or people framed by exaggerated out of focus objects—and that's just the beginning.

X-Style

For want of a better term, I'm going to use "X-style" (for x-treme) to indicate what has become common in today's stock—an extreme approach to photography in terms of angle, cropping, and framing, as well as color.

This simply means, in contrast to what had previously been considered standard, today's photography pushes composition to its furthest limits by showing only fragments of the body or cutting off body parts in new ways. This gives the photograph a high intensity sense of action and spontaneity. There is an impulsive quality, as if the people in the photograph are not only not aware of the camera, but are shown in all their artless impetuosity. We believe in their unstudied reality.

Another aspect of the X-style is an extreme approach to the angles in a shot. You see many more photographers shooting from below, shooting from above, using extreme wide-angle lenses for exaggerated perspective. Effect is everything; standard reality is passé.

Alternative Marketing

In addition to the X- style of photography, we've seen the emergence of an approach to advertising both in video and print called "viewer-created content," "crowd-sourcing," or "guerilla marketing."

There has been a burgeoning of creative content originated mostly by amateurs, probably inspired by the success of YouTube™ (*www.youtube.com*).

One move that caused considerable stir at the time was the approach taken by the Doritos Company in their ads for a Super Bowl game. The company invited viewers to design and shoot their own video ads, naturally on the topic of Doritos chips. The submissions were narrowed down to five finalists (who received payment and a trip to the Super Bowl). Fans were invited to vote online for their favorite of the five finalist videos to help select which commercial was aired during the Super Bowl. The VP for marketing of Doritos was quoted as saying, "In today's increasingly reality-driven world, people are looking for new ways to interact with, help shape, and even personalize what is important to them."

Clearly it's also a way to get five times the response to the ads, and to do it in advance of their airing.

Another trend from the same period of time has been termed "guerilla marketing," and encompasses a variety of innovative, unconventional, and sometimes

outrageous marketing schemes. Essentially it is the process of breaking the boundaries in order to get attention for a product. For example, in February 2006, battery-operated, lighted devices were attached to buildings, highway underpasses, and other unconventional locations in Boston. The city was brought to a standstill until it was discovered that these devices were not bombs, but merely part of a guerilla marketing campaign for a TV series on the Cartoon Network.

It remains to be seen if guerilla marketing is a flash in the pan or if it will continue to flourish and install the "YouTube" manner of creating content as a staple of advertising both in video and stills. The effect this has on stock photography bears watching. It seems logical that there will always be a market for somewhat mainstream depiction of family, lifestyle, and the corporate world for use in selling products to a traditional audience of buyers. However, each generation brings its appetite for something different. If your strength is in expressing that something different, by all means, exploit it.

Some photographers still shoot with predictable composition to meet the needs of clients looking for traditional photography. But your greatest success in stock will come from trying to be ahead of the curve in terms of style, not behind.

Your Place in the Trends

You can research what's current by looking at advertising and magazine photography to learn what styles are in favor. However, there is no point in trying to shoot in a style that is current if you aren't adept at it. As important as it is to be aware of market trends and sometimes faddish swings toward specific styles in stock, what counts most is understanding your own photographic abilities and where they fit within these trends. Express your version of the current style with panache and your own interpretation.

This is where Polonius comes in. Know who you are as a photographer. Have a sense of your own style and be true to it. In pinpointing your style, a first clue is how you feel about photography. Do what you care about—what you can do wholeheartedly with the full passion of your love for photography. Keep what is spontaneous and authentic in your view and style.

Many photographers are lured by the stories of huge sums to be garnered from certain types of pictures. They leaf through catalogs, read articles on best-selling stock, and visions of sugar plums (or bank accounts) begin to dance in their heads. However, trying to shoot in a style that isn't natural to you is a recipe for failure. That doesn't rule out experimenting with new techniques or taking risks to stretch your photographic abilities. What it does mean is that you should avoid shooting what doesn't feel right or what doesn't excite or please you photographically—saleable or not. If it's contrary to the way you see the world, to what you care about visually, then it won't work—for you or for stock.

If you are represented by an agency, don't simply ask your agent what is the most lucrative area of stock, ask yourself, "What is it that excites me, gets the

juices flowing?" Then get your agent's view of the potential market for this type of work.

Use your strengths and improve on them rather than trying to mimic what you can't carry off. You don't want to be a second-rate copy of another's style. The stock agencies are bombarded by photographers offering pale imitations, but they are unlikely to be accepted. Or these same mediocre imitations if put out on a photographer's Web site are less likely to sell than an authentic, well-executed style.

Trust your abilities, be proud of your style—hone and polish it. If you shoot what you feel passionate about in a style that excites you, the chemistry will show and those pictures should be saleable to the right client.

If you bring to your stock an authentic, original quality, it won't feel like pat and predictable stock, but like photography—and it will be yours. Understanding the philosophical underpinnings cannot be overemphasized. It is as important as choosing the right material to shoot. You may be lucky enough to have a clear grasp of your work and a well-defined shooting style. Regardless of the specific photographic technique being used, the best of current work will be imbued with a distinctive flair and vibrancy.

ANALYZING YOUR STYLE

A number of years ago I learned something about my style, quite unexpectedly, through the eyes of a photographer friend. We had both been to China on different types of assignments. Hers was magazine travel photography; mine included an editorial shoot for a book publisher. We decided to have supper one evening and view each other's China pictures. "It's fascinating to see how you shoot," she said, after seeing my work. "It's so different from what I would have done with that scene."

When I seemed puzzled, she continued, "Your pictures are telling me a story of how people live in China—they give me information and understanding of the culture. Mine, on the other hand, are designed to make the country look attractive, to be appealing to a visitor or a tourist." It was suddenly clear that she had identified our distinct points of view with great accuracy. Her comment told me something I should have known about my work but hadn't—I had never stopped to analyze or assess my style.

Using the insights of other photographers is just one of several steps that can help in defining your style. Here are some others:

- Look at your assignment portfolio and tear sheets. Sort them according to the various styles you have produced on assignment for clients or on your stock shoots. Which ones have been most successful for you photographically? Separate the portfolio pieces to represent the work that you most enjoy doing or that you are most proud of and see where it falls. Is it most suitable to advertising? Editorial?

- Look at the history of your personal, non-assignment work. What choices have you made in terms of style? What appeals to you? Have you been using your photographs to tell a story? To make a graphic statement? To create a fantasy?
- Consult with colleagues, workshop leaders, or photography teachers. Whether with photographer friends or teachers, ask which aspect of your style is most successful, what your strengths are, which aspect needs more development, and where your work might fit in the market. Take them off the hook. Let them know that you are not looking for a "good" or "bad" judgment. You can get a very valuable professional critique if the reviewer believes that you are ready to listen and not be defensive. If you are simply looking for praise, you'll learn a lot less.

At workshops when I review portfolios for students, I usually ask, "Where do you see yourself in the market? Where do you want to be in five years? What kind of clients have you targeted?" Then, after discussing their marketing focus, I ask them to show me the work that embodies their artistic and stylistic preferences.

This helps to see if the students have analyzed these questions for themselves. Based on their answers, I can give a useful critique. If you offer this information to a colleague or teacher who is willing to review your work, it will say to them that you've taken the first steps to understanding your own work.

- Compare your style.

Match your work to photographs you see in magazines, annual reports, brochures, etc. Is your approach most consistent with these photographic uses? One easy research technique for the purpose of pinpointing your style is a clip file. As you'll see below, a clip file is composed of samples of photography you cut from a variety of publications.

SETTING UP A CLIP FILE

A clip file will be very helpful in developing strength in every aspect of stock photography. You'll use the clip file for market research; to identify concepts; to analyze lighting techniques, use of color, gestures, and the integration of the photograph with the copy—in short, for everything that you can learn from dissecting a photograph. In addition to photographs, you will find headlines and tag lines from ads that will help identify concepts. Creating a clip file is an exercise I've advocated for years. In working on this book, I stopped to consider if it still seemed useful. The very next day I got a credit-card bill, only to find a very interesting mailing piece enclosed. The brochure had photographs that caught my attention because they showed yet another batch of styles and an approach I hadn't seen. So, yes it's still useful to keep a clip file.

Start your clip file by collecting photographs from magazines, brochures, annual reports, and newspapers. If you don't subscribe to many magazines, invest in a big batch to get your file started and your mind whirring. Buy copies of

magazines covering a wide variety of topics from news to sports and fitness, business magazines to travel, and social events from bridal to parenting magazines. Some libraries have places where people can deposit used magazines; you can stock up there too. Don't forget the foreign language publications. Inundate yourself.

Your clip file can be kept in a physical form by sorting clippings into categories in actual file folders. Or you can make low-resolution scans of each clipping and organize and cross reference them in digital form.

Once you've exhausted what's available on the newsstands, scour your dentist and doctor's offices for medical magazines (beg for some back issues). Then make a trip to the library for some annual reports. Select a few corporations that use fine photography in their annual reports, then write to them asking to be put on their mailing list. Even junk mail finally has a use—some of what you receive will be sales-pitch mailings from credit-card companies, utilities, and other businesses using high-end consumer marketing tools. Look at the style of photographs they use to help understand lifestyle trends and the markets they are trying to reach. Finally, don't forget the streets; bank ads in windows shout slogans at us every day—and provide great "tag" lines to think about.

The one thing you *won't* use your clip file for is copying. That is copyright infringement and, very simply, it's against the law. Even if you make small changes in your version of a photograph that you have seen, if it is "substantially similar" you could be held liable, as you'll learn in chapter 13. To avoid the dangers of copyright infringement, use the reference photos in your clip file to identify the idea behind a photograph—the style of execution—to distill the concept and look for a new way to express that concept.

A great value in looking at published photographs is that, like them or not, these are the pictures that won out—they were chosen for use over many others being considered. Keep in mind that any photograph you see published went through a complicated screening process—whether in the planning of an assignment or the often painstaking photo research to locate just the right stock picture.

Keeping a clip file will help raise your awareness of how everyday subject matter can be distilled into basic generic concepts and messages that are the essence of saleable stock.

ELEMENTS OF STYLE

Once you have a clear idea of your style, the next step is to match it with what is useful for stock. Let's consider the elements, including composition, backgrounds, color, and gesture elements that are used to express or reinforce your personal style. When used properly, they will enhance a photograph's usability as stock. Conversely, there are other elements and flaws that can diminish a picture's useful life as stock.

Here we'll concentrate on the design components of a photograph. Later, in chapters 4, 6, and 7, we'll cover the technical and production details that also have a strong influence on your stock.

USES FOR YOUR CLIP FILE

Clip photographs of all styles from magazines, brochures, and annual reports, as described in this chapter. Organize into basic category groupings (family, executives, lifestyle, socializing, etc.) Use your clip file to understand the following aspects of photography:

1. Identify Concepts

Analyze advertising photographs to determine underlying concept portrayed. What symbols were used to convey the concept? List them. Do a flash test—what words or symbols are instantly communicated by the photograph? For editorial photographs, analyze what information is conveyed. Is there an immediate message?

2. Negative Space

Analyze advertising photographs for empty or negative space where the copy is placed. Imagine the photo without type or logo. Where was extra space placed—which quadrant of the photo? How large is the "subject?" Where is it placed in relation to type?

3. Shape/Format

Look at the design of ads, book, and magazine covers. How many are verticals, how many horizontals? Note the elements that make the verticals successful.

4. Style

Look at photographs to discern the aesthetic choices coupled with the photographic techniques that went into the photograph.

5. Color

Analyze the use of colors—which colors predominate? What mood or effect was created? Was color used to direct the eye?

6. Gestures

Analyze the gestures in a photograph—are they authentic? How close are models? Is there eye contact? Does the body language seem genuine?

7. Headlines

Note the headline copy used in ads. Find new ways to illustrate the concept expressed—a new execution to fit the old concept. Compile your own list of tag lines to illustrate.

8. Analyze Your Style

Looking at a wide range of published photographs, see where your work fits or how it might be developed. What market are you best suited for—advertising, editorial?

Once again, don't use your clip file to copy the execution of a photograph—use it for understanding the structure and the stylistic approach. When you have finished work on the clip file, you should have a good idea of what is being used in the media and how your work matches up.

Composition

The composition of a photograph has an important impact on its effectiveness as stock and includes:

Shape

"Your 35mm camera will not break if turned on end" is one stock agent's way of bringing an important point home to photographers.

The message is: shoot verticals—vertical pictures are very much in demand. Full page ads, posters, book covers—all lend themselves to this shape. Further, there is a paucity of vertical photographs in the hands of stock agents. When a subject lends itself to either a horizontal or vertical shape, photographers seem to compose more often in a comfortable horizontal. If a subject seems to work only as a horizontal, stop. Look over the situation to see how you can get a good vertical out of the scene. Challenge your creativity. Hoist that camera upright! Whenever possible, cover yourself by shooting both shapes.

If you can't remember to do verticals try imagining that the picture you're shooting is for an ad appearing on the back cover of the *New Yorker* magazine. The fee alone should be an incentive. There will be some situations that don't lend themselves to a given format—but a flexible, imaginative photographer will meet the challenge by designing an arresting photograph in any shape. Solve this one: shoot a horizontal picture of a totem pole.

Space

"Great picture, but where can we put our ad copy?" Neutral space in a photograph is a boon to advertising-agency art directors or corporate-communications executives. It can be defined as an area that is more subtle than the rest of the picture—it might appear as blank space, such as an area with puffy white clouds or a snowy hillside, or simply be space that is less busy than the rest of the photograph. Art directors need a place for their logo, headline, or copy that won't destroy the photograph. Designing some neutral or blank space, into a photograph solves that problem—your challenge is to do it artfully.

This may not come naturally to you. If not, try making a series of grids for your viewfinder (or do it mentally) and compose variations with your subject in different areas of the picture; top third, middle third, bottom third and left, right, or center of each of those thirds, leaving negative space for type. (See the sample storyboard sketches in chapter six, page 124.)

You may resist this idea, thinking that it is a corruption of your photography shooting to fit an imaginary art director's layout. But remember: done properly it can, and should be, a dramatic photograph on its own, without the text. Over the centuries visual artists have used negative space for dramatic or surreal affect. The photographer's challenge is no different.

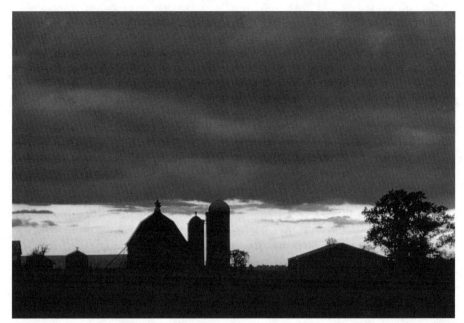

Neutral or negative space is obvious in the top portion of this photo. Imagine the color version of this photo with streaks of yellow and crimson separating the looming blue gray clouds from the silhouette of the barn and silos. It was licensed to a farm machinery manufacturer who put their ad copy in bold white type over the clouds.

I learned the value of negative space almost by accident, one twilight evening, early in my career, while on an assignment for a farm-equipment manufacturer in Wisconsin. Having finished the day's work, I was drawn outside by the glorious light and the dramatic chiaroscuro in the clouds. My final shot was a silhouette of farm buildings against the sunset with a brooding cloud overhead. I shot the picture for the love of a beautiful scene, but it happened also to have a perfect balance of space for type—the upper third was the dark storm cloud, the center was a slash of red and gold, while the bottom third showed the darkened barn roofs. Though it hadn't been part of the assignment discussion, the client paid for brochure cover usage and it has sold very well ever since as stock—all that and I enjoyed shooting it!

Look at the ads you see in magazines and imagine that the copy isn't there; some of those photos still work beautifully. Notice that sometimes text is dropped-out in white from a dark background, other times an art director will want to surprint dark type on a light background. It's part of what designers call "using negative space."

Take it as an artistic challenge to design exciting photographs that have neutral space—space that works well with or without text.

Cropping and Angles: the X-Style in Practice

There are unlimited approaches to the framing of photographs and the positioning of elements inside the frame. Going back to when Henri Cartier-Bresson first captured his "decisive moments," we have seen fine art and documentary photographs showing human figures cut off in strange or unexpected ways. But that approach wasn't prevalent in stock photography until recently. In traditional stock photography, the bodies of persons in the photograph were usually presented in predictable ways, if not in whole, at least with cropping done in a way that didn't startle the viewer.

You saw earlier in the chapter that this extreme approach to composition is reflected in TV and print advertising. In photography, this simply means the use of a radical approach to the way we show people, interaction, buildings, or horizon lines—an approach that has been pushed to its furthest limits and has become acceptable, even inviting. You see the use of drastic angles and exaggerated perspective to warp a scene from the reality we knew into a heightened, frenetic view of the world. It conveys a mood of life on the edge that characterizes this century.

Focal Point

Sitting in a darkened room, a person is wired to a computer and is viewing a magazine page displayed on a monitor. This is a common market-research technique. By means of the computer analysis, one can measure the position of a viewer's eye as it scans each page of a magazine. This allows it to track and chart where the eye moves and record how long it stays on a given subject within a photograph. The machine knows how long the eye lingers on the headline copy, the text, the photos, and the captions. Advertisers are using this technology to give accurate readings of what attracts and holds the viewer's attention.

What they have learned can help in designing effective stock photographs. Photographs that hold the viewer's attention have a simple, clear, arresting center of interest. Viewers look first at people in a picture, more closely at the face, and come back again to the eyes, and then to the rest of the face. They respond most to evocative photographs with a sense of immediacy. If the viewer's eye doesn't know where to go in a picture, you have a confusing message. The viewer's eye then often goes quickly to secondary areas of a picture. However, a strong directional movement or color should bring them back to the central element, the theme of the photograph that reinforces the concept.

Backgrounds

In general, backgrounds should be clean, simple, and clear of distractions. Keep in mind that distractions are not just problematic in esthetic terms but can adversely affect the salability of your stock. Distracting elements such as logos and brand names on signs in a background or on a models clothing are a death

STYLE TIPS FOR STOCK

To enhance your natural style, keep in mind the points in this checklist that will affect your stock

TRY FOR PICTURES THAT ARE	AVOID PICTURES THAT ARE
Simple, clean in design	Cluttered, confused, busy
Have clear messages, strong impact	Too detailed, burdened with information
Have interesting angles, unusual viewpoints	Predictable, standard perspective
Variety of color to suit the mood of the scene	Color used in any conventional way that does not enhance the message
Believable in gesture, filled with interaction and emotion	Contrived, artificial, stiff or posed
Authentic in body language	Out-of-sync with topic in use of body language
Clear of brand names	Filled with logos, trademarks, trendy sayings, ads
Vertical and horizontal	Horizontal exclusively
Designed with space for type	Designed without room for copy
Model-released/Property-released	Not model- or property-released.

Don't bend these rules in terms of not getting releases or by showing logos, but you can bend them in terms of color or angle. If you have courage and an imaginative presentation, most any photographic style can be successful.

knell to stock. Though it's an easy retouch in Photoshop to remove them, start by avoiding logos when you can. Good stock should be usable by a wide variety of clients and they have no interest in advertising a product other than their own.

A good background can take many forms but must always support the main purpose of the picture. Some successful backgrounds are neutral: uninformative settings for the subject, such as an out-of-focus wall of trees framing dad, as he strides forward with a child on his shoulders.

Another form is the supporting background, which gives information that reinforces the theme of the picture. Consider the concept "Memory." The setting is a cluttered attic. The subject could be a person reading old letters, a girl playing dress-up, or a middle-aged man with a football trophy. He or she will be surrounded by

trunks, clothes, and artifacts of the family's past—possibly a rain-spattered window under the eaves. Richness of detail reinforces the point of the photograph. However, the details must be blended and merged, creating a pattern that highlights the dominant character. Otherwise you have merely distracting clutter.

In terms of the X-style represented in backgrounds (or foregrounds), there has been a return of the use of blurred objects to frame an image. Framing is a technique we all used when we first discovered how to play with photography, but we kept it harnessed so they didn't intrude on the subject. Now, instead of just framing a subject, the blurred object may cut into someone's face, again to heighten the sense of impulsiveness.

Color

The emotional impact of color on a viewer is profound. It may be the single most influential element in a photograph—followed closely by the authenticity of gestures. Color attracts the eye, sets a mood, and, ultimately, can reinforce societal values.

Research shows that color creates subliminal associations in the viewer and touches us on a nonverbal level. In the color coding box in this chapter, you'll see the evocative aspects of the colors of the spectrum. Use them to affect your photographs. Understanding the evocative nature of color will help you use it to send clear, strong messages; a contradictory use of color may confuse or distort the intended message.

For example, understanding that reds and warm colors attract the eye and signify love and strength will make them desirable in such photographs as a family sporting scene, or that of a romantic couple by a fireplace. Your agent may advise on color trends, but watch for changes you see in publication photos or on the Internet. In the 1980s, stock agencies reported that warm colors tended to sell better than cool ones. But after a few years of power reds dominating photos, the palette shifted to gentle pastels, and subtle grays and whites were skillfully introduced to stock.

Today, color in photographs often takes its cue from the reality—or from the advertiser's perception of reality—to create a mood for dramatic effect. Advertising or fashion photography often mimics the style of the latest movies, music videos, or Internet videos, especially when targeting the influential 18-to-30 demographic. These films or videos may have color tonality that runs the gamut from high-key, bleached-out color to rich sumptuous color, or even murky, shadowy color.

Advertisers have adopted the use of color to evoke real life, so the photograph will resonate with the viewer. If we can identify with the reality of the viewer in the scene, it lends an authenticity to the advertiser's message—or so research tells us. "See, we're giving you the real deal." But their presentation of reality reflects the reality given to us in the movies and videos. So nothing is real until the viewer accepts it as such.

Of course, at the other end of the spectrum, the traditional fantasy images with lush color in the blue seas and palm tree-lined beaches are still used. The "blue skies from now on . . ." view of life can sell products. Everything goes, as long as it's done effectively.

Keeping up with Color

"Wasabi" green was a trend. And you thought wasabi green was found only in Japanese restaurants. Well, so did I, until I read an interesting article in the *New Yorker* magazine profiling the color industry. You may have known, or at least suspected, that there is a profession in which the practitioners are called "colorists," "color consultants," or "color-trend watchers."

These practitioners first identified the color wasabi green. It was spotted and became prevalent, along with its cousins chartreuse, mint, and pistachio, in the past few years. Colorists work for every imaginable type of product manufacturer—anyone who uses color in paint, fabric, furniture, carpeting, cars, sports equipment, and so on.

Many color consultants belong to a trade organization called the Color Marketing Group. While the results of the CMG meetings and forecasts are closely held by members, you can watch for the influences. At least go to their Web site, *www.colormarketing.org,* to learn information that is available to visitors and the media. The point here is that you can keep your eyes out for color trends and put them in your stock photos before you see them in all your competitors' photos.

Gestures

Body language is of primary importance in a photograph, and a close second to color in the impact it creates in a photograph. The physical relationship of people in your photographs should send a clear message to viewers.

There are two elements to consider. First is the authenticity or appropriateness of the body language to the role of the person in the photograph. Is the person or relationship believable? If you even have to think about it, the photograph doesn't work. Having the right gesture is a part of the all-important, nonverbal communication of good stock.

For example, a traditional view of the successful executive is that he or she stands with an air of authority. The average person in a suit is not necessarily going to convey an appropriate commanding impression for a traditional presentation of a businessman. If you don't have the real thing, try to find a model who understands power and can act the part. Then consider the "new" executive. Today we have young billionaires dressed in blue jeans overseeing airlines, search engines, and software companies. Create scenes that show people involved in the new culture of business.

It helps to do research and even make sketches. Watch people in offices, on the streets, in the halls of power. How do competent, successful men and women stand, use their hands, tilt their heads? Use your clip file to see which pictures of executives feel convincing to you. Observe parents and children in a park. What are the tender gestures that come naturally between them? This knowledge will aid you in directing your models and helping them to role-play their parts.

A second aspect to keep in mind is the relationship among people in a picture as expressed by physical space. Does a given group feel like a family? What are the clues? Is the picture intimate? How close do they stand to each other? Is this pair really a couple? Are they touching? Is there eye contact? Do you believe? Any contrived or awkward mannerism will undermine the conviction of your photograph. (See chapter 7 for tips on working with models.)

Spatial relationships also imply hierarchy and role. Who is in charge? Are the people seen in this group colleagues on equal footing? Or are we seeing a boss with staff? A traditional approach to office settings and wardrobe is still seen in many parts of the country and therefore may be suitable to stock. But be aware that in some parts of the new business culture, casual is the norm. When executives have basketball hoops in their offices, the old uniforms don't apply.

Other Aspects of Style

The style of your photographs will be very much influenced by technical choices in lighting lenses, and format (as you'll see in chapter 3).

Details count. Careful attention to propping, models, locations, set decoration, and choice of models is essential to the success of any set-up shooting you do for stock. (Chapter 6 will provide guidance on production elements, which can affect the style and value of your pictures, and how to avoid the pitfalls that can ruin your stock.)

CONCEPTS

It's been said by successful stock agents that they are not just looking for good photographers—they are looking for good photographers with brains.

Now that you have a grasp of what is involved in shooting for stock, we can turn toward the "what" to shoot. This is where you can separate yourself from the crowds of stock photographers out there by being a thinking photographer. "OK, so what *should* I shoot?" The temptation for many photographers is to grab at subject matter (which is given through specific assignments in chapter 5) and to ignore the integral relationship between subject and concept.

The most successful stock is that which conveys an immediate message to the viewer; it will communicate a thought or a concept. If concepts are the ideas or emotions conveyed in a photograph, then it is through the use of icons or symbols that the idea is conveyed. Find the right symbol and there's your subject matter.

For example, the concept of winning can be conveyed by a photograph of a runner breaking a tape in a race, a still-life of first-place medals, a silhouette of a hand with a trophy raised high, a horse's nose edging ahead of another's on a racetrack, a blue ribbon on a calf, or a simple laurel wreath. The actual subject matter may be track, horse racing, 4H, or a classical Greek wreath, but the icons chosen convey the concept of winning.

This is nothing new. Thousands of years of history have honed and polished the symbols that we recognize and respond to in art. The bull as a symbol of power

and mystery may have first been used by the cave painters of Altamira, Spain, appearing again (reincarnated) as the Minotaur of Crete. A scroll represents not only the Torah of Judaism but all things ancient and sacred. A slingshot is the weapon of the biblical David, but also has come to mean the triumph of the weak. In the catacombs of Rome, the fish read as the symbol of the early Christians as did the icon of the lost lamb in Byzantine mosaics. Out of the decadent eighteenth century came the cherubs of romance and love borrowed from an earlier and more innocent use.

The flag, the bald eagle, and George Washington emerged in nineteenth-century American folk art and endure as symbols of integrity, pride, and patriotism.

The relatively new science of semiotics (symbols and their function) became an area of fascinating research in the twentieth century. Through his seminars, photo agent Richard Steedman brought semiotics and the value of understanding nonverbal communications to the attention of the photo community.

For centuries painters and sculptors have tapped into the collective emotional consciousness of groups and nations through the use of icons. When we use icons in a photograph it is merely an update filtered through the sociological and marketing points of view of the early twenty-first century.

How well you make use of this information and match your concepts to a symbol (subject matter) will make the critical difference in your success in stock—especially in the big-money area of advertising.

Decoding a Photograph

An excellent technique for understanding concepts is to start with your clip file (here it is again), study the photographs in ads, and decode them. Take each photograph and identify the concept, then study the icons or symbols that conveyed the concept. Were they successful, were they an imaginative use of symbols, or were they clichés (overused icons)? What symbols could you use to convey a similar message? How could you say it better? What fresh approach could you bring?

It is important to understand that this process does not mean copying another photograph—what one agent calls "creative cloning." Not only might it expose you to a legal action for copyright infringement but the imitation would simply undermine your creativity. The reason to study these pictures is to understand their success or failure and to bring an innovative solution to the photographic problem.

ILLUSTRATING CONCEPTS

Convey these concepts through the use of visual symbols by illustrating the following ideas:

Togetherness (family)	Tenderness (couple)	Fun
Togetherness (couple)	Romance	Independence
Tenderness (family)	Sharing	Winning

Achievement	Fear	Stability
Victory	Values	Courage
Teamwork	Trust	Role reversal
Cooperation	Tradition	Freedom
Partnership	Security	Heaven
Competition	Loyalty	
Stress	Responsibility	

In terms of stock photography, there are several ways to make the transition from thinking and shooting subject matter to thinking and shooting concepts. You can take headlines from your clip file and dream up a new way to illustrate those headlines. Let your mind roam. Or take a group of concepts and see how many possible images you can list that would make interesting visuals. Start with symbols you've already seen used for a given concept. Now push your imagination to come up with new ideas for photographic illustrations. (There will be some suggestions for concept shooting in the stock assignment section.)

The concept of teamwork and cooperation has been illustrated with a variety of symbols: tug-of-war, barn raising, hands across a stream, and the ubiquitous handshake.

You can reverse the process by looking at what appeals to you: a prop, subject matter, or a location nearby, and pull out the inherent concepts. For example, if you live near a farming community, rather than planning a literal photographic coverage of farm activities, scout the location to find the symbols it has to offer.

A farm provides metaphors for abundance, harvest, fruitfulness, growth, sowing, and reaping. Once you've considered the concepts it can offer, choose some specific subjects to use as your symbols. Perhaps a close-up of a backlit hand dropping seeds in a freshly plowed furrow for sowing, a cornucopia basket full of fruits and vegetables, or a hand plucking from the tree a succulently ripe fruit glistening with dewdrops to show reaping or harvesting.

FINE ART

Stylistic boundaries in stock are broadening rapidly to include esoteric imagery formerly considered only as fine art. Buyers looking for a fresh approach are open to conceptual images, from hand-tinted black-and-white photos to painterly images created digitally. Stock-agency catalogs are devoting sections to conceptual images. If your work is in this area, research to see which agencies have embraced a fine art style within their collection.

Finally, the premise that governs stock photography today is that life isn't neatly packaged inside a rectangular camera frame. Nor do we expect to see natural color that reflects the actual, physical world. The X-style, with its oblique or

unpredictable use of angles and motion or blur and its palette of color that reflects the world of YouTube more than the world of traditional advertising, offers a clear message: anything goes—especially if it hasn't been thought of before. You can't say photographers are breaking the rules because there are no rules: the only requirement is to have an effective image.

As stock photographers, we can become visual translators—from concept to icon to subject matter or the reverse—finding the symbols inherent in the subject and finally ending up with the expression of the concept. The excitement of this approach is that you are able to cut through the mundane and find fresh ways to see and you are free to use your brain as well as your eyes. It is a great creative escape.

SYMBOLS

Like the icons throughout the history of art, visual symbols are used to evoke certain emotions and associations. In stock, they are commonly used to convey a series of basic concepts. Build your own list. Do you see other associations with these symbols used in photographs or other symbols that would clearly express a concept?

Ball (baseball, football, soccer)	competition
Ball (toy or rubber ball)	childhood, innocence
Sports (football, running, boxing, pole-vaulting, tug-war)	controlled warfare, business competition, pushing to the limit
Teams	cooperation
Barn raising	cooperation
Hands—shaking	cooperation, partnership, trust, honor
Hands—fist	anger, threat, power
Hands—holding	security, tenderness, trust, friendship
Dog	loyalty, friendship, trust
Horse	endurance, strength
Bull	strength, mystery, power, Wall Street
Columns	strength, security, power, history, tradition
Stone wall	permanence, stability, dependability
Fences	stability, order, traditional values, good neighbors

Family	traditional values, warmth, nurturing, roots
Graduate	achievement, pride
Teddy bear	childhood, innocence, comfort
Attic	memories, tradition, fantasy, dress-up
Apple pie	mom, America, wholesomeness, traditional values
Apple	health
Bread, wheat	health, staff of life
Patriotic symbols (flag, eagle, Statue of Liberty)	America, democracy
Rural icons (picket fence, front porch, barber pole)	America
Current technology: cell phone, iPod, Blackberry	up-to-date
Road	straight and narrow, mystery, adventure, unknown
Arrow	hitting bull's-eye, hitting mark, straight arrow
Wheel	simplicity, eternal, movement
Clouds	heaven, cloud nine

EVOCATIVE COLOR

Note some of the predominant associations and moods connected with colors, both the positive and negative connotations which can be used in designing your stock. Remember that the color associations listed may vary in other cultures and may not translate well across cultures. Consider where your stock is to be marketed and adjust it accordingly. For example, red equals money or good luck in some Asian societies (brides wear red), but in our culture it can mean sin, passion, or adultery as well as power. Similarly, white is the color of death in some Asian countries, but here brides wear white.

RED:	Dominant color, the eye goes there first
Evokes:	love, passion, heat, bravery, stop
Negative:	war, rage, blood, danger
Examples:	valentine, god of war, red-handed, seeing red

YELLOW: Life-giving color, the sun
 Evokes: joy, optimism, happiness, prosperity,
 gold, riches, glory, power, splendor
 Negative: cowardice, warning, sickness, quarantine,
 jaundice
 Examples: yellow journalism, yellow streak, gold
 credit cards, "not all that glitters . . ."
BLUE: The color of tranquility, the cosmos, infinity
 Evokes: relaxation, trust, integrity, security,
 escape, cosmos, universe, among the
 stars, blue water
 Negative: sadness, melancholy, depression,
 cool, cold
 Examples: Blue Skies Smilin' at Me, blue
 chip, blue Monday, Singin' the Blues,
 blue with cold
GREEN: The color of nature and life
 Evokes: health, growth, fertility, spring,
 rebirth, renewal, lushness, cool, go/safe,
 money, youth, inexperience
 Negative: envy, jealousy, poison, nausea, sickness
 Examples: green light, green around the gills
BLACK: The color of mystery and power
 Evokes: sophistication, chic, elegance, classicism,
 power, authority, mystery, uncertainty
 Negative: death, mourning, fear, evil
 Examples: tuxedos, limousine, blacklist,
 black sheep, black magic
WHITE: The color of peace
 Evokes: purity, cleanliness, innocence,
 light, truth
 Negative: cowardice, surrender
 Examples: white knight, white horse, white
 elephant, white flag

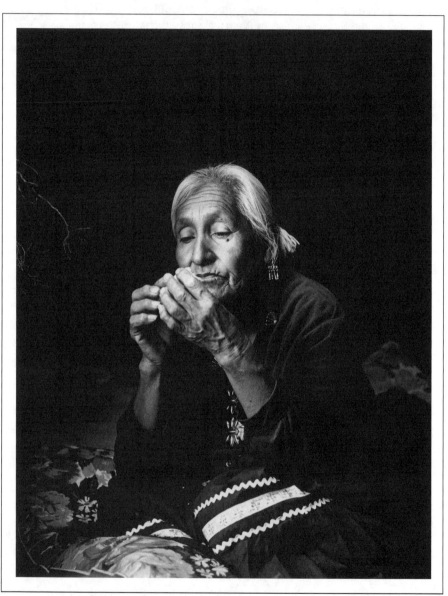

Navajo woman, Dora Pino. Magdalena, New Mexico

Equipment for Capturing and Scanning Images

The stylistic decisions you make with your eye and brain must be transferred to an image. Your understanding and mastery of equipment and technique will determine how close your images come to your original vision.

If you are an experienced assignment or stock photographer, you have all the equipment and technical knowledge you need to prepare for your foray into digital stock. You will adapt your skills and understanding to stock and this chapter will not necessarily be for you. But if you are an entry-level photographer in assignment or stock, you must make sure to build the needed equipment and master the skills for lighting, shooting, and manipulating images. This chapter will give an overview of the tools you need to strive for excellence.

First, even if you are relatively new to photography, the assumption in this book is that you will be shooting and handling your photography in a digital environment and that includes creating images as well as the complete running of your business. This chapter covers the hardware required for a well-functioning stock operation. (Useful software will be covered in chapter 8.)

FINDING EQUIPMENT

After "What do I need in the way of equipment?" comes the inevitable follow up question: "Where do I learn more about it?" Once you have gone through this chapter and made some decisions about what to buy, research tools are at hand. You've undoubtedly done a lot of research online. For almost all the equipment in this chapter, you can get basic information from the many Web sites which post and review photographic equipment. Two of the venerable New York City photo dealers are Adorama (*www.adorama.com*) and B&H (*www.bhphotovideo.com*). They each handle a huge mail-order business and maintain Web sites with equipment listings as well as forums, equipment reviews, and articles of all kinds. An independent site

33

I really like is Digital Photography Review, *www.dpreview.com*. This site has detailed reviews on equipment but also a good forum and extensive, informative articles. Also check out Digital Camera Resource, *http://www.dcresource.com*. One helpful aspect of online articles as opposed to complex books on digital photography is that you can take the topics in small, easy-to-swallow mouthfuls. The other advantage to online information is that it is easy to get lots of it quickly and to target what you want to know.

WHAT'S NEEDED

There are choices to make in the areas of lighting, cameras, lenses, as well as the method of digital capture, transferring and backing up digital files, and scanning film images. Consider carefully the contribution your equipment makes to the mood and style of your photographs, to their marketability as stock, and to your ease in running your stock photography business.

LIGHTING

Lighting sets the tone for a photograph, so decide first on the atmosphere you want in a picture and then choose the lighting that will create that mood. Whether you choose interior strobe lighting or exterior available light, your conscious decisions will influence the mood of the picture. The right lighting can reinforce a sense of intimacy, the drama of technology, or the power of an institution.

Going back to the elements of style in chapter 2, you want to create lighting that enhances the style you've chosen. You will choose between a traditional type of lighting or an X-style, which may be surreal or super-real.

If you choose a traditional approach to light, then good lighting for a stock photograph will be consistent with the setting and mood of a picture. For example, the romantic glow of warm, golden lighting would be appropriate for a couple by a fireplace but would not be consistent with a forensic lab scene. The exception might be when a sense of the past is warranted—such as in a recreation of a nineteenth-century laboratory scene in an ad for a pharmaceutical company.

It isn't necessary for lighting to mirror the reality of a setting, but it should enhance, rather than conflict, with the message. Lighting in a textile mill may be the flat, greenish, institutional fluorescent, which renders the worker and the threads of the weaving loom with a boring sameness. Use strobe lighting to highlight the texture of the threads, creating patterns on the workers face. Color gels can be used over the background lights to differentiate the worker from the weaving equipment. It isn't the real lighting, but it dramatizes one aspect of the plant and is consistent with the essence of the location: a textile factory. Or, in post-production (the step after shooting when you have downloaded the file and adjust the image), take the color and manipulate it into a two-color wash of a toned print.

One word of caution: if you develop a single, standard approach, especially in your strobe lighting, using it as the one solution for all situations, you could limit yourself. Some photographers have a tendency to use a flat, even lighting for everything, just to be safe. All the details are clear and sharp, but there is no extra contribution made by the lighting to the message of the picture. By relying on this approach, the photographer is missing a good opportunity to differentiate the pictures and reinforce the mood. Good lighting is done primarily during the shoot, but digital tools can be used to enhance lighting especially in terms of contrast.

Interior Lighting

Because buyers have become accustomed to the technically expert photographs currently found in agencies, they will accept nothing less than top-quality lighting. For interior shooting in stock today, controlled artificial lighting is virtually essential and in most cases, strobe is the choice of professionals. Photographers who have a command of interior lighting often mix their lighting for more dramatic effect; this includes using tungsten lights with strobe, and, on big productions, even the use of movie lights. Tungsten lights can be tricky. They draw more current and are uncomfortably hot on the models. However, tungsten can be useful as a contributing mood light where your main light source is strobe. Tip: For a golden glow of warmth in a nighttime home scene, insert a 500-watt bulb in a lamp that's in the picture, shoot on a tripod, and expose with a slow shutter speed (1/4 to 1/2 second). The shutter triggers the flash, exposing the main scene lighted by the strobe, but then stays open to fill with tungsten, adding a natural-looking glow from the lamp. (For more lighting tips, check the book *Photographic Lighting Simplified* by Susan McCartney, listed in the bibliography.)

The next decision to make is among the strobe units—whether to choose a battery-operated unit or one that requires alternating current (an electrical outlet). Travel photographers or those working out of reach of electrical outlets get good results with battery-pack strobes, which are sometimes rigged with a small umbrella over the shoulder or bounced off a reflector card.

But these are devices for special circumstances. Mainstream situations will give the best results when lighted with at least a basic plug-in strobe lighting system. If you have been working with strobes for your assignment work on location or in the studio, the transition to stock is easy.

If you are just learning to work with strobe, you're in luck. There have been many improvements in equipment over the past few years, making strobe lighting easier to use than ever before. Equipment is lighter, simpler, and more flexible.

There are two basic designs in strobe systems. The more commonly used design has a power pack on the floor with lamp heads, containing the actual flash

35

tubes, attached by long cables. The power pack houses the capacitor, which stores the electricity until you fire the flash tubes, and all controls for light output to each head, up to four. The advantage is that you can control the ratio of light to the heads from one spot, instead of having to move light stands or go to each head for adjustment. The disadvantage is that you have power packs and cables on the floor for models to trip over. The heads however, contain only flash tubes, so are light and easy to handle.

The other design features the power pack as a part of the lamp head itself. This type is generally called a monolight. The head is heavy. Variations in light output are controlled individually on each head, which means if you are using three to four lights you have that many places to go to when adjusting power output. Their design makes monolights useful on location for working in small spaces because there's no power pack on the floor.

Visiting your dealer, trade shows, and photographer friends will give you the basic research needed for a decision. Before investing in a system, see if you can rent a set of the lights you're considering and try them out for a few days to learn their quirks and strong points.

What to look for:
- A lightweight power pack
- Fast recycling time (seconds needed to recharge capacitor)
- Variable output control (click stop)
- A manufacturer with a good reputation among photographers
- A manufacturer who has been around a while (longevity)
- Good service facilities (fast turn-around time)

You can do a professional lighting job on moderate-size spaces such as a 10 by 12 foot room with two power packs totaling at least 800 watt-seconds of power; but eventually, you may want to move up to three or four units with a total of 1200 to 2400 watt-seconds. (A word about watt seconds. The term has been commonly used by manufacturers and photographers to indicate the relative power of light output of a strobe. Variations in the construction of the capacitor can affect the actual power, the watt-second output. When you've narrowed down your choices, ask the dealer for a detailed explanation of the power output of the unit being considered, so you can compare apples with apples.)

A basic starter set should include:
- 2 lamp heads
- 2 light stands
- 2 soft boxes (one large, one medium)
- 2 reflectors
- 1 radio slave unit.
- 2 sync cords—one for backup
- 1 power pack, 800 to 1000 watt- seconds, or equivalent monolight heads protective case(s)

As you gain command of the lighting and feel comfortable working on location, you will want to add the following: some additional heads, umbrellas, stands, and slaves (to light larger spaces with greater subtlety); a remote sync unit; a soft box (for more subtle lighting of people); barn doors; scrims; snoots (for directional lighting); color gels (for dramatic effect or color correction); color-temperature meter; and an exposure meter which measures ambient light as well as flash.

One other useful tool for improving exposure accuracy and taking the guesswork out of lighting is a good flash meter. Though it's less critical than when we were shooting with film, a meter is still a valuable way to fine-tune your lighting. Certainly you have more control with digital capture, and variations in exposure can be corrected easily in post-production. However, the better image you start with, the greater quality you'll have at the end; doing sloppy lighting with the intention of fixing it in post-production is shortsighted.

In the days of film, a Polaroid camera for testing light, often through use of Polaroid backs, was the norm when shooting with strobe lighting. It allowed you to forecast the look of an image. You could check your lighting to find hot spots and reflections in a window or computer screen. And you could see a harsh shadow where you didn't want it, or an unflattering fall of light on a model's face.

The use of digital capture has removed all of that uncertainty. Now you can see exactly what you are getting. One caution: be sure to look carefully at the LED on the back of your camera or, better, take the time to download a test image to the computer so you can scrutinize every detail of the image before you shoot the entire scene. Everything that you correct while shooting minimizes the time, hours of time, spent later in post-production. Don't get seduced by the, "Oh, I'll fix it in post" attitude that some digital photographers adopt. Post-production is wearisome enough even when your image is perfectly lit.

Exterior Lighting

Though exterior lighting is familiar terrain for photographers, it doesn't hurt to remember the old maxim that the only light worth shooting by is from dawn until 10 a.m. or from 4 p.m. until sunset. That's a truism. In most cases you do want to avoid the harsh overhead light of noon.

Back or side lighting with or without reflector fill is inevitably more pleasing in photographs of people; light overcast or open shade is another style of lighting which is flattering to people. Avoid those harsh shadows from direct sunlight; eyes disappear and features are exaggerated. Reflectors or fill flash can be used to eliminate the greenish cast caused by foliage overhead as well as the blue from deep shade.

DIGITAL STOCK PHOTOGRAPHY

CAMERAS

If you are having success with the equipment you own, then use what you've got—or whatever you think would improve your way of seeing. Having a wide range of lenses available for whatever cameras you have is as important as which brand or model camera you use.

For the purpose of this book, we'll assume that you are shooting with digital equipment. If you aren't shooting digital, this is the moment to convert. If you need convincing, see the box, "Uses of Digital" in this chapter.

There are many choices for your digital camera system; many photographers choose based on what system of film camera they've been using. Satisfaction and loyalty to a camera brand can be strong. Another factor is the investment you have in lenses for your film camera. If a photographer has Nikon lenses, then she will likely buy a Nikon digital camera; the same is true for users of other brands.

If for any reason you are determined to continue to shoot film, OK. Just know that you will have to makes scans of your selected images for use by your agency or on your own Web site. One important reason for working in a digital environment is that if you don't, you are out of the mainstream as far as clients are concerned. Virtually everything in the world of photography is digital, so you create unnecessary roadblocks if you aren't digital. Plus, it's truly exciting. As one colleague put it, "I find digital so much easier, cheaper, more rewarding, more fun, plus, compared with color slides, I can shoot under many more lighting conditions without worrying about filtration and color correction." Don't be reluctant to move into digital.

Format

Far and away, the most common image size in use is 35mm, but some photographers who are comfortable with medium or large formats may use the digital versions of that equipment. The size of your digital file is infinitely more important than the format of camera. Some stock agencies require a file size of 50 to 60 megabytes. Some of the high-end digital cameras provide an image file in that range but a mid-range camera will give file sizes in the 18–20 MB range. Check with your stock agency for their file requirements.

Photographers shooting with cameras that deliver around 18 MB files sometimes use the technique known as upsampling to improve an image. Upsampling is an image editing process that enlarges the original photo, making up, or interpolating, additional pixels to fill in the spaces. There is disagreement about the value of this process and the best technique and software to accomplish it. It can be done in Adobe Photoshop, as well as other programs like Genuine Fractals at *www.ononesoftware.com* (see box "Software Overview" in chapter 8). Be sure your agency approves of this technique. The general rule is, if possible, create a larger file from the beginning.

38

Synch

If you plan to use a digital camera with studio strobes (as most digital photographers will) be sure that the camera you buy has the capacity to sync with strobes. Some low-end cameras don't have sync capability.

Warning about Camera Choices

Some stock agencies and portals (more on these in chapter 9) are imposing requirements on photographers' submissions regarding the type of camera that captured the image, as well as having requirements for image file size as mentioned above. It doesn't seem completely logical, much less fair, because there are other cameras that produce excellent digital quality. However, each agency sets its own rules. Whether fair or not, before plunking down your cash on a new system, it might be wise to check several of the major stock agencies to learn which cameras they prefer. If you can find a camera on their list that has the functionality, features, and fits the budget you've set, it is so much better to buy an approved camera rather than swimming against the current. (Agency Web sites also have technical requirements for preparation of scans from film, as you'll see later in chapter 8.)

The following are requirements from the Getty Web site:

> If you are shooting on a 35mm digital camera it must an approved camera from this list: Nikon D200, Nikon D2X, Canon EOS 30D, Canon EOS 5D, Canon EOS 1D MK 11, Canon EOS 1Ds, Canon EOS 1Ds MK 11. All medium format backs (e.g., backs by Phase One and Leaf etc) produce sufficiently high quality images to be accepted by us.

This information is by way of an example. The list from Getty and those from other agencies may be updated to contain new models or different cameras; go to agency Web sites to see the most current requirements.

LENSES

The choice of focal length is a matter of aesthetic choice but will affect the look and, therefore, the market for your pictures. A rule of thumb is that wide angles characterize editorial photography—you get a broad view, the whole picture, with lots of information in both foreground and background. In advertising, there is a tendency toward a close-up feeling—a sense of immediacy, often with the background out of focus.

Go back to your famous clip file and quickly separate advertising photographs from editorial photographs. Note what lens appears to have been used in each. See how many of the ads look like they were taken with 105mm or longer and how many editorial shots feel like 24mm. This will help when you're experimenting with your style and composition and give a clearer understanding of what lens choices to make. Just so it doesn't come as a shock, know that the

lens you used in a film camera will give you a different width when used on most digital cameras. The common description is that a 24mm lens becomes a 36mm. Many digital photographers buy a 17mm to fill the gap in the 24mm range. You'll get used to this change because what you see through the lens is what counts, and not the number of the lens. Just experiment shooting with your old lenses and see what width you get from each.

MEMORY CARD EQUALS FILM

In place of the chemically treated plastic which makes up film, the digital image is made up of bits of digital information that are recorded on a *memory card*, also called the *media*.

The memory card inserts into the camera and acts as a storage device. The memory card is also used to take the image from the camera to the computer via a card reader. One of the commonly used brands of memory card/media is Lexar, though there are others. At the time you're ready to buy, check with your dealer to learn what is the newest, best media and largest capacity card. Media cards come in sizes with a small capacity of 256 megabytes (there are smaller) up to a larger capacity of 4 gigabytes (GB) of information, and larger sizes are on the horizon. The larger the media card, the more information—and more images—you can fit on each, and the less often you have to change cards. (A simplistic comparison is between a twenty-four exposure or thirty-six exposure roll of film.) The number of images you get per card depends on the settings you choose when you configure your camera.

File Formats

Any discussion of the size of memory cards takes us to the subject of file formats. Image file formats are one of the choices you make when preparing your camera to shoot. The common file formats are JPEG, TIFF, and raw. Consumer level digital cameras may store images only in the JPEG or TIFF file format. Make sure the camera you choose will write raw files as well as JPEG and TIFF.

You'll want to spend some time understanding the characteristics of each format but here's an overview.

JPEG File

This is a commonly used image format that is very popular due to its excellent compression capabilities. This makes it suitable for use on the web, sending images by email, or to use as reference images. The problem with JPEG as a final image format for top quality stock is that JPEG provides what they call "lossy" compression, meaning that you lose some data from the original image each time you work with it. When you lose data you lose quality.

TIFF File

This is a format that is commonly used for delivery to clients or stock agents. It is called a "lossless" format because you can open, save, and close without a loss of quality. (Raw files are never sent to a client.) JPEG doesn't offer that stability but degrades each time you work with it.

Raw File

Raw is considered the optimum shooting format by most professionals in most situations primarily due to the ability it offers to make changes without losing pixels (and therefore quality) in the process. Raw format stores the data from the camera sensor in an almost unprocessed state, which allows great flexibility in adjusting the image. Raw can be considered somewhat analogous to the film negative. You'll get the best print quality by going back to the original negative. There is more detail below in the section, Shooting Raw, and in Ethan Salwen's comments in this chapter.

Photo Yield per Memory Card

Now, back to the size of a memory card and how many photographs you can shoot. It may differ slightly in each camera but, for example, on a 2 GB memory card with the camera setting for raw "highest quality," the 2 GB will store seventy-six images. On the next setting, for "fine quality," the top JPEG setting, the same card will store 445 images. And on "normal quality," a lower JPEG setting, the card will store 878 image. Each camera has different settings for the varying image sizes, but the idea of low, medium, and high resolution holds true.

An obvious advantage of a media card over film is that media cards are reusable. You simply erase (format) the card after the images are safely stored in other devices, such as your computer's hard drive and a backup external hard drive. In principle, the cards can be used limitless times, but in practice they can break down. You'll need to have an ample supply of cards available when you are shooting. It depends on your brand of camera and your media card, but, to give a rough idea, if you are shooting raw and want to be able to shoot about 700 images in a day (with film, that would have been twenty rolls of thirty-six exposures), then you'll need about nine cards of 2 GB capacity.

Downloading the Media Cards

As you'll see in the discussion in chapter 9, the first step after shooting is to download the images to a computer or portable storage device. This is commonly done by using a *card reader*. Some card readers are designed for USB and are relatively slow. Be sure to get a FireWire card reader, which is ever-so-much faster. The difference is amazing and worth the slight additional cost for the faster reader.

Card vs. Cables

There is an alternate to shooting to a card commonly known as "shooting teth-ered." Especially suited to controlled studio shooting and much less so to exte-rior locations, instead of the digital information recording to a memory card, shooting tethered allows you to shoot directly to the computer, bypassing the step of downloading the information on the card. One advantage is that you view the images, large, on the computer monitor immediately, instead of hav-ing to review them on the camera's small LED. I've found it to be terrific when shooting people and capturing expressions. You can have an assistant watch-ing the monitor to tell you if expressions are good, if you're getting eyes closed, etc. It's much quicker than doing the same on the LED. The tedious part is that you are tethered, and with a propensity to get tangled, I find that part a bit hampering. However, there are top-end cameras that will shoot wireless to the computer. That's about perfect. For now I'll wait until the cost comes down a bit.

Image Quality

As we saw above, you can select the image quality on your camera. Different cam-eras have quality levels, from low resolution and varying medium resolutions to the highest. This highest level is called raw.

SHOOTING RAW

Learning all the intricacies of shooting digital is a book in itself. But one aspect of digital should be emphasized, once again, in the context of using the best film for the job. In digital, the best "film" is raw.

Raw is commonly described as the highest quality you can get from a digi-tal camera, but as Ethan Salwen so aptly points out, it has only the *potential* for highest quality. You can mess up a raw file by not processing it properly. (See his "Tips from the Experts" box in this chapter.)

Raw offers the ability to control and manipulate your image in wondrous ways without losing quality. Go to the detailed books on raw to understand the depth of the science behind the practical results—particularly Bruce Fraser's book, *Real World Camera Raw with Adobe Photoshop CS2*. Put in simple terms, when you make changes in some file formats such as JPEG, you are throwing away pixels, degrading the image. If you lighten the exposure, oops, yes it's lighter but you threw away pixels. If you remove color red you are throwing away pixels. In a raw file you can make global changes (exposure, color balance, etc.) without losing any pixels. No degrading. Do I understand how? Nope. But I can see the results and I am a believer. The upshot is that you have the possibility of making global corrections without losing quality.

TIPS FROM THE EXPERTS: ETHAN G. SALWEN

The Importance of Shooting Raw and Using DAM

At this point it is common knowledge in the picture industry that when it comes to photographing digitally, raw captures produce the highest quality images. But be careful. This common knowledge (like most common knowledge) is not correct at all. It is more accurate to say that capturing data in the raw format gives photographers the greatest *potential* to produce the highest quality images. However, this potential can be easily squandered with improper raw image processing.

What Exactly is a Raw File?

A raw image file includes all of the unprocessed data that is captured by a camera's digital sensor. This data, which is actually black and white and looks nothing like the JPEG preview we see on our camera's monitors (or even the preview in a browser application like Bridge), must be converted into a format that can be used by Photoshop (or another image manipulation program). The camera's onboard computer (using relatively simple algorithms) can process raw captures into JPEGs on the fly. And this is exactly what is happening when we shoot in the JPEG mode. This is convenient because JPEGs can be opened directly into Photoshop, or even printed without the use of Photoshop. But when we select this option, the camera's algorithms discard a tremendous amount of image information, which can never be recovered. By waiting to process a raw capture in a conversion program (like the powerful Camera Raw plug-in that is part of Photoshop, or Adobe's newer, stand alone Adobe Photoshop Lightroom application), photographers have an incredible amount of control over how to best maximize the potential their digital captures.

Why Raw is a Must for Stock

It is important to note that there are many highly successful (and often brilliant) image makers who are shooting in the hi-res JPEG mode, particularly journalists, event photographers, and other professionals working on tight deadlines where the very finest resolutions are not so critical. But for greatest distribution channels in the stock market (read: bucks), photographers really have no choice but to shoot in the raw mode. It takes an extra step to be able to get your raw files into Photoshop than it does with JPEGs, which requires more time as well as additional skills. And raw files are larger and take up much more space on CompactFlash cards and other storage media. But raw files give photographers as much control over our final output as possible. Just as important, raw files can be processed again and again (and again) over the years (just like printing a negative). This gives

photographers the opportunity to take advantage of better conversion pro-
grams that are sure to be developed in the future. It also gives us the chance
to reprocess raw files for use in Photoshop when our own processing skills
have improved (which are also sure to develop in the future).

"With great power comes great responsibility." This line from the recent
Spiderman movies perfectly sums up the sentiment that people should
embrace when converting their raw files for use in Photoshop. The same raw
file converted differently can yield vastly different final images, namely by
providing much more (or much less) image data to work with in Photoshop.
A well-converted version of a given raw file (that is well-handled in
Photoshop) might look stunning printed poster-size. A badly converted
version of that very same raw file might look terrible printed even at post-
card-size, no matter how much tweaking is applied to it in Photoshop. (In this
case, you might as well start out with a low-res JPEG.) So be careful.

Although you wouldn't guess it by the title, Bruce Fraser's book *Real World
Camera Raw with Adobe Photoshop CS2* is particularly valuable for under-
standing best practices for exposing and converting raw images in a manner
that retains the most information, especially because Fraser clearly explains
the underlying *whys* along with his clear how-to instructions. (Sadly, Bruce
Fraser has passed away since this article was first published. However, the
value of his insights on raw exposure—particularly, what your camera's his-
togram is all about—and processing techniques will remain valuable well into
the future, even for photographers who use other raw conversion programs.)

Bottom Line: Only Three Camera Controls Affect Raw Exposure

There are many subtleties to making the best raw exposures. But it's
extremely helpful to understand that only three camera controls actually
affect the quality of a raw capture. They are: ISO setting, shutter speed, and
aperture. That's right. No matter how sophisticated your digital camera
might be, and no matter how many gobs of settings you might be able to
access in your custom features menus, the only controls that influence raw
exposure are really, thankfully, *exactly* the same as the basic controls of a
totally manual, film-based camera.

If you were not aware of this aspect of shooting in the raw mode, you might be
wondering why you've heard so much about settings that affect color space,
white balance, and sharpening. These controls relate to two things. The first
is that when shooting in the JPEG mode, the camera's computer uses these
settings to determine how it will process your raw files on the fly. The second,
subtler issue is that your camera's setting will be saved in the metadata of
your raw file, and this information can influence the speed of efficiency of your
digital work flow down the road. But again, this metadata information does not
change the fact that your raw file still includes *all the image information* to

work with in any way you want for years to come. So if you are hitting road-blocks with your digital exposure, keep in mind that ultimately none of your camera controls matter except ISO setting, shutter speed, and aperture.

In relation to the ISO setting, I need to say again: be careful. One thing that photographers like about shooting digital is that they have the ability to change their ISO setting as available light changes. This is definitely cool. But it can also be dangerous if you don't know what you're getting into. Many people new to digital exposure and processing don't realize that they must strive to shoot on the camera's lowest ISO setting to get the best quality image. The lowest ISO setting is the camera's "native" ISO, and any setting higher than this setting will introduce very noticeable amounts of noise. This shouldn't stop you from using higher ISO settings, and I myself have done so intentionally for artistic effect and to create images that I would have not otherwise been able to record. But if you are shooting for high-end stock distribution (and you should always aim high), you really need to keep your ISO at the lowest setting possible. (Think: tripod.)

Adopt Damn Good DAM Practices

Forget what kind of sound a tree falling in the woods might or might not make. The more important (and much lengthier) question for digital photographers is, "If a raw digital capture is not intelligently renamed, given copyright information, uniformly ranked, clearly captioned, and well keyworded, as well as being safely backed up in a archival file format in multiple locations, all in conjunction with a good, searchable cataloging software program (like Extensis Portfolio or iView Media Pro), does that image have any value?" The answer: not much.

The phrase that embraces all of these critical practices is "digital asset management," or DAM for short. And while image manipulation (the stuff you do in Photoshop) relates to how we photographers created one, excellent image, DAM practices are about how we store, access, and manage an entire archive of tens of thousands of images. And stock photography is all about having a great, *accessible* archive of images.

In a way, digital photography tricks us into a false sense of security. As we shoot we can look at our camera's monitor right away and say, "I got it." But although the image on our camera's tiny monitor might indicate that our framing, focus, and use of flash are correct, and although our histograms might indicate that our exposure is correct, we are actually looking at the digital version of a latent image. In traditional photography we were used to the concept of a latent image being the invisible image on an exposed piece of film that *might* become a permanent, usable image—if the film had been exposed correctly and if the film were developed properly. In the digital era, I have tried to shift my concept of the latent image. To me, a latent digital

image is any image file that has not gone through every step on my DAM checklist, which begins with renaming a raw file and ends with creating multiple backups of that file and storing these in different locations.

I'm going to be honest with you and admit a dirty little DAM secret that few digital imaging gurus seem inclined to share: even for a computer savvy, experienced digital photographer, digital asset management is one hell of a bummer to master and keep up with. And the difficulties relating to this task are often amplified for the stock photographer, who is shooting at higher volumes, who is often away from the office, and for whom adding quality metadata (think: keywords) will have a big impact making or breaking sales (think: to eat or not to eat). Even when my DAM system is running relatively smoothly (which doesn't seem to be that damn often), I am regularly frustrated by the amount of time I must now spend stuck in front of my computer, trying to keep up with the thousands of files that just keep pouring in. And like a moving target, DAM practices keep changing and evolving (as we are seeing with the emergence of Adobe's Lightroom that is hitting the shelves as this book goes to print).

Yet, the frustrations associated with mastering and keeping up with good DAM practices are a small price to pay for the potentially high returns. Ultimately, it is our excellent, consistent DAM actions that will truly set us free and allow us to take full advantage of the power of electronic imaging in a way that we could never have even dreamed with traditional photography. It is our DAM activities that allow us to create, archive, publish, share, search, license, and ultimately *enjoy* more of our images in ways than we could have never even imagined with a film work flow. (Think: rows of cabinets stuffed full of chromes in your basement that you can't share with anyone versus searchable access to every one of your images on your computer that you can share with almost anyone on the planet.)

Peter Krogh is the master scribe on DAM practices, and his *The DAM Book: Digital Asset Management for Photographers* remains invaluable even though technologies have advanced rapidly since it was published. I've thrown *The DAM Book* across the damn room more than one damn time, trying to wrap my artsy brain around this nerdy stuff. But there is no getting around the fact that Krogh does all digital photographers an incredible service by succinctly relating the underpinning conceptual ideas surrounding excellent DAM practices. You can download a free copy of chapter 1 of Krogh's book at *www.thedambook.com*. So get to it, damn it!

Bio: Ethan G. Salwen is a photographer and writer specializing in Latin American cultures and (*obvio!*) topics on photography (*www.ethansalwen.com*). He was living in Buenos Aires, Argentina, when he adapted these comments from his

article, "Raw Power—Buenos Aires Style," which first appeared in the #4, 2006 issue of *The Picture Professional*, the magazine of the American Society of Picture Professionals (ASPP). With a membership comprised of professionals from all aspects of the stock photography business, Ethan highly recommends that stock photographers join ASPP (*www.aspp.com*).

Digital Language

Before untangling what I call the pixel puzzle, those new to the digital world might want information relating traditional photography to digital photography. In traditional, film-based photography we are used to considering the basic technical functions of sharpness (focus), exposure (light), and color balance as being critical to professional-quality photographs. Naturally, these are separate from the aesthetic aspects of composition, mood, and concept in a photo. We'll take a look at how these three basic technical terms translate into the digital arena. If you've experienced even a little work in Photoshop, these points will be easier to follow.

Resolution/Sharpness

In the digital world, sharpness can lead into some apparently confusing areas of terminology.

I'll start with a definition from Joe Farace, photographic columnist and author:

> Resolution of the final digital file determines quality. An image's quality is measured by its height and width in pixels. The higher an image's resolution, the more pixels it contains—the better its visual quality.

You'll note that the word sharpness doesn't appear in this definition. However, sharpness is a word and a concept dear to the hearts of photographers working with film. It is commonly used to describe one aspect of a photograph's quality, indicating clarity and good focus. (We say the negative is sharp, or the print is sharp, or the chrome is sharp, or that's a nice, sharp film, and so forth). The word "sharpness," not often used in the digital world, is a concept now embodied in the word resolution. In the film-based world the term, "resolution" is used more specifically to refer to the chemical characteristics of film (resolving power) or the optical quality of a lens.

As a side note on sharpness in the digital image, this was the most difficult change to wrap my head around because I grew up on the idea that there's "sharp" and "not sharp" and if it ain't sharp in camera you're out of luck—you can't sharpen it later. But in digital you have the ability to sharpen more or less. Warning: some stock agencies want you to sharpen very little or *not at all*. They advise that this way you can let the buyer apply the amount of sharpening they want. They won't accept images that have been sharpened. It puzzles me, but I suppose because photographers sharpen to varying degrees there'd be no consistency. And over-sharpening can cause weird looking pixel patterns.

A

B

The effects of over sharpening can be seen in this photo, a profile of Appalachian woman, Betty Roark, scanned from an original BW print. Photo A shows the image sharpened at 25% which approximates the sharpness of the original.

Photo B has been over sharpened to 95% with exceptionally unpleasant results, especially when the image is enlarged.

C

D

This contrast is even more obvious in the close-up details of the eye, photo C is sharpened at 25% and D at 95%.

Some photo buyers prefer to do their own sharpening. Always check with your photo agency or client to find out their requirements regarding digital sharpening.

Those who like to hang on to the former vocabulary will think of low resolution (lo-res) as low quality, fuzzy, not too sharp, while high resolution (hi-res) represents sharpness or high quality in an image. Also, we speak of "grain" in film, which refers to high-speed film of 1600 and will have large grain or be "very grainy." Digital uses the term "noise" to indicate what we call a grainy image.

If you aren't sure that this discussion of sharpness in digital is central to your decision of which camera to buy, consider that the minute you start shooting it will be. It could be a rude awakening if you haven't encountered the concept.

Light and Exposure

The principles of exposure are similar in film-based and digital cameras in that your shutter speeds, aperture, and film speed (ISO setting) are used to get a balanced exposure.

"Film" Speed

Even though we don't have film in digital cameras, we do have choices that affect the image in the same way the speed of a film would. You can adjust the ISO setting on your digital camera, which is sometimes called "sensitivity setting" in place of "film speed." Most professional cameras give you a choice from 100 through 1600.

As with film, the faster the ISO setting, the more degraded the image will become. With film, it was the grain that degraded the image, producing in extreme cases a mottled, rough appearance. But with digital, it is something called "noise" that has the same effect as grain—it changes the appearance of the image, giving, to some taste, a lower quality.

Digital cameras do throw us a curve, however, in the area of ISO settings. The familiar ISO/ASA ratings from film don't equate exactly with the ISO of a digital camera. A mid-range digital camera may have the capability of setting the ISO from 400 to 1600. That's a nice wide range. It's like having several different speeds of film in the camera at the same time. But what about the resolution on the low end, which is ISO 400? What if you prefer to shoot a tight-grained, sharp ISO 100 film? Does this mean that you are stuck with the low-quality, grainy resolution we think of as inherent in an ISO 400 film? Apparently not. Because of the way the chip captures an image, there is much less "noise" or grain in a digital file set at ISO 400 than you would find in the equivalent film ISO of 400. You have to take it on faith. Actually, ISO settings lower than 100 are available on some digital cameras, but they are less common.

When you have your raw digital file in the computer and you go into Photoshop, you can change the ISO to see the effect. As you change the image from one ISO setting to another, it will show the quality, and you will see the different noise levels. It's a great way to view the impact of different ISO settings on your image quality.

Exposure

One distinct benefit is that the digital camera is more forgiving than film in the area of exposure. To produce a top-quality color-transparency film image suitable

for a stock file, the exposure must be exact: a difference of one-third of a stop can undermine the quality. In working for a good exposure, photographers shoot a lot of film. Photographers often bracket their exposures as a technique for getting the exposure right on target. This uses lots of film, whereas shooting digitally can provide substantial savings on film costs without losing exposure control. In addition to the value of being able to write over a digital file later, this film savings is due to the lack of extensive bracketing which would be needed if film were used. (Caveat: though the saving in film is real, it's offset by your expenditure of time to process the digital images in post-production, so it's your time in "post" versus cash spent on film processing.)

And in terms of adjusting the exposure, another of many advantages to shooting raw is you can correct exposure without loss of quality.

Color

When you embark on digital photography or digital manipulation of film-based photographs, start by having your monitor calibrated so that the color balance in your computer and as seen on the monitor matches your printer. This critical step is called color management. You wouldn't edit your transparencies by viewing them held up to a ceiling fluorescent light (a habit that was so enraging for us whenever a client did that). In the same way, you don't want to deliver a digital file to a client that doesn't match the enhanced color you've so painstakingly corrected. Most assignment professionals deliver a "match print" to a client along with the digital file. This match print indicates the color you know is inherent in your digital file and also lets them know the color you intend for them to match. With a stock client you often don't have that direct contact, so you should check your own image files to see that they are as close as possible to what you envisioned.

You must be able to know that the color is balanced the way you want, whether viewing your images on the monitor or as the printed output. There are new devices on the market that make color calibration much easier than in the past (I use Eye-One Match 3 but there are many others). If you are not comfortable handling this, then hire a computer expert capable of doing this calibration. Don't delay in taking this crucial step. Two books that will be a big help are *Real World Color Management* by Bruce Fraser and *Color Management for Photographers: Hands on Techniques for Photoshop Users* by Andrew Rodney.

In printing and digital photography, there are two acronyms central to any discussion of color. They are RGB and CMYK.

RGB, meaning red, green, and blue, are the primary colors of light. RGB is the color space, a digital term, we find in transparency film. It represents the three layers of color chemicals on the film; it is also the color space found on TV tubes and computer monitor tubes. The black in film is created, as it is in nature, with

the overlapping of RGB to an intensity that creates an impression our brain reads as black.

CMYK:
- C means cyan
- M means magenta
- Y means yellow
- K means black

CMYK originated with commercial printers who had to name the four colors in the four-color process printing. Each original piece of artwork to be printed on paper was filtered to produce a film negative and then a final printing plate, one for each color. (They say that K was used to indicate black instead of B because of possible confusion with the color blue.)

CMYK is designed for the printing process, whether in commercial magazine printing or the prints from many computer printers, where four colors are needed to create a realistic color image on paper.

If you look at the printed page of a magazine and examine the reproduction of a color photograph under a loupe, you'll see that the image is made up of dots. Look closely and you'll see that those dots are cyan, magenta, yellow, and black—combining to make all the color tones we see in the final printed page. Again, working with Photoshop will familiarize you with these terms.

COMPUTERS AND WORKSTATION

If you've been involved in digital photography for any length of time, you know how critical your computers and back-up systems are to the management and safeguarding of your images. In the box "Equipment for Your Digital Stock Business" is an outline of what you need for a fully functional stock-photography business. However if you are new to the field, or just leaving photography school, you can cut a few corners until your budget increases—and you can justify the investment which right now will seem big enough to choke a horse.

Clearly you need the best quality hardware you can afford (to beg, borrow, or steal). The power inherent in Photoshop and the other imaging and digital management programs demands equal power in your hardware if you are to take advantage of their potential. Remember that you are already investing your most precious commodities, your time and energy, so find a way to dignify and support that personal investment with matching power in your equipment. I know a young photographer in Indiana who has been applying to all his relatives for birthday and holiday gift contributions to his equipment fund. He sends out emails with his wish list (not unlike a bridal registry) itemizing everything he needs from a $60 FireWire card reader and $200 portable external hard drive to a $2,000 laptop. Contributions were received and the relatives were pleased to learn which equipment they had made possible. They also received updates on his newest stock

photo projects. If you don't have such accommodating relatives, the point remains: you will need to go out on a limb for some of the essential equipment.

Ideally, your equipment would include a laptop for use on location in the field and one or more workstation (desktop) computers in the studio. An entry-level photographer can make do with a laptop for both functions—location and studio work (preferably top of the line if it's to serve double duty). Just make sure to back up regularly so you can remove the photographs from the hard drive. At this writing, my workstation computer has a speed of 2.33 GHz with a hard drive of 500 GB and 2 GB of RAM. My laptops have 120 GB hard drives and 1.5 GB each of RAM. But by the time you read this there will be faster and larger capacity available. And I'll be saving up along with you to buy them.

Time Management

"Seconds saved" as a colleague once remarked, are "gold in the bank of digital imaging." Saving time in the complex world of digital photography is the key to survival. So you can't over emphasize the importance of streamlining your systems (more on that in the work-flow section in chapter 8). Employ each seemingly minor time saver. Get the fastest devices on the market. As an example, use a high speed, FireWire card reader and a FireWire portable storage device. A moderate additional outlay will truly repay you in speed and absence of frustration.

Platforms

If you are reading this book, the chances are you have made the decision on which platform, PC or Mac, works for you. If not, it's easy to summarize by saying it almost doesn't matter because digital experts can excel on either. A highly regarded teacher of digital work flow, Maria Ferrari, teaches her classes demonstrating techniques for both. She shows the keystrokes for each and explains that you can conduct your photography business on either. I have Macs, as do many photographers, but it's not out of the question to use PCs, especially if it's what you already own.

STORING, PROTECTING, ARCHIVING IMAGES

Back up, back up, and back up again. Because you can make identical copies of digital images, there is never an excuse for losing one. Yeah. But we have all done it. Consistent and multiple backup systems are the answer.

Equipment for backing up can include burning CDs and DVDs, as well as use of a portable external hard drive. The one I use and love is a 120 GB external drive called FireLite, made by SmartDisk (*www.smartdisk.com*). It's pretty close to palm-size and fast, fast, fast. It makes me feel much more comfortable leaving a location with images on the laptop and in the FireLite as well.

Archiving Backups

Once you have edited and processed images, you must create a backup system for your archive of images consisting of at least two external hard drives which mirror each other. Some photographers use hard drives of 500 GB and continue to fill additional hard drives as needed.

As you'll learn in chapter 8, Peter Krogh, author of *The DAM Book: Digital Asset Management for Photographers,* has taken the high ground on this issue. His recommended backup systems put me to shame, but they are certainly the gold standard we should follow. Even if we were half as careful as he advises, most photographers would have improved their safety factor.

DAM (Digital Asset Management) is a study unto itself. But the basic guidelines are to backup in at least four ways. On your laptop, on your portable external drive, on your work station computer, on DVD, and on at least two external hard drives, performing a mirror back up so you have identical sets on each. Once the images make it through post-production processing (chapter 8), you can erase them from the laptop and portable hard drive.

Cause for Concern

An alarming reality has come to anyone working digitally for more than a few years, which is that today's storage or backup device make not be worth any more than parts for an Edsel car five years down the road. Or if you prefer a more recent analogy, that a five-year-old computer may not be any more useful than a doorstop. And does any one remember the SyQuest disk? That was an early state-of-the-art storage device that is now obsolete. There are photographers who got trapped by the departing tide and had images stranded on those early storage devices.

In addition to everything else we must tend to, it's necessary to *migrate,* or transfer, your entire back up archive on a regular basis to newer storage devices. That box of CDs you have in the closet may not be readable in five years. If they were burned with older burners they may not be recognized by current drives. Compatibility is the culprit and we have no control over it, hence the need to transfer to newer media.

Photographer friend and software developer James Cook has gone a step further. In addition to migrating his complete digital-image archive, on a regular basis, to the newest storage devices, he protects his signature photos and portfolio pieces by going back to transparency. Yes, to film. His prime images are output to 8 × 10 transparency and stored in the way we always protected our color film, in a cool dark place.

SCANNERS

So far, the digital capture of images has been the focus of this discussion. How about the many fine film images produced by veteran photographers? To compete in stock photography, they must be in digital form, so that means scanning.

As you acquire the equipment for your stock shooting, you should add in one or more scanners. Certainly a basic flatbed scanner for digitizing reference material is a must for office use. As for scanning film images from your film archive, evaluate two things: your time spent scanning versus the quality you can achieve once you're past the learning stage. If you invest in a good scanner and spend the time to learn it, what is your return on that investment? Consider, on the other side of the equation, using a first-rate scanning company to do the work for you. Having taken the position that I'm not likely to be an expert in everything (or even very much), I decided against making a full investment in scanning my film archive myself. Before coming to this decision, I had gotten a good scanner and set about learning to use it. But one day, in a pinch, needing some scans fast I used a scanning service—and became a convert. You can get good scans at reasonable prices, especially if you send a large volume. Ask about discounts for scans of more than 100 photographs. I found the price to be quite reasonable, and then I could work with the editing of the 35mm transparencies themselves instead of what I found a tedious process of doing the scans. Others may find the process pleasing and economical.

There's another caveat here from the Getty requirements, and many other agencies also have stipulations about scans. Here's what Getty says:

> We only accept digital files from scanned film if they have been drum scanned by a professional scanning house or scanned using the approved desktop film scanners from the following list: Imacon 949, 848, 646, 343; Fuji Lanovia Quattro and Finescan; Creo EverSmart Supreme 11, EverSmart Select 11, iQsmart 1, 2, 3.

Many stock agencies have discount deals with prominent scanning companies who provide a special price to members of the agencies. At the very least, find out what types of scanning equipment you need to buy to meet the requirements of an agency or portal.

TECHNICAL EXCELLENCE

Mastery of the technical aspects of shooting for stock—the lighting, lenses, and image quality—is essential to building a file of marketable stock. But the key to your success is how well you merge your own style with these techniques and equipment you use. Enjoy and embrace the equipment. It really is your friend in the digital world.

EQUIPMENT FOR YOUR DIGITAL STOCK BUSINESS

- Digital Cameras: It must have the capacity for shooting raw to be in the mainstream of producing professional quality images. (Check with colleagues. Also consider the camera models approved by major stock agencies on their Web sites under requirements for contributors.)
- Digital camera: Point-and-shoot quality for taking low-resolution reference file images.
- Computer: For your workstation, try to get the highest level available of the following capabilities:
 speed (GHz),
 hard drive memory
 RAM (Random Access Memory) minimum 2 gigabytes.
 You will need a large amount of RAM to manipulate large photographic files. Be sure to follow the old axiom regarding RAM: buy as much as you can afford and twice what you think you need.
- Monitor: 17-inch minimum, preferably 24-inch monitor, or larger, with the highest quality monitor you can afford. This is important for viewing and manipulating images.
- Mouse: wireless mouse, touch pad and stylus; track ball according to your preference.
- Disk drives: the fastest and most current drives on the market for burning CDs or DVDs as back up or delivery method.
- Laptop (second computer): A Power Book or MacBook Pro, in addition to a desktop, is invaluable for working in the field. This could be the one computer for those new to the field.
* External hard drives: (two at least) to use as back up.
- Printer: Within your budget, select the best printer for producing high-speed photographic color prints. Start by checking the newest products from Epson and Canon.
- Scanner: 35mm dedicated scanner. Also research the professional labs to evaluate cost of scans versus owning the equipment and producing scans. Note that stock agencies have requirements for production of scans.
- Flatbed scanner: for larger format transparency or opaque art.
- Cable or Satellite Modem: fast enough to handle large digital files.
- ISP: Internet Service Provider capable of handling large digital files.
- Email: separate program if not offered by your Internet Service Provider.
- Software/Applications: for all aspects of management of digital images (see chapter 8).

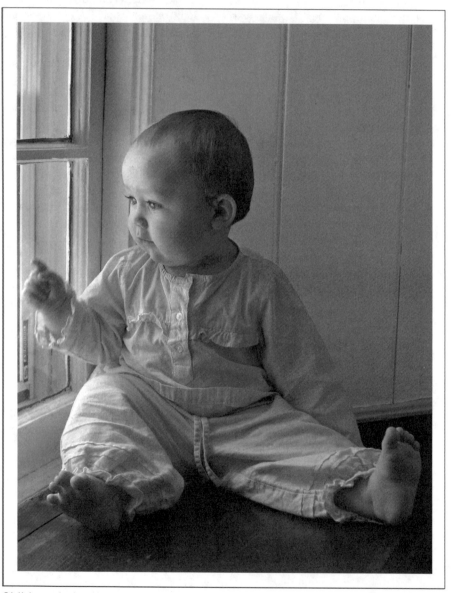

Child at window.

Shooting What's Needed

Some years back, when I first started writing about stock photography, there were many gaps in agency files—significant, saleable subjects for stock photography that were largely ignored, even by many professionals. That's less true today because of the dramatic influx of photographers shooting stock. However, a new phenomenon has occurred, providing openings for stock photographers. Though there are many more photographers in the business, there is also a much wider market for stock.

To understand the influences that shaped this change, let's stop and reflect on the different ways in which the ordinary person relates to photography. There have always been family snapshots, but with the proliferation of digital photography, those snapshots now permeate our lives. Supplanting the old family album you now have Web galleries. For example, a recent college graduate moves from the East Coast to Washington State. Her family can view, daily on her Web gallery, changes in her new apartment (more detail about her closets than you might need), the view from her window, and the new puppy's first walk.

Whether shot with a cell phone, a point-and-shoot digital camera, or a professional quality camera, daily visual updates keep people in touch. They have become a predictable and anticipated aspect of communication. Photographs are the vocabulary, a primary means of communication, of the twenty-first century.

Most observers credit the Internet with fueling this rapid expansion of image use—both personal and commercial. Admittedly less lucrative than traditional markets, the Internet has made stock use much more widespread—it serves as a market for photographs as well as a method of transmission. Stock photography has become an increasingly competitive field. Easy lists of what to shoot are not a guarantee of success. However, good new material is always needed because of the speed with which images are used and the almost universal awareness that images are central to marketing products or disseminating information.

So, are there still gaps, holes to be filled? Certainly. It's simply that there are fewer gaps and more photographers trying to fill them. But by shooting smarter and better, there is always room for the determined photographer.

WHY WERE THERE GAPS?

Let's take a quick look at the way stock shooting has evolved. In the past, stock photographs came mainly from assignment outtakes. Some of the gaps in stock agency files existed because certain topics had simply never been part of an assignment. Other subjects might have been available in stock as assignment outtakes but were shot with the narrow purpose, style, and shape of the assignment in mind, rather than a generic approach. This severely limited their resale value as stock photography.

Photographers who shot only for stock soon began to fill the gaps left behind by assignment photographers. We entered an era of the stock photographer who stepped away from assignments and shot only for stock. Today more photographers are blending stock with assignment shooting rather than putting all their eggs in the one basket of producing stock as their primary focus.

Making your way in stock photography now means doing some careful research to find the gaps, the niches where your work and style can make an inroad.

WHAT ARE THESE GAPS?

Essentially, they fall into three categories:

- Holes: Those subjects or concepts that have rarely, if ever, been covered. There are fewer each year, but the phenomenon of marketing through Web sites has actually created a new kind of hole. No matter how powerful a Web site the stock agency maintains, there are spatial and economic limitations on how many photographs it can display. So some topics may exist, but don't see the light of day, at least through agency marketing.
- Style: Those subjects that have been covered but not in the right style. For all the reasons discussed in chapter 2, there are many photographic topics that are available in stock but that have a limited application due to the style in which they were shot.
- Supply: Those subjects that are available, but never in enough supply, or which constantly require updating.

Let's talk about the holes—those photo topics that you can't imagine haven't been shot. The saga in chapter 1 of my client's search for a Hispanic family picnic is not an isolated incident. With regularity, I hear stories from clients of photos that should be easy to find but aren't. Here is another one: gymnasts.

For a trade ad featuring a new vitamin supplement, a client needed a photograph of people—teens or young adults—doing gymnastics, something that would show physical health and vigor. They wanted to avoid celebrity or world-class competitors. Wouldn't you expect them to find it in stock with ease? I did. But no, their search turned up two categories of gymnastic photos, not what they needed. First they found lots of grainy pictures shot with high-speed color film

in available light—without model releases. Most of the pictures appeared to have been shot during local competitions and were set in school or community gymnasiums, grabbed during the actual event under existing light.

Next they found quite a few conceptual shots of gymnasts that were graphically very interesting, but didn't convey healthy bodies as the primary visual concept. Some were shot in dramatic light, which almost obscured the vigorous physicality of the gymnast. Others showed only body parts—hands grasping a ring or feet on a balance beam. All were interesting, usable images—but not for this client.

What the client needed, which would have secured the sale for an enterprising stock photographer, was a bright, sharp, strobe-lighted picture, of healthy looking (and model-released) athletes in bright gym clothes doing routines on the balance beam, rings, or parallel bars. In the end, unable to find an appropriate existing photograph, the client gave out an assignment.

The gaps in stock supply also result because there are recurring areas in which there can never be enough pictures—family and couples, especially ethnic, top the list; as do any subjects that are part of a rapidly expanding market, such as upscale Hispanics and the elderly.

And there are topics that require constant updating, such as scenes that include, even incidentally, any electronic equipment. Gadgets, as well as mainstream equipment, go out of date very quickly as you know from the need to update your own computers, PDAs, or music devices. These can make a photograph look just as outdated as passé hairstyles or clothing.

Trends in societal activities change rapidly, so watch for the topics that reflect these trends, whether seen in leisure-time pursuits or business-office etiquette. You can be sure that advertisers and magazine editors watch these trends like hawks. To be ready for the next wave of picture requests, stay up with the times and read newspapers and magazines to know the mode of the day. Don't wait until you see new trends reflected in someone else's stock-photo Web site.

In today's stock you maintain a delicate balance. You can shoot the traditional style in an effort to create an almost timeless photo that will go out of date slowly. Or you can try to be on the cutting edge, but then the image may have a shorter shelf life. You can solve this dilemma by shooting what is most natural to you or, if you are adept enough to master both, shooting some of each. Mix it up.

The stock assignments in the next chapter will give you a jump start into current and classic stock needs. But you can maintain that advantage by staying informed.

STOCK ASSIGNMENTS

As stock shooters, we are often out there alone, handling everything from the concept to the final execution—and sometimes without the necessary tools to make sure that saleable stock results from a shooting. The assignment photographer receives guidance, information, and support from an art director. With the

stock-photo assignments provided in chapter 5, you will have the same edge for your stock shooting.

The twenty-five stock assignments in the next chapter are designed as a series of step-by-step outlines with detailed photo specifications. Their purpose is to give a cohesive approach to each day's shoot, by helping you concentrate on the essentials of your stock shooting without losing sight of the critical details. They target specific areas of overlooked subjects and also outline certain concepts that are in constant demand. Just as important, you will learn how to get from the idea stage to the actual shooting, by using the stock-assignment forms. The assignments are designed to help make the pictures happen by cutting through the confusion of what to shoot, the morass of details, and the production procrastination that can block your way from an idea to finished stock. Once you have the concept for a stock shoot you need to execute it. Chapter 6 will give you guidance on finding models, locations, handling wardrobe, and all the details that go into producing a successful stock shoot.

Going from an idea to the actual creation of good stock is not easy. It can be a formidable task to organize a shoot and then carry off a flawless shooting day. There are just too many things to remember.

You need to:

- Make sure all the models are dressed properly. (Does that jacket need ironing?)
- Ensure that the props are in hand. (Are all the labels removed?)
- See that the location is the way it looked when you scouted it. (Someone has been doing repair work on the steps—can I avoid it with a different angle? A mantra to be learned is: *don't save every thing to be fixed in digital post-production; make the original shot as clean as you can.* It's easy to be seduced into thinking all flaws can be fixed in Photoshop. But there is a price to pay in the time you spend doing the fixing.)

Having the tight shooting script provided by the assignments in chapter 5 gives you something to hang onto in those moments of chaos, something to give focus and direction to the shoot.

Just as an assigning client gives you explicit instructions, these assignments will let you know what to shoot: the underlying concept, the problem to be solved, and, in most cases, the subject itself. There are lists of models and props needed, and tips on what to avoid or include. To help you get the most out of each shoot day, the assignments detail four to six variations for each scene.

These assignments go beyond what most clients put on a storyboard or photo specification. You'll have the information on procedures needed for a successfully planned shoot. You'll find the most useful approaches—the do's and don'ts, advice on avoiding the most common pitfalls—available, at your fingertips, while you're shooting. Then you are free to add your own unique interpretation, just as you would be on an assignment, your creative vision is what makes these pictures come alive.

Because the stock assignments are your version of having an assignment client working out the specifics of a shoot for you, all that is left for you to provide is someone breathing down your neck to make sure it gets done!

PLANNING A STOCK PROJECT

Experts in the field, including experienced stock shooters, agree that the most valuable stock is an extensive body of work on each concept you shoot. This, with rare exceptions, is much more useful than having random single shots of various topics. Agents and buyers want to see coverage in depth. That means various executions of the same concept or area of interest.

But many photographers make the mistake of shooting in a haphazard way, not realizing the importance of developing a cohesive coverage. Specialize! At least for the short term. Concentrate in an area either that especially interests you, one that lends itself to your skills, or one for which you have easy access to locations.

In-Depth Coverage

Go for in-depth coverage. It's not possible to overstate the importance of having deep coverage of your topics.

How do you calculate what is deep coverage? If you are building a file of photographs of family scenes, shoot different concepts with each of, say, five families. Then you should try to create eight to ten basic scenes with each family—that's just the beginning of coverage. Naturally you will have many variations—horizontal and vertical, profile and three-quarter angle, wide and close-up pictures—to offer for each of these situations. So for the five family shoots, which had eight to ten scenes each (40–50 photos), you now add additional variations in shape and angle for each scene. This could be up five times the variations to bring you to about 200–250 photos for those five families. Mind you, this is by no means the entire shoot. These 200–250 photos are the selects from each scene, concept, and variation—the outtakes are many, many others that won't make it in front of a client. If you have this kind of coverage of just five families, imagine how strong your collection when you have ten or twenty families. Your agency (or your Web site) won't display this many but it's good to have the depth of coverage.

The way to make this body of work happen is to choose your areas for shooting and then set a production schedule. It helps to actually write out a plan. A colleague of mine photographed a wide range of musical instruments, first those used primarily in classical music, then those used primarily in jazz.

Create a stock project, give it a title, and then create a schedule for completion. You can use this plan, and the stock-project approach, to keep yourself motivated and to explain your purpose to others—especially when you're asking for their help.

The best way to use the assignments in chapter 5 is to select them based on technical and aesthetic considerations. To aid you in doing that, understand your skills and your preferences. Then look over each of the assignments to see which match them best.

Once you've chosen eight to ten assignments from chapter 5 that seem right for you to start with, go to the concept lists in chapter 2 and expand from there. This will give you a broad scope from which to make your plan.

STOCK-SHOOTING SCHEDULE

At this stage, you should plan a six-month shooting schedule. Plan the amount of time you will devote to building a stock file. It won't happen just by thinking about it—there is never enough time. But if you create a schedule, it becomes manageable and you will make it happen!

List the number of assignments you will shoot per month:
- How many shoots per month can you handle (one day each)?
- How many pre production planning days will each shoot day require?

Put proposed shooting dates on a calendar, then work to meet that schedule. There will be some adjustment, as you learn of model or location availability and work with changing weather conditions, but having a schedule gives you a step up in planning.

Before making final assignment choices, look ahead to see the production forms—sample letters, storyboards—to help carry out the production aspects of a shoot. Knowing that these production aids are available will enable you to plan for shoots that might otherwise seem too daunting and open up certain stock assignment possibilities.

Creating a stock-shooting schedule will avoid the low yields that result from scattered shooting and help you build an integrated file of stock subjects in an amazingly short time.

Diversity

Be alert to multiculturalism. Most stock photographs are more useful if they include people of various ethnic backgrounds engaged in mainstream pursuits. There is also a need for photos that integrate cultural activities of different national or ethnic groups through photographic coverage of festivals and crafts. Advertisers realize that cultural and ethnic diversity and the subtleties of expressing not just the color of a face but the foods, flavors, and textures of a culture must resonate within a photo. So most valuable are the pictures that realistically reflect the dignity and richness of cultural groups in the United States and around the world.

You'd be in great shape if you covered every ethnic group in all assignments that called for people! That's a possible long-range goal, but it's nearly impossible when starting out—and a recipe for frustration. (There are so many things to do that, like the laboratory rat in the maze, you could run yourself ragged and end up finally frozen in place not able to do any of them.)

When setting your stock plan, one approach is to take a category of assignments, for example families, and cover them in all variations and in as many

ethnic groups as you can until you have excellent in-depth coverage for all groups in those specific topics.

Another equally sound approach is to take one ethnic group and cover it in a wide range of topics and concepts, until you have that group very well covered. An excellent file, say, of African-Americans or Hispanics, in every assignment listed here, would have great value.

The value of photographs of ethnic groups can be pegged in a rather analytic fashion to the percentage (and thus the buying power) of the population they represent. In addition to ethnic diversity, balance your representation of gender (about 50 percent), the elderly (19 percent) and persons with disabilities (5 percent). The box in this chapter was based on figures published on the occasion of the U.S. population hitting 300 million in October 2006.

DIVERSITY BREAKDOWN IN U.S. POPULATION

White: 80 percent; 239.9 million
African-American: 13 percent; 38.3 million
Hispanic: 15 percent; 44.2 million
Asian: 4.4 percent; 13.1 million
Native American (including American Indian, Alaska Native, Hawaiian and Pacific Islanders): 1.2 percent; 3.42 million

Of course, this diversity breakdown may vary greatly depending on what regional markets you target. Along the Gulf Coast of Louisiana and Mississippi for example, African-Americans represent between 54 and 60 percent of the population. Hispanics represent large percentages of the population in South Florida, California, and the Southwest.

Look at the most recent census figures carefully. Seeing where the changes are will give some direction for your coverage of specific ethnic groups. Interim demographic studies have shown that Hispanics are the most rapidly growing segment of the population, with Asian-Americans next.

If you live in the Southwest, have an interest in the culture, and speak a bit of Spanish, you might concentrate on photographs of Hispanics. If you have good contacts in the African-American community, this might be a logical group to work with. In this country, we have a diverse culture—good stock should reflect that for one very pragmatic reason: stock photography clients market to all segments of that diverse buying public.

Concepts in Assignments

As you approach the assignment section and begin to make choices, note that among the assignments, some are expressed as concepts, whereas others are expressed in the more traditional subject format.

No matter which assignment you choose to shoot, remember that almost any subject can be expressed in a symbolic, as well as in a literal or pictorial fashion. Thus, starting with the same raw material, you have two possible approaches. The symbolic approach is suited to ads, public service messages, campaign literature, book covers, or chapter openers. The literal, pictorial approach might be used for textbooks, encyclopedias, and government brochures. If they are model-released and professionally executed, both will be good stock. (See chapter 15 for a full discussion of model releases.)

In terms of planning a shoot, the three major markets—advertising, corporate, and editorial—actually boil down to two, advertising and editorial, because corporate clients can often use photographs that are suited to the advertising market. So the choices you make in designing the style of your shoot will affect whether the photograph is likely to be considered by the lucrative advertising market or only in the high-volume but lower-paid editorial area. This is why the conceptual approach is critical to keep in mind, as it is the key to successful sales to ad agencies and corporations. Turn any subject matter into a concept—it will benefit you in the long run.

It's worth a look at some other subject areas to see how they translate into concepts. A word about photographs of families: no matter what the specific activity involved, a successful stock photo of a family should convey one or more of the following concepts: intimacy, togetherness, caring, play, and/or leisure. There are some markets, especially textbooks, for photos of nontraditional families, gay couples, single parents, adoptions, and foster care. These topics lend themselves to a positive, happy rendition just as you'd find in photos of traditional families. In addition, there are uses for scenes of family conflict, generation gap, and dysfunction. To make these topics salable, look for a strong, graphic (and not too depressing) way to convey the scene. However, the most lucrative market is still in advertising where the happy family is in greatest demand.

When you are shooting any of the family scenes in these assignments, keep these concepts in mind. As the scene is set up, ask yourself: Does it feel intimate and caring? Is this group a unit, are they interacting? Does it show playfulness, people having fun? If not, adjust the activity, the positions, or the action of the models until it feels right.

In the assignment forms, there is an indication of the concept (or concepts) that can be conveyed by the subject. If, in the energy and enthusiasm of getting a great stock file going, you exhaust the assignments provided, you'll begin to create your own. (In chapter 5 you will find a blank form to use for creating additional assignments.)

When preparing your own assignments, consider how to approach each shot. Again, start with the concept you want to convey, then match with subject ideas that are appropriate and interest you, as well as with the locations and models easily available in your area.

Approach your photo concept from another angle. If you have a particular subject you're really dying to shoot, continue to analyze that subject in terms of concept. What basic concept does it symbolize? Can it be read to mean something general, universal? If that is clear in your mind before shooting, there is greater assurance that you'll have a terrifically usable stock picture.

A subject as simple as fishing, for example, with certain variations in the actual photograph, can convey different concepts. Fishing has been used:

- As a metaphor for peace and tranquility; the quiet pond with a lone angler.
- As a sport, showing action, vigor, and the challenge of nature; a person with rod bent double, landing the "big one."
- As a symbol to show togetherness; a grandfather teaching a boy how to bait a hook.
- As a sign of the contentment of retirement; a silver-haired couple fishing contentedly on golden pond.
- As a symbol of the emotion of pride; a person with trophy-size fish held up in triumph (or child with pride in a fish of any size).

But before you spend time and film on a fishing scene, or any scene, be clear about what concept possibilities are inherent in the subject and which ones you want to try for. Design the picture accordingly. Otherwise (forgive me), the resulting picture may be neither fish nor fowl in stock terms.

Also, the more you clean up your shoot, the less time you will need to spend in post-production removing distracting details. For example, in the fishing scene there may be a dead branch intruding on the framing you want. Tossing that branch aside will clean up your shot. Also, if the boat containing the father and son fishing isn't close enough to the covered bridge downstream for your taste, change your angle or re-position your models, if possible, to make the juxtaposition you want with the covered bridge. Though all of those changes might be made in Photoshop, doing it on site is preferable. Just because distracting details can be fixed by photo manipulation doesn't mean you want to invest hours in doing it that way.

Digital Imaging

Post-production digital imaging is a valuable component in your efforts to create a conceptual photo. Keep in mind that once you have a strong image, you can alter the photograph in subtle ways to enhance its symbolic aspect. You can merge the most interesting elements of several of your photos to create a fresh new photo. In addition, you can use digital retouching to remove a national brand or any unsightly distraction in the background of an otherwise very useful image.

Your digital expertise (or your partner's expertise) can be a critical element in the success of your stock business. Build that capability as early as you can in the development of your stock business.

The assignments are next. Make your choices and get started. Have fun!

TIPS FROM THE EXPERTS: JON FEINGERSH

On Balancing Creativity with Commerce

I try to do things that interest me visually and creatively. But then I research the market to find out what's the best way to shoot so it'll sell. Of course, sometimes I will do the reverse. I might think about different topics, searching for a niche that hasn't been filled. Once I've identified a saleable concept, then I look for a way to make it interesting and satisfying in a creative sense. The two go hand in hand. Do it for love, do it for money. And if you don't do it for love, you may not get much money. Successful stock must be a blend of the two.

On What to Shoot

My work is composed of 30 percent corporate (or what photographer Greg Heisler calls "guys in ties on business highs"), then 30 percent families, and the remaining 40 percent are all "other" topics. For example, I know from experience that hospital shoots will do well, as do photographs of Hispanic families.

I continue to ask myself what I can do that nobody else has done—that challenge intrigues me. It's what led me to my current interest in auto-racing images. Car racing is a huge market, not just racing magazines but anybody who wants to illustrate a concept such as: *the winner, competition, coming in first, raising the bar, meet the challenge.*

But shooting the right images at a real race is virtually impossible, so I devised a way to create powerful, believable images by blending multiple

shots. I took some images at a race to get the track, the crowd, and other details. Then I shot everything else around the studio. I worked with the digital artist in my studio, blending as many as fifteen to twenty pieces for an image. For example, one scene of a winner celebrating required separate shots of the car, the driver, the crowd in the stands, the champagne bottle spurting, the confetti, etc. You get the idea. It's a lot of work, but imagination and ingenuity will give you stock that nobody else is producing.

Nobody else takes the time, expense, and care to do this, but I believe it's worth the investment because of the wide market for icons of "winning" and "competition."

A new person won't have my experience or the studio I have at my disposal. But the principle is the same only on a different scale. If a newcomer builds just ten strong images with complexity and visual interest, they have a good start. Then back those up with a hundred, and just keep going.

On What You Need to Succeed
What you need above all today is knowledge. The only way to make more money is to be smarter than everybody else. To gain the knowledge, you must work with an established stock photography producer or a high-end distributor such as a stock agency. The only way is to learn is to pay dues as an apprentice for a little while.

What you learn from the distributor is what sells; what you learn from the stock producer is how to shoot it. Some people who used to work for me are doing well on their own.

On the Economics of Shooting Stock
The most important thing to understand is that you don't have to spend a lot of money to make your production values look "high." If you don't have money, make sure that your "look" is exceedingly good through careful choice of locations, models, and props. Shoot less, but better.

On Changes in Style
You will always have a need for some photographs in a traditional approach, but each generation finds a way to differentiate itself from everybody else. There will be style shifts to an unconventional, experimental photograph—what some used to call "edgier."

What does the word "edgier" mean? Edgier is a word that was coined by older people in the industry to denote something that younger people are doing that the older people don't understand but is different from what the older people do.

On Changes in Outlook

The fact is that most of the art buyers, most of the art directors, most of the people who have interaction either buying or shooting these photos have a completely different interaction with the pictures than we did twenty or even ten years ago.

Consider the changes in the manner in which stock is now accessed:
- We had slides, they have digital files.
- We had catalogs and books; they have computers and Web sites.
- We had researchers who you'd give an idea too; they have keyword searches.

Everything is Different

The new generation of photographers and buyers won't want the same styles as we have. People who are buying photos with centrist styles are older people or more middle-of-the-road industries. But the visual lexicon has changed completely, and even mainstream industries want to appear newer and "edgier." So you have to be aware of what's happening and look to see what's the current flavor of the day.

On Contemporary Photography

The new digital composites are fascinating. We aren't dealing with traditional straight photography anymore. Contemporary photography is heading in the direction where the line between photography and illustration vanishes. Photography is certainly part of the illustration, but pushing pixels is another part of it. If you are young then you understand and are comfortable with the way photographs and illustration are blended.

The key is to look and look and look. Then you must find your own style and path.

Bio: Jon Feingersh is one of the world's best-known stock photographers. With a studio located in suburban Washington, DC, and a staff of seven, Jon's work is distributed by numerous agencies: Getty, Blend, Corbis/Zefa, Iconica, Masterfile, Image Source, and their subagents. Every business day, the license rights to more than 20 of his images are sold somewhere around the world. Jon has taught and given seminars about stock production for more than fifteen years. Search *www.gettyimages.com* for some samples of Jon's racing images, or visit his Web site, *www.jfstudio.com*.

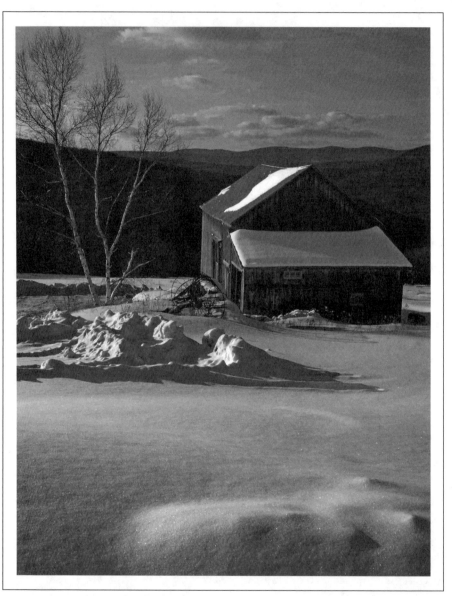

Barn. Catskill Mountains, New York

Twenty-Five Stock Assignments You Can Shoot

N ow to the photography itself. The assignment forms indicate the purpose or concept for each shooting—what an art director would have assigned you to convey. The forms include specific guidance on models, lighting, and props to make sure each assignment results in saleable stock. They also tell you what not to do.

BUILDING COVERAGE IN DEPTH

This system will be most effective if you approach it as a starting point. Take each assignment and expand on the variations as if you were building a file from each one.

To begin your shooting, narrow down the assignments in this section to those that interest you most—those which match your style and abilities. Carefully analyze each one to find additional variations that are inherent in the topic. Imagine how you could cover each model in each situation and find new ways to express the idea behind the subject. The variations I've listed on the assignments are intended to lead you to other possibilities, not to limit you to what's there.

For example, look at Assignment 1, Sports (gymnastics). There are just six variations listed, but if you use a greater variety of ages for each model, using each piece of gymnastic equipment, it adds up fast. You could do each of these with an instructor in the picture, and some should be repeated with different ethnic groups.

Clearly, you will need a number of shooting sessions to cover all of this. (Remember, you are not grabbing pictures, but building a file of professional-level photographs.) Each variation should be as fine-tuned as if it were the only shot on an advertising assignment. Assignment 12, People (elderly in northern environments), also lends itself to multiples. Consider it a two-winter project. The first year, take three couples through a series of winter events and sports. The second year, do another group. Think long term. Not every assignment will yield multiples in quite such a convenient manner, but imagine every conceivable approach.

That's how you come up with fresh angles and variations. You are building deep coverage. That's what justifies the investment in advance planning. This effort will pay off handsomely. Stock clients (or your stock agent) will come back to you for depth of coverage. It's important that they know you are not just a one-shot file.

WHY THESE ASSIGNMENTS?

The topics in these stock assignments are needed because most stock photographers have not covered them in the right style, or because there can never be enough coverage on certain subjects. Some assignments are fairly easy to organize and set up, while others are major productions that require considerable advance planning, such as assignment 13, People (crowds). Because of the effort involved, however, there have remained gaps in these topics—meaning the situation is ripe for the enterprising photographer. These topics are well worth your time and energy.

Let's look at the assignments with problems of style: #1, Sports (gymnastics); #2, People (groups/teams of kids); #7, Family; and #9, Emotions (pride). From time to time you will find a decent team photo—perhaps of a school soccer team or a Little League game—but these pictures rarely have the critical elements required for saleable stock: model releases, role reversal, and players from different ethnic groups. Often these team pictures are shot casually when a child or friend's child is playing—documenting (or grabbing) reality, complete with uniforms that have sponsors' brand names.

There is some coverage of professional and amateur gymnastics. But such pictures may be shot in available light indoors, creating problems with sharpness and color balance. Some are taken during actual competition when additional lighting would not have been permitted. Even editorial clients, unless they are showing a specific, newsworthy individual competitor, are demanding a higher level of quality in color and sharpness than previously. And without a release, there is no advertising use. Though you can find some well-executed shots, often they are somewhat unusual views, such as graphic close-ups of an athlete's hand on the rings or feet on a balance beam. But there is still a shortage of good, general gymnastic scenes.

This gap may seem surprising considering the coverage of the subject. Until I saw a wide selection of gymnastic pictures a client had received from various agencies, it did not strike me that such a seemingly common subject had not been covered as thoroughly as it could be. And if you do various ages, it will help to fill the gaps further.

To shoot a photograph that shows the feeling of pride (assignment 9), there must be a context to convey the emotion. There are many photographs of sports winners that indicate pride and pleasure in achievement. But they are usually news photographs—busy, confused ones showing signs in the background and unidentified people. For advertising use or even a psychology book discussion of emotion, stock agencies need clean, clear depictions of emotion done in rich, sharp color. Two things must be evident: the facial expression of pride and the

source of the pride. An artifact, such as a trophy or blue ribbon, can give a visual clue. All distractions must be removed. This is quite a simple set up.

Assignment 15, Animals (domestic) is an interesting topic but it's been done to death in a predictable manner. There is a large market for domestic animal photos and it is an extraordinary opportunity for the imaginative photographer who can bring a new style and look to it. Don't bother if your approach is the same as what's been done.

The following topics are so valuable in stock that there can never be enough of them or there is a combined need for the right style and quantity: Elderly (6 and 12), Family (7), Houses/Housing (8), and Teens (11,17,19). The Hispanic family-picnic anecdote in chapter 1 clearly presents the problems associated with many family photographs that aren't designed for stock: careless propping, unsuitable wardrobe, cluttered backgrounds, poor model interaction, and a lack of model releases. Older Americans have been a force in society for some time. Advertisers know from demographic research that the over-fifty population is rapidly increasing and they must pay attention to this market. You can rarely go wrong photographing active older adults—the topic is a perennial best seller.

There is good material currently in agencies on this subject, but they run through it fast. In spite of the number of pictures available, there are relatively few photographers who are successful in this market. If you are good at photographing people and have access to attractive elderly people, get in on this action. (This is where choosing models, having model releases, leaving space for type, and being sure to have verticals will make a big difference in sales.)

The challenge is to find new and interesting settings in which to show the elderly as happy, productive people. The coverage of older people in northern environments (12) will be particularly valuable because the enjoyment of winter by the elderly has not been well covered. Most portrayals of seniors show them in warm, Florida-like climates. Advertisers want to show seniors in a broad spectrum of life styles.

There are never enough photographs of Housing/Homes (8) that have property releases. The gap here is in the available quantity of photographs and in the need for releases. We see the exteriors of houses regularly pictured in ads for insurance, banking, and so forth, but there are not many photographs available in proportion to the need. Stock agencies are always looking for a fresh supply. Releases are critical to obtain good sales here. Getting them will be easier for photographers outside the major metropolitan areas. In small communities, the offer of a portrait of the house will often get you the release.

Houses are an excellent topic for the photographer who is not proficient with strobe lighting or not yet comfortable with directing models. It could be part of an ongoing project to build a file of different styles of housing. Once the location research is done and property releases obtained, this coverage could easily be handled on weekends, or with just a few hours at a time devoted to it during the

week. It can be a very pleasant type of photography because you don't have the pressure of finding models.

A collection of house photographs taken correctly with property releases; in good light and in a variety of seasons; avoiding telephone wires, dented mail boxes, and the like would be valuable on your Web site or in your agency's collection.

Any coverage of teens is useful; assignments 11 and 17, People (teens and dating) and People (teens), fill specific needs for editorial as well as lend themselves to advertising usage. There is good overlap here. There is wide application for these pictures: ads for acne medicine, insurance posters, bank ads for education loans, textbooks on family living, community service warnings about drugs or AIDS—the list is endless.

Anyone who has raised teenagers can imagine the reasons why these photos are hard to get—adolescents don't like having their pictures taken, especially with the opposite sex. Researching the models (and getting releases) is the key to this topic. There are outgoing teens who would find it a lark to be in pictures. High-school or junior-college drama students are ideal, as are professional models, of course.

Assignment 14, People (verbal communication) is also a neglected topic. There are photographs that incidentally show communication, but which were not shot for that purpose—and usually they don't quite make it. Photographs of people making speeches usually have much to do with who the person is. Photographs in this assignment featuring teens have salability to book publishers, while the executive and management types are useful for corporate brochures. Be sure to show current technology, such as PowerPoint presentations.

Some topics are naturals for photographers working in the friendly atmosphere of small cities or towns. There is often less cooperation in large cities, where life is hectic and where a photographer requesting assistance is more likely to be a nuisance than a novelty. Coverage of commerce and business (assignment 3) is quite low. I've had numerous requests from clients for these topics. The trick is to find a good location that has universal appeal.

You can find photographs of malls in some agencies, but they rarely include models who have signed releases. The subject is especially good for photographers in warm climates like Florida, Arizona, and California where malls have ample daylight because of open designs featuring skylights, atriums, and patios. Community activities such as benefit raffles, art shows, and musical events are also more likely to be held right in the mall. Permission from the mall corporate headquarters will be needed. You might be able to arrange a trade with them.

The preoccupation with health care will continue to expand now that the baby boomers are of retirement age (assignments 10 and 24). Today's business life blends executive power with an unabashed casual outlook (assignments 18 and 21). Look around for your own examples.

If all of this seems too daunting, remember you will do these one or two at a time. Perhaps you are thinking, whatever happened to the just-walking-around-

shooting-whatsee-like-method of creating stock? Is there any market for that? After all, these assignments are not as simple as grabbing a camera on Saturday and going out to find the light. Of course, good photographs on almost any subject can be applicable and may sell very well. There are a few brilliant photographers who have been doing it that way for years. Be aware, however, that you will be competing with those who have grabbed that niche already.

My system is designed to help the photographer who is dedicated to building saleable stock in a short period of time. Once you have a start on a good file, by all means continue to walk around and shoot. With your heightened awareness of what makes good stock, your spontaneous shooting may have greater potential.

MARKETS COVERED

Though some of these assignments are limited to specific markets suitable only for corporate or advertising use—many of the assignments could be used in any of the markets. It simply depends on your style and execution. As we discussed in chapter 2, the literal, informational, wide-angle approach leans toward editorial style, while advertising is looking more for the close-up, the graphic, and the symbolic.

You can illustrate travel without leaving home. Assignment 5, Travel (still life, studio setup), suggests destination symbols created in the studio and without travel costs. You can use artifacts you bring from a trip or items you collect locally. To create a list of travel destination images, play a word-association game on your own or with friends. Name a city or region to learn the first object or image to come to mind. These are familiar topics, but there is an ongoing market for new images to sell familiar travel destinations as well as for emerging travel destinations.

DIGITAL

All of these assignments should be shot with digital capture. It's not that you can't shoot film and scan it, but the extra workload makes it a less desirable approach. Furthermore, you can use your expertise at imaging to enhance any of these assignments.

Many traditional photo topics lend themselves to image manipulation, so use the assignments as a jumping off spot. The business person multitasking can be made more interesting by digital manipulation and composite imaging. Try creating an image of the "cyber nerd" to portray the twenty-first-century hacker in total absorption and obsessional involvement with electronic technology. Or approach a more complex issue such as global warming. Or a sober icon of terrorism. Let your imagination run. And have fun.

CREATING YOUR OWN ASSIGNMENTS

Once you've completed all the assignments, apply the same approach to other subjects that appeal to you. The blank assignment form in this chapter can be used to modify any of the assignments or to create new ones for yourself. Go to it!

STOCK ASSIGNMENT 1

Category: Sports (gymnastics)

Purpose: To symbolize skill, poise, concentration, and competitive spirit. To show strength, muscle tone, good health.

Subject: Gymnast alone and with class or instructor, doing range of gymnastic exercises.

Variations:

a. teen on high bars

b. boy on rings

c. girl on balance beam

d. single with instructor

e. group with instructor

f. teen on parallel bars

Frame Shots	Space for Type	Lighting
☑ Horizontal	☑	
☑ Vertical	☑	☑ Exterior (available light)
☑ Wide	☑	
☑ Medium	☑	☑ Interior (strobe light)
☐ Close-Up	☐	

Models: 15-19, boy and girl

Props: Leotards and exercise clothes in bright colors

Include: Extra space in horizontal and vertical for type

Ethnic: White, Asian, African-American, and Hispanic

Locale: Nice-looking gym

Avoid: Leotards with busy print, writing, or logos; bare legs

Note: Lighting is important to this assignment. Need strobe coverage to get sharpness and good color balance. Also, have instructor point out proper form so that photo shows accurate gymnastics. Take notes of various maneuvers for caption purposes.

STOCK ASSIGNMENT 2

Category: People (groups/teams of kids)

Purpose: To show varying aspects of team sports as an icon for cooperation, concentration, strategy, health, energy, and healthy, active kids as symbol of future. Concept of group.

Subject: Team in action—soccer or baseball (Little League), include girls (role reversal)

Variations:

a. goalie in action

b. girl catch/throw, close-up

c. pitcher (and catcher), close-up

d. coach with 1–2 players

e. team prep/psych for game

f. opposing teams shake hands

Frame Shots		Space for Type	Lighting
☑	Horizontal	☑	
☑	Vertical	☑	☑ Exterior (available light)
❑	Wide	❑	
☑	Medium	☑	☑ Interior (strobe light)
☑	Close-Up	☑	

Models: Kids, age range 8–10, and coach

Props: Ball, bats, gloves, etc. If team shirts have brand name, create fictitious teams and use colored sweats.

Include: Clean background, trees, fields

Ethnic: Ethnic background mixed Gender mixed

Locale: Attractive playing field

Avoid: Team shirts with sponsor names, brand names, billboards, graffiti in background

Note: It would be good to do this as two separate shoots. First, shoot what happens naturally at an actual game. Then do a recreation shoot using one team at practice or at a special session for photography (offer team portrait as inducement). Do the best scenes you remember from the real game with extra coverage, e.g., the girl with the most intent expression at bat, two kids with coach, two kids in opposing jerseys shaking hands.

STOCK ASSIGNMENT 3

Category: Commerce (downtown, central business district)

Purpose: To symbolize small town/city America. "Main Street" as center of commerce, services, culture, and values of traditional town.

Subject: Central business district of town or small city—include stores, bank, post office, church.

Variations:

a. street level/crosswalk

b. with small office building

c. pedestrians/traffic light

d. with school, library

e. with town hall

f. with cars/traffic jam

Frame Shots	Space for Type	Lighting
☑ Horizontal	☑	
☑ Vertical	☑	☑ Exterior (available light)
☑ Wide	☐	
☑ Medium	☑	☑ Interior (strobe light)
☑ Close-Up	☐	

Models: Family or 1–2 adults to position walking, crossing 1–2 teens on bikes

Ethnic: Varied

Props: Nice clothes, shopping bags on arms of models, flowering plant to place in foreground, bicycle (optional)

Locale: City/town

Include: Flags, trees, flowers, colorful awnings, church spire. Stores: barber, hairdresser, pet store, shoe repair, icecream parlor, restaurant.

Avoid: National brand-name stores, gas stations, fast food logos, bare legs, food, liquor stores, wires, graffiti, dated posters, X-rated movie marquees

Note: The location search is the crux of this shot. Bird's-eye angle good (try for second- or third-story view), intersection with stores, park, possible view of residential streets behind. For ground-level shots, use models in foreground to give activity. Need bustling, cheerful look. Clear bright day, crisp color. With digital capabilities you can remove signs with brand names.

STOCK ASSIGNMENT 4

Category: Travel (detail)

Purpose: To create an icon to illustrate a travel destination.

Subject: Close-up photographic details shot on location, which identify, almost instantly, a travel location and evoke the mood and appeal of that city, region, or culture. Use extreme close-ups to create strong graphic images.

Variations:

a. architectural detail

b. faces with appeal and regional identity

c. textiles: weavings, embroidery, lace

d. costume detail

e. jewelry detail

f. flora, fauna

Frame Shots		Space for Type	Lighting
☑	Horizontal	☑	
☑	Vertical	☑	☑ Exterior (available light)
☑	Wide	❑	
☑	Medium	☑	☑ Interior (strobe light)
☑	Close-Up	❑	

Models: Any local person wearing jewelry, costume of a region or with an extra-ordinarily appealing face. Get model release.

Ethnic: Various

Props: Anything elegant or charming that identifies the location

Locale: Anywhere in the world you travel, local or international

Include: Appealing, identifiable details

Avoid: Vague or confusing details. Sloppy execution or lighting

Note: Think of the airline posters that instantly communicate their location. That is the goal. Examples: Central America—exotically plumed parrot; China—panda face; Spain—mantilla on dancer in Seville; Mexico—close-up of Olmec face. When traveling, look for small moments or close-ups of objects to identify a location.

STOCK ASSIGNMENT 5

Category: Travel (still life, studio setup)

Purpose: To create, using still life, an icon to illustrate a travel destination.

Subject: To identify a location, use an object that evokes the mood and appeal of that destination and immediately identifies the city, region, or culture. Should have almost universal recognition.

Variations:

a. artifact

b. craft

c. musical instrument

d. architectural symbol

e. food

f. flowers

Frame Shots		Space for Type	Lighting
☑	Horizontal	☑	
☑	Vertical	☑	☑ Exterior (available light)
❑	Wide	❑	
☑	Medium	☑	☑ Interior (strobe light)
☑	Close-Up	☑	

Models: n/a

Props: Any object that symbolizes a country or region

Include: Stunning, appealing objects to attract a potential traveler

Ethnic: n/a

Locale: Anywhere in the world that you know well enough to create a symbol.

Avoid: Tacky props. Unclear symbols, objects that aren't recognizable by the general public.

Note: Think of the air lines posters that instantly communicate a location. That is the goal. Create images for places you've been or have researched thoroughly. This assignment can be done in the studio with objects you've brought back from travels or acquired locally.

Examples: Spain—castanets; Paris—a statue of the Eiffel tower (rendered in digital colors for the new Paris); New Orleans—jazz instrument; American West—spurs; American Southwest—close-up of turquoise and silver Native American jewelry; Hawaii—exotic flower; American Midwest—succulent kernels of corn in half-opened husk; Mexico—perforated tin lanterns glowing with light.

STOCK ASSIGNMENT 6

Category: People (elderly with technology)

Purpose: To portray the elderly as alert, productive people leading active lives, participating in society, and managing modern life.

Subject: Elderly couple and/or a single elderly person in various activities including confident interaction with digital technology to symbolize the acceptance of change.

Variations:

a. playing computer games, using the Internet

b. man (or woman) using computer email

c. woman at computer, financial program

d. man w/laptop in retirement setting, golf course

e. woman using multimedia w/grandchild, homework

f. woman gardening using cell phone

Frame Shots	Space for Type	Lighting
☑ Horizontal	☑	
☑ Vertical	☑	☑ Exterior (available light)
☑ Wide	☑	
☑ Medium	☑	☑ Interior (strobe light)
☑ Close-Up	☑	

Models: Male and female, 60–70, attractive and energetic but natural, believable—not plastic or perfect. Optional: grandchildren 6–7 years

Props: Computer (conceal brand names), cell phone, gardening props, checkbooks, kids' notebooks

Include: Air of confidence and competence in elderly using technology, not fearful or tentative; playful energy

Ethnic: Various, especially Hispanic

Locale: Home exterior and interior or golf course.

Avoid: Stereotype of glamorous elderly

Note: The portrayal of the elderly should be authentic, believable, and real. Okay to shoot standard scenes (e.g., bike riding, tennis), which are always used, but much preferable to show elderly accepting change and adapting to technology. Do some silhouette or deep shadow for symbolic shot of elderly with technology.

STOCK ASSIGNMENT 7

Category: Family

Purpose: To symbolize family togetherness, communication, warmth, security, good health, food and nutrition, social interaction, concept of "group."

Subject: Family at dinner table, eating meal. Parent serving food, passing plates. Cheerful conversation and smiles. Also, more informal version—eating on the run.

Variations:

a. teen standing, serving others

b. teen seated, interacting w/Dad (medium shot)

c. teen talking, interacting w/Mom (medium shot)

d. child (seated) serving self

e. child talking w/Mom, then Dad (wide)

f. kitchen, kids standing and eating as they leave

Frame Shots	Space for Type	Lighting
☑ Horizontal	☑	
☑ Vertical	☑	☐ Exterior (available light)
☑ Wide	☑	
☑ Medium	☑	☑ Interior (strobe light)
☑ Close-Up	☑	

Models: Mom, Dad (30–40) Teen (13–16) girl Child (8-10) boy

Ethnic: Shoot this assignment 4 times with white, African-American, Hispanic, and Asian families

Props: Colorful (solid) tablecloth. Food—chicken or fish, rice, salad, tomatoes (or ethnic food if non-stereotypical). Beverages—milk, water. Clothes—bright colors, simple, classic styles.

Locale: Home dining area, interior or outside patio.

Include: colorful foods: greens, reds, etc.

Avoid: Unhealthy food, high cholesterol food, brand names on products (ketchup, condiments, etc.), alcohol, ashtrays, cigarettes

Note: Shoot after real dinner is eaten, so models won't get hungry or cranky during shoot. Provide "prop" food. Don't really eat (chewing looks ugly). Have them serving or poised, food on fork, ready to eat, while talking.

STOCK ASSIGNMENT 8

Category: Housing/Houses

Purpose: To show American homes in a variety of styles, sizes, landscaping, locations, and economic range. As symbols of stability, security, contentment, family goal.

Subject: Housing/homes—modern, ranch, Victorian, split-level 1930s, charming with porch.

Variations:

a. small/cozy/modest

b. large/imposing/expensive

c. near the water

d. lighted windows/twilights

e. family with real estate agent

Frame Shots	Space for Type	Lighting
☑ Horizontal	☑	
☑ Vertical	☑	☑ Exterior (available light)
☑ Wide	☑	
☑ Medium	❑	❑ Interior (strobe light)
❑ Close-Up	❑	

Models: Optional for some variation **Ethnic:** Varied

Props: For-sale sign, planter with flowers by the door **Locale:** All regions of United States; all attractive seasons

Include: Various materials—adobe, clapboard, stone. Optional—mailbox, fences, birdbath, sundial. **Avoid:** Signs of disrepair; scruffy lawn/landscaping; cars in driveway; clutter on porch, steps, or walk.

Note: Get property release. This is critical to the value of stock photographs of houses. Offer of a "portrait" of the house (or of the family in front of the house) may be a trade for permission (and possible introduction to models for other uses). Shoot varying amounts of yard, lawn in foreground, and sky in verticals. Be careful to square up horizons; avoid having buildings tilt inward.

STOCK ASSIGNMENT 9

Category: Emotions (pride)

Purpose: To capture the emotion of pride in achievement, accomplishments, and the sharing of that emotion.

Subject: Person (adult or child) alone on stage, podium, finish line holding trophy/award/ribbon

Variations:

a. smiling/thrilled

b. arms up triumphant

c. shaking hands with donor

d. showing award to parent/friend

e. blue ribbon or painting

f. with dog and ribbon

Frame Shots	Space for Type	Lighting
☑ Horizontal	☑	
☑ Vertical	☑	☑ Exterior (available light)
☑ Wide	☑	
☑ Medium	☑	☑ Interior (strobe light)
☑ Close-Up	☑	

Models: 1–2 adults or 2–3 kids (age 7–10), or teens

Ethnic: Various

Props: Trophies—baseball, bowling, track, soccer; blue ribbons

Locale: School, stage, sports area, horse show, dog show, crafts show, 4H, music recital

Include: Symbol of event—finish line, bleachers, curtains/stage

Avoid: Busy backgrounds, extra crowds, signs/ads. Retouch to remove logos.

Note: Spontaneity and believability of emotion is crucial. If the scene is a setup, give models something to feel or laugh about—teasing can help get the right look. Keep the scene simple—concentrate on expression. Make symbols of the event subtle and non-intrusive.

STOCK ASSIGNMENT 10

Category: Health care

Purpose: Symbolize the role of health care workers for the next decade by showing health care professionals providing care using the current approach.

Subject: Health care professionals—nurses, nursing assistants, and home health aides, male and female, giving treatment to patients of all ages.

Variations:

a. male nurse taking blood pressure

b. female nurse adjusting IV

c. nursing assistant cleaning patient glasses

d. nursing assistant reading get-well card to patient

e. nursing assistant adjusting pillows

f. nursing assistant feeding elderly

Frame Shots		Space for Type	Lighting
☑	Horizontal	☑	
☑	Vertical	☑	❑ Exterior (available light)
☑	Wide	☑	
☑	Medium	☑	☑ Interior (strobe light)
☑	Close-Up	☑	

Models: Male and female, patients all ages

Props: Medical wardrobe, health aide or nursing smock, white pants, flowers, plants, get well cards, small personal objects, bed jackets, robes. Medical props—blood-pressure cuff, IV tubing.

Include: Interaction between patient and health-care worker

Ethnic: Various

Locale: Clean, bright hospital, clinic, or nursing home

Avoid: Sterile or depressing locations, busy backgrounds

Note: Medical wardrobe—nurses never wear all white. Pastel color tops are used with nurse's pin and stethoscope. Nursing assistants wear smock tops and white pants but no nursing credential pin. Because doctors have been widely covered, there's more need for mid-level health care workers who will assume increasing amounts of the health care burden in coming years.

STOCK ASSIGNMENT 11

Category: People (teens and dating)

Purpose: To show teens learning to build interpersonal relationships. Symbol of future.

Subject: Teens dating—enjoying each other's company; couple alone and with peers; in activities.

Variations:

a. walk home from school/talk

b. walk/talk hold hands

c. group hanging out near car

d. goodnight hug/kiss

e. close to monitor/computer game

f. teen couple at dance/party

Frame Shots	Space for Type	Lighting
☑ Horizontal	☑	
☑ Vertical	☑	☑ Exterior (available light)
☑ Wide	☑	
☑ Medium	☑	☑ Interior (strobe light)
☐ Close-Up	☐	

Models: 2–6 teens, attractive, appealing; 15–17 years old

Props: School books, jackets, tennis rackets, guitar, Video Games

Include: Activities—playing music, talking, laughing, computer games

Ethnic: Repeat with all ethnic groups, as well as mixed ethnic.

Locale: Locale: Home—party, recreation room, ping pong; school dance; street; park; movie

Avoid: Trendy clothes, fad hairstyles

Note: Mood and physical closeness are important. Use good acting students or kids who are actually dating. This will make the scene more believable. Include scenes of teens viewing MySpace, Facebook, and YouTube.

STOCK ASSIGNMENT 12

Category: People (elderly in northern environments)

Purpose: Portray vigorous elderly people actively pursuing interests in a northern environment. To show that seniors can cope with and enjoy winter activities and that they are more than hothouse flowers.

Subject: Elderly couple enjoying winter activities and sports, having fun, being playful

Variations:

a. walking on a snowy trail

b. cross-country skiing

c. playing, throwing snow

d. making snowman

e. grandchildren/snowman

f. standing with sled

Frame Shots	Space for Type	Lighting
☑ Horizontal	☑	
☑ Vertical	☑	☑ Exterior (available light)
☑ Wide	☑	
☑ Medium	☑	❑ Interior (strobe light)
☑ Close-Up	☑	

Models: Attractive, slim couple with silver hair in their 60s.

Ethnic: White, Hispanic, African-American

Props: Colorful ski clothes—hat, scarf, mittens, sled, snowman skis

Locale: Snowy fields, rural look, fresh snow

Include: Smiles. Must look comfortable, warmly dressed. Good interaction.

Avoid: Models looking cold and miserable, brand name on sled.

Note: Need bright, sunny day, so winter looks appealing. For skiing shots, rural setting is necessary, but close-ups of couple having snow fight or building snowman can be in any backyard or park with neat, clean look. Elderly are rarely shown in cold-weather sports. This breaks the stereotype that all seniors loll in a warm climate.

STOCK ASSIGNMENT 13

Category: People (crowds)

Purpose: To show the diversity of America (melting pot). A cross section of the culture and the buying public.

Subject: A crowd of alert, happy faces watching event.

Variations:

a. laughing, applauding

b. looking intent, serious

c. looking pleasant

d. looking off camera

e. looking on camera

f. some with kids/teens

Frame Shots	Space for Type	Lighting
☑ Horizontal	☑	
☑ Vertical	☑	☑ Exterior (available light)
☑ Wide	☑	
☑ Medium	☑	☐ Interior (strobe light)
☐ Close-Up	☐	

Models: Mixed ethnic and age groups. 20–35 people, a few with silver hair.

Ethnic: All. Important to represent white, African-American, Asian, and Hispanic.

Props: Request models wear simple, brightly colored casual clothes. Too many hats or sunglasses distract. Take extra pens, clip boards for signing releases.

Locale: Locale: Use stadium bleachers of local college or high school

Include: Use university, sports club, or church group that might be getting together anyway (e.g., Little League parents, faculty picnic). Check ethnic and age breakdown and bring models to balance out. Include some teens, some kids.

Avoid: Cigarettes, beer, or soda cans. Clothes with obvious sayings, logos.

Note: This is not an easy one, but very valuable if carried off. Pass out model releases before shooting. Have assistant go through crowd and collect signed releases, noting a description, hair, or shirt color on the release. Throw a picnic as a thank you—or bring a cooler for after the show. Offer comp prints or donations to the club.

STOCK ASSIGNMENT 14

Category: People (verbal communication)

Purpose: To show verbal communication, power of persuasion, efficacy of spoken word and gesture

Subject: Person speaking with energy, enthusiasm, conviction, using hand gestures, eye contact, presenting/receiving awards, giving a speech, sales report

Variations:

a. adult man speaking using mike

b. adult woman speaking using mike

c. woman using PowerPoint

d. older woman speaking

e. teen girl sports banquet

f. adult presents award to teen

Frame Shots	Space for Type	Lighting
☑ Horizontal	☑	
☑ Vertical	☑	☑ Exterior (available light)
☑ Wide	☑	
☑ Medium	☑	☑ Interior (strobe light)
☑ Close-Up	☑	

Models: 1 or 2 each scene. 2 adults, 1 woman silver hair. Teens—male and female.

Ethnic: White, African-American, and Asian groups, as well as mixed ethnic.

Props: Microphone, water pitcher, flip chart, pointer, award plaques, index cards/notes, laptop w/PowerPoint; clothes—professional look

Locale: Auditorium, podium, or conference room.

Include: People speaking with notes, props to indicate sales conference, business meeting, charity drive, poetry reading

Avoid: Closed eyes (watch for light-sensitive models), awkward or stiff gestures

Note: Not a complicated setup. Use props and signs to indicate variety of scenes for communication. Good acting needed here. Provide real speech ideas or reading material to help models gain authenticity. School drama club or local theater group can provide good models.

STOCK ASSIGNMENT 15

Category: Animals (domestic)

Purpose: To show the evocative nature of pets in a variety of strong, graphic statements. To capture their essence and appeal. To communicate loyalty, trust.

Subject: Symbolic or unusual views of dogs, cats (puppies, kittens)

Variations:

a. Paws—extreme close-up

b. limpid eyes—super close

c. tail wagging, blurred motion

d. dog/cat curled, asleep

e. mouth profile, tongue hanging out

f. profile of elegant cat

Frame Shots	Space for Type	Lighting
☑ Horizontal	☑	
☑ Vertical	☑	☑ Exterior (available light)
❑ Wide	❑	
☑ Medium	☑	☑ Interior (strobe light)
☑ Close-Up	☑	

Models: Clean, well-brushed, class (not exotic) breeds, the "everyman" of pets

Ethnic: n/a

Props: Use clean dog collars or avoid collars if they are distracting

Locale: Simple, clean field or interior

Include: Fields, tree limb

Avoid: Puppy in basket, ball of yarn, "poster cute" postures—overdone

Note: Texture and lighting (evocative mood) are important.

STOCK ASSIGNMENT 16

Category: Housing/Homes (gardens)

Purpose: Show the lawn as accoutrement of upscale housing— landscaping used as setting for corporate or domestic architecture.

Subject: Lawns—fresh, green, well-manicured sweep of grass, with and without buildings in background

Variations:

a. in corporate setting

b. with border gardens

c. in traditional garden

d. include curb/sidewalk

e. Southwest "dry" lawn, stones

f. Southwest, include cactus

Frame Shots	Space for Type	Lighting
☑ Horizontal	☑	
☑ Vertical	☑	☑ Exterior (available light)
☑ Wide	☑	
☑ Medium	☑	☐ Interior (strobe light)
☐ Close-Up	☐	

Models: none

Props: Flowering plants to place as needed

Include: Curved path, flagstone, railroad ties, other landscaping features

Ethnic: n/a

Locale: all regions of the United States, include types of grass bred for different climates

Avoid: Cracked sidewalks, curbs, weeds, scruffy plants, bare spots

Note: Avoid lawns with dappled sunlight. Need good, rich light for saturated color (late day, early morning). Uses: ads for a wide variety of landscaping equipment (watering devices, lawn food, cement manufacturers) builder/contractor brochures.

STOCK ASSIGNMENT 17

Category: People (teens and affection)

Purpose: To symbolize romance, affection, and physical attraction (in a discreet manner) for use with sensitive editorial material or advertisements.

Subject: Young couple, in profile, silhouette, or symbolic close-up, showing affection and physical contact.

Variations:

a. holding hands (close-up)

b. hands, fingers locked

c. swinging hands, walking

d. kissing, backlighted

e. head on shoulder

f. hugging/arms/shoulder

Frame Shots	Space for Type	Lighting
☑ Horizontal	☑	
☑ Vertical	☑	☑ Exterior (available light)
☑ Wide	☑	
☑ Medium	☑	☑ Interior (strobe light)
☑ Close-Up	☐	

Models: Good hands, well manicured. Slim, attractive. Use real-life couples, actors, or professionals.

Ethnic: White and African-American primarily but also Asians and Hispanics.

Props: Girl's bracelet, school books, blue jean jackets, casual clothes

Locale: Studio or exterior; park twilight

Include: Full length-figure silhouette, back to camera, walking away from camera

Avoid: Recognition of models

Note: Use professional models, actors, young-looking twenty-one-year-olds (using real-life couples helps avoid embarrassment and if over twenty-one they don't need parental signature on a release). Make sure that models and parents understand the nature of the pictures, let them see samples of finished photographs to show that anonymity was preserved. Note on release that prints were shown and nature of possible use discussed.

STOCK ASSIGNMENT 18

Category: People (overworked executive)

Purpose: To show the concept of the overworked, harried executive. To illustrate the headline: "Is multitasking doing you in?"

Subject: Harried man or woman, multitasking to an exaggerated degree.

Variations:

a. woman executive

b. senior executive

c. clutching briefcase

d. briefcase in teeth

e. one hand only, emerging

f. close-up face, gasping

Frame Shots	Space for Type	Lighting
☑ Horizontal	☑	
☑ Vertical	☑	☑ Exterior (available light)
☑ Wide	☑	
☑ Medium	☑	☑ Interior (strobe light)
❏ Close-Up	❏	

Models: Business man, age range 38. Business woman, age range 38. Also, Silver-haired executive.

Ethnic: African-American, Hispanic, white.

Props: Laptop computer, Blackberry, cell phone, iPod, etc.

Locale: Office setting, both traditional and casual plus home office setting; street and car.

Include: Enough props to make the scene convincing

Avoid: Makeshift or sloppy props.

Note: Shoot both formal and informal versions, in office and en route to and from work.

STOCK ASSIGNMENT 19

Category: People (teens and hobbies/sports)

Purpose: To show the current action hobby/sports for teens as a portrayal of exuberant youth pushing to the limit. To symbolize the intense competitive energy of adolescence.

Subject: Teens involved in individual action hobby/sports, including most popular skateboarding, wake boarding, snowboarding, and rollerblading. May also include the traditional skiing and surfing.

Frame Shots	Space for Type	Lighting
☑ Horizontal	☑	
☑ Vertical	☑	☑ Exterior (available light)
☑ Wide	☑	
☑ Medium	☑	❏ Interior (strobe light)
☑ Close-Up	☑	

Models: Boys and girls, ages 14–17, proficient in their sport.

Ethnic: Any

Props: All sports gear including protective helmets, knee pads; clothes—simple, non-trendy, no logos or brand names.

Locale: Parks, track, beach, or other natural setting.

Include: Dramatic, high-energy action. Movement, exciting angles. High off the ground —leaping and jumping.

Avoid: Obvious brand names on products or clothes.

Note: Concentrate on the sports special to your climate or region. For more compelling action, use on-camera fill-flash and a rear curtain to get controlled blur and to heighten action. Check magazines for sports competitions near you, and then make a contract with the best competitors to use as models in later set-up shooting.

STOCK ASSIGNMENT 20

Category: Still life (healthy food)

Purpose: Symbolize health, nutrition—essentials of life.

Subject: Close-up, graphic of essential, symbolic foods—bread, grains, fruits. Dramatic lighting, texture. Space for type essential.

Variations:

a. bread—whole and sliced

b. bread, grains, sheaf

c. apple—whole and cut

d. apple with other fruits

e. fruit and vegetables

f. rice grains

Frame Shots	Space for Type	Lighting
☑ Horizontal	☑	
☑ Vertical	☑	☑ Exterior (available light)
☑ Wide	☑	
☑ Medium	☑	☑ Interior (strobe light)
☑ Close-Up	☑	

Models: None

Props: Only perfect specimens of food, need to show close up detail.

Include: Use second-choice fruit as stand-in; when lighting is right, bring perfect food from refrigerator

Ethnic:

Locale: Studio (or possible exterior—weathered barn siding, stone fence, natural backdrop)

Avoid: Blemished fruit, foods

Note: This topic has been covered many times, but it is constantly being requested. Need excellent execution. Try new approaches, experiment with variations in lighting.

STOCK ASSIGNMENT 21

Category: International Business Communications

Purpose: Show pervasive need for instant communication. Express with symbols of United States, Europe, and Asian cultures.

Subject: Person in business clothes with cellular phone on moped, stopped at light or moving with blurred background. Use neutral unidentified background. Make international through use of ethnic models and props.

Variations:

a. dark-haired male/moped and cell phone

b. dark-haired female/moped and Blackberry

c. Asian male/car and cell phone

d. Asian female/moped and cell phone

e. male on racing bike and cell phone

f. female on racing bike and cell phone

Frame Shots		Space for Type	Lighting
☑	Horizontal	☑	
☑	Vertical	☑	☑ Exterior (available light)
☑	Wide	☑	
☑	Medium	☑	☐ Interior (strobe light)
☑	Close-Up	☑	

Models: 3–4 trim business types

Props: Cellular phone, car, bike or moped, briefcase, helmet, Blackberry

Include: Shoot tight on person and vehicle

Ethnic: Dark-haired, Hispanic, and Asian

Locale: Street/urban keep unidentifiable, out of focus buildings, green trees, park behind

Avoid: Legible names on background or props

Note: This short calls for a sense of motion, the person communicating while on the move, in a hurry, just paused at traffic light, or moving out—impatient, energetic. Also, should have an international look as natural to Madrid as to Chicago.

STOCK ASSIGNMENT 22

Category: People (ethnic women)

Purpose: To portray ethnic women in upscale or powerful roles in society.

Subject: African-American and Hispanic women alone (or with men in background) as well-dressed consumers, discerning shoppers, using leisure time, or in business context.

Variations:

a. discerning buyer window shopping

b. at boutique/mirror, trying on elegant clothes

c. black or brown hand with Blackberry

d. relaxing in resort w/drink, umbrella table

e. close-up black or brown hand with cool drink

f. close-up black or brown hand with fan

Frame Shots		Space for Type	Lighting
☑	Horizontal	☑	
☑	Vertical	☑	☑ Exterior (available light)
☑	Wide	☑	
☑	Medium	☑	☑ Interior (strobe light)
☑	Close-Up	☑	

Models: Very attractive young women plus some fabulous fifties; may need hand models for close-ups.

Ethnic: African-American and Hispanic

Props: Fine clothes, jewelry, make-up, high end electronics

Locale: Upscale resort or shop

Include: First-class props, make-up, manicure

Avoid: Tacky details

Note: The impression of these photos should be of ethnic women with discretionary income, in command of their world, women who have made it. Men can be out of focus in the background. Any resort setting should have blue sea, palm trees, or other indicators of privilege.

STOCK ASSIGNMENT 23

Category: Health

Purpose: To create an icon of a healthy body to symbolize health and fitness.

Subject: The female and male body shown in simple graphic shapes, silhouette, and anonymous close-ups as well as full body. Any activity—emphasis is on health and perfection of the form.

Variations:

a. torso front or back in repose

b. torso front or back movement

c. reaching arms

d. runner or swimmer stretching

e. touching toes only arms and feet

f. back or side view arm with weights

Frame Shots	Space for Type	Lighting
☑ Horizontal	☑	
☑ Vertical	☑	☑ Exterior (available light)
☑ Wide	☑	
☑ Medium	☑	☑ Interior (strobe light)
☑ Close-Up	☑	

Models: Perfectly fit young adults

Ethnic: All

Props: Simple sports wardrobe, avoid collars if they are perfect specimens

Locale: Clean, natural setting or studio

Include: stunning lighting

Avoid: Clutter

Note: A simple, elegant execution with exquisite lighting is critical to this photo. Use the human form as a still life. Could have digital version: create echo of shape, heighten movement, alter colors. Superimpose over background of healthy food. Symbolize the key to good health—the combination of healthy eating and exercise.

STOCK ASSIGNMENT 24

Category: People (elderly and health care)

Purpose: Portray the current trend of providing health care at home with the new approach of restorative and rehabilitative approach to health care.

Subject: Show an elderly person being cared for at home or in a facility by a compassionate health professional, receiving care and encouragement through restorative activity, communication, and interaction with a nurse, nursing assistant, or home-health aide.

Variations:

a. exterior porch—read letter to elderly

b. exterior porch—peel potatoes/ fruit together

c. elderly and nurse looking at photo album

d. elderly and nurse potting plants, smiling

e. nurse walks next to elderly, encouraging, smiling

f. assisting elderly to feed themselves

Frame Shots	Space for Type	Lighting
☑ Horizontal	☑	
☑ Vertical	☑	☑ Exterior (available light)
☑ Wide	☑	
☑ Medium	☑	☑ Interior (strobe light)
☑ Close-Up	☑	

Models: Male and female

Props: Health aide or nursing smock, white pants, letters, photo album, snapshots, fruit, vegetables, bowl, pots of flowers, food tray

Include: Eye contact, pleasant interaction

Ethnic: All—as many as you can.

Locale: Attractive settings in and around the home

Avoid: Depressing look, cluttered details

Note: Create scenes that give a sense of independence and dignity to the elderly. The health-care provider assists when necessary in an activity but encourages and supports with words and smiles and gestures, what the elderly person is doing.

STOCK ASSIGNMENT 25

Category: Sensitive issues

Purpose: To symbolize the conflict between smokers and nonsmokers—particularly the issue of secondhand smoke.

Subject: Show various scenes of smokers creating smoke and non-smokers being affected or trying to protect against second-hand smoke. In some the smoker has a self-righteous expression and the nonsmoker is aggrieved or innocent. In others the smoker appears more adamant or aggressive about the right to smoke.

a. smoker wreathed in smoke halo

b. nonsmoker choked by wreath of smoke

c. smoker and nonsmoker bound by a rope of smoke

d. smoker with cigarette as a sword

e. nonsmoker with shield or gas mask

f. smoker with child breathing secondhand smoke

Frame Shots	Space for Type	Lighting
☑ Horizontal	☑	
☑ Vertical	☑	❑ Exterior (available light)
☑ Wide	☑	
☑ Medium	☑	☑ Interior (strobe light)
☑ Close-Up	☑	

Models: 1–2 young adults

Ethnic: white

Props: Cigarettes (smoke) normal wardrobe, mask/goggles

Locale: Studio for base shots

Include: Skillful lighting

Avoid: Faces in some shots.

Note: In order to achieve the desired effect, you will have to employ digital manipulation; however, this is a less complicated procedure than some others, because you need only one to two models photographed singly against a dark background plus smoke shots for the base. The key is refined imaging with the shapes created by the smoke. Could do variation showing a pregnant mother, smoke shaped as a dagger pointing at the unborn child. Sensitive issues must have a model release with the subject of the photo especially noted. Also, check with your stock agency for their handling of sensitive-issue photos. (Must have access to top equipment and expertise in photo-manipulation software.)

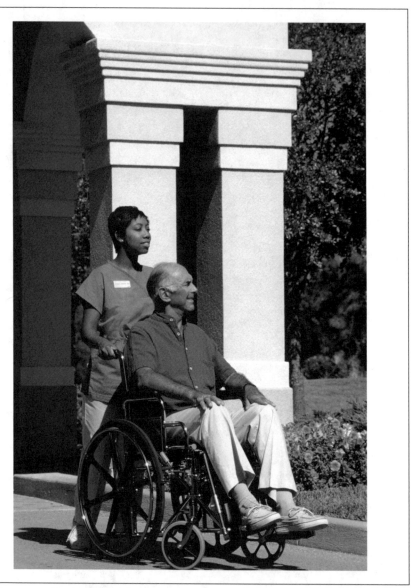

Nursing care. Venice, Florida

Preparing the Shoot

The production of good stock photography is an extremely complex undertaking. There are many details that must be planned and organized in order to have the bright, well-executed, relevant professional stock that is required in today's competitive market. The information, techniques, and sample letters in this chapter will go a long way to making this manageable. They will take the drudgery and uncertainty out of producing stock. Organizing a shoot is easier in the digital environment, but what stays the same is the need to plan ahead and thinking through all the details in advance. Only then can you use your digital tools to full advantage.

PLAN YOUR PROJECT

Before dealing with the logistics of a shoot, it's important, as you saw in the last chapter, to have a cohesive stock plan to give focus and direction to your shooting. You will have chosen stock assignments listed in chapter 5 based on your interests and on what your locale has to offer. Now consider grouping them into themes. Pick a theme and give it a name. It will give direction to your shooting and make it much easier to explain what you are doing to prospective models or those who grant permission at locations.

Start with a title, for example:

- Family Life in the New Century
- Aging Comes of Age
- The Changing Seasons
- Where We Live: Houses and Homes
- Fitness—Health or Obsession
- Fitness—At All Ages
- Sports—Extreme Efforts
- Power Women

As you progress with these projects, they may change shape. These titles are not merely intended to suggest the classic photo-essay approach, which covers

various aspects of a story. You may very well end up with a series of single photographs in differing executions that symbolize the concept of your project. The purpose of a theme title is to help you explore one topic thoroughly, finding as many creative solutions as possible. Move on only when you've exhausted your imagination in one concept area. It's the stock equivalent of quality time.

Once you have a title, you have to get your foot in the door. Compose a written statement to explain your stock project. It'll help you get a grip on what you're doing with the shoot. You'll be more convincing when it comes to asking for access to locations you want to use.

A vague approach such as: "Well, I want some pictures for my stock file" is not likely to win you that access. You have to be more persuasive. This is not to suggest that you should misrepresent what you are doing. Believe in the reality of your concept and share it. If you have a professional commitment to your stock project and feel a genuine enthusiasm, that excitement may intrigue others.

If the project intrigues you visually and intellectually, it will bring you personal satisfaction. You won't get far if you treat stock like sausage production and crank it out, but a genuine interest in what you're doing will make it more fun and have the additional merit of creating the best stock.

If you have a stock agent, remember to share your project description with your agent. Explain your photographic plans—make it easier for agents to provide guidance. (An organized mind is highly prized by agents.) Also, post on your Web site that you are engaged in a special project. This could open doors, create client interest, or uncover leads who will help bring your project to fruition.

This approach is much like the preparation that goes into a typical assignment like an ad campaign, a series of books, or an annual report—all are groupings of photos unified by a single need, style, or subject matter, and all are carefully thought out beforehand.

In writing your stock description, include any potential uses, in addition to stock, that you see as possibilities. These might include exhibitions, book publications, etc. Or, if this is unlikely, be straightforward about the fact that the shooting is strictly for stock. Just make clear that it is a project of aesthetic and intellectual interest to you.

Incorporate your description in your letters requesting assistance from models, organizations, or location sources. (See the sample letters in this chapter.)

SETTING UP SYSTEMS

Start your files immediately. Set up an organization that will work to gather source information and will provide a framework for you or anyone who works with you. Valuable model contacts or source information, if written on scraps of paper and stuck in your pockets or random corners of your desk, are as good as down the drain. The sooner information is entered in the computer, the better. With the always tedious task of filing, sooner is always better than later. Start

before it gets out of hand. Avoid the unnecessary frustration of not being able to put your fingers on a valuable snippet of information.

The files listed in this chapter provide a place to safeguard the valuable information you collect. Make sure the following files and systems are in place before beginning any production shoots:

- Clip file (scan image pages)
- Location files—digital reference photos (contact sheets and on CD)
- Model file—sources digital reference photos (contact sheets and on CD)
- Model-release file—scan releases and save on a backup drive
- Prop/supply source file
- Assistants file (names and addresses)
- Stock job forms—in numerical order
- Stock photo files (category organization)
- Keyword/category lists (These will come with your software for cataloging. See chapter 8.)

It won't take more than a few hours to set up the formats for all these files. It's a matter of deciding the arrangement and design for each type of information and entering it into your database. Some people use Excel to create a master list for many types of information. I usually make a simple form in Word using the Table function. Then it's easy to enter small amounts of information on a daily or weekly basis. But if you haven't created a filing system, it could cost you dearly six months down the road when you urgently need a model's home number or a bit of prop information and can't put your hands on it. Some of the business software for stock (you'll see in chapter 9) provides systems that can be altered to suit your way of working.

Now to the shoot. This section is devoted primarily to setting up production shoots on location. Usually we use the term "production" to mean fairly complicated set up photography involving models and props, though the term can also refer to other types of shoots. Architectural shoots are one example; you would need to acquire permissions even if models aren't involved. The key here is to understand that you need to set up a system for each "production." Most photographers working in studios already have a production system worked out. But for those who want to adapt these techniques to studio work, there's nothing to it. You have simply saved one step: finding the location.

The success of the shoot depends on the preplanning. Let's look now at the procedures involved.

SETTING UP LOCATION PHOTOGRAPHY

The preliminary work needed for stock photography on location can be handled by the photographer or by a variety of people in different combinations and with different titles. Once you analyze which parts of the preparation and shoot you'll handle yourself and which parts you need a helping hand with, you'll have a

better idea of the type of person to bring in. No matter how it's divvied up, there are three the basic areas of responsibility:
- Photographic (lighting, shooting/capture)
- Production (planning, organization, and styling)
- Digital technology (preparation and post-production of digital files)

If you are just beginning a stock business, you may want to handle all of these jobs yourself on the first few shoots. This will help you to understand the complexity of the setup process and to know the qualities you'll want in an assistant. It will also ease up on your finances.

Ideally, you need a minimum of three people to handle the three types of work listed above: the photographer; a producer (sometimes called a photo coordinator or a production coordinator); and someone who is knowledgeable in managing digital files both on the shoot and afterwards. If your business doesn't warrant three people, then you need to combine talents. Either you handle the digital files or you find a production coordinator who has that ability.

Until you have the business to justify more than two people, I find that a team consisting of the photographer (with digital skills) and a production coordinator works well. This person may be an assistant, a spouse, or an intern. To the degree that you can create a long-term partnership, your investment in learning the systems will be more amply rewarded later.

As you progress on stock shoots, it will be more efficient to use a coordinator so you can put your valuable time into conceptualizing, shooting, and editing. As a matter of fact, you'd be crazy not to delegate the chores. A good production coordinator can handle all the logistics of making a shoot happen and ensure it's done right. The activities handled by a stylist, location scout, and general gofer are all rolled into one for the purposes of a stock shoot.

On major assignments done by advertising photographers, there are often seven to ten people preparing a shoot: production assistants, stylists, location scouts, casting, prop, digital technicians, and lighting assistants. If you are an experienced advertising photographer, you'll have the team and the techniques at hand. For obvious financial reasons, your goal in producing stock will be to reduce that team to its leanest and most efficient size. That doesn't mean cutting corners or sacrificing quality. In the past, especially in the area of advertising, large investments in stock production were justified and repaid to photographers with ample profit. But changes in the market dictate that frugality and sensible use of your resources is now the norm. Meanwhile, if you can, start with just one excellent person working with you.

In searching for the right first person to work with you, it will be helpful to have an overview of the functions of a coordinator (see the coordinator checklist box). This list will also be useful in training a new person into the job, as it gives an idea of what needs to be done in preparation for a shoot and on the set during the photography session.

FINDING HELP—THE PHOTO COORDINATOR

If you have a partner or spouse willing and able to handle the coordinator's job of setting up your productions, then you are one step ahead.

Mind you, when we say "productions," that doesn't only mean complicated setups involving models and props—it can mean nature photography in a local wildlife preserve. For example, if you want to enter a park before dawn for a sunrise photo, you'll need special permission. Almost every kind of photography, no matter how simple it may appear, requires some advance preparation in order to assure success.

What Do You Need in a Production Coordinator?

At first glance it seems as if you need someone with qualities of almost mythic proportions: organizational ability, energy, good taste, and a good nature. That person should be meticulous, able to think on their feet, able to handle pressure. But most of all, he or she should realize the critical importance to your photography of having everything in order before the shoot. "Winging it" should not be considered a standard option. A good coordinator will help you avoid a crisis atmosphere.

In addition to these qualities, a producer should visualize the job from start to finish to know what is needed for planning and estimating the cost of the job. This way the photographer can judge the cost effectiveness of a potential shoot. By the way, I will use the terms producer, production coordinator, and coordinator interchangeably in this chapter. Due to the fluid nature of the job and the variety of skill levels you might find in the people you hire, choose the term that fits your person.

A production coordinator may need to handle the work of many specialists such as:
- Location scout
- Casting/talent scout
- Hair/makeup artist
- Prop and wardrobe stylist

My good friend, colleague, and experienced producer Catherine de Maria defines it this way: "Simply put, the producer is the person who gets it done. The producer does the who, what, when, where of making a photo shoot happen based on the photographer's layout or concept. In production, the buck stops here. If anything goes wrong, it's the producer's fault. And the ability to anticipate the photographer's needs is key."

Finding the right person(s) may seem a tall order, but they are out there. And if you can't afford an experienced producer, there are often entry-level photographic students looking for the experience and excitement of working in photography. But with them, you'll have to do some training.

Major metropolitan areas will have a large photographic community in which you will find beginning stylists, photo assistants, photographic interns, production assistants, many of them in search of experience. Some will already have some experience and/or downtime. They will often be more than happy to assist on your projects. Another avenue is to look for the stage manager or lighting engineer of a community theater or a college drama group. These people are skilled in handling details under pressure.

What do you have to offer them? Flexibility (scheduling the stock shoots in between their productions), additional experience for a resume, sample prints for their book, and whatever fee you agree upon.

Actually, teachers can make excellent assistants; a little patience and searching will uncover the right one. They have weekends and afternoons available during the school year and a long stretch in the summer. I've had great success using teachers as production coordinators. They are thorough, have the patience to work with a bureaucracy (e.g., getting location permits), are good at thinking on their feet, and usually bring a strong commitment to whatever they do.

Until you can justify a full-time employee, using a teacher offers the advantage of having someone who doesn't depend on you for their full-time income. If you can be flexible in planning stock shoots around their schedule, it's a good solution all around.

FINDING HELP—DIGITAL TECHNICIAN

Managing the digital files while you shoot is a central part of the process of photography. It is especially important when you are shooting a stock project on your own, without the benefit of a client's budget to hire an assistant to keep the digital files safe and orderly. The main question is deciding which member of your team has the best digital skills and abilities. If you are adept at digital imaging, then you can build in some time to your shoot schedule to do the digital management yourself, freeing your production coordinator for other duties.

What Do You Need in a Digital Technician?

Whether you are working on location or in the studio, you need to keep up with the shoot by downloading digital files as you go. Your digital technician should be fully familiar with imaging software and your camera's operating software. This person will download memory cards from the camera into the laptop, organize them into folders by shot name (prepared in advance based on the shot list), and begin making sure the digital file images are ready for the photographer to review when there is a break in the shoot. The digital tech will spot check to see if everything looks good as you shoot—is the exposure consistent, are the expressions good? If you shoot with the camera tethered to the computer, the digital tech person will be at the computer watching the files as they load, alerting you to any problems.

Preparing the Computer for the Shoot

A useful step ahead of the shoot day is for you or your digital technician to prepare folders for the desktop of your laptop computer of the topics or concepts you have planned for the shoot day. You will make folders for each category or sub category you hope to shoot. Then you will have a place to put images as they are downloaded from the memory cards. You can have an extra folder or two for topics that spring up spontaneously, but making an effort to have a way of separating images at the earliest stage will help later in the editing process. A folder for caption information is useful if you are working on an exterior location. Reference images shot to keep valuable identifying information can go in this folder. (You may also want to use your digital technician to assist with editing and post-production work flow, as outlined in chapter 8.)

PRE-PRODUCTION

Now, where do you (or your coordinator) start? With the organizing of the shoot. It is in this pre-production stage that everything gets arranged: models, locations, wardrobe, and props. Thoroughness and attention to detail at this time can make the difference between a professionally executed production and amateur, "nice-try" stock photographs.

MODELS

The people in your pictures, whether professional or amateur models, must be attractive, appealing, and convincing in the roles in which you've cast them. Ask yourself if a person looks like an executive (whether a casual entrepreneur executive or a stereotypical stock-broker type), a teacher, or a construction worker. Are your models believable?

The ideal model has a pleasing or interesting look (they don't all have to be gorgeous) and a relaxed manner. While you may be tempted to use a willing neighbor or that handy brother-in-law, if they don't have the "look" or are extremely stiff in front of the camera, you may be wasting their efforts and your time. Someone who has worked all his life as an accountant may not be a convincing carpenter in your photograph.

Finding Models—The Sources

It's possible to build a rich file of good, nonprofessional or semiprofessional models in a wide spectrum of ages and types if you're systematic. The work of finding models and researching locations will sometimes overlap. When requesting permission for access to a source, make it clear exactly what you need.

- Sources for adult models: professional modeling agencies; professional actors (between engagements); university or community drama groups; high-school drama coaches; friends, acquaintances, and other "real" people (e.g. actual construction workers or executives who look the part)

- Sources for child models: schools, camps, community groups, scouts, church organizations, crafts, or science clubs. Local drama groups or children's theaters are especially good sources, as the children usually have some commitment to the process and their parents consider acting (and/or modeling) a good experience and discipline for the child. The downside is that they may already be busy with after-school activities. Child-model agencies are possibilities in some locales. Keep in mind that because a child has been registered with an agency doesn't always mean they are experienced professional models—it just means that they are interested in modeling. They are still children, with the shyness and hesitancy appropriate to their ages.

Try starting with relatives, friends, and neighbors as your models. The sources above are for later when you have outgrown your immediate contacts or are looking for a wider range of choices. Though I discouraged use of relatives and neighbors earlier (if they did not look the part you are casting), it's wise to save some money on your earliest productions until you've worked out the kinks in your system. Then you can move to the semi professional actors and models, at which point you might have to spend some money.

Finding Models—The Approach

The basic approach to obtaining models is good common sense, such as writing letters to community groups or calling a person recommended by a mutual friend, but there are variations. Working with children, for example, will require a bit more effort, like getting permission forms signed prior to scheduling the shoot. Some organizations, especially schools, will have their own permission forms which parents sign to give the school the authority to allow your photography. Your model release is needed in addition to those forms. Parents and organizations are naturally cautious about permitting access to children in their care. And unless you have an unlimited supply of nieces or nephews, you will have to go farther afield sooner or later. Schools have the most stringent permission requirements compared with community groups or even families. Those will be spelled out separately in the steps that follow.

Perhaps you or your coordinator have a friend or a contact at some organization, school, or company. Use that person's advice and influence to obtain an introduction to prospective models and locations. This can save you a lot of time and gain you access to places and people you might not otherwise have a shot at (no pun intended).

Contacting Modeling Agencies

Even if this isn't your first choice for finding models, it's good to know, before you go another route, what resources are available in your area. Visit an agency or its Web site and check the head shot files to see if the models match your taste or are suitable to your style of photography. Find the agencies in your

area by googling "model agency" and the name of your nearest major city. You will do best to ask photographer colleagues for advice on model agencies in your region. Discuss fees. It is sometimes possible to negotiate a lower fee for novice models, or if you choose a model who is not heavily booked with assignments. It may help your negotiation to explain that you are working on stock photography rather than a firm assignment. Beginning models will sometimes trade their time for some experience and prints for their portfolio. (Be sure the model release they sign reflects what the "value received" actually was.) Above all, be fair.

Contacting Corporations

When contacting a company or corporation, you will often be searching for both models and location access. Whether you need the help of a computer manufacturer, an insurance company with newly renovated offices, or a nearby lumber mill, your approach must be made with finesse.

How to make contact depends on your locale. In small towns or cities, you can go right to the corporate-communications or public-relations department with a reasonable expectation of cooperation. In major metropolitan areas, where nobody has time for anybody, the avenue is the same but access may be more difficult. Owner-managed companies are more approachable and make decisions more quickly. They don't have to go through a corporate approval structure of many levels. The very best way, of course, is to have a friend or a contact on the inside.

To help sway them in your favor, there are some assurances you can give a company:

- You will not show their company logo in your pictures.
- You will not allow any pictures taken on their premises to be used by one of their competitors.
- You will not photograph any employee without the employee's permission.
- You will schedule the photography at their convenience.

You are often going to have to offer an incentive. That will be discussed below.

Contacting Community Organizations

Find the name of the person in charge—the one who has the authority to give permission. Again, that friend you may have on the inside would be the best channel for doing this. Remember, you are asking for access to people (potential models) in their organization or program. You will be requesting permission to photograph individuals or permission to photograph in their facility, or both.

An explanation of your request by telephone may work to open the subject, but a letter or email is preferable—especially if you are speaking to an underling

who will have to report to the boss. You can suggest: "Why don't I send a brief note of explanation that you can give to the administrator of the department?" This way, you are sure that all your important points are communicated to the decision maker. If you are refused access, it's important to know why. Is it against their policy? Or didn't you present yourself clearly?

Contacting Schools

Depending on the district, it is often advisable to start with the superintendent of schools for permission. Some school principals will feel the need to get final clearance at district level anyway, so if you've started at the top, you've saved a step and had a chance to present your case firsthand. However, it's quite possible to go directly to the principal if the person making contact on your behalf (your coordinator?) has a good relationship already established with a school.

Explaining Your Request

For all sources—corporate, school, or other—let them know the purpose of your stock photography project and your needs. Use the title and description of the project along with the sample letters (see samples later in this chapter). Even when the request is handled verbally, as mentioned earlier, it's a good idea to have a letter to leave with the person you speak to or to send afterwards as a confirmation, to make sure that they remember the details discussed.

At the earliest opportunity, it is helpful to have a tour of the facility, offices, grade level classrooms, etc. You should also meet department managers, club leaders, coaches, or teachers and explain the project directly to them. Their involvement is critical. It's both helpful and courteous to consult them. Examine your prospective locations—and if you want to use any of them in a shoot, consider taking reference shots (it's useful to carry the small digital camera) of the area so that you remember what physical features make the space useful or difficult for photography.

Permission Forms

Provide the organization, club, or school with sample permission forms if they don't have their own. Make sure your form indicates that a model release will be signed by each participating model on the day of a shoot (see chapter 15). It is a professional courtesy to offer to pick up the cost of photocopying these releases or the actual work of having the copies made. It is important to establish good public relations by avoiding, when possible, any extra burden on the organization you've chosen for your shoot. Remember, they will probably be understaffed.

This procedure is especially important when dealing with children. It is absolutely essential to have parental permission prior to the shoot. Some administrators at a school or company appoint a contact person, such as an assistant or office secretary, to make logistical arrangements once permission is given. Easy

112

access to this contact person in the office speeds up the process and avoids having to bother the administrator with mundane details.

Reference Photos of Models

Always carry a compact digital camera when visiting prospective locations. A quick explanation to your contact person will get you permission to take reference photos of locations or prospective adult models. These file pictures can be enormously valuable. You may wrack your brain later trying to remember where you saw that great-looking silver-haired woman you need for a shoot—was she the plant manager of XYZ Electronics or the sales assistant at the stuffed animal showroom? A quick digital shot (with name and phone number filed) can be worth a great deal.

With rare exceptions, taking reference photos doesn't work with children. You should *never* photograph *any* child without prior parental permission. Kids don't understand the difference between a low-resolution reference shot for your file and a professional photograph suitable for reproduction. The child only knows that "some lady took my picture." The incident could lead to an unpleasant misunderstanding.

With children, you can get your reference photos at the next stage of your contact. You or your photo coordinator will call to see the status of returns of permission forms. Once most forms are returned, it's useful to go to the next club meeting or to the classroom, releases in hand, to meet the children.

After you select the children you need, based on their general look, liveliness of manner, expressive eyes, ethnic background, or the advice of the teacher, scout leader, or gymnastics coach, consider the following: out of a sense of decency (which will also please the school and parents), make sure that the children are not aware of the selection process. Take discreet notes, followed by consultation with the teacher. Quietly ask which children are the most cooperative, and the best able to follow directions. The valuable insights of the adults involved can steer you away from kids with behavior problems you might not be able to detect in a glance.

Explain to the children that each will be chosen for different pictures, that some will be taken now, some another day, but that all will be included. Then, when your project photos are complete, take general photos of the group (anyone who was "released") to include any child not yet used. The important point is to make sure that no child feels left out. This is essential when you use nonprofessional child models.

What to Offer as an Incentive

The cooperation of friends, neighbors, and corporate or community organizations is critical to the stock shooter. You will have to find ways to make it a fair trade. You get the photographs. What do they get?

Models

What you offer models in exchange for their help in photographs will vary greatly according to whether they are professionals who are paid for their services or friends who act as models for the fun of it.

Probably the single most prized reward for any model, after money, is a print of the photograph, closely followed by tear sheets. It's tough enough to get tear sheets from assignment clients, much less from stock buyers. This makes tear sheets a valuable commodity. Share them. It is the best investment in good will you can make. Information about ordering a magazine, book, or brochure containing their picture is also valued by a model.

Be expansive and generous—don't be chintzy with models during a session. Buy treats for the kids, or when shooting in a home, order pizza or a Chinese dinner for the family whose afternoon you've taken up. Send a box of candy or flowers to the office personnel you've used. Do this especially when you can't afford a top-of-the-line fee. Courtesy and a small gift will show your appreciation. And in terms of enlightened self-interest, it may smooth the way if you want to return some day for another shoot.

If a family has given me extraordinary cooperation over several days and I've photographed everyone including the cat, sometimes, in addition to complimentary prints or a gift, I will send them some extra photos. I usually take time for a few head shots of each child even if it's not part of my stock needs. I make some nice prints of these portraits. Then I also send along a CD with some of the extra, funny reject photos, accompanied by a note explaining that the "rejects" are the throwaways, pictures that didn't work because of blinked eyes, tongues out, or just funny expressions. I send these soon after a session. It's simple enough to do while you're editing and especially easy in Adobe Bridge, or other editing software. When you start your editing process, in addition to your folders for selects, make a file folder labeled "Send Smith family," "Funny shots to send," or "Rejects to send models." Instead of deleting all the rejects as you edit, just drag a few funny ones to your reject folder as you work. In your note, be sure to mention that these photos are for their enjoyment, for personal use only, and not for reproduction. Of course, you'll have your copyright notice in the metadata of any files you send. Another approach, if you don't want models to have the digital files on a CD, is to select these funny or reject images during the editing process, then make them into a contact sheet, and print out a set of contacts to give to the models.

When using professional models, even with those willing to barter their services, discuss the question of residual fees. Once you've recovered costs, try to share a percentage of a sale of their picture with your models—it's a great way to keep good talent.

People like to be cooperative, but no one likes to be exploited. Sadly, when it comes to models, we photographers are known to "love 'em and leave 'em."

This is particularly true once we have the photograph we want. To be successful in stock, a dependable stable of models is essential. Treat them right.

Corporations and Institutions

Occasionally, some stock photographers trade photographic rights for access to models or locations. I advise against this practice. It is necessary and reasonable to give a company or institution something for their trouble, but it is not necessary to provide free use of professional photographs they would otherwise have to pay for by assignment or from a stock agency. This sends the wrong message about the value of your photography. How will they feel the next time they are asked by an agency to pay normal rates if they know you are willing to give it away? (See chapter 12, Negotiating Prices, for more on this.)

You can offer several other valuable things, however. Complimentary prints for the company to display in a conference room or in a manager's office, or for any of the employees depicted, are often greatly appreciated. Do some "good will" portraits for the personal use of the managers—once, I even did some quick pictures of an executive's visiting nine-year-old. However, if this is a prospective assignment client, make sure the portraits are professional quality or don't offer them. Having to explain later, "That was only a grab shot" may not foster confidence in you if the quality is less than it should have been.

Make sure that all complimentary prints you give out are clearly marked with your name, address, and copyright notice. Add the note: "For personal use only. Permission to reproduce must be obtained in writing."

If they are impressed with the pictures and want to use them in a brochure or company report, you may then want to give them a break on the fee. Let them know that you will happily give them a discount for specific usage, but not for free. (Think of it this way: the corporate communications officer of an electronics firm probably wouldn't expect to trade you a new VCR in exchange for your helping him out with some photographic advice on taking pictures of his pets.)

LOCATIONS

Locations truly are the setting for your gem. They should be believable, generic, and not distracting. First judge a proposed location by its authenticity. What you look for in a location is a clear, direct statement of what that location is. Whether it's a room, an office, or open field, a location should communicate its essence immediately. Does it feel genuine? Does it look the part or can you make it look the part? If you are doing a picture of a pediatrician examining a child, it's possible to use the examining room of an internist by simply adding a few child-related props. But you'll be hard-pressed to create a convincing scene if you are working in the corner of a community hall.

Scrutinize each prospective location. Does a particular office look like a top executive's seat of power or is it barely more than a cubicle? Or, if you are seeking an offbeat office location for a casually dressed and stylishly funky new executive, is your chosen location convincingly retro or is it merely old and dreary. Will a family kitchen you've used reinforce the warm interaction that is expected by the photo buyer? Anything that distracts from your message must be changed or avoided.

Locations—What Works Best

A good location is attractive, clean, well-maintained, and in good repair or up-to-date. For stock, tacky or down-at-the-heels spots won't do. This is not a documentary.

Next, look for large spaces, whether in a home or office. (You need space for your lights.) In home settings, try for rooms with pale colors or quiet wallpaper. Avoid mirrored or dark-paneled walls, flamboyant wallpaper, and high-gloss enamel paint.

When working outdoors, does your nature location evoke a Robert Frost poem? Will a location read in a photograph as "an inviting trail through the forest?" Or will it merely look like a dark woods with tangled underbrush? Just because it's natural doesn't make it a good location. Even natural sites must be selected to show their features off to the best advantage.

Locations—What to Offer

Finding the right locations—and the approaches and incentive needed to secure them—is handled very much like the search for models. When dealing with organizations or corporations or government facilities, make a clear request, in writing when possible, and let them know what you can offer them for their cooperation.

Location fees are sometimes requested by an organization, a store, or a school—especially those that have been used before in assignment photography. Determining when a location fee is a necessary investment will depend on how important a location is to your project (and to the size of your pocketbook). Often an organization is asking for acknowledgement more than for money; however, they want to know that you realize their time and cooperation has value. If you offer a modest donation to one of their funds or to a favorite charity of theirs, along with an explanation of why you can't pay a higher location fee, they will know that at least you are treating them with respect.

A possible approach: "I wish we could offer you a location fee, as movie makers and television people do, but our budget on this project just won't allow it. Could we make a small donation to XYZ Charity in your name? We can't afford what your time is really worth, but we'd like to show, even in this small way, how much we appreciate your cooperation."

Other small gestures, which may seem insignificant to you, will be appreciated if they are handled in a sensitive way. For example, a community crafts club may be pleased to have the used seamless background paper that you were about to throw out. Their kids can use the reverse side to make a mural. We are sometimes cavalier about items that others will value. Also, don't forget the power that photos can have over adults as well as children. Sending contact sheets of rejects or emailing some photos the day after the shoot will increase your good will.

Researching Locations

For the purposes of building your file, never go anywhere without a point-and-shoot digital camera so you can make visual notes of good locations you come across in passing. Transfer the pictures and pertinent information, such as directions to the location and the property owner's name, to your database.

Exteriors in Nature

As you shoot your file pictures of a natural setting, be sure to note the angle of the sun, time of day, and the directions (north, south, east, and west) at the site, based on your proposed camera angle. Also note the time of year and what plants or flowers are in bloom.

Exteriors with Structures

It's not possible to find the owner of every building in a street scene, but for a significant building, and if you want to sell to the advertising market, it's essential to find the owner to get permission before using it in a photograph.

Interiors

Take reference shots of all four walls of a location room, whether office, store, or home setting. Note the rough dimensions, the location of windows and doors, reflective surfaces, obstructions. Note other characteristics. Is it high-tech, traditional, cozy, elegant, simple? Use your location file form to fill in the contact's name and all other details.

Permits

Contact the mayor's office or the Chamber of Commerce for guidance about what permits are needed in the area in which you want to shoot.

National parks have restrictions on where visitors can go and what they can do based on a concern for resource protection. Photographers are supposed to be treated no differently from any other visitors, provided they act as any ordinary visitor might act. So, for example, photographing with a tripod in an area open to the public might be ok, but entering a restricted area, or setting up lights in a public area, would

not be permitted. National park restrictions on photographers can vary from location to location. Professional photographers can sometimes gain access to locations not open to the general public with a special request to the park superintendent. There are guidelines from the Department of the Interior, but considerable autonomy is given to individual national park superintendents to determine what constitutes a threat to the environment or wildlife of their area. For the latest information you can go online to *www.nps.gov* and check the regulations for photography in the specific national park you plan to visit. If you haven't done advance research, the next best practice is to check for restrictions when you first arrive at a park. Then contact the office of the superintendent if you want to shoot in a location or in a way that is different from what the general public is allowed.

There are certain privately owned attractions, such as Disneyland, Sea World, and various amusement parks, which prohibit showing their facilities in a photograph for trade or advertising. Despite this, it is sometimes possible to get permission for photography through the facility's public relations department. But before setting up a complicated shoot, get your permission straightened out. You'd be heartsick at having to cancel in the middle of a shoot with a family of models looking on because a security guard takes issue with what you're doing.

Some photographers shooting with a low profile may avoid detection by the security guards—two cameras and a shoulder bag are common for tourists—but without permission, the resulting pictures have very limited value, unless you want the risk of a lawsuit down the road.

Changing Locations

In order to avoid unpleasant surprises, try to double check your location just before a major shooting session. I remember the time that jack hammers were ripping up the courthouse steps I had selected as a good location for a shoot, checked just the week before. Then there was the morning in North Carolina when I was greeted by a bodybuilding contest, complete with a giant Budweiser can, on the pristine beach I had scouted for a family scene just the night before. At times like these you have to be flexible and think on your feet. We made a quick exit, loading models as we raced the good light to the next beach down the coast. Then there was the spring flood that washed away carefully arranged stepping stones the night before a shoot. The scene had been planned to have seven models, in colorful hiking gear, crossing a mountain stream. It took two of us in waders to construct another "stepping stone" location downstream.

Wardrobe

You should be able to rely on professional models and sensible nonprofessionals to bring a reasonable selection of appropriate clothes to a photography session. But don't count on it. I've been cautious ever since the time in Florida when a

professional model arrived with a critical piece of wardrobe missing—the shoes. In his first scene, he portrayed a young father, dressed in sporty attire, playing with his kids on the front lawn. The flip-flops he wore were fine for those first shots, but were not appropriate to his second role, as a business executive (even at a "dress down" office) leaving home for work. We were on location far from the model's home, but the day was saved when a friendly onlooker volunteered her husband's size tens.

You can't be prepared for everything (with every shoe size at hand), but you can minimize or avert certain disasters. You can assure the right look by having some emergency wardrobe available at all shoots. It's useful for times when two models arrive wearing the same color, for children who stain their shirts at lunch, or for the model who doesn't understand a concept, such as "dressing for power."

If you happen to be working in or near models' homes, an easy solution is to help them select the right clothes. A bit of tact will avoid the implication that they don't know how to dress. You can put them at ease by explaining that their wardrobe is excellent, but that because of the effect of photographic lights, certain colors and styles work better than others. As to the fit of a model's clothes, you can point out that loose-fitting clothes are more graceful in pictures.

You will greatly improve your chance of having a model bring the right wardrobe if you provide him in advance with a clothing guideline letter, like the sample later in this chapter.

Props

Props in pictures set up for stock can range from the fishing rod used by a grandfather and grandson at the lake to a tablecloth for the family dining at home or the desk calendar in the executive conference scene.

Whether you are choosing candlesticks, glasses, coffee cups, wall hangings, planters, or kids' toys, the rule is to use top quality or don't use it. A good photograph shot with a tacky prop is a wasted effort. We all know how to judge tacky merchandise, but when faced with saving some money on a prop, some photographers have been known to go against their own instinctive good taste.

Here's a technique to use if you're not sure: Ask yourself if you would give this prop as a present or have it in your own home. It may be tempting to pick up a cheap or available prop that isn't quite up to snuff. Resist the temptation.

Within the general range of taste, choose the classic, simple, and elegant—whether the item is a traditional or contemporary piece. If you use "retro" items, make sure they are clearly that, and not just old looking. Use the newest models of anything that becomes outdated fast, such as computers, cell phones, iPods—or use timeless, well-designed items, perhaps out of focus in the background just to suggest equipment. Avoid showing the year on calendars. During your postproduction process, scrutinize your images for such offending details. Remove them in Photoshop. Remember, a few good props are far preferable to an abundance of mediocre ones.

Consider the following incident. An art director, viewing research photos for Mother's Day greeting cards, saw a series of setup photos featuring wide-brimmed, beribboned "feminine" hats set in different fields of flowers. The client liked the concept but not the execution.

"This picture is so close to what we want, the color of the flowers is lovely, just the right season for Mother's Day, and the lighting is gentle and beautiful. But that atrocious hat kills it! Look, it's made of cheap plastic. You can see the rough-edged seams. I don't understand why a photographer would go to all that trouble, find such perfect locations and light, then ruin the picture with such a bad prop. It can't even be improved through retouching. One simple, well-made straw hat would have been perfect. It's a shame but I can't use it—we need something with better style. Now what do I do?"

Careful attention to the details will give your pictures a clean, current look that enhances their salability. Decide on the look that you want in a location or the look that it has, and use your props to reinforce it. With some ingenuity there are ways to get around a tight budget and still have stylish props.

The right props are used to decorate the set. They can improve a mediocre location, even make an empty room work. Imagine that a friend has a spare room that's rarely used—that could become your location studio. By using the right props it can become the room of almost any family member you want.

Collect props and wardrobe piecemeal. When you see them at a good price at clearance sales, yard sales, or catalog closeouts, buy them. And don't forget to haunt the thrift shops the, outlay will seem minimal, and the props will be on hand when they're needed (again, choose simple, good quality items). Another good time to gather props is when you are traveling. Pick up small souvenirs, museum artifacts, posters, crafts. If it was easy to buy and pack them on your travels, it will be easy to transport them to your location shoot.

When making or buying props, keep in mind that things look smaller in a photograph, especially when dwarfed by human beings. All props should be as large as possible and more plentiful than in real life so as not to get lost in the photo. Any signs you create should be larger and clearer than normal.

Prop Storage

Have cheap, lightweight suitcases to carry props to the location, and garment bags for wardrobe. Also useful is an artist's oversize portfolio case for posters, wall hangings, and signs. Cardboard filing boxes help transport and store props (line the inside with plastic bags for weather protection and use a luggage belt to secure them).

Organize props by type of location—for example, office, home (living room, kid's room, kitchen), and school. Have each in a different suitcase or labeled box.

Finally, enjoy it. Collecting props is easy and can be fun. It's a justification for indulging in your penchant for picking up odd bits and pieces. How nice to have a rationalization for haunting thrift shops and flea markets.

PRODUCTION COORDINATOR CHECKLIST

Pre-Production Procedures:
- Find models.
- Set up "go-see" for professional models from agency. Get head-shots or take reference photos; mark digital file with names, day, and evening phones.
- Research locations. Check if location fees, permits are required. Make appointments to visit, check spaces.
- Get permission from organizations/corporations for location use or as source of nonprofessional models. Check availability of empty rooms for shooting. Weekends? Custodial fees?
- Prepare model release/permission letter to be sent home to parents of nonprofessional child models (or to schools, clubs, etc.)
- Pick up signed releases. Return to school/camp/drama class. Check each face against release. Choose models.
- Visit location. Take reference shots and make notes on space. Check availability of models (adult) for pictures.
- Schedule shoot. Call models (or models' parents) to advise on clothes, hair, make-up, and jewelry requests.
- Wardrobe. Ask models to bring a selection of clothes (two to three extra sets). Explain role model is to play. Coordinator bring backup wardrobe from prop closet.
- Props. Buy, borrow, rent, or make props. If necessary, retouch, tape over brand names.

- Pre-check location, note reflective surfaces, obstructions, windows, ceiling height, etc.
- Make shot list; assign photo spec numbers to keep track of each photo. Set shooting schedule with photographer.

Shooting Day on the Set—Bring:
- Makeup kit: combs, brushes, elastic pony holders, kids' barrettes (non-reflective, neutral colors, simple design), hair spray, hairpins, nail file/clipper, nail-polish remover, powder, cover-up stick in all face tones.
- Utility supply kit: tape (white, black, double-face), gum stick, glue stick, white-out liquid or white paint-sticky labels in several colors. Black marking pens. Color marking pens. Safety pins. Iron, scissors. Spray cleaner and paper towels.
- Props: specific to location (see the box "Prop Closet" below), organized by shot.
- Snacks for adults: soda, cold drinks (in cooler), fruit, coffee/tea.
- Snacks for kids: fruit, cookies (not chocolate), juice or soda (colorless—no orange or cherry which will stain if spilled).
- Helper/baby sitter (teenager) as an extra pair of hands and eyes. Useful if adult models bring their kids or parents of child models bring siblings. Also useful for walking home kids that are finished and as a gofer.
- Distractions for young kids: extra crayons, paper, books to keep them occupied while others are shooting.

Functions on the Set:

- Decorate the set. Remove distracting or messy items, add props as needed.
- Wardrobe: as models arrive, check clothes and accessory props they've brought (e.g. shoes, briefcase), match with what others in photo are wearing, match to role appropriateness, consult with photographer. Request changes of clothes as needed.
- Makeup: check and request removal of extreme nail polish, eye makeup.
- Hair: adjust style (stay classic), keep off face if possible. Avoid trendy styles that will date photo. Remove all large hair ornaments, shiny barrettes, ribbons.
- Jewelry: match to the photo concept. If not suitable to concept, ask models (kids and adults) to remove extreme or trendy jewelry.
- Double-check schedule with models as they arrive. Make sure they can stay as long as needed.
- Have model releases signed by model before shoot. With kids have parents sign a release as kids arrive (unless release was sent in to school or camp and has already been signed). Note on each release your photo spec number, the subject of the photo, and date. When possible, attach a reference shot.
- Check photo specs you have made up for each scene: make sure all props are in shot. Review photographer's first test images to see if all props are in proper place.
- During shooting, help photographer watch for details: clothing awry, prop not in correct spot or held properly, hair mussed, bad expression, eye blinks, etc.
- Pay models (if fee was agreed upon) or sign model agency voucher. Get address to send prints if different from on release.

Follow-Up

- Send models thank you letters, complimentary prints, and/or gift.
- File model releases (with reference shot for ID of model).
- File head shots in model file (add comments).
- File location information, contact names, telephone numbers.
- Return props to prop closet.

PROPS: REMOVING BRAND NAMES AND LOGOS

Digital retouching on the final photo will remove unwanted logos or brand names. However, while it's possible to retouch the final photo, consider the cost in terms of your time. Skillful digital retouching is not a quick, slap-dash solution. When selecting props for a shoot, you may still want to conceal brand names with some of the following manual techniques, then, if needed, final touching up can be done in Photoshop.

Decide the technique you will use based on whether you want a temporary concealment for borrowed props, or, if you own the prop, a permanent one. Tape is

usually easy to remove from painted, varnished, or metal surfaces. Any changes to paper or fabric surfaces tend to be permanent. Run a test to be sure.

If the picture is a close-up, taping on a prop may show (and look tacky) so use the more delicate approach of white-out or paint. But if the prop is at a distance or in an action shot, tape or paper labels may work.

Supplies:
White/black/gray gaffer tape
White/black/beige color paper
Masking tape
Correction fluid (white and various colors)
Labels (self-adhesive, removable)
Colored paper (artist's)
Double-faced tape
Stick-tack gum adhesive
Spray adhesive

Techniques:
1. Props with white background:
 Cover with white correction fluid, or white paint/tape.
2. Props with black background: black marking pens, black tape.
3. Props with colored background: Use colored tape of a similar or complementary color. Use colored paper, cut to size of label in similar or complementary tone. Attach to prop with double-faced tape, spray adhesive. Color edges with marking pens.

Prohibitions

A vigorous, attractive, silver-haired couple is walking off the tennis court, looking into each other's eyes, swinging their tennis rackets happily. Back lighting reinforces the mellow quality of the moment. You worked for days getting this shoot organized and now you've caught it perfectly—including the brand name on their tennis rackets! That simple detail can certainly be removed in Photoshop. But be sure to take care of it before the image leaves your studio. It's easy to understand why a pharmaceutical company placing an ad for vitamins in the AARP magazine doesn't want to plug the tennis racket manufacturer.

If you do forget to remove that or other offending details, you may not lose all sales, but you certainly diminish your chances somewhat. If the researcher has two photos vying for selection by the art director, could it tip the scales against you? Maybe. Regretfully, they might pass over your lovely photograph and use one that is ready to go and doesn't need any work on their part.

If yours is the best they've found, they would still use it, and retouching away your mistakes wouldn't be a big chore. But that makes your sales battle more uphill than necessary. Either create photos that are clean in camera or do your own digital retouching before sending out your photographs.

Be aware that there are certain prohibitions (listed in this chapter) for stock that should be kept in mind when gathering props and when shooting. For example: no logos, no brand names, no alcohol or cigarettes. Also, have workers and sports enthusiasts use correct safety devices (helmets, goggles, ear protectors, etc.) and procedures. Keep in mind that being sloppy about these details can be a hindrance to saleable stock.

Also remember that not everything can be retouched away as easily as one might think. The Photoshop expert could add goggles to workers who aren't wearing them. But at what cost? Shoot smart. Make your props and backgrounds clean. You'll save energy and time.

There are legal reasons for caution as well. Some of the props that you include in a photograph may be trademarked (protected by the U.S. Patent and Trademark Office), and you cannot use these without permission. A trademark is defined as "a distinctive motto, symbol, emblem, device, or mark, which a manufacturer places on a product to distinguish in the public mind that product from the product of rival manufacturers." Some examples of trademark items that might be tempting to use as props in a photograph are Disney characters and the Rolls Royce and Mercedes Benz hood ornaments. Even skylines may not be safe. Recently, a distinctive skyscraper in Dallas was trademarked. (The Dallas Chamber of Commerce helps photographers clear permission.)

CREATING A STORYBOARD

It's the day before the shoot. All the models are ready and you're familiar with the location. Now, take a deep breath, go back to your assignment form, and build a storyboard with sketches of the variations you want to try, plus a shooting list for the order in which the pictures will be done. You can vary this on the spot, but without having some order in mind before you begin, mass confusion can result. Imagine arriving at a park with five models and a dog for a series of family pictures—with no plan in mind. Well, you get the picture.

In planning the order of events, remember that kids tire easily. Schedule the most effervescent pictures, where lively expressions are critical, early in the day. Leave the quiet, family-strolling-by-the-lake-in-silhouette shots, where a lower energy level is OK till the end.

In working out a storyboard, you are acting as your own art director. Let your imagination roam. Think of angles, the juxtaposition of people, the directions models could lean or touch, in order to show the required relationship. Go back to your reference file of body language pictures for reminders of effective placements and authentic-looking movement. Sketch possible relationships of models to be used.

Think of ways to design negative space for the insertion of copy. Draw those on the storyboard. If the placement of the subject and background can be controlled, be sure to do your variations with different thirds of the picture free for type. See the sample in this chapter—it shows a downhill skier placed

STORYBOARD

Remind yourself to design negative space into photographs by drawing variations on a storyboard. In these sketches, the empty space (sky or snow-drifts), will allow an advertising client to superimpose type. Choose dramatic snowdrifts so your photographs will be elegant in their own right even without the client's text.

You can also use this technique to plan various postures, gestures, and relationships between the models.

in different sections of the frame. This approach works best with inanimate objects in a scene—a lighthouse, for example.

It's important to plan your variations before the shoot, when your mind is free to concentrate because once you're in the middle of shooting there may be too many distractions. This is your chance to devise the creative variations, which will improve your yield from the shooting day.

PRE-PRODUCTION PLANNING

Work with a coordinator to double-check everything. Use the coordinator's checklist and your assignment sheets to check props and wardrobe. Go over storyboard with the coordinator to make sure that you are working in concert.

Discuss how you'll handle the unforeseen. Are you working in a public place? Will there be a need for crowd control? If so, who should handle it? Sometimes you can hire a teenager for the day to mind kids, to keep extraneous people from walking into your picture, tripping over your light stands, and all the other little jobs you'll need assistance with.

PRODUCTION—SAMPLE LETTERS

The more thorough your pre-production planning on a stock shoot, the greater your likelihood of success. The techniques outlined in this and the next chapter are easily put into practice with the use of the sample letters and forms in this section.

Drafting Letters

Writing letters is a tiresome business. A thorough, well-written letter, however, can mean the difference between getting permission or being turned down by a valuable source. It is well worth the effort.

You will remember the earlier discussion that a key element of success is your enthusiasm about your stock project.

In this section you'll find sample letters that you can modify—scale up or down, make more or less formal—to match your style or the circumstances. The following are points that should be covered in any letter you write requesting help on a stock photography project:

- What you're doing (stock project description)
- Why the project interests you (contagious enthusiasm)
- How it will be used (stock and other use planned)
- What you want from them (access to location, models)
- What safeguards your offer (work at their convenience)
- Their reward, incentive (fee, complimentary prints)
- Who you are (credentials/professional associations)
- Coordinator's name (and description/credentials if known in the community)

All of these items may be incorporated in one letter, or, if you prefer, some of your information (e.g., stock project description, professional credentials) may be put on separate sheets to accompany a shorter letter.

When thanking models or location sources, add a personal touch: a reference to the great weather on the shoot day, delight in the location, or the enjoyment of a meal shared.

If you live and work in a small community, you might want to make special efforts in thanking those who help you. A slide show I held for a group of models engendered the greatest good will of any thank-you gesture I've made. About ten families had helped me as models for a series of shoots over a six-month period. I put some of the better rejects (and at least one flattering one of each person) and some funny rejects onto a CD, held a slide show at the local library, and served coffee and desert. This kind of sharing does a lot to create future cooperation. And it was fun.

Use the boxes and sample letters in this chapter to create your own forms. Preparing your shoot thoroughly in advance will increase not only your productivity, but your pleasure. The shoot will yield better pictures as a result.

PROHIBITIONS

For generic, saleable stock, avoid:

BRAND NAMES and LOGOS
- On clothes, products, all props, backgrounds
- On food products, cereal boxes, soda cans (no Coke, Pepsi, Dr. Pepper)
- In street scenes, shopping centers (e.g., Radio Shack, McDonald's, Exxon)
- In scenics (e.g., Shoprite or Mayflower trucks on highways)

TRADE-MARKS	Need permission to use proprietary symbols (e.g., Disney characters, Rolls Royce hood ornament)
LIQUOR	Including hard liquor, wine, beer—bottles and cans with or without labels
SMOKING	Cigarettes, cigars
DRUGS	Drug paraphernalia
FOOD	Unhealthy (high cholesterol, caffeine, sugar, salt)
CLOTHING	Extreme, ill-fitting, trendy, loud-patterned
JEWELRY	Extreme, trendy
DATES	Year on calendars, posters
PRICES	Fruit and vegetable stands, store windows

Keep food and beverages as vague, generic, and healthful as possible. Show meals with salads and vegetables, chicken, or fish. For example,

adults having a conversation might have cups, presumed to hold coffee or tea, but avoid the "action" of spooning sugar in; kids should not appear to be drinking coffee or soda—items high in caffeine or sugar.

No packs of cigarettes on a table.

Avoid anything that will date a photograph and limit its saleable life.

There are occasional exceptions to the rules above if you are shooting with a particular product market in mind. For example, if you are directing your shoot toward liquor ads, then the upscale couple by the fireplace will need cut-glass tumblers filled with amber liquid. However, keep in mind that cigarette and liquor advertising is a tough market to crack. In order to reduce the risk of cutting out other markets, the smart approach is to cover the scene two ways—once with the amber liquid and again with a generic liquid or opaque glass. This way you may have your cake and eat it too!

BUILDING A PROP CLOSET

General

Props should be: simple, classic, non-trendy, free of logos, lightweight, easily transported

Materials: wood, straw, fabric, nonreflective

Handy items: baskets, containers for plants, framed items, mounted on Styrofoam (no glass), straw mats, fabric wall hangings, pieces of fabric—decorative throw-cloth, tablecloths, colored paper—construction paper 8" × 10" and 11" × 14"

Utility items: tape (white, black, double-face), gum stick, glue stick, correction fluid, labels in several colors, safety pins, pushpins, thumbtacks, rubber bands

Office

Interior: Both modern and traditional styles of all items. Need simple, quality, dignified look for executive offices or casual if you plan the offbeat-lifestyle look.

Desk: well-designed pencil holders, letter openers, desk blotters, clean blotter paper, plant containers, plants on day of shoot

Wall hangings: Maps, prints (antique look). Need simple, high-quality, dignified look for executive offices.

Casual office: sports paraphernalia

Home

Kitchen: baskets, brightly colored dish towels, plants, colorful plastic

mixing bowls, utensils. Fruit in bowl. Solid, brightly colored tablecloths. Construction paper (8" × 10") to create instant kids' drawings (use to cover hot-spot reflections on refrigerator or high-gloss kitchen cabinets). Calendars (obscure year).

Living room: Plants, colorful pillows, baskets, non-glare wall hangings (fabric). Ethnic artifacts where appropriate, including: bark paintings, Ojo de Dios made of yarn, Chinese-style paintings. Prints mounted on foam core, floral prints.

Child's room: All school supplies. Desk blotter, pencil cup, trophies, model cars, stuffed animals, pennants, posters from museum, zoo, or historic site. Animal and science posters good—won't go out-of-date. (Avoid commercial ventures: Batman, trendy movies, music groups, product ads.)

School
Desk: school supplies, notebooks (blue, red, green), folders (all colors) yellow pads, pencil cases (all colors), pencils, erasers, protractors, etc. (Real kids' notebooks may be too scruffy, or have rock-star covers, logos.)

Classroom: If you have empty room in school, recreate a "classroom" look with posters and decorative material available at teachers' supply stores.
- Corrugated colored paper (to make bulletin board)
- Sheets (30" × 40") of colored cardboard
- Foam core sheets covered in bright-colored felt
- Packs of construction paper (8" × 10" and 16" × 20")
- Props—"school papers:" kid drawings, reports, balloon shapes (have kids make for you)
- props—commercial (nonreflective): ABCs, animal posters, name charts, homework assignments, science posters, biology (skeleton, muscle diagrams, etc.)

SAMPLE STOCK PHOTOGRAPHY PROJECT DESCRIPTION #1

"Family Life In The New Century" is part of an ongoing stock photography project on which I am currently working.

Through this body of photographs I hope to portray the changing aspects of American family life, sometimes using actual families, at other times using a group of people in situations that characterize salient aspects of the modern family. By creating photographs that reveal the intimacy, spirit, and strength inherent in family relationships, I hope to reflect a current trend: the return to the traditional values of family life.

I am still exploring the various possibilities for final publication of these photographs—this has not yet been determined. There is the possibility of a gallery show next year and also the possibility of them being used as a group, in a book publication, or as a photo essay.

In the meantime, I will be placing them with my photo agent and putting them in my stock photo file where they will be available for use by a variety of clients.

I am excited about the aesthetic possibilities of this project and hope that viewers of the final photographs will share my enthusiasm.

If incorporated in a letter:
Your cooperation on this project is highly valued and very much appreciated. I am excited about the aesthetic possibilities of this project, and, when we have a chance to discuss it further, hope that you will share my enthusiasm.

I look forward to discussing this project with you and answering any questions you may have.

SAMPLE STOCK PHOTOGRAPHY PROJECT
DESCRIPTION #2

I am currently involved in a stock photography project titled "A House, A Home," part of a work in progress through which I am trying to build a body of photography on the architecture of the American home. My purpose is to visualize a complete representation of types of dwellings: various periods and styles of architecture, of differing economic levels, ethnic influences and in all locations—urban, suburban, ex-urban, and rural.

In addition, I am looking for a variety of geographic settings in order to show how the design of a house is influenced by its surroundings and climate—in the woods, by the water, in the desert, etc.

I hope to highlight the individuality (gardens, flags, decorative touches) imposed by each owner on a structure—those elegant, charming, and sometimes eccentric details that add a personal stamp.

But, perhaps most important, I want to capture the special warmth that distinguishes homes from all other buildings and that satisfies the most basic human needs:

Home as a symbol of safety, stability, and security.

Home as a source of pride and accomplishment.

These photographs will become part of my permanent photographic collection of stock photography available from my files (through my stock agent) to a variety of clients for their publication use.

I welcome suggestions for homes of unusual interest, such as adaptations from other buildings (barns) or in special settings, and would be pleased to discuss this project in greater detail.

SAMPLE LETTER—CORPORATE LOCATION

Mr. or Ms. Higher Up

Vice-President of Corporate Communications

Corporate Row

Technologyville, USA

Dear _____:

As I explained in our telephone conversation today, we are currently working on a stock photography project, "Technology for the Next Generation," and would appreciate your assistance in allowing us to photograph in your facility (name it).

I have been working as a professional photographer for x years, specializing in photography of people in their environment. Attached is my professional resume. A special interest of mine has been the interaction of workers with sophisticated equipment.

We would like to photograph the following operations in your research facilities:

(list them)

The photo coordinator for this project, Pat Perfection, of Upper Rocky Point, Lands End, will be working with me to make necessary arrangements. Pat, the former director of the Community Alliance for Communities, will work with your administrative assistant to schedule the photography at a time that will not disrupt your operations.

As we discussed, I would be happy to make available for your personal use, and for that of any of the workers portrayed, complimentary prints of the photographs.

Your consideration of our request is very much appreciated. We look forward to working with you. Please don't hesitate to contact me with any questions.

Cordially,

Frances Photographer

SAMPLE LETTER—PERMISSION REQUEST TO SCHOOLS

Can be modified for clubs, camps, theater, or church groups

Pat Principal

Date

Elementary School

Town, State

Dear _____:

Thank you for considering our request for permission to photograph in your school for our current stock photography project.

As we discussed, the following is the way we usually work when setting up photography in schools.

First, we provide permission request forms, which the students take home for their parents to sign (sample attached). Though these forms are sent home to all children in a class (or grade), any child who does not return a parental permission form is not photographed.

Sometimes it's possible to find small tasks behind the camera for these children, so they do not feel left out of the process. If not all children who bring back forms are used, we take some general class pictures (at the teacher's discretion) to include these children.

When the releases come back, we consult with the classroom teacher for his or her advice on which students have the best attention span and ability to cooperate and concentrate.

All photography done in the classroom is planned with the classroom teacher to avoid unnecessary disruption of the teaching schedule. If available, it is helpful to have an empty classroom in which to set up the photography.

Because photographs of children must be bright and colorful, we use strobe lighting equipment to make sure the color is good and the scene is bright and clear.

This lighting requires some setup time, which we keep to a minimum.

When working in the classroom the photographer will make an effort to:
1. Consider the needs/schedule of the teacher.
2. Make all children feel included.
3. Minimize disruption.
4. Make it a learning experience for children—with emphasis on the discipline, cooperation, and social skills needed to be in pictures, and to instill pride in their participation.
5. Explain (at the teacher's discretion) how the "job" of professional photography works—giving a career vignette for appropriate grade levels.

For the school we provide:
1. A set of prints (or a CD of the digital image files of the pictures) so the teacher can create a bulletin board to share the experience with the children and show them the fruits of their labors. These photos are available once we have completed the editing process—about four to six weeks after the photo session.
2. A complimentary copy of any publication that we are able to secure that includes the photographs.
3. A modest honorarium to the school.

Most photographs will be taken in the school. If possible, we contact parents the night before particularly for a child with a featured part, in order to suggest the type and color of clothing suitable to photography. Parents generally appreciate this advance warning.

It is sometimes possible that photos may be needed in other settings such as homes, parks, or stores. Naturally, parents would be contacted in advance for permission and to arrange a convenient shooting schedule. Many parents enjoy watching the process at weekend or after school photography sessions.

A few questions:
1. Do you have any empty rooms that we might use?
2. If we have a schedule problem, may we arrange to shoot in the school on weekends (with payment to the custodian required to open and safeguard the school)?
3. If we have permission from the parents in advance, may we do some photography after school?

Please let us know if you need more information about this project. We understand your time pressures and appreciate any cooperation you are able to extend.

Thank you for your consideration of our request. This is a very exciting project and we hope that you and the students will enjoy participating.

Yours truly,

(signature)

Photographer (or) Photo Coordinator Telephone _____

SAMPLE LETTER—ADULT MODELS: WARDROBE

Date: _____

Dear _____:

Thank you for agreeing to help with our stock photography project, _____.

We will be in touch regarding the location and schedule for the photography session. In the meantime, we hope the following information will be of help in choosing your clothes for the shoot.

As we discussed, in the photograph you will be playing the role of "Executive in Sales." Please keep in mind what would be appropriate wardrobe, for example, a suit or dress with a jacket.

Do you have any of the following accessories or props:
briefcase?

In order to coordinate with the colors that other models in the sequence will be wearing, we would appreciate your bringing a selection of clothes and accessories. If possible, we need three to four different tops (blouses, shirts, sweaters, and/or jackets).

We hope this request isn't an imposition and that you realize it is necessary in creating a successful photograph.

To make it easier for you to select what clothes to bring, the following is what is most suitable for photography and what works best under photographic lights.

COLORS:
For home, leisure, or sports: solid, bright colors; some bold stripes or simple plaids. (For certain age groups, such as teens into early twenties, subtle colors such as gray, black, or navy may be more suitable. If you're not sure, ask the teens advice on what they'd wear.)

For business scenes: neutral colors, including tan, beige, and gray.

For casual office: blue jeans, sweat shirts of gray or subtle colors.

Preference:	Please Avoid Extreme Darks/Lights:
red, blue (periwinkle or royal),	black, dark brown, maroon,
kelly green, bright purple,	forest green, white
clean yellow	

STYLE:
Simple, good clothes, not too elaborate.

Except for special requests, timeless,

Classic styles are better than trendy fads.

Natural fabrics—wools, cottons (including tweeds) usually work better than synthetics.

Please, no brand names or logos. It's best to avoid all writing.

Loose-fitting, long sleeved clothes tend to look more graceful in photographs.

HAIR: Simple hair styles work best in photos.

JEWELRY/MAKEUP: Please avoid extremes in jewelry and makeup.

We hope this information will be a help. Again, thank you for your cooperation in this project. When you see the pictures, we trust you will find it was worth it. If you have any questions, feel free to call.

Thank you.

Photo Coordinator _____

Telephone _____

Photographer _____

Telephone _____

(This sample letter can be modified for use with child models.)

SAMPLE LETTER—THANK YOU TO MODELS

Date

Dear Friends:

Thank you so much for your help during our recent photography session for my stock photography project, _____. We are very pleased with the photographs. They look really good and we appreciate your cooperation and hard work. They were a great contribution to the success of the pictures.

Here are prints of some of the photographs for your personal use. I hope you enjoy them. (As you see from the stamp on the back of the pictures, anyone who wishes to reproduce them will have to contact me.)

We've also included a CD with some of the reject pictures—the throw-aways—in the hope that you might find it interesting to see why we have to shoot so many pictures. There are variables, such as lighting, sharpness (focus), expressions (eyes closed), wind-blown hair, and so forth, that can spoil an otherwise good picture and make it unsuitable for professional use. Plus you'll see those group shots we took for fun.

Keep in mind when you look at the rejects that there were many excellent photographs in which you looked great and the scene was very natural. These rejects should provide some amusement at least. [Or, to take a more casual tone, give you some laughs! Also refer to some incident that happened on the shoot.]

Once again, our thanks and appreciation for your warm welcome. I hope we can work together again soon. [Include personal variations specific to that shoot, e.g., "It was great working with you in the sunny, friendly Southwest" or "Next time, let's hope there's no snowstorm to slow us down."]

Best wishes,

Photographer _____

Coordinator _____

[This can be personalized to the individual models. If you don't have a coordinator/partner on the project, use the singular throughout the letter.]

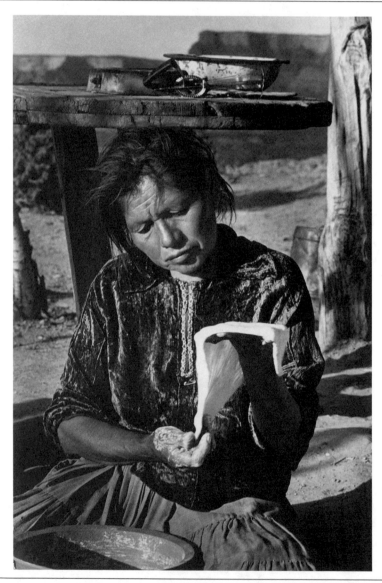

Stella Whitehorse making bread. Haskennini Mesa, Arizona

On the Shoot

Whether you are shooting on location in a natural environment, in a research laboratory, in a family home, or in a studio, you are still "on the set." You will select, arrange, and adjust the location to your stock purposes.

In addition, you and an assistant must be completely prepared to handle all the functions listed among the photo coordinator's procedures in chapter 6. This is the day that counts. Any slip-ups now will affect the pictures.

You will have your equipment in order. Props and wardrobe will be ready, the models scheduled.

As mentioned in Chapter 6, it's wise to make sure you have folders in your laptop, labeled by topic or shoot schedule, to receive the shoots as they are finished and downloaded from the memory card.

Unless you've had a chance to be there the day before, it's wise to arrive at a location early in order to make any necessary adjustments to the set.

DECORATING THE SET

Strangely enough, real places seldom look really right for photographs. Taking a real location and making it look more real for a photograph is done by decorating the set. First, decide on the look you want. Select what's actually in the location that works, then enhance it with your own props. Through a process of elimination, you can remove distractions and retain significant props that reinforce a message.

Some examples: Antique candlesticks on a mantelpiece give an air of quiet, traditional stability to a room. If that's the look you're after, they should be retained. You might, however, eliminate a distracting mirrored vase of artificial flowers.

In a kitchen scene, a simple, colorful canister set would stay on the counter for most types of stock photographs, while the beat-up blender, the rusty Brillo pads, and grimy recipe box would go. Some brightly colored dishtowels and hot pads from your prop closet could be strategically placed to cover blemishes

on the counter, or help draw your eye to the center of the picture. Does it look too sterile now that you've cleaned up? Add a note pad, child's drawing (on construction paper), or a calendar (with the date removed) on the refrigerator door—all from your prop collection. If you've checked the location beforehand, you'll know what to dig out of your prop closet. (See the box, "Prop Closet" in chapter 6 for more ideas.)

The ideal is to create an attractive, uncluttered location that has an air of reality without distracting from the focus of the picture.

In an office scene, you may want some clutter present to show that real work is being done there. Or you may need a look of quiet elegance, depending on whether you are portraying the average office worker or an executive or even a casual executive. You need to set the tone.

The decision-making, power-wielding executive will have a restrained, dignified, highly polished image. Show this by placing a few expensive-looking items on the desk. For the casual executive, place some funky, retro objects as needed.

WORKING WITH MODELS

If you hope to get their best performance, it pays to remember that professional models are only human, after all. But when it comes to nonprofessionals, the requirements are more acute. They want to do well or they wouldn't have agreed to work with you, but their inexperience requires extra understanding, reassurance, and guidance.

Here are a few guidelines to get the best possible results from the models you use.

Set Your Models at Ease

Take the pressure off them. Take on the responsibility yourself for a successful shoot and you will hear sighs of relief. That will free them to listen to your instructions—tense models often can't hear what you're asking them to do.

This approach is especially important when working with children, even if they are professional child models. I will ask them if they are uneasy or how they feel about being in the pictures. I say: "Don't you worry about anything. It's all on my shoulders. You'll be fine. I'll let you know exactly what I want. It's my job to make the picture good and to tell you what to do. If something goes wrong, then I messed up, not you. I want you to have fun."

The over-active child who has volatile reactions or occasional fits of silliness requires special treatment. I give the same reassurances, and follow with a pleasant but firm declaration: "Now it's time to settle down. I'm really depending on your help. I need your cooperation so try to listen and do as I ask. Please be patient so that we can all finish and go home."

Be Respectful

Make any suggested changes in wardrobe or hairstyle gracefully. Present reasons rather than criticisms: "That's a very nice blouse you're wearing, but I may have to ask you to change because the color is too close to the tone of the background." Or: "The floral print is charming, but spaghetti straps suggest summer and the other models are wearing long sleeves." A little delicacy will go a long way.

Be Clear

Tell your models what you want and why. Explain the concept and purpose of the pictures, who the characters are, what their roles are, what the mood should be, and what actions you expect.

Explain that you understand it may take a while to find the right action, and that you will try many variations. Tell them that if one variation doesn't work or feels awkward, you'll try another. They sometimes come up with helpful suggestions.

Let models know roughly how much time you will spend on each segment. Explain why you shoot so much, and need so many pictures. In short, include them in the process.

Devise an Appropriate Dialogue

To help them act out the proper roles, have your models enact an assigned dialogue—lines you suggest. Sometimes it works to let them chat about anything they like. But generally, to get the right expression, you need dialogue with the right tone. Chatting about a recent comedy won't create the serious mood needed to show two executives conferring.

Give Them a Break

When you notice glassy eyes or stiff body language, it's time for a respite. Give two kinds of breaks, and state them clearly. One should last just a few seconds to relax hands and shoulders. Have them stay in place, but allow them to loosen up. Then provide a full-scale, ten-minute break during which they can leave their "mark," have a cold drink, or a brief walk.

Make it Fun for Everyone

If you maintain a professional manner with a relaxed and friendly undertone, it can be an enjoyable experience all around. Models who enjoy themselves will want to help you again. Creating the atmosphere of a gulag for people who give you their Saturday afternoon isn't pleasant or smart. Your purpose in shooting stock is to make it good without the pressure exerted by clients. Work to find a balance so that it's enjoyable as well as productive, for everyone.

WORKING WITH ANIMALS AND TODDLERS

There are special complications when working with what I call the "untrain-ables"—toddlers and nonprofessional animals. Animal trainers can provide every imaginable creature trained to act on cue, but the fees involved are considerable. Few stock shoots can justify that expense. Toddlers and untrained animals should be used sparingly for visual flavor, and only when you are lucky enough to find an adorable, well-behaved dog or a self-possessed toddler.

If you are using both people and animals in the same scene, check to see if there are allergies to consider. Are your models comfortable with cats, dogs, or other animals? Some people are allergic to animals. Others are afraid of them. In choosing a nonprofessional animal, determine whether or not it is accustomed to being held and played with. Perhaps it usually runs wild.

If you want lively animals, don't feed them immediately before a shoot. They will look more alert. An added advantage of hunger is that it serves to keep them in position. Bits of food will get their attention or help direct them to stay in the spot you want. If you want a sleepy look (by the fire) or a cuddly quality (in a lap), warm food will sometimes calm an animal and induce a drowsy state.

An early mistake I made was combining a wild country kitten with a city boy who had never held any animal before. Finally, after several plates of warm milk were fed to the cat, they got cozy and I got the intimate look needed for the photograph.

Toddlers are another question. They don't react well to hunger, nor do their mothers. Make sure that a toddler in a picture has something to do (or someone to entertain him). That entertainment needs to be more interesting than the photographer, camera, and flashing lights.

Create action in the picture that uses the toddlers profile or catches him from the back if you don't want him staring at the camera. Keep them contained in Dad's arms, holding hands with a sibling, or in a high chair. If allowed to run loose, there is no stopping him. And be fast—there can be some lovely sponta-neous moments. Be ready for them.

Finally, let animals and babies get used to the flash of the strobes, which might startle them at first, before you start to shoot.

GETTING A MODEL RELEASE SIGNED

Getting a signed model release may be the single most important thing you do aside from taking great pictures.

The technique you develop for getting a release signed is a very important skill. This is especially true in a situation that you have not set up, one where you don't know the people in the picture you have just taken. Many photog-raphers are reticent about asking a stranger for a signed release, feeling that

it's an imposition. Or they are not sure how to handle the situatio॑
are turned down. Others, foolishly, are abrasive or aggressive an(
turned down.

As we'll see below, different circumstances call for different approaches and
can vary, depending on whether you are working with:

- professional models
- semiprofessionals (aspiring actors, models, amateurs from a drama club)
- local community contacts
- friends
- strangers who speak English
- strangers who speak a language other than English

Getting a signature is part of the bargain you strike with your photo subject,
so it is important to be clear and straightforward about your needs and about
what you have to offer. Don't make promises you can't (or don't intend to) keep.
If you promise prints, send them.

When models agree beforehand to be in a picture (which happens as you
set up the photography), you are reasonably certain to get a release. (Be sure to
get the release signed before starting to shoot.) The relative certainty of getting
releases is why setting up your own productions is highly recommended for
stock shooting. This practice will cover professional models, friends, and com-
munity contacts.

That just leaves working with strangers, which can constitute a much more
delicate situation. If you are on location, especially doing travel photography,
and a perfect picture depends on a pair of strangers walking through the slant of
afternoon sunlight in your picture, it's worth the effort to try for a release. If a
mountain trail photograph just cries for some hikers, it's tempting to photo-
graph the ones that appear around the bend, worrying about the formalities
afterwards.

A sure way to get turned down is to stick a full legal release under someone's
nose, without any explanation, just after you finish shooting a picture.

A surprising number of people will cooperate if you approach them in a
friendly, professional way. Also, as you'll see in chapter 15, there are ways to
soften the presentation of a release to make it less threatening.

The best tactic is honesty, with a bit of tact and friendliness or hominess.

Introduce yourself as a professional. Say a few words about your project, and
explain that you'd like to send them some copies of the pictures. Say that you'll
need their address in order to send the prints and their permission on this form.

While they are digesting all that, you can go on to explain what you'll be
doing with the pictures. Some photographers use a release that has a definition of
stock photography on the back. I use a variation of my project description as a
letter of introduction (see sample in chapter 6).

Offer them a copy of your introduction letter to take home. It relieves people to have your name and address. Giving a signature to a mystery person who then vaporizes in the distance is unsettling to most people. I have much greater success when I am exchanging addresses, not just demanding theirs (and I haven't had it abused with a rash of pestering calls).

In the United States, always carry copies of the release and letter in English and Spanish—and have it translated into the language of any country in which you'll be doing a lot of photographing.

CAPTIONS

Keep notes on any important information that would be useful for captions or for your location file. For easy and accurate gathering of caption information, especially for travel photography, just shoot a frame of every entrance sign, informational plaque, botanical label, historical marker, or street sign near your subject. If you use your main camera for this purpose, there is the additional advantage of the caption photos being on the same memory card with the batch of images they apply to, handily available when you are editing and ready for captions. As you edit, dragging digital images into "selects" folders, you can create a folder named "captions," and drag any images with identifying signs or useful information into that folder. Some photographers carry a separate point-and-shoot digital camera just for making quick, low-res shots of identifying information for their captions.

Other photographers write in notebooks, or use a pocket-sized tape recorder to take verbal notes on location. However you collect it, the value of accurate caption information cannot be overestimated.

DIGITAL PRECAUTIONS

In chapter 8, you'll find information about the need to allow time for tending to the digital aspects of the shoot, including downloading memory cards to the computer and doing appropriate backup procedures. Too much work goes into your production to risk the loss of any image.

PHOTOGRAPHY

The final stage of your production is the actual taking of the photograph. This is what all the work has led up to—an exhilarating, fleeting moment of visual delight. Savor it.

Later, you can edit and enjoy the results.

THE LAW AND USING CHILD MODELS

- Always get releases for child models prior to beginning the photography. Make sure that the signatory of the release is the actual parent or guardian and that they are authorized to sign for the child. The age of consent (reaching majority) varies by state. In many states, it's eighteen instead of twenty-one, but you should check your state law to be certain. In most states, a foster parent is not authorized to sign a release.
- Do not work alone with children. Always have an assistant or parent on hand. It makes the child comfortable. It also gives you a witness to the fact that the child was treated with kindness and respect, that the photographs were on the same topic as the one explained to the parent, and that they were done with propriety.
- Check your state law for any special requirements relating to the use of child models. Some states, like California, have stringent restrictions and may require that a certified teacher be present during the shoot.

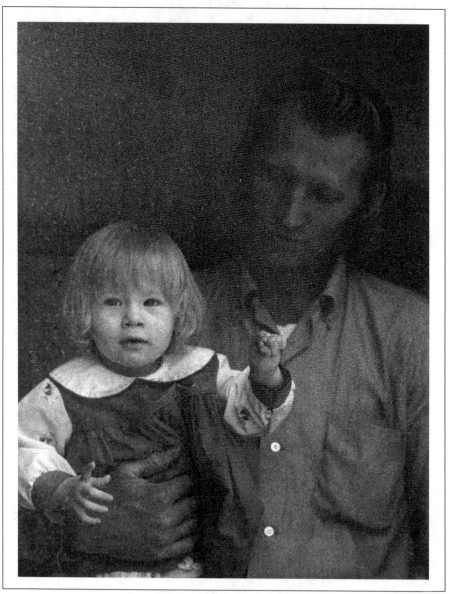

Carl Lee and Tessa behind screen door. Kings Creek, Kentucky

Editing and Post-Production in the Digital Work Flow

You have shot wondrous images; now we come to the methods for editing and managing these images. An efficient system is imperative to forge the link between shooting and selling stock. Take the time to build a strong system; build it carefully, with precise and consistent techniques. Learn to streamline your system to get the fastest possible results from your time.

In this chapter, we'll take the image from the camera through the processing, editing, and preparation for the file and discuss the software needed to accomplish it all.

For the purposes of this chapter and unless otherwise specified, references will be to images made through digital capture in raw format. There will also be discussion of digital images created through scanning film because there are many photographers with large archives of film who are bringing their key images into a digital file.

There was a certain kind of simplicity to handling the physical property of film. Yes, systems were important when we worked with film, but, within reason, you could edit, caption, and file images, and be ready to market them in a more straightforward manner than seems the case with digital. In a way there was less you *could* do, therefore less you *had* to do.

The good thing about digital is how much you can do with each image. The bad thing about digital is how much you can do with each image. The use of that old bromide is suitable if not imaginative. The way to success is by using the incredibly powerful tools for working with images and harnessing them to your goals, but not letting them sweep you away. Don't get bogged down by doing more than is needed just because it's possible. Use skill with restraint. Take the time to learn the most efficient ways of handling each step of the work. This will be a recurring theme in this chapter (partly because I've been guilty of just that inefficiency, which leads to extreme frustration).

If you are currently shooting photographic assignments, then you have developed your own digital work flow methods that can be adapted to your stock. The hardware and software you have for assignments will be useful as well. But the photographer venturing into assignment photography *and* stock photography at the same time will need to build a foundation from the ground up. Learning the equipment and software for digital photography can be a daunting, though exciting, venture.

SOFTWARE

One of the major challenges when embarking upon a career in digital photography is understanding the categories of software programs needed to run a digital stock business. In addition to the software that comes with your camera, you will use software to process images in raw format, to edit photos (adjusting and manipulating exposure and color balance, removing and adding elements, cropping, etc.), to caption images, to catalog and retrieve images, and, of course, for business management.

Clearly, we need this software because the handling of a digital image requires its own set of digital methods very different from what is needed with the tangible object of a roll of film. Remember that with film these tasks are spread around. Processing (at least for many photographers) is done by the lab. Editing and archiving is done by the photographer, but it is a physical job, not one handled by the computer. So software has been developed and is being continually refined to perform these tasks as we take a digital image from the camera to a final photograph. We need a variety of software programs because as you get deeper into running a stock business, you'll recognize the value of specialized programs.

Don't know what to choose? My preferences are fairly straightforward. I have been using Adobe Photoshop CS 2 and just bought CS 3. Within "CS," the Creative Suite, I use Adobe Camera raw for processing raw images, and Adobe Bridge, with its terrific browser, for editing images. Then, because the browser is connected to Photoshop, you can move easily into the image adjustment stage. For archiving as well as business management, I use InView and StockView by HindSight Ltd. These integrated programs are powerful enough to handle the rest of my digital stock needs.

There are other good programs available. The box "Software Overview" later in the chapter lists software widely used by photographers for these purposes. You'll come to a decision from your own education and experience, recommendations from photographer colleagues, reviews you see in photo magazines (online or not) or equipment sites (see appendix), and by trying demo versions of the software.

LEARNING CURVE

As a professional photographer in assignment or stock, you need to master the applications for handling digital images. Invest time in choosing equipment and in learning the software required for working in digital photography. (See the boxes later in this chapter for an overview of what's needed.)

It's best to learn a few applications thoroughly before venturing to others though you need to be aware of the basics of each step of the work flow, as you'll see below. There's a certain contradiction here because it's easier to proceed step-by-step, application by application, acquiring and learning software as you have the time and budget, yet you truly need all of the software right away. What to do. You should learn Photoshop imaging and editing in Adobe Bridge. But if you leave the purchase and mastering of cataloging software until later, you may make decisions, on naming files for example, that conflict with the cataloging software you eventually choose. The best way out of this dilemma may be to bite the bullet and purchase the software. My advice is to learn Photoshop and Bridge as thoroughly as you can. Get a rudimentary understanding of the cataloging software so you know how you will need to name images. Then move on to cataloging. You'll find there are a variety of software applications available for tasks such as editing and cataloging. However, virtually all professionals agree that for digital imaging, there is no substitute for Photoshop. It's the gold standard. A great support system, whether you are a novice or an expert in digital imaging, is the National Association of Photoshop Professionals (NAPP, *www.photoshopuser.com*). I highly recommend becoming a member.

Mastery of digital imaging is a life-long process and an exciting one. You will learn and continue learning. To stay active in stock photography, understand that you must invest your energy in mastering these skills and then in keeping abreast of the changes that come fast and furiously. The more thorough your commitment, the greater the satisfaction you'll find.

Digital Education

How and where do you learn digital imaging? Extensive courses as part of a college or photo school curriculum are the answer for many who are starting out in the profession. As an entry-level person without the habits built from years of working with film, you have the advantage of developing your photography skills and your digital skills at the same time, in a seamless flow. For photographers who recently switched from film to digital, the transition is sometimes daunting, but there are a variety of ways to get up to speed. Courses in digital imaging can be useful, especially those that cater to photographers in transition from film to digital. In many major metropolitan areas, there are short, intensive courses designed for professionals. These are helpful because they assume photographic knowledge and concentrate on digital skills without worrying about the basics of how to take a good photograph.

One caveat: Take a course when you have the time to practice what you are learning. If you can spend the morning following a class applying the techniques learned to photos in your file, you'll retain much more than if you leave it for a day, a week, or longer. I once signed up for a four-week, one-night-a-week course in digital imaging during a time when I had a heavy assignment schedule. My time and thoughts were absorbed by the assignment, so Photoshop practice time went out the window. And without applying the lessons, a lot of the information simply dribbled away. For this reason, weekend workshops can be very productive; you learn and apply what you learn at the same time.

A terrific resource for this type of intensive education, if you are in the New York metropolitan area, is the workshops presented by Maria Ferrari. Take a look at the box "Tips from the Experts" in this chapter for advice from Maria Ferrari on aspects of digital work flow.

Another method of learning digital skills is through a quasi-tutorial system. You can do this by hiring a knowledgeable assistant to work with you on a few projects. I have found that learning while actually doing a project is the best way to understand and retain the skills. When you plan a stock shoot, hire an assistant with excellent digital skills. Work together on the shoot and on the post-production work. You will have taken the process out of the classroom and applied it to your immediate needs. As you are learning, you are also accomplishing important tasks.

Books: Photoshop and Beyond

Finally, embellish what you've learned with reading. Once you've had a course or two, reading some of the excellent publications on digital imaging and digital work flow can deepen your understanding of the techniques. But if you try to read about what is essentially a visual process, before you've had any experience with it in real life, you might be overwhelmed with the jargon and not assimilate the process. (That happened to me along with a whopping headache when I started in digital.) There are plenty of really good books, some listed in the bibliography, about imaging with Photoshop.

That's not all you need. Photographers become intoxicated with image manipulation, but often overlook the less glamorous chores, including what we used to call "filing", as well as managing and archiving digital files. The premier book on this subject is *The DAM Book: Digital Asset Management for Photographers* by Peter Krogh. It's dense with information and can be slow going, but this book is complete and clear, formidable but excellent. I think each chapter should be treated as a one-day course.

Another wonderful book is *Camera Raw with Adobe Photoshop CS* by Bruce Fraser. This is a clear exposition of shooting raw, written in a friendly, open style. (A new edition based on Photoshop CS3 should be out shortly.)

Remember to check out workshops and classes offered by organizations such as ASMP, ASPP, and the Advertising Photographers of America (APA). Some

sponsor classes in conjunction with Adobe or other software developers that offer top-flight information at special rates.

POST-PRODUCTION

Ready to start? The many tasks that need to be done to a digital image after it leaves the camera are lumped together under the term "post-production." The term, borrowed from the movie industry, includes processing files, color correction, retouching and manipulating, and captioning. It's common to hear digital photographers referring to a photographic flaw say, "Never mind, we'll fix it in post-production." Certainly you can repair a lot, but don't let yourself get sloppy during the shoot just because it can be fixed. The cleaner your image, the less work you'll have in post-production.

WORK FLOW

Work flow in the digital environment is what you do, how you do it, and in what order you do it. It's the organization of all your post-production activities. The term had a slightly mysterious aura when it first came into use with the advent of digital photography, but it simply means codifying your system of working once you have created efficient methods. It should encompass all the steps needed to take an image, or group of images, from the camera to delivery to a client, stock agency, or posting on your Web site, and ending with cataloging and archiving of the photographs. What work flow means is simple to understand, but the implementation of a successful work flow is anything but simple.

Keep in mind that the goal of a work flow is to get the most out of your time. Therefore anytime you are repeating a step on multiple images you may not be using the system efficiently. Use that concept as the test for any system you develop. Ask yourself: Is this the most efficient way to do this task? Be open to suggestions you read or hear from colleagues regarding more effective work flows.

Creating Your Work flow

A work flow provides a series of steps that you follow, steps that ensure an orderly way of working. In devising your own work flow, make a brief outline of the steps you want to accomplish. Then develop this outline into a checklist to be used as a reminder each time you complete a stock shoot. (There is a sample of the steps I use later in the chapter on page 61.) But many variations are possible. A primary purpose in establishing a work flow is to create an efficient system.

Curing Inconsistency

We've said that efficiency is a goal for your work flow. Well, a sister goal is consistency. Inconsistent methods are inefficient. I suffer from terminal inconsistency which I fight every day. If you recognize that virus in yourself then get help.

There's no purple pill to cure inconsistency. But if you understand that it is the enemy of competence, then you'll make the effort.

The process of creating a work flow and the guidelines you set up for yourself allow you to be consistent by following your own rules. A wonderful, feisty assistant forced me to paste a chart of my work flow on the wall and refer to it each step of the way. When I protested that, "just for today," I'd revert to familiar bad, old habits because I didn't have time to follow the new ones, she cheerfully smacked me and put the work flow checklist under my nose. I still have relapses, but make great efforts at consistency.

LEARNING SOFTWARE

Just before proceeding to work flow, remember that software is your life raft in the choppy seas of work flow. You must establish your work flow, but you will need the right software—"right" being what works for you—to carry it out. As mentioned earlier, the box "Software Overview" lists some software programs in wide use among digital photographers. Look into them and compare features. Try them out before buying. Also consult colleagues and books for advice.

Once you have software, learn it. That should sound self-evident. But photographers (I've been guilty) have been known to buy programs and then not spend ample time to learn the software. Foundering because of the pressures of daily business, the photographer gives up in frustration because all is not made clear in the first ten minutes spent learning the program. The software sits unused and unable to help you. Not spending time to learn your software is like ordering a gourmet meal and letting it sit uneaten, getting cold. Not very nourishing.

WORK FLOW

To recap, here are the rules that you need to follow if you want to develop efficient and productive work flow habits:
- Be consistent
- Be disciplined
- Have the right hardware
- Learn the software

WORK FLOW TASKS

You can name the tasks in your digital photography with any terms that make sense; you can organize them into any work flow that keeps you moving and, most important, you can maintain with consistency. Having a more complex work flow than you will use is self-defeating. Routinely I hear photographers who are immersed more in technology than in photography, claiming the virtues of

a work flow system that can do everything but mow grass. If it does more than you need and therefore stymies your progress, dump it. Whether you choose a simple work flow or a complex one, make sure it helps you (within your style of working) be more efficient. In the box "Post-Production Work Flow Tasks," there's an outline of one basic approach to work flow. There are more complex systems, but I find this manageable. Check books, including Peter Krogh's, for other approaches. Then tailor one to your work.

Before the Shoot

The process of work flow begins even before you shoot. It's valuable to take a few moments the day before a shoot to make folders and put them on the desktop of your laptop computer. Name these folders with the photo topics and concepts you expect to cover during the day. You'll need a place to put your digital file images during the shoot and it's also the first step of the editing process. If you have designated a place to put images as you download from the memory card, it can save time later. I often make "topic" folders and then other folders within each topic folder for "selects" and "outtakes," or rejects. I also make a catch-all folder for the day, which I call "production" or "send models," adding the date or shoot title. This is handy later when editing, so you can easily drag funny or silly shots into the folder and have them in one place.

Memory Cards

As you saw in chapter 3, the memory card, also called a "media card," is the device on which the camera records digital information—the files which are your photographs. You will carry a lot of memory cards with you on a shoot because you never want to run out of space to record images.

Formatting the Card

Memory cards are reusable. You can erase the images and start over. The process of erasing or deleting all the recorded photos is called "formatting" the card. This can be done through the camera software or in the computer. Many people recommend doing it with your camera's software.

Prior to the shoot, check that all memory cards are formatted, i.e., empty of images.

DURING THE SHOOT

There's a lot to tend to during the shoot itself without worrying about digital management. At this stage, it's helpful to have an assistant who is digitally savvy working with you on the shoot. If you don't have one available, then you need to allow some extra time between scenes for changing the media cards and downloading them onto the computer, in addition to tending to the models, wardrobe, and props. A trick

that many photographers use to keep track of which memory cards have been used is to put a mark (a large black X will do) on the back of them. Then all the fresh, formatted media cards are put in their plastic cases with the card's brand name facing out. Once a card is used and downloaded to the laptop, it's placed in its plastic case with the X facing out. This way, at a glance, you or your assistant can see that there are, say, four used cards, and three unused cards. It's helpful during the shoot to know how many more shots (digital files) you have space to record.

Download

It's a good idea to download the images as often as is practical during a shoot day. Downloading the cards is generally done on your laptop computer by means of a device called a "card reader." You remove the card from your camera, insert it in to the card reader, and the images will either meander or race into the computer, depending on the specific device you use. There are slow or fast card readers. Some memory card manufacturers include a free card reader with the card. But these free card readers are excruciatingly slow (the meandering type), so a small investment in a faster, FireWire reader (the racing model) is worthwhile. A fast media card reader is worth its price because of the many minutes, not just seconds, it saves.

If you have an assistant, he or she can handle the downloading of images from one card, while you continue shooting with another. Also, ask an assistant to sort the digital files by topic into the folders you set up on the desktop of the computer. This is what I consider the first backup of images—from the card and into the computer. But you also need a second backup!

Second Backup

I do a second backup—which means downloading all the digital files to a portable hard drive—during lunch or at the end of the shoot before leaving the location. This means I have the pictures in three places: on the cards, in the laptop, and on the portable hard drive. That's a safe feeling on the way home.

Some photographers format the cards after they are downloaded, thus erasing all the images from the card leaving only the one set of images in the computer, which seems risky. I'm superstitious, so I don't format them until the next day—when I've double-checked that *all* my backups are complete.

AT THE STUDIO

The evening of the shoot or early the next morning, you continue the job of protecting the images and get ready for processing. This is when you become the lab. The only benefit of film was that there was time when the film was at the lab and you could put your feet up and take a deep breath until it was processed and ready to edit. Even if you used a big-city lab just down the street and could get four-hour processing of film, you still had some respite between the shoot and the edit. With

digital, because it's all in your hands, there's no break. This is a point where the assignment photographer feels pressure from the client to deliver edited images. But as a stock photographer, you have the luxury of taking your time—or do you? Procrastination is a slippery slope. The sooner these images are on your Web site or with an agent, the sooner they might earn money, and the sooner you can go out on another shoot.

More Backing Up

At the studio you will back up the images in several more ways. You'll download images from the day's shoot (still unedited) to your workstation computer. This is where you are going to do the majority of the work on them. Another backup should be made by burning images from the day's shoot to DVDs. Finally, do a backup to one or more external hard drives. Most photographers back up regularly to two different, but matching, external hard drives. Each mirrors the files in the other. Devices are vulnerable and can go down at any time. They can also quickly become outdated so, as we saw in chapter 3, you must migrate regularly to newer devices.

This means you have made six backups by the day after the shoot:

1. Card to laptop
2. Laptop to portable hard drive
3. Portable hard drive to workstation computer
4. Burn to DVDs
5. Download to external hard drive
6. Mirror to second external hard drive

Quite soon you will format the cards and clean out the portable drive, so that leaves you with only four backups. That's not enough by the most exacting standards. See Maria Ferrari's strong opinions on backing up in the "Tips from the Experts" in this chapter. We should all heed her guidance, me included. I haven't had a tragic equipment failure (yet), so I've stayed with these four back ups, but I'm probably living on borrowed time.

EDITING

When editing images, be quick and be ruthless. It's almost impossible to be too critical with your professional work. Editing is the process of choosing images, selecting the best, and giving them a hierarchy, which means a rating in terms of professional quality, salability, aesthetic quality, and, sometimes, simply personal feeling.

When to Edit

Some photographers do a little editing during the shoot because digital allows the instantaneous ability of seeing what you've caught. You have the option of editing out serious rejects, such as closed eyes and gruesome expressions before leaving

the shoot location. But that can be distracting and dangerous if you are relying on the camera's LED viewer to make decisions. If you are shooting landscapes or other stationary subjects, you might consider some editing on the spot. Or, if you are shooting in a studio with the camera tethered to the computer, you can do some instant deleting of images. Generally, it's much better to leave all editing until you are back at your computer workstation with all images backed up safely.

Even a photo that seems like a reject may be useful later on in a composite photo. For example, if you have an image that is wonderful except for an awkward position on one of the model's hands, you may solve it by replacing the clumsy hand with one from an outtake photo that shows the hand at just the right angle. Where do you get that hand? It may be found in the outtakes and have come from a picture that was a reject because of a bad expression. But there it is in the image junkyard, ready to supply spare parts when needed.

The next important decision is whether to edit images before processing the files or after. You don't want to spend time processing true rejects or mediocre extras, so I try to do a first, tight edit in the beginning prior to processing. You can always pull a photo from the outtakes and process it later, but if you process too high a percentage of the take you'll never finish. (You will remember that processing in raw is covered back in chapter 3 in Ethan Salwen's "Tips from The Experts." Also, you will find extraordinary depth on shooting raw in the book "Real World Camera Raw with Adobe Photoshop CS2" by Bruce Fraser.)

Editing your images soon after a shoot will make the entire operation easier. You will have a much clearer idea of what you are looking for because the details of the shoot are fresh in your mind. You'll know which expressions to look for and which to ignore. If you remember that there were a few boring shots as the models were getting adjusted, you can skim the work, looking first for the pictures of that special, spontaneous moment you recall—the one when the cat jumped into the grandfather's lap and the child giggled. After selecting those, go back over the earlier shots when the grandfather and child are simply reading together to see if they can hold a candle to the others. If you wait too long to edit, you'll waste time slogging through the dross before you find the gold.

FIRST EDIT

Your first edit of raw images should be very tight, selecting only the really excellent pictures. Later you can revisit the outtakes if necessary. I separate the files into two folders at this stage (sometimes with a third folder for odds and ends, funny shots for models, etc.) Folder A for the first selects, and folder B is for the outtakes, i.e., extras and rejects. Working in Bridge, it is very easy to select and drag images into each of these folders. Later, you'll see that you can fine-tune your selects by giving ratings for "first selects," "portfolio pieces," "very good," "good," or anything in between. For now, I suggest that you process only the pictures in the A folder. Leave the B folder as raw files, waiting in the wings to see if they are needed.

PROCESSING

To understand processing, note that there are four different stages to accomplish different tasks. You have global corrections (stage one), detailed corrections (stage two), retouching and enhancement (stage three), and finally (stage four) assignment of the file format which you will use for archiving.

- **Global corrections** are those that apply to all the pictures. Global corrections are done to the raw files and can include a wide variety of adjustments, from exposure and tint to brightness, contrast, and saturation. Take an excursion into Adobe Camera Raw to see the extraordinary range of modifications you can make. (You'll find it as part of your Photoshop CS2 or CS3. If you don't own it, try a demo at *www.adobe.com*.) I counted (don't hold me to it) at least twenty-three types of adjustments possible. For example, under the menu tab "Calibrate," you can alter "Shadow tint, Red Hue, Red Saturation, Green Hue, Green Saturation, Blue Hue, and Blue Saturation"—and that's just under one tab. The key to raw is that you have great control with no loss of pixels, as we learned in chapter 3.
- **Detailed corrections** are done after you have left raw and saved your image in your preferred format (more on that below). Now you are working on your files in the Photoshop area of CS3 (instead of Adobe Camera Raw which is where raw processing is done) to make the detailed changes. Here you can make changes that affect only one portion of the photograph, as opposed to raw, where all your changes are global. You work with all the standard Photoshop tools to further alter brightness, color balance, or contrast usually in subtle ways or in one area of the photograph only.
- The **retouching and enhancement stage** includes everything you do to improve the picture, from retouching unsightly wrinkles to blending two or more images.
- Deciding on the **file format** takes some investigation. Currently I save in TIFF format those images with detailed corrections and those for delivery to clients. But I have started using the digital negative format, DNG, for archiving. While not yet accepted by all photographers, some experts believe that DNG will become the standard format. DNG was created by Adobe with the hope that it would become a universal file format.

Note that you don't want to make decisions about image file formats or metadata (see below) in isolation. Make sure you are in the mainstream of what is being accepted by clients following industry standards, particularly with the requirements of any stock agency or portal you work with. A survey of what several of them require might give you guidelines to see if you are in conformity. See the requirements listed recently by a major stock agency in the box "Agency Image Requirements" in this chapter.

Edit With Ratings

Once your first selects have been processed and are looking their best, you need to create a hierarchy among them. Take a moment to give them a rating. You'll decide which go on the Web site and which to submit to an agency or portal.

In Bridge, it is extremely easy to rate or rank, and then filter the ratings to double check what you've done. You have the option of applying one to five stars to an image; using a color rating of red, yellow, green, or turquoise; or you can use both stars and color. Just as with all your work flow procedures, decide on the rating significance of each star or color, then make it into a list and post it above your computer (remember consistency?). Having applied the ratings, you can then review your selections by using the "filter" feature, which allows you to view, say, the three-star images. Or you can see all the ones marked with red, if you so choose. Then you are able to make a final evaluation of the comparative quality level you've assigned the images.

METADATA

A while back I learned the definition of the word "metadata." It is simply data about data. So if the image (file) is made up of data, then the caption and all other information about the picture is the data about the data. Understanding the range of possibilities within metadata takes some study. It's a complex enough subject that author Peter Krogh devoted twenty-six pages of his book, *The DAM Book: Digital Asset Management for Photography*, to metadata alone.

There are two kinds of metadata. The first kind is automatically attached to the digital image by the camera. This includes camera information such as camera manufacturer, as well as information about how the image was taken (the f-stop, exposure, ISO, lens used, etc.). This metadata appears without you doing anything but taking the shot. Also, it cannot be removed—at least, not without considerable skill and difficulty.

The second type of metadata is information you enter yourself; anything about the picture you want to enter. You want to be able to enter credit and copyright (some programs enter copyrights automatically), a caption, a file name for each image (including reference numbers), and the model or property release status. For cataloging and searching purposes, you want a clear cross-referencing function through use of keywords. Make sure any software you consider can handle all of this easily.

If you want to be scrupulously precise, there is almost no limit to the information you can record in the metadata about an image. A key issue is having the ability for any metadata that you want to stay with a picture and be able to travel with it. Most of the programs for archiving images allow you to enter bulk metadata which is a real time saver. Certainly make sure that's a feature of the software you choose.

Captions

Caption information includes everything you can tell about a photograph as concisely as possible. The journalist's "who, what, when, where, and why" is the classic and still a serviceable guide for writing captions. Storing caption information

is an important function of metadata. Remember, the file name is not a caption. The file name may contain a hint at the content of the picture, but it should stay short to allow room for any numbering you may use as part of your file name. More about naming below.

The information in a caption can make the difference in a sale. Imagine that your vineyard photographs are being considered for a calendar to be produced by a major wine and spirits distributor. For the July page, the art director has narrowed the selection to two equally strong photographs, one from the Napa Valley in California and your scene of the Finger Lakes wine region in New York State. All of the pictures chosen for the other months are from California. For balance and for sales reasons, they would be likely to choose the Finger Lakes picture because they are adding distributors in that area. For lack of a detailed caption in the metadata, labeled only "Vineyards, Domestic," your picture might lose out. Metadata allows you room for detailed information and keyword labeling. In the days of the space limitation inherent in slide mounts, one might be forgiven for scanty captions. But now, with space available, make the extra effort to caption and keyword thoroughly.

Captions and all other metadata can be added in Adobe Bridge, Adobe Light Room, Apple Aperture, as well as a number of programs listed in the Software Overview box. (I use the InStock program mentioned earlier.) As you review the programs in our Software Overview box, make sure you are comfortable with their features for handling metadata.

Naming Files

Each photograph—that is, each individual digital image file—has a name. It is born with a name from your camera, often a combination of letters and numbers assigned by the camera's software. You can change these file names to suit your cataloging and archiving system. Remember when deciding upon naming conventions that you may have to integrate digital captures with any scans you have made from film, so you certainly want them in the same filing system.

File names can be changed in many places. A single image can be renamed in many programs; it can even be done on your desktop by highlighting the name and typing in a new one. But batch re-naming, which is the most efficient method, is often done in Adobe Bridge and in the programs mentioned earlier (Adobe Lightroom, Apple Aperture, and others).

More from the vineyard shoot. If you have images from a day of shooting in the Sonoma region, the image name for one of the pictures might be "Sonoma_4367.dng." But the caption entered in the metadata could be, "Massimo Brothers Winery, Santa Rosa, Sonoma County, CA. Manager, Hugh Ogden, close up, checking ripeness of grapes. Vineyards at sunset. August, 2008."

Keywords

Finding images through a thorough cross-referencing system is the end purpose of keywording. It's an expansion of the caption but attaches additional specific details as well as concepts to the photograph. Many people are familiar with the function of keywords through the use of Internet search engines. With photography, keywords are important to ensure a photo buyer actually sees your images. The more thorough and imaginative your keywording of your stock photos, the more likely it will match a buyers search criteria.

You can base your keywords on the lists used by your stock agency and modify it to your photo topics and concepts, or you can build your own as you start the process. Your goal is to think of every word that would bring up your image, both in the specifics as well as the conceptual use of a photograph, which is quite a task. There are basic keywording lists available in Adobe Bridge and other software, but they are limited. The most promising I've seen is "The Controlled Vocabulary Keyword Catalog" created by David Rieck *(www.controlledvocabulary.com)*. In advice that emphasizes the need for consistency in keywording, Peter Krogh suggests that photographers create what he terms a "controlled vocabulary," which is a set of descriptive terms also known as keywords that have been standardized into a list. Go to his web site for more information *(www.theDAMbook.com)*.

Keywords don't describe the photograph so much as they create triggers that might fit a particular image and jog the memory—yours and that of the software. Those vineyard images above might carry these keywords: wine industry, vineyards, Sonoma County, Santa Rosa, California, portrait, Ogden, sunset, golden, peaceful, ripe, maturation. A visit to any stock agency Web site will give you practice entering keywords and seeing what comes up. Sometimes they are almost silly in their thoroughness. I once entered "Hispanic Family Picnic" on an agency site and got, among other hundreds of Hispanic family picnics, a portrait of Crown Prince Felipe of Spain with his wife Letizia.

Be aware of the importance of naming your photo with appropriate variations such as Hispanic, Hispanics, Hispanic-American, Latinos, Latinas and so forth.

Cataloging: Filing and Finding

If you can't find it, you can't sell it. The only reason for going through all the trouble of creating a filing category and numbering system is to enable you to find a picture surely and easily. Take plenty of time to test out cataloging software to make sure it seems sensible to you. You may think that once you've posted images to your Web site, the problem of locating pictures is solved.

ARCHIVE—BACK UP ONCE MORE

Once you have the images completely processed and entered into your catalog, or library, you have an archive. This archive is the master set of important

images. It's your stock file. This must now be backed up on the duplicate external hard drive backups.

At last you have a system, and a set of wonderful photographs ready to send out into the world. You can move on to running your business and marketing the images.

AGENCY IMAGE REQUIREMENTS

Requirements will change as systems and formats evolve. But these stringent instructions, from Getty Images, make clear the importance of matching the requirements of an agency. Each agency will have different requirements, so you should inquire. If you are not with an agency, do a survey of several major agencies to see what the current industry standards are.

Files: All images must be uncompressed 47.5–52 Megabyte TIFF files (flattened, with no layers, paths or channels), 24 bit RGB Color, 8 bits per channel (8 bit file) and be supplied on a CD or DVD. We don't accept RAW files or JPEGs.

Retouching: All isolated visible logos must be removed via retouching prior to submission, as must dust, hair, scratches, etc.

Model and Property releases are required with all images where relevant and must be supplied in digital format.

Metadata (also known as captioning) must also be supplied to us digitally in IPTC, XMP, Excel or Text File formats.

POST-PRODUCTION WORK FLOW TASKS

Among the elements you need to include in a post-production work flow are:

Prior to shoot:
Set up folders for the project on the laptop.

Check that memory cards are formatted (erased, empty, all previous images deleted).

During shoot:
Download memory cards to laptop.

Download memory cards to portable hard drive.

After shoot/At studio:
Backup images from day's shoot (unedited) to computer workstation.

Burn images from day's shoot (unedited) to DVDs.

Backup images from day's shoot (unedited) to external hard drives.

Edit:
First edit of raw images. Separate into two folders, A and B. Folder A is for the first selects. Folder B is for the outtakes, i.e., extras and rejects. You don't want to spend time processing all the extras and rejects. But you should keep most to go back to later if necessary.

Process:
Process edited images, raw files in Adobe Camera Raw.

Make global corrections to exposure, color balance, color temperature, etc.

Apply quality rankings to processed images. Ratings can be stars, one through five, or colors: red, yellow, green, turquoise. Explore Bridge to see what's available and how easy it is.

Save in the file format you use (DNG or TIFF).

Metadata: Caption/Rename/Keyword

Catalog: Put in your filing system

Archive the processed images in backup systems.

SOFTWARE OVERVIEW

There are a number of powerful software applications designed for working with digital images and more on the horizon. Here are some of the most useful and widely used.

Among the functions you need software to handle are: processing raw files and image enhancement; digital asset management, including editing, metadata (copyright, captions, keywording), cataloging, and backing up; business forms, and stock pricing and negotiating tools.

Before choosing any software be sure to:
- Research with colleagues, books, and forums.
- Check any programs that interest you to see which capabilities they offer.
- Take a test drive. Almost all software manufacturers offer some sort of trial run. In addition to getting the features you need, be sure to see if it feels intuitive.

Software Function	Program Name	Company	Web Site
Processing raw	Adobe Bridge ACR	Adobe Systems Incorporated	*www.adobe.com*
Imaging	Adobe Photoshop CS3	Adobe Systems Incorporated	*www.adobe.com*
Image management software	Adobe Photoshop Lightroom 1.0	Adobe Systems Incorporated	*www.adobe.com*
Image management software	Aperture	Apple, Inc.	*www.apple.com*
Image management software	iView Media Pro3	iView Multimedia Ltd	*www.iview multimedia.com*
Image management software	Extensis Portfolio 8	Extensis Inc.	*www.extensis.com*
Stock Business Management	InView	HindSight Ltd	*http://hsltd.us*

Stock Business Management	StockView	HindSight Ltd	*http://hsltd.us*
Stock Business Management	searchLynx	HindSight Ltd	*http://hsltd.us*
Stock Business Management	Photo Price Guide	HindSight Ltd	
Stock Business Management	FotoBiz 2.0	Cradoc foto Software	*www.fotobiz.net*
Stock Business Management	FotoQuote Pro 5	Cradoc foto Software	*www.cradoc.com*
Enlarging images (Upsampling)	Genuine Fractals 4.1	One on One software	*www.ononesoftware.com*
Noise reduction	Noise Ninja	PictureCode LLC.	*www.picturecode.com*

TIPS FROM THE EXPERTS: MARIA FERRARI

Work flow is a step-by-step procedure to adjust and improve your images in a timely and efficient manner while preserving the integrity of the original, whether it be a scan or a digital capture.

On Efficiency in Your Work Flow
My advice to students is don't waste any time. Efficiency is the key to good work flow and anything that slows you down is inefficient. As an example, you can save time by using Photoshop keystrokes instead of the mouse to access tools. Just this simple change in work habits can be a time saver. It may seem like the difference of only seconds, but moving your mouse to the top menu bar or to the tool bar over multiple photos can really add up and slow you down.

On Digital Cameras
Buy the best digital camera you can afford, but remember that you can do very good work without having the most expensive model available. Digital cameras deliver an image file approximately three times the number of

the camera's megapixels. So a ten-megapixel camera yields about a thirty-three megabyte image file.

Be aware when buying a digital camera that some stock agencies will accept files only from a specific list of cameras. If you don't shoot with one of their pre-approved cameras, they won't accept your image files. My personal view is that as long as the image is of good quality, then it shouldn't matter how it was captured or scanned. A good file is a good file.

On Imaging Software
I have strong opinions on software for digital photography. In the industry today there's so much discussion about new software that it can get confusing and distracting.

Photoshop is a must. As professional photographers, we cannot live without it. Photoshop, the program itself, is basically a retouching tool. It's a color correction and enhancement tool. It does both global corrections and selective, detailed corrections. It's the most incredible tool out there. With the enhancement of Bridge in CS2 (going further in CS3), you have the ability to process multiple raw image files at once.

There are many other applications out there that are competing for the same market. I feel it's best to stay with Photoshop and Bridge. I can address all my correction and enhancement needs without having to jump around in different programs.

Dazzling features may be fun, but why spend extra time learning yet another program? If you're going to use these tools to earn a living, then you have to learn the programs very well. Instead of spreading yourself thin, learn the essential programs thoroughly. Stick with Bridge and Photoshop—they're all you really need, especially if you are on a limited budget. But if you have plenty of time and money, then certainly feel free to explore.

On DNG
DNG is an image-file format created by Adobe. The company wanted to create a file format that would be universal and compatible for future use. Adobe's justification is valid. I'm an advocate of DNG in principle, but my hesitation is that not all of the major manufacturers are complying.

The idea is that if you convert your files to DNG, you will always be able to open them in Adobe Camera Raw. When a raw file is opened in Adobe Camera Raw, the Adobe program is still "guessing" on a few issues. That's because some of the major camera manufacturers don't want to divulge their secrets about how the image is being captured. That leaves the program

Adobe Camera Raw having to default for some aspects of the capture. So when these features are interpreted by Adobe, it's a guess. The program comes up with a fair assumption on what that particular detail, say of color tone, should be. The Adobe corporation needs the cooperation of the camera manufacturers.

But if you use the proprietary raw converter software that comes in the camera provided by the camera manufacturers, that proprietary converter reads the color and exposure exactly as shot. So, you ask, why not use their software? Because it's not nearly as sophisticated, as easy, or as smooth as what Adobe Bridge offers.

The key to this discussion of image formats is to think of archiving for the future, and that requires that you stay flexible. Creating a DNG file from your original capture is a good thing if you are concerned about the future of your archive.

On Backups

The brutal truth is that everything will fail at some point. Unlike our negatives which were easier to protect so long as they were properly processed and stored, all forms of digital image storage will break down eventually or become obsolete. It's not a case of *if* they'll fail, but *when*. DVDs and CDs will fade, equipment can malfunction or new storage devices will emerge that can't read information from older storage devices. What to do? First, back up to several different devices. Making backups or migrating your files to a new system shouldn't be a major chore. Keep a unified, orderly archive so that it's a simple matter to move your archive when necessary. This is your life's work. Protect it.

Bio: Maria Ferrari has been a successful commercial still-life photographer working in New York City's photo district for the past twenty years.

She is known for her attention to detail and for her relentless dedication to the craft of photography and lighting.

Maria also enjoys teaching. She has been helping other photographers grasp the power and creativity of digital imaging through Photoshop. Students remark on her patience and ability to communicate and simplify the complex are remarkable.

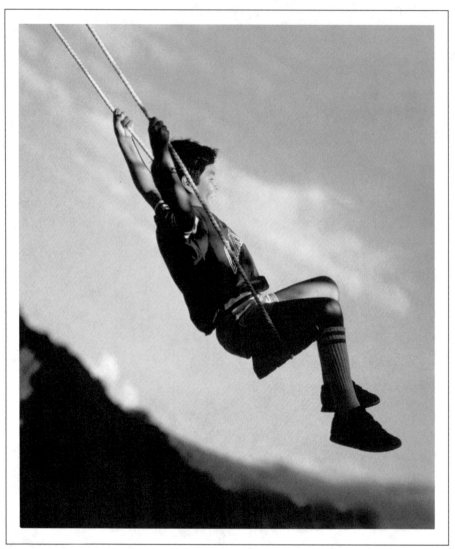

Jeremiah Carpio. Catskill Mountains, New York

Running a Stock Photography Business

U nderstanding that there is no money in stock without sales, your next step is to get your pictures into the hands of stock-photo buyers. The question is: how will you market your photographs and get them in front of those prospective buyers?

This chapter will cover two areas. First, it will tell you what you need to know to make an informed decision on how to market your work. Second, it will give a complete presentation on the process of running your own stock-photo business. (Chapter 10 will provide specific advice on the marketing aspects of stock. If your decision is to try for representation by one or more stock agencies, chapter 11 will show you what's involved in that process.)

In the past there were several ways to find outlets for your stock:

- Representing yourself—handling all aspects of stock-photo marketing
- Marketing through one stock photo agency on an exclusive basis
- Marketing through several agencies in the United States and abroad
- Representing yourself and using multiple agencies
- To that list we now add the use of portals, as you'll see explained below.

KNOWING THE REALITY

As you consider the options for selling your stock, it will help to have a clear idea of the marketplace. The world of stock has been transformed several times in the last few years. Your options for turning your stock business into a profitable venture may change and, in areas like agency representation, become more limited. In other areas, the possibilities will open up as portals become more viable for individual photographers.

In order to understand the climate of stock, let's look in detail at the ways you can market your work and at the evolution of the business.

MARKETING YOUR OWN WORK

Maybe, like some photographers, you just stumbled into selling stock without having made a conscious decision to do so. It just happens—a few emails, a few requests, and you are selling stock. However, if you are to build a successful, long-term stock business after an initial (accidental) foray, you must be aware of the pitfalls you face and of the need for professional planning.

Actually, there are some real benefits to selling your own stock, at least for a brief time early in your stock career. Handling your own work gives you the experience to understand what kind of time and skills are needed. It also helps you gain an appreciation of what a good agency or portal relationship would do on your behalf.

Here are some good reasons to market yourself.

- Profit. You set your own prices and do your own negotiating. You receive 100 percent of the reproduction fee instead of the 35 to 50 percent commonly paid to the photographer by an agency. (Caveat: You will probably spend all of that 50- to 65-percent savings covering the costs of work that an agency would have handled, but if you have a spouse or partner working with you, at least it may keep the money in the family.) Spending decisions on that additional 50 to 65 percent are also in your hands. You will have greater control over costs—deciding, for example, how much is apportioned to marketing, how much to clerical staff, and so forth.

- Productivity. You usually know your own photo files better than an agency can. You should be able to do a more accurate pull from the files, which could result in a higher yield of sales per request. You may be willing to search into your back files for images not posted on your Web site. As important, when talking (via email or phone—yes, some people *do* use the phone as an alternative to written communication) to a buyer, you are in a good position to suggest alternate photographic ideas to fill her request—photographs from your file that agency personnel might not remember. You won't get lost in the crowd, as sometimes happens in an agency. In your own file there is no internal competition.

- Opportunity. You may have a chance for assignments. By having direct contact with the stock buyer, you may convert a stock request into an assignment. Sometimes a client requests a photograph that doesn't exist in your stock. However, if you suggest a creative shooting solution, you have a chance to talk your way into a job that might not have existed.

- Marketing. When handling your own sales, you may have some direct contact with buyers. You can learn the specific needs of their market and sometimes find out about their future projects. You can then plan your stock shooting with their needs in mind. This practice is simply taking advantage of market information and should not be confused with the self-defeating "shooting on spec" for assignment clients, which should be avoided.

- Control over the business. You run the whole shebang. It's your show in every detail. Some photographers find this complete control very appealing.

The main reasons for *not* selling your own stock and for going with an agency or portal are:

- Loss of shooting time. There used to be mountains of paperwork associated with marketing your own stock. Now it's all electronic, but still very time consuming. Running the business cuts into your creative time.
- Overhead. Many photographers don't acknowledge the real costs of selling their own stock. There is a myth that you will have extra money if you sell directly to buyers, because you receive 100 percent of the fee. The extra 50 to 65 percent you receive on the reproduction fee is not a bonus—the perceived extra profit may go up in smoke when you calculate the actual added expenses connected with marketing your work.
- Limited marketing capacity. You can't be in touch with as wide a range of buyers as an agency or portal can. Until you are very well established, buyers are much more likely to know an agency than they are to have heard of your files.
- Limited access. You will miss out on the valuable market research that is shared with their photographers by many agencies.

Once they are balanced, it may look as if the advantages are countered by equal disadvantages, so where have we gotten?

It boils down to two questions. First, what are your expectations for finding an agency? Is that route open to you at this stage in your career? Second, are you temperamentally suited to running a stock business? To answer the second question requires an honest, accurate assessment of your abilities and an understanding of how you enjoy spending your time. You may enjoy handling the business details yourself—some people do. On the other hand, you may enjoy the photography exclusively and work better without the clutter of extra paperwork.

What's needed? If the idea still appeals to you, take a look at what's needed to be successful in running your own stock business later in this chapter.

An important point to keep in mind is that being a photographer is a full-time occupation. Being a photo agent is also a full-time job. Either you add a person to your staff or you divide yourself in half. Simplistic? No, it's really just that simple. If you decide to handle both functions, photographer and agent, understand that you will be spreading yourself thin.

The good news is that many of the paperwork burdens pre-digital have been removed. The less-cheerful aspect is the much greater investment needed in technology. In addition to your digital camera equipment and lighting setup, you'll need a minimum of two computers: a laptop to take on the shoot and a workstation computer (with calibrated monitor). Starting out in stock, you may not be able to afford both computers. If so, you can get away with one good laptop to serve on location as well as in the studio. Just try to keep saving for the work station as your business grows. You'll also need scanners, printers, and external hard drives for storage.

PSYCHOLOGY OF STOCK

Evaluate your temperament, expectations, and goals. Do you enjoy keeping control, handling every detail? Are you willing to build a business for long-term growth? If so, then running your own business may make sense.

It's important, also, to understand that not everyone can get into the agency of their choice in the current competitive climate—another reason to consider marketing your own work. On the other hand, is it your goal to spend most of your time on shooting and on thoughtful, creative photographic planning? If you are looking for a collaborative relationship with an agency—one where your expertise is in producing the pictures and theirs is handling the marketing—then it's worth the research and effort to find the agency that will represent your work.

Because the odds of getting representation by an agency these days are fairly low, except for the most dedicated, determined, and innovative photographers, it might seem a waste of time to consider the traditional advantages of being represented by an agency. First, you should not give up and roll over. The agencies will always have openings for new blood, it's just not the sure thing it once seemed. Second, even if you don't want to make the effort to get into an agency, understanding how an agency works is an important part of your perception of the business. If you do run your own stock business, it's good to know how the competition runs theirs. To do that, it will help to see how the agencies have evolved.

THE STOCK AGENCY BUSINESS

Powerful companies have taken charge of what was once a mom-and-pop industry, as you saw in chapter 1. Traditionally, the marketing of stock had been through a number of stock photo agencies of varying sizes and specialties, as well as by individual photographers selling their stock individually, often working through specialty stock catalogs and Web sites. There were lots of outlets to choose from for your stock. That has all changed dramatically.

The Giants

This is the era of the power agencies. In competition for the billions of dollars spent each year for stock photography, two mega-agencies have taken over the high ground: Getty Images (started with the lucre from the Getty Oil family) and Corbis (Bill Gates's creation). You'll see later as the story unfolds that Jupitermedia is nipping at the heels of the giants. More on Jupitermedia when we get to the section below on royalty-free images.

These two agencies, Getty Images and Corbis, swallowed up dozens of midsize and large stock agencies, amassing huge files of varying topics and styles. Searching for photos at either of these agencies, a client can find everything from sports to life style, from underwater to photojournalism. The goal of these two entities seemed parallel: to corner the market on stock photography. They propose to offer clients

one-stop shopping for stock photography. Heavily discounted prices are available to clients who enter into a volume-purchase contract. This practice benefits the agency, but usually short changes individual photographers, who may only have a few photos in the volume sale.

After the Giants

What's left after the lions have had their feast? There are a diminishing number of agencies to live off the scraps. However, a relative handful of boutique and midsize agencies are still functioning very well to give clients some variety to what the mega-agencies have to offer. The emphasis in the mega-agencies is toward advertising and what is often called the "commercial market." Editorial, which has been a mainstay of the midsize photo agency, is still holding its own.

RIGHTS-MANAGED VERSUS ROYALTY-FREE

When a photographer retains the ownership of his images and is able to license them for usage fees, these photographs are termed, in the new stock photo agency parlance, as rights-managed (R-M) photographs. The terms came about as a way to distinguish those pictures from royalty-free (R-F) photographs. In most cases, royalty-free photos are sold, not licensed. This is a reversal of everything many photographers fought for since the 1950s in terms of managing their own images and getting paid each time they were used. Though photographers didn't have to agree to participate in royalty fee arrangements, there were enough who did to bring about a dramatic shift in the way stock is produced. The change was virtually inevitable with the advent of electronic technology and the Internet.

Royalty-Free: The Beginning of the Change

A dark cloud appeared on the stock photography horizon about twenty years back when some entrepreneurs got the idea to start a company based on marketing "free" photos. They hired photographers to shoot photos especially for them on which they, the company, would own all the rights. The photographers got a one-time payment for the shoot without any prospect for residual income and in most cases, they were required to sign away all their rights. The companies also bought rights to certain existing photos not shot specifically for them. In this way, they built collections of wholly owned photographs that the company would then sell to clients. Under this scenario, a client/photo buyer could purchase a CD of images, any and all of which it could use over and over again at any size and for any usage, from advertising to place mats, and never pay any other fee beyond the few hundred dollar cost of the CD. The purchasing patterns for royalty-free have become more complex in recent years, but this was the initial method.

Regarded by photographers as another form of clip art, royalty-free was decried by many, including me, as short-sighted at best and at worst an abomination that

175

could spell death to the stock business. It was felt to be an insult to the creativity of the professional photographer. The companies who promoted royalty-free stock were treating an artistic creation as a mere commodity. And it was putting a knife in the heart of the photographer's long term economic outlook. The price structure of photographic usage had been, in part, based on the fact that a photographer kept the copyright and was able to license a photograph over and over to different clients. So the photographer was able to give usage to the client at a moderate fee, knowing she might make up for an initial low fee by the income stream over the life of the copyright. Now, photographers were competing with virtually free photos.

The photographers participating in these royalty-free shooting ventures were sometimes young and inexperienced, but seemed happy to get the immediate money and didn't see down the road the effect it would have on the asset represented by owning the copyright to their own image. Mainstream photo agencies and photographers drew themselves up in horror with disdain for the perceived low quality of the images and the threat to the market.

Impact of Royalty-Free

Royalty-free turned out to be detrimental to some of the photographers who sold off their rights thereby limiting any future income from those photographs. And it did make a dent in sales of stock photography, especially among the low-end client user who didn't need or want to pay for the most creative images. But when the euphoria wore off, clients realized that when they searched their collections of disks of free photos, they often had an itch that didn't quite get scratched. Free photos didn't always measure up and they certainly weren't fresh. So the clients found themselves returning to search among the traditionally rights-managed images.

Then, in the kind of ironic turn often found in business, the strange bed-fellows of rights-managed and royalty-free began cohabiting at some major photo agencies. The mega-agencies, Corbis and Getty Images, have bought up some of those very companies that initiated the concept of royalty-free images. But now they are allowing clients to license a single image without having to buy an entire CD. In another twist, there are circumstances where a royalty-free image is more expensive than a rights-managed image, depending on the negotiations and or volume-discount contracts clients have with agencies. In addition, clients can buy yearly subscriptions to a royalty-free collection. The big difference is that for royalty-free images, none of the photographers who created them will see a piece of the pie. It's been a controversial and adversarial element within the stock world that is still playing itself out.

Jupitermedia

Since the beginning of the royalty-free era, the concept grew until, unfortunately but inevitably, royalty-free companies proliferated. They had found a product

the market wanted. At this writing, there are dozens of royalt
It wasn't long before we had a giant among the royalty·
Jupitermedia, in a relatively short time, is now third place i
behind Getty Images and Corbis. It's quite a phenomenal busir
a period in early 2007, Getty Images had been in negotiating to
but the deal foundered to the relief of many in the industry who reared even less
competition if the three major players became two.

Is Jupitermedia a stock agency or actually a new breed of image provider?
Jupitermedia built its business primarily on royalty-free images. Here's the
Jupitermedia description from its Web site, *www.jupitermedia.com.*

> Jupitermedia Corporation is a leading provider of original images and informa-
> tion for creative, business, and information technology professionals.
> Jupiterimages provides photos and other graphic images electronically while
> JupiterWeb is the online media division of Jupitermedia. Jupiterimages offers
> online subscriptions and single image downloads for clipart, Web graphics, pho-
> tos, footage and music (including flash versions) via a comprehensive network of
> design-oriented Web sites for industry professionals and individual consumers.

Jupiter is beyond the definition of the standard stock photo agency, but in step
with the new ways of marketing images and information. If you want to keep up
with the changes in the industry, one good resource is the newsletter "Selling
Stock" by veteran industry analyst Jim Pickerell (online at *www.pickphoto.com*).

PORTALS

Many photographers found themselves stranded when the midsize agencies with
which they'd had a productive and lucrative relationship evaporated, chewed up
in the maws of the giants. Some photographers resigned from agencies because
they didn't agree with the pricing policies of the mega-agencies. Other photog-
raphers weren't prolific enough to suit the new agency and their contracts
weren't renewed.

The response to the dilemma created when Corbis and Getty Images began
gobbling up agencies was that enterprising stock photographers and agents created
a new entity known as a "portal." This new marketing vehicle emerged to help
counter the power of the two Goliaths. Most photo buyers want to go to Web sites
that have hundreds of thousands of images to choose from in order to see as much
as possible in one place. Unfortunately most photographers and small agencies
can't offer enough images on their individual Web sites to attract these clients. So
the portal provides a mechanism to fill the gap between the two.

Essentially, the portal is a Web site that gives photo buyers access to a large
group of subagencies or individual photographers in one location. The benefit for

ent who has not found what they need at Corbis or Getty Images is that ey don't have to go to dozens or hundreds of individual Web sites to find fresh images. They can see a large collection within the portal. For the photographer, it is like being in a good midsize agency, but in many cases they handle their own price negotiations, which an agency had done in the past.

How Portals Work

A portal may work in several ways. One type gives access to a number of subagencies and individual photographers Web sites. The more technically advanced portals will allow a client to cross search. So entering a keyword in the more-advanced portal will bring up all images, from all the subagencies and individual photographers' Web sites that match that search criteria. Other portals require you to search each subagency site individually, a much more cumbersome method that is rapidly becoming outdated. Make sure that any portal you consider can be searched across the portal.

Using a Portal to Market Stock

Much of what is said about preparing yourself and your work for a stock agency holds true for working through one or more portals. You will benefit most from having carefully produced, carefully edited images. Some portals have a policy of reviewing work before accepting. Others will accept most of what is submitted within normal professional parameters. It's in your best interest to edit stringently; if you have to pay for keywording or other services, make sure the cost is confined to your very best images.

Here's good advice given by one portal company: "Before contacting us, we invite you to view work by other members of the network and judge whether your photography stands up against the quality presented. Please note that we prefer to work with digitally savvy photographers who can scan, transmit, and caption images electronically." (In chapter 11, you'll find a list of portals.)

A Portal to the Portals

Even though there are portal Web sites that take images from a large number of small contributors to create a site with enough images to compete with the mega-agencies, that's not always the easy answer to marketing stock. It may be difficult for the emerging photographer to know which portal to choose and to determine if one portal is big enough to provide a suitably wide market.

With innovation flourishing in this time of change for photography, one company, Stock Connection (*www.scphotos.com*) found a niche by acting as a portal to the portals. Started by veteran stock photographer and industry analyst Jim Pickerell, the company helps photographers place their images onto

several of the largest stock photography Web sites. Their photographers get exposure to a variety of markets but only have to scan and keyword their images once and deal with just one agency. Because each portal has different requirements for scans and keyword data, Stock Connection will do most of the work to caption, keyword, and submit your images to each of these portals. Among the portals where Stock Connection currently places photographers work are *Alamy.com, PictureQuest.com, Workbookstock.com, IPNstock.com, REXinterstock. com, Fotosearch. com, Austral.com, and Stockphotofinder.com*—and the list keeps expanding.

THE NEW ECONOMICS OF STOCK

The proliferation of royalty-free images, coupled with fewer outlets for rights-managed images, means that the income stream for stock photography has been sharply affected. The economic reality is that the newcomer to the field must keep costs in line for any production of stock and balance the costs of photo production versus the projected income that might be generated.

There were days when high-end stock photographers did nothing but produce stock. The top photographers may have grossed $300,000 to $500,000 per year and invested at least $200,000 back into the shoots. The quality of the photography they produced was significant and well above what you could find in royalty-free images. But even faced with the disparity in quality, more and more clients took advantage of lower-priced royalty-free images. That kind of high investment in the royalty-free arena just wouldn't pay you back. Shooting for the royalty-free market—or shooting traditional rights-managed to compete with royalty-free—you must maintain strict budgets and plan shoots that can yield a high volume of photographs in a day. Now, it isn't cost effective to make such a high-level of investment because the earnings from stock are less likely to bring a high enough return. Shooting for stock will require ingenuity in designing shoot topics and concepts that can be carried off to give a high yield of photographs for the investment.

YOUR BUSINESS STRATEGY

Now that you understand the evolution of stock agencies, consider that in running your business you may be involved in some aspects of an agency or a portal. But you will still need to base your business on running your own operation.

It's important to emphasize what we mentioned earlier: being a photographer should be a full-time occupation, but being a photo agent is also a full-time job. If you handle both functions, photographer and agent, understand that you will be spreading yourself thin. Until your business is big enough to need (and support) two full-time people, your photo coordinator (described in chapter 6) might handle some stock-marketing duties or might help with the digital preparation needed to get images ready for market.

Here's what's needed to be successful in running your own digital stock business.

- Space. Additional workspace will be needed for equipment and for your assistant. Fortunately, you no longer have to provide a place for clients to work while selecting pictures because virtually all photo reviews and other transactions are done electronically.
- Equipment and functions. In addition to the standard business equipment, to compete effectively, you will require a full complement of digital capabilities with a workstation for yourself and another for your assistant/partner. You may need to set up a file transfer protocol (FTP) site to handle accessing images for clients, as well as the capability to build light boxes on your Web site to allow clients to review images.
- Access. In addition to electronic delivery of images, overnight courier services are still occasionally useful. There are times when you'll want to ship DVDs, contact sheets, or match prints to clients. To be competitive, you should have access to overnight courier services. (No matter how beautiful your remote mountaintop may be, it could be a liability to your stock marketing if couriers won't guarantee overnight delivery service from your area.)

As a final question, are you visual, energetic, creative, obsessive, compulsive, dedicated, hardworking, and disciplined? If so, great. Then let's get started setting up your stock business.

RUNNING THE BUSINESS

The process of representing yourself is complex, but can be handled if you approach it with order and organization, strong digital skills, and boundless energy. Where do you start? Assuming you are building a good collection of stock images, your next steps are to set up your files, forms, and digital systems; train staff; and plan your marketing (which is covered in chapter 10).

Setting Up Systems

To see why systems and forms are so important, just take a look at the variety of tasks involved in selling stock, many of which can happen simultaneously. For a quick overview of the process, see the box "20 Stages in a Stock Sale."

Each step of the process takes a relatively short time, but when your business takes off, many of these functions may happen simultaneously, so efficiency will be well rewarded.

It is essential that each step be handled accurately to avoid compounding problems later on. The dangers of shipping and tracking original transparencies have been removed by delivering digital images to a client whether on a disk or

via the Internet. Review the following steps and use your systems, digital or standard, to advantage:

1. The Photo Request

A request may come in the form of a list sent by email, or, once in a great while, in a telephone call. Occasionally, and somewhat rarely, you may stumble upon a request in a casual conversation with assignment clients, who ask, "Say, do you have any pictures of . . ." You will immediately send them to your Web site (they should already have your business card with Web site listed) and then you'll follow the steps below.

2. Getting the Information

If there is little or no description on the request list, email back or try to reach the client by phone to get clarification.

Try to find out the name of the project, the image use and size, fees, concept, and the layout or design needs, such as whether they need a horizontal or vertical photo. Find out if there is a scheduling issue. Using the phone in place of email can be a bonus if you are friendly yet efficient with your queries. Start by saying, "If this is inconvenient I can email you these questions, but if you have a minute, can you tell me . . .". An occasional phone conversation is sometimes an antidote to all the electronic static in a client's day. But be prepared to cut the call short if it's clearly an imposition.

Another approach is to email your queries regarding a photo request, then, if there is no reply, follow up the next day with a phone call. (Your email could have gotten lost in the shuffle.) In that case, start your call with, "Regarding your photo request for X project, I'm not sure if you got my email questions yesterday, but if you have a moment can you tell me . . . ?"

If you should have a phone conversation, fill out your own stock-photo request form as you speak (see the sample later in chapter 14). Using this form as a checklist will help you remember the questions to ask and whether you are in touch by email or phone. As you'll see in the section on Web sites in chapter 10, a brief request form can be included on the Web page under "Contact Us." Above all, make sure you understand the underlying concept, the shape the client needs, and the deadline if it wasn't in the original request. If you haven't worked with this client, you should make clear your fees and let her know your terms and conditions which will appear on the back of your delivery memo. If they haven't made clear how they want to see images, give them the options list below in number 7. (Full coverage of negotiating techniques is in chapter 12; see chapter 14 for more on delivery memos.)

3. Researching the Files

In addition to what's posted on your Web site, find other images suitable to the request. This process is sometimes called the "pull." No matter how many photos of a topic you have on your Web site or how good they are, it's wise to send more than the client has seen if you can. It gives the client an idea of the depth of your file.

If a shape wasn't specified in the request, be sure to include horizontals and verticals. This makes an effective visual presentation and, if the picture is on the right topic, the odds are higher that they will pick one of the four. A one-picture display on your Web site may not make the same impact.

Many of the stock agency Web sites do not offer that type of variation on a topic. They post one image, one composition, one type of framing. Take it or leave it. You may be able to distinguish yourself from the agencies by providing more variety.

Clients may prefer one of the variations to the picture they saw on the Web site. Also, they may buy an additional photo or two because of the variations you have to offer. So sending variations becomes a sales tool to show the kind of service they can expect from you.

4. Arranging the Selection

If the request is a simple one and you have suitable photos on your Web site, then there is nothing to arrange. If the request list is short, you can simply email a few photos in addition to those on your Web site.

However, if the request is complex and warrants a careful submission, then organize your pull in a way that matches the request list. If you have the capability of creating a light box on your Web site, organize the images so that it's clear if there are alternate ideas included. If you are submitting images on a CD, separate images within the CD into folders to match the categories of the request; a contact-sheet format will also work well.

An orderly submission will increase your sales and gain good will with the buyer. If it is immediately clear how each of your photos matches the photo request, it will be much easier for the client to organize their internal approval presentation. Some photographers arrange their submissions willy-nilly with topics mixed. Imagine the appreciation of a harassed photo editor when your submission, whether on CD or a light box on your Web site, is structured enough for her to do an instant edit before her presentation deadline.

Make it gorgeous. Make your submission as attractive a visual presentation as possible within the order that matches their request. If you have time, arrange the images in the light box so that the colors enhance each other.

Think of each submission sheet as a portfolio presentation. If possible, take the time to make it dazzling. If the first impression of the light box is stunning, this few

minutes will be well worth it. By creating the impact of a richly colored patchwork quilt you'll have predisposed a photo editor toward your work. Have compassion for the weary photo editor, who, week after week, views dreary-looking, haphazardly organized submissions. This is where you can have an edge. And the day you hear, "It's a pleasure just to glance at your light box" will be the proof of that pudding. (See the sample "Light Box Submission" at the end of this chapter.)

5. Preparing the Images

This may overlap with the previous step, but if you have to make final adjustments for the submission, this is the moment. After you have selected the photos for the submission above, you do the final work of preparing the submission for posting or emailing. You make any needed contact sheets. In addition, scan any film images from your archive that you think are suitable to the submission.

6. Protecting the Images

This is when you double-check all forms of legal protection and caption information. By this stage, your basic information should be part of the metadata of the image (chapter 8). However, if you want to add some caption information to make the photograph more pertinent to the client, you can do it at this stage.

Be sure your copyright notice is both in the metadata and displayed on the image. It should appear on the bottom line of the frame as a c in a circle (©) with your name and the year (see chapter 13). Make sure that the model release number is marked, and that the caption is full and accurate. In addition, provide only low-resolution images to avoid having your photograph pirated. Some photographers consider a watermark good protection against unlawful usage of your image. Skillful poachers can remove the watermark. (I find it annoying when reviewing an image to have to look through a watermark, so I don't use them.)

In the days when we sent film images to a client, it was important to protect the physical property of the transparency. Today, if there are rare instances when film is required (though it should be avoided), cover each slide with a protective plastic sleeve, place in a plastic slide page, and then sandwich the page or pages between two sheets of heavy cardboard. However, it's unlikely that physical delivery will be necessary. It's almost always possible to do a quick, low-resolution scan of a film original to send a client. Then, if the image is chosen for use, you can provide the high-resolution image file by scanning the image to their specifications.

7. Delivery Memo

Use your delivery memo to express the terms and conditions on the photos you provide (sample form in chapter 14). The better software programs for running a photographic business provide a variety of forms and capabilities,

including the automatic assigning of a delivery memo number software is listed in chapter 8). If you are not using business software, then be sure to assign a memo or consignment number to the delivery form you use. Enter this number and basic information about the delivery, in numerical order, in a log of delivery memos. Next, on the delivery memo, list the file number and a brief description of each photograph in the submission. Indicate that no usage is granted without payment. Indicate that the low-resolution files being submitted are for examination only and no reproduction rights are granted. This is the place to make clear all your conditions.

8. Delivery to Client

Delivery methods depend on your capabilities and the client's preference. As mentioned earlier, you can offer delivery by email, by posting images to a light box on your Web site, posting to your FTP site or to the client's FTP site, and also, simply by burning the submission to a CD and shipping by courier. Sometimes a print of a contact sheet is sent with a CD.

9. Invoicing the Research Fee

This is the stage to make out your invoice for a research fee to be included in the submission. Many agencies and established photographers charge a research fee to help defray the cost of preparing photographs for submission and to discourage casual shopping. This fee can be deducted from any usage fee. (Note: Since the advent of digital submissions, research fees are not often charged by photographers; however, it is still an option, especially to help defray scanning and post-production costs.)

10. Filing the Forms

Have a system for keeping track of delivery memos. Many of the software applications for running a photography business will do this automatically. But whatever your system, it's useful to have the delivery memos so you can follow up with clients. In addition, you should file all photo requests, because they may contain ideas for future stock shoots.

11. Follow-up on Submissions

If you have time, it's a good idea to follow up on a photo request, usually in an email. Ask: "Did you get what you need? Can I get you anything else?" You might even ask if decisions have been made, but don't pester!

12. Approved Photos/Request for High-Resolution Files

When clients want to use one of your photos, they usually want the high-resolution files as fast as possible. Be responsive. Make this process as quick and

easy for them as possible, so they don't get caught in a deadline crunch. The delivery of high-resolution files may be different from what they requested for the initial low-resolution submission. So don't make assumptions, be sure to find out how they want them. It seems that about 90 percent of clients want delivery to an FTP site. The rest want a CD or DVD. With the delivery of the high-resolution files, make sure you have another delivery memo stating that permission to reproduce is contingent upon payment of your invoice.

13. Purchase Order/Billing Request Received

You may receive the request for high-resolution files at the same time as you get a purchase order (PO) or billing request. It should be very close in time because you have to let them know that they don't have permission to use high-resolution files until they pay the invoice. Some clients automatically send you a purchase order or billing request. With others, you have to ask the client what's being used and how in order to bill them correctly. If an amount is specified on the billing request, see if it agrees with the reproduction fee you discussed.

14. Price and Usage Negotiation

If not handled at the beginning of the photo-request process, now is the time to be sure of fees and usage. (The full discussion of the important skill of negotiation is in chapter 12.)

15. Invoicing the Client

Make sure your invoice clearly spells out the specific, limited rights granted. Always use an invoice number for easier record keeping. Again, photography business software will have invoice forms to aid you in this process. At this stage, request a tear sheet, which is truly pie in the sky. It's rarer than hen's teeth to get a sample of the work, but if it's a major usage or a large number of photos used it will be worth the effort. Get all the information about the publication date so you can mark on your calendar to follow up later. There are times when it's worth buying the magazine or book if the usage is particularly good.

16. Receipt of Payment

The check comes in. Examine it for fine print to see if the usage has been extended or any conditions added that were not part of your negotiation.

17. Entry Into Your Bookkeeping System

It is important to follow up on payment as well as to log information you need at tax time. To track these payments, enter them into whatever accounting or photography business software you use.

18. Return of High Resolution Files

Photographers and photo agencies often request the return of the high resolution files, but it's almost silly to do so. Even if the client returned the actual DVD you sent, they have had to make other copies of the digital file for their own layout and printing processes. If they return one copy, they still retain others. So in this situation, you are dealing with trust. The client knows they don't have permission to use the files again, and as long as you are working with reputable people, that must be your safeguard.

19. Check the Email for the Next Request

This is the cheerful time when another request comes in. And when you arrive at the point where you get more requests than you think you can handle, that's a time for celebration (or hiring an assistant).

20. Breathe Deeply and Start Over

Be grateful for digital. In an earlier edition of this book there were five more steps, which covered handling and safeguarding and tracking film originals. These are no longer necessary.

This is what it's all about to follow through on a stock sale. The next question is: Do you want to handle it all yourself, or should you get some help and train an assistant so you can go back to shooting photographs?

TRAINING STAFF

Only you will know the right time to go from doing it all yourself to using an assistant. My advice is to get help sooner rather than later. If you assess the value of your time, you'll see that shooting new photographs or planning a marketing strategy is an infinitely better use of your time than entering bulk metadata or posting submissions to an FTP site.

Identify the areas in which you want help and the degree of expertise needed for each task (see the levels listed below). Assign work as the experience and qualifications of an assistant warrant. Remember that accuracy is far more important than speed when working with digital photography.

Office Work, Level A—digital /clerical:
- Entering bulk metadata from your sample
- Writing delivery memos (for photos you've pulled)
- Preparing invoices (fees specified by you)
- Handling delivery/posting of submissions
- Qualities needed: good digital skills, accuracy, neatness

Office Work, Level B—digital work plus contact with clients:
- Respond to photo requests/call buyers, get usage info
- Scan from film archives for submission

- Pull request from file
- Organize photo submissions for light box or contact sheet
- Negotiate prices
- Qualities needed: excellent digital skills, understanding of photography,
- some experience and sophistication in business, good phone manner

Photography-Related Work, Level C:
- Processing raw files, color management of files
- Editing photographs (selecting for sharpness, exposure, expressions)
- Qualities needed: top digital skills, photographic experience, good "eye" and/or training

During the training period and until you are sure a staff person is capable of a specific level of work, double-check everything. It will take some pressure off both of you and make for a more relaxed working environment.

Your staff should understand the extraordinary value of your photography and the need for careful handling and manipulating. Be sure that all original, master digital files are backed up in an archiving system so you don't have to panic if an assistant makes a mistake. Make it clear that you value their thoroughness because certain tedious digital work is integral to the success of your business. Also, if you find someone competent, you can never show enough appreciation.

Finding staff is a process of research as well as trial and error. The right person might be found anywhere. The best assistant I ever found was a former actress who had worked as a freelance digital layout artist and who was studying for an MA in education. We had complementary needs at the right time. A person's experience may be less important than their qualities of thoroughness, accuracy, dependability, and that old standby, common sense. A sense of humor is a bonus.

If your business isn't ready to support two full-time staff people, you might use one person for two jobs. Use a photo coordinator who can help set up your stock shoots and work in the office as well.

In chapter 6 you learned about sources for finding a photo coordinator. Many of those same sources could help you find an office person. Among those possible to fill this job are photography students or interns, theater people, and teachers.

For help with Level A, the most basic clerical work, some photographer friends of mine use high-school students because so many of them have digital skills. There may be some exceptionally trustworthy teenagers out there, but I will not put that degree of responsibility upon such young, inexperienced people. College students, however, can work out well. Make contact with the placement office of your local college.

Also, see if any of the students in your area are in work-study programs. If you explain the qualities you need in an assistant, a placement counselor will help screen for the right person. I have found dance students (they're disciplined),

science majors (they're meticulous), and computer students (they're precise) to be excellent prospects for office work. Art or photography majors are often interested in the aesthetics of your business, but may not be aware of the importance of detail work or will merely tolerate it. Be aware that they may become dissatisfied quickly. The exception is those who are digital-imaging specialists. As I mentioned earlier, I've also had good success with teachers—they often want to fill some of their vacation or after-school time. Community colleges have photography and digital-imaging courses, and because high schools have expanded their computer courses, you may find a teacher from that curriculum to help you part-time.

It is very important to have your procedures written down. An outline of your system will help a new office person understand your initial explanation and will serve as a guide to answer questions they may have later on. Though it's second nature to you, the information may appear to be overwhelming to an outsider. It's frustrating to believe that you explained to an assistant how captions should be entered into the metadata only to find it done wrong with time wasted, work to be redone, and dispositions soured. In fairness to your staff, and to avoid frayed nerves, written procedures will assure that you have indeed conveyed the information clearly. The training of future staff will also be easier. By creating a cohesive structure, you have increased the likelihood of competence on everyone's part.

A well-trained staff can make it possible to run your stock business efficiently, leaving some energy for the primary goal: making wonderful pictures.

The Support System—Professional Photographic Organizations

Are other photographers having a problem similar to yours? Or are you the only one who feels frustrated? Where can you go to talk to someone?

You aren't alone. Much cheaper than therapy, the various professional-photography organizations are there to help you. Investigate them all and see which one is designed for your interests, professional level, or goals.

The primary benefit is in associating with colleagues. You'll want to meet with other photographers to discuss similar problems and solutions. In addition, informative newsletters, meetings, and seminars on various photographic topics are offered. The important side benefit is that at these meetings, you have a chance to learn how established professionals handle their businesses.

Most organizations have various levels of membership, from student or entry level to that of established professional.

The organizations most likely to be of interest are:
- American Society of Magazine Photographers (ASMP), *www.asmp.org*
- American Society of Picture Professionals (ASPP), *www.aspp.com*

- Advertising Photographers of America (APA), *www.apanational.org*
- Professional Photographers of America (PPA), *www.ppa.com*
- North American Nature Photography Association (NANPA), *www.nanpa.org*
- National Association of Photoshop Professionals (NAPP), *www.photoshopuser.com*

Having been an active member of ASMP, I'm a fervent supporter of that organization. ASMP has been protecting photographers' rights since the 1940s. It continues in that effort as well as in educating members, sharing valuable information and insights into the complexities of today's photographic world. There are chapters throughout the country. There must be one near you.

I can't encourage you strongly enough to join the professional organization that fits your needs. It's the one thing you can't get from a book.

EXPECTATIONS AND GOALS

Your success in selling your own stock is in direct proportion to the commitment you bring. Stock is open to everyone. Not all will succeed. But anyone who brings dedication and quality and is willing to make a long-term investment has an excellent opportunity.

LIGHT BOX SUBMISSION

Organizing your submissions to match a client's request can greatly increase your chance of sales. Whether you post photos in a submission as a light box on your web site or submit a contact sheet delivered by email or to an ftp site, having an orderly presentation makes it easier for a client to find what they need.

It's preferable to deliver electronically, but if a client wants a CD sent then group the topics in folders labeled by the request list. The photos of Japan on these pages would fill three requests: 1. Traditional Japanese culture, 2. Passing on traditional culture, and 3. Contrasts in current Japan. Often, in a well constructed light box, when you click on each image, there would be an additional selection of variations below the image clicked.

Japan Lightbox

Traditional Japanese Culture

Japan_a02-005

Japan_b02-001

Japan_c02-020

Passing on traditional culture

Japan_d02-015

Japan_e02-018

Japan_ f02-017

Contrasts in current Japan

Japan_l02-009

Japan_n02-008

Japan_o02-021

20 STAGES IN A STOCK SALE

1. The photo request.
2. Getting information.
3. Researching the files.
4. Arranging the selection.
5. Preparing the selection.
6. Protecting the images.
7. Delivery memo.
8. Delivery method.
9. Invoicing the research fee.
10. Filing the forms.
11. Follow-up on submissions.
12. Photos approved/prepare and deliver high-resolution files.
13. Purchase order/request for billing received.
14. Price and usage negotiation.
15. Invoicing the client.
16. Receipt of payment.
17. Entry into your bookkeeping system.
18. Return of high-resolution files (don't count on it).
19. Checking the email for the next request.
20. Breathe deeply and start over. Be grateful for digital.

TIPS FROM THE EXPERTS: CRAIG JACKSON

It's all about speed, quality, efficiency, and getting images to your customers as quickly as possible. That also helps me spend more time shooting and less time at the computer.

On Systems

Keep it as simple as possible. When you are setting up and running a stock business, create a system that works for you by adapting software or systems available in the industry to your own business.

Just don't make it complicated. Don't feel you have to do everything that the software allows. Use only what you need, when you need it.

I like things to be fast and easy. We use two different software programs—iView for keyword search and NikonView for downloading images and converting to JPEGs and contact sheets for client submissions. Working with film was much harder. For a long art list from a client, I might have spent

several days searching film archives, preparing prints or contact sheets. Now it's easy. That same request might take less than thirty minutes to fill with the right keywords attached to the pictures.

Work Flow

I do as little as possible in the beginning. I do a quick edit, throwing out only the true rejects. The rest of the pictures go into my stock archive, keyworded and cataloged. The images that go out in the initial client submissions have not been completely fine-tuned. I try to get the images close to perfect in the camera so a lot of my quality control is done during the shoot. The only images that get careful processing are the images for my Web site and the final selections requested for use by a client. That's done when we send out the high-resolution files.

My philosophy is don't work on making them perfect until it's needed. That's just wasting time for no good reason.

On Equipment

A laptop has become as important as the camera to have on a shoot.

On Back Ups

Everything can fail (except film) so back up, back up, back up. I use four levels of backup. First, from the card to the laptop, then the files from the laptop to my workstation computer at the studio, then to my first external hard drive, then a mirror image to the second external hard drive (I use LaCie hard drives), and finally to DVDs. Odds are that they won't all fail at once.

Keep your DVDs in a fireproof vault. Maybe it's because of my work photographing fire scenes that I'm aware of the devastation that a fire could cause to my business. It's a small effort to save you from a complete loss. It's your art and your business to protect.

Bio: Craig Jackson started as a photojournalist in Syracuse, NY, more than twenty years ago. Assignments as a photojournalist led him to a specialty in EMS, fire, and police photography, which is now the mainstay of his stock photography business, In The Dark Photography (www.inthedarkphotography.com) which now serves editorial, advertising, and corporate clients. He runs the business with his partner Tracy Mack-Jackson, who is a photographer and Internet marketing consultant for The IDP Group. Her Web site is www.theidpgroup.com.

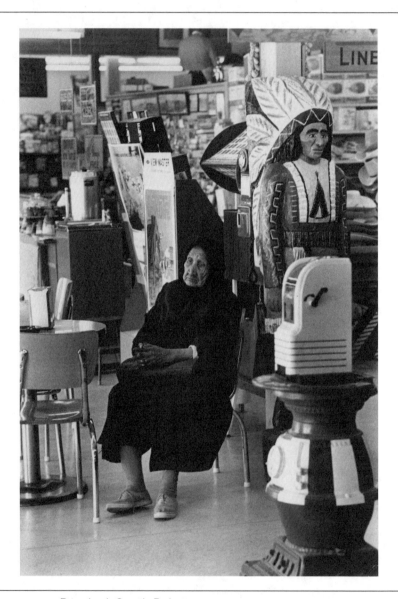

Sioux woman. Rosebud, South Dakota

Marketing Your Stock

The wonderful photographs you've taken (carefully edited, meticulously captioned, and protected with your copyright notice in the metadata) are now ready to go out into the world. How well they help you achieve your goal of a successful stock business depends on your ability to market your work.

In simplest terms, marketing is letting people know who you are, what you can do, and then convincing them that they should come to you for their photo needs. It can also be defined as the process of finding out which buyers might need the type of photographs you have, and letting those buyers know you have photographs for them—a sort of matchmaking. While marketing may be the least pleasant part of a creative person's life, it is arguably as important as all your other skills. Without marketing, your work could languish unseen and unused.

Because of a dramatic increase in the number of photographers selling stock, your marketing efforts must be carefully developed and stringently followed. You will be competing with the mega-photo agencies as well as other photo-graphers, so you will need to offer a high level of quality and service. Your marketing must emphasize why it's worth a client's while to deal with you and benefit from the individual service you offer.

Start early, make a plan, and take it in small steps. Marketing is not so overwhelming if it is integrated with the rest of your stock business. Don't lose heart; there are some very useful books listed later in the chapter for when you are ready to outline your marketing strategy. But first you must believe in its value.

Here are the basic steps in your marketing effort:
1. Develop a marketing strategy and a business identity
2. Develop marketing materials (tools needed and design)
3. Understand the photo markets
4. Find buyers/clients
5. Reach buyers/clients
6. Deal with clients

DEVELOPING A MARKETING STRATEGY

When first considering your marketing strategy, take an overview. Keep in mind that an ideal marketing effort should have two overlapping components: a universal as well as a targeted approach. Using both of these methods will ensure that you reach the widest possible audience without being random or unfocused in your efforts.

The universal aspect of your marketing means that you make yourself appealing to all types of buyers. You do that by having consistently excellent photography displayed on your Web site, as well as by letting clients know of your sophisticated ability to deliver services quickly and efficiently. You want to make it easy for the buyer, any buyer from any market, to see what you have to offer.

Even though your collection may not seem to suit all buyers (and realistically you can't be all things to all people), you do want everyone who sees your Web site or other marketing materials to be impressed and imbued with the confidence that you can deliver professional services. The reason for keeping an umbrella view is so you don't limit yourself or narrow the possibilities.

The targeted approach means that you identify the specific photo markets you want to reach—the markets where you have the best chance of meeting the buyers needs. These are the ones where your concepts, content, and style seem to have the very best match. You'll figure this out based on the analysis of your work made back in chapter 2. That exercise was intended to help you relate the style of your stock with the potential markets you've identified. This is where your most intensive marketing should be directed.

What are these markets? Later in this chapter you'll see a detailed analysis of the major photo markets—advertising, corporate, and editorial—which will help you figure out where your work fits best.

Business Identity

Who are you and what do you have to offer? Creating a business identity starts in your mind and then is translated into the preparation of all your materials.

To hone in on your identity, decide on a name for your business and consider an icon. Back that up by making a list of what makes your stock business special. This list will provide an outline for your written copy in all materials. And it becomes the foundation for your Web pages. A look at various Web sites will give you an idea of how other photographers describe themselves and their services. To find samples of Web sites, look up the names of photographers whose work you admire. Or simply Google different types of photography that interest you and see what turns up. After viewing fifteen or twenty Web sites, you'll have a good idea of the patterns common to most. And you'll begin to see what works most effectively. In the box "Web Pages," you'll see a few of the common pages presented on Web sites.

What's in a Name?

A name for your business is extremely important. Don't feel shy about naming a business even before you have any business—every hardware store had to put up a sign before opening its doors on the first day. You want to be ready to open your stock photography doors. It can be a simple combination of your name with the word "photography," or a word that denotes your type of business. (More about whether to include the word "stock" below.)

If you specialize in one area of stock photography, that may figure into your business name. A terrific example (unfortunately taken) is the name of the photo agency, "Animals Animals," which leaves you in no doubt about what its files include.

Another approach to naming is to try a catchy play on your last name. Photographer Andy Sacks in Michigan uses *www.saxpix.com* for his Web site, "Sacksafone@ . . ." for his email, and Photography SAX PIX as his business name. It connects the name to the business, and is eminently memorable and fun. But if you don't have a name in mind that lends itself to being catchy, then at least make sure that it relates as clearly as possible to what you do.

Later in the section on Web sites you'll see how critical your name will be in helping you be recognized for what you do, attracting the kind of clients you want, and keeping from getting lost in the crowd.

Next you should find or an icon or logo that represents what you feel about yourself and your work, or ties in with your name. Here's where collaboration with a good designer will help. Bounce around concepts with designers and they will often surprise you with an arresting logo or icon. Long ago an art director friend drew an elegant silhouette of a bird called a heron (my last name), which I have used on my materials for many years.

The process of defining yourself never stops and should be reflected in your logo. A successful photographer friend had been using a logo that intertwined her name and a roll of 35mm film with sprockets. Certainly not a unique image in the business, but hers was clean and well executed. Several years ago she knew she had to jettison that film image, because it might place her in the past and obscure the fact of her digital capacities. She and her designer came up with a fresh digital icon, giving her a more current look.

Names on the Internet

Going back to the subject of naming, realize that in the pre-Internet days, print was the major marketing medium. In print, your name didn't carry the same weight as it does today. Previously a simple name, such as "Jane Jones Stock Photography," was fine for marketing when buoyed up by strong design, fine photographs and a good client list. Today, because of the competition on the Internet, it's hundreds of times more important to have a name that can be positioned well. You must find a

name that works for you on the Internet in two ways. First, the name must be clear about who you are and what service you offer. Next, you must get positioned where that name can be found, not lost in the teeming masses. Work with your Web designer to find strategies to get your Web site to come up as early as possible in a search engine response. The tricks for this vary from month to month so work with an expert to secure the most advantageous positioning you can.

Copywriting

Remember that in all your materials there will be a written as well as a visual component. Work with the list you made (above) outlining your experience, services, and the content of your photo collection. As you'll see later, many of the page components in a typical Web site include written commentary, information, and sometimes a photographer's philosophy about his or her work. You'll see that the basic written material, common to almost all Web sites, are variations of the categories "About Us," "Contact," and/or "Bio." On these pages of a Web site, you'll find brief commentary and a list of accomplishments or sometimes a presentation of upcoming stock photo shoots or travel plans. When you visit the Web sites as suggested later, take a good look at the concise but informative writing. Note the tone, which is confident and professional, but without braggadocio or exaggeration.

In addition to your service capabilities listed below, other written information will be needed in your marketing, whether on the Web site or in printed materials.

Once you have compiled the information that you think is important about you and your stock business, have what you write reviewed by an editor or writer friend. A good editor can make your words say more clearly what you had intended. Don't underestimate the value of clear, concise writing to underscore your photography and the services of your stock business.

On a Web site and in written materials write about your:

Capabilities

- Speed of service. "We can respond immediately to any request you have for research beyond what you see on our Web site."
- Depth of coverage. "We have much more than what you see on the Web site. We have back up of a thousand images to provide you with the variations and alternate images you need."
- Digital know-how. "We have the ability to create digital photo illustrations to your specifications."
- Light box capability. "We can create a convenient, easy-to-use light box of photo selections for your approval. We can send selections via email or we are happy to post a photo selection to your FTP site; we maintain our own FTP site for your convenience in viewing."

- Detailed captioning. "We provide in-depth information about all photographs."
- Fresh material constantly updated. "We are shooting constantly to update our files. Please ask for any topics you don't see on the Web site, because new material is added on a regular basis."

Experience

A list of clients indicates that you have experience (even pro bono) and that your stock photography has been selected for publication. You can include assignment clients as well as stock sales.

Collection Catalog

A brief list of stock photography categories shows the extent of your stock collection. You get the idea. Know what you can offer and make that clear to the photo buyer.

Design

After preparation of your written notes, a next step, and one of the most pleasant, is to develop a visual identity for yourself.

First, a word about the importance of design quality in your materials: use a professional to be a professional. Don't shortchange your Web site or marketing materials by using mediocre or unprofessional design help (including yourself, unless you've been trained in graphic design). If your budget is tight, you can sometimes trade services or get a lower fee from a graphic arts colleague. Your marketing materials will represent you to the world of stock buyers, so why do anything less than a professional job? You probably resent the idea of amateurs setting themselves up as photographers. Then don't let yourself be an amateur designer. Have respect for the abilities of other professionals by understanding that you need their expertise. You are putting precious time and money into your marketing, so skimping on the design is worse than foolhardy—it's self-defeating.

I hate to use this preaching tone, but it's a heartfelt belief that your stock photography deserves the best showcase, and using professional design is the route to that end. You can have strong input into the graphic statement that accompanies your photography, but let the designer translate it from your ideas to reality.

Research what's being done. Before you go to a design professional, do an exploration. Review Web sites and all the print materials you can so you identify the approach that appeals to you. The trade newspapers, such as *Photo District News (PDN)*, have regular articles about photographers' self-promotion; you can see the trends in those materials. Take a look at the various vehicles that advertise to the photo buyers. For example, check the ASPP magazine to see the ads from stock photography sources, including individual stock photographers.

Design begins at the earliest stage by simply choosing the color and type face you use for your name on letterhead, business cards, and mailing labels. Then you

move on to designing a logo and establishing a color scheme for the Web site and all marketing materials.

DEVELOP MARKETING MATERIALS

All of your marketing efforts and materials should be integrated to reinforce the message of the excellence of your stock photography, the depth of your photographic collection, and the range of services offered. There are a variety of materials and vehicles for carrying out your marketing plan.

Though electronic marketing is certainly the vehicle of choice, certain print materials such as postcards, posters, brochures, and press releases can still be useful. Basic marketing tools include:

- Web site/blog
- Portfolio
- Electronic or Internet marketing
- Promotional print materials (ads, postcards, public relations press releases, stock collection category list)
- Gift reminders

Web Sites

A Web presence is an obligatory part of your marketing plan. It pulls together all aspects of what you want a client to know about you. There are technical and pragmatic considerations. Web designers will help with the technical side, but you must hold on to the reins of content and presentation. You are the visual person and can best understand how you want your work to appear and judge how the client wants to see it. Though the word "design" is part of a Web designer's title, some of them are less graphic and more electronic experts. Be cautious about relinquishing your influence. As I said above, that's why you want a graphic designer as part of your team.

Web Site Design

There are several components to designing a good Web site. To get a feeling for the style you like, first research as many Web sites as you can of professionals in your field to see which appeal to you. It's helpful to have a client's view on Web site preferences. As soon as you have done some work with clients, pick their brains. Ask what they like and don't like about sites: what attracts them, brings them in, keeps them looking, and also what frustrates them or turns them off. Most of this is common sense. The following are things I've heard from clients and what I've experienced. A good Web site has:

- Good organization and a structure that makes sense. It should be easy to figure out where to go and how to go back. Make sure that lettering and prompts are clear enough to see. There are Web sites where the "go back" arrow is in such a subtle color

that it is all but invisible—very elegant but a pain in the neck. As a tech person might phrase it: the interface should be clear and simple.

- Speed. There is nothing more frustrating than a Web site that is sluggish in loading images and text. So many Web sites are lightning fast that if yours isn't, a client probably won't stick around to see your work. The goal is to have pages that load instantly.
- High-quality pictures. As with all portfolio presentations, put only your best work on your site. You can include tear sheets with magazine covers, book covers, or ad pages to show published work. The lack of good design or bad printing won't be as detrimental as it is in a physical portfolio. Plus the original of the published image can be displayed along with the tear sheet.
- Coverage. Make sure that you have enough depth of coverage in a topic. Follow the homepage photos with a gallery that shows additional images.
- Clarity. Written information on a Web site should be brief, to the point, and add to the visuals.
- Web sites can include:
 - Contact information
 - Client list
 - Client testimonials
 - A vision statement from the photographer or picture professional (be brief)
 - A biography (different from the vision statement) with background, experience with any special skills, pilot license, languages, etc.

Give your prospective client easy access to your information. Don't make them have to stop and look up anything. All information should be at their fingertips. All your emails should have a footer with your contact information in full, including a link to your Web site.

Web Sites and the Blog

As you conceptualize your Web site, realize that once you have one (presumably functional and very attractive), you may want to go a few steps further and incorporate a blog. It's become fairly common to find photographers using blogs in addition to their Web sites to allow interaction with the buyers. For more on blogs, see the box "Tips from The Experts" by Ethan G. Salwen in this chapter.

TIPS FROM THE EXPERTS: ETHAN G. SALWEN

Marketing Success in the Blogosphere

Fuse the words "Web" and "log" and you get "blog," the latest phenomenon to sweep the Web. Using incredibly simple (often free) online blogging applications, anyone with Internet access can publish any combination of text and photographs for a worldwide audience. These customizable, dynamic, journal-styled blogs often focus on the blogger's personal experiences. However, blogs can also be used to promote a business, directly and indirectly. And blogs are particularly well suited for stock photographers seeking to regularly share fresh content, market aspects of services and collections, and increase interaction with current and potential clients.

Stock photographers can link their blogs to their main Web sites and vice versa, thereby easily creating a much richer, more dynamic Web presence. Blogs can also include direct links to stand-alone photo galleries. These galleries are excellent for sharing interesting, marketable images that might not be appropriate for your more polished main Web site, which is likely to include only the best of the best of your images.

By their nature, blogs are very personal. And the key to successfully marketing images and services with blogs is to share engaging and relevant personal information with your established clients, future business prospects, as well as friends and family, but in a way that paints a picture of your image collection, expertise, professionalism, and skill set. The best blogs come across as casual and relaxed, yet it can take a lot of work to achieve a casual but polished feel.

To use blogs to increase stock sales, photographers will need to keep their overall marketing and business goals in mind while blogging. However, blogs are also about freedom, and they shouldn't be overthought or seen as a chore. If approached properly, blogs offer you a fun, quick, cheap, and incredibly effective way to market your stock images. And a few simple concepts and strategies will best keep your blogging efforts on track.

Stock Photography Blogging in Action

How an individual stock photographer successfully employs blogging for self-promotion is only limited by that photographer's imagination. One photographer might choose to simply add a quick posting every couple weeks; another photographer might blog daily, providing readers with

insights into intriguing aspects of her image-making process. However, the following example offers insight into one potentially successful way to approach blogging.

After returning from a weeklong stock shoot in Peru, you post a blog about your experiences. You keep the stories fun, engaging, and informative, and focus on sharing your experiences with friends, families, and fans. But you also keep stock buyers in mind, being sure to mention the locations you visited, but not pushing the point. (Blogging is all about the soft sell.) With your posting, you include two to five images (which can be personal and not a regular part of your image collection) with great captions. That's it!

Because blogging is so easy, you can upload this posting before you have even begun to process, keyword, and archive the bulk of the images from your trip. Without even saying it explicitly, potential buyers will know that you have a collection of images from Peru. They will also get a feel of your personality, which plays a critical role in establishing and maintaining business contacts. If you want to take it a step further, you can add a "See more pictures from Peru" link within the posting, which can direct viewers to a gallery that you generated quickly from your asset-management software. (You can even add this link to the post weeks or months later if you don't have time to do it before you fly off to Guatemala.)

This posting can serve your soft-sell efforts well into the future. For example, imagine that a year down the road you are fulfilling an image request for a lama walking the ancient streets of Cusco, Peru. Thanks to your blog, in your email to the buyer, you will be a position to send a link to your Peru blog posting inviting them to have a look. This is an easy way to potentially draw this buyer into the world of your images and services. This soft-sell marketing technique could have tremendous payoffs in the long run, even if you don't make the sale of your great lama shot. (Turned out those finicky editors really wanted an image of an *alpaca* walking those ancient streets.)

Tips for Power Blogging

Plan your blog before you begin. Blogs are incredibly easy to start and maintain. And one of the joys of blogging is the pleasure of finding one's blogging voice over time. However, unlike those blogging only for fun, professionals need to plan carefully (if quickly) to ensure their blogs best serve their marketing initiatives. It's a good idea to even write a simple planning document that outlines your marketing objectives, audience, editorial focus, intended content and publishing schedule. This will greatly focus your blogging efforts.

Familiarize yourself with the blogosphere. Review a wide range of blogs over at least a couple weeks before you launch your own. What draws you in? What turns you off? By the time you have digested a few dozen blogs, you will have a much better sense of what you want to emulate.

Add new content regularly. There is nothing worse in the Blogoshere than encountering a dead blog—one that has not been updated for many months. (Your most recent blog posting will always be the home page of your blog.) So before you begin blogging, make sure you are committed to adding content on a regular basis. Pace yourself. Don't start out too fast and then fall off. Take it easy and be consistent.

Focus on the text. Ironically, professional photographers are possibly the last people who should start photologs (blog postings with images only). Photographers already have main Web sites with image galleries to serve that purpose. More importantly, quality writing is essential in a blog geared to market a photographer's services. At the same time, you should need to be very realistic about your own writing skills. If you are a weak writer, limit your writing to a few sentences that describe your images or photographic process.

Keep your client audience in mind. Even if your blog efforts are mainly geared for family, friends, or just personal satisfaction, keep your most critical clients in mind. This will ensure that the imagery and text you post— even on personal topics—represent you in the best professional light.

Get personal, but not too personal. Your blog offers clients a chance to learn far more about you than they ever could from your main Web site. So blog with sincerity and feel free to share personal musings. At the same time, think "business casual" and not "nudist colony." You don't want to turn anyone off. (Yes, the Web and blogging are about liberty and censor-free communication, but you can start other blogs to share photographs and ideas that, if included in your professional blog, could potentially hurt your business.)

Promote your blog. Send an email announcement to appropriate clients when you post particularly interesting or pertinent content. You should also add a link to your blog from your main Web site, as well as to your email signature and your business card.

Seek feedback. There are a number of interesting (often free) tracking applications that will allow you to monitor traffic to your blog. And you should employ one of these. However, such statistics will not be nearly as helpful to you as seeking out critical, honest feedback from

discerning friends and professionals who understand the soft-sell marking goals of your blog.

This information was adapted from an article that first appeared in the Year End 2006 issue of the *ASMP Bulletin*, the magazine of the American Society of Media Photographers. See chapter 3 for a biography of Ethan G. Salwen.

WEB SITE PAGES

Here are some samples of the page title tabs you might find on different photography Web sites. Consider what list would work best for your business:

Sample A
- Home (including copyright protection language)
- Gallery of Visuals
- About Us
- Contact (includes email photo request form)
- Special Features:
 -Photo of The Month
 -Working Projects
 -Anticipated Travel

Sample B
- Home (including copyright protection language)
- Stock Specialties: Architectural, Commercial, Digital Imaging, Lifestyles, Medical, Travel
- About Us
- Links and Clients
- Special Events

Sample C
- Home (including copyright protection language)
- Portfolio
- Commissions
- Fine Art
- Bio
- Clients

You'll find sample wording for copyright protection in chapter 14.

Portfolio

You can adapt the concept of a portfolio from assignment photography. When you prepare a presentation of your stock photographs, you should design it partly as if it's a portfolio as good as what you'd use to show potential assignment clients, only this portfolio will be promoting your stock collection. The premise is that a portfolio is carefully edited with only your finest work. Some photographers think that a stock presentation can be simply a collection of images shown in a pragmatic way. They do not see it being as elegantly presented as a portfolio. That's the wrong approach. The purpose of a portfolio is to show what you can do, what you have done, and what you plan to do more of, as well as the power of your images.

Traditionally, a portfolio was a physical presentation including various formats such as prints and transparencies. Today, the presentation of a physical portfolio is rare in stock because virtually all dealings are in digital form. But a portfolio serves the same purpose as always: getting you and your abilities in front of a buyer and convincing that buyer to use your stock. The concept of a portfolio is translated into an electronic presentation.

Some basic factors apply to all portfolios.

- Show only your best work—be brutal, have a colleague, or better, a marketing coordinator, review it. Don't include lesser photos because it's "just stock."
- Don't show material you can't back up. If you have a category in your stock listings, make sure there is enough to show when a client asks to see more, otherwise, you will have muffed an opportunity.
- Show as much published work as you can to indicate that you have experience. Whether small local assignments or pro-bono work, if it's been published, someone liked your work enough to use it and a prospective client will find that significant.

Because just getting a client to look at your stock Web site is a significant accomplishment, make sure the portfolio or gallery section (whatever you call the place where the stock photo collection is highlighted) has the impact to make a great impression and that it tells something about you. Photo buyers will generally concentrate on images in your presentation rather than on the written materials. However once they've been grabbed by the images, they will then see and respond (even if it's subliminal) to intelligently written information. It will reinforce their confidence in you as a professional.

All of the information in this chapter should be integrated to appear as part of your overall marketing strategy on all pieces, promotion cards, ads, and Web site. You never want to miss the opportunity to reinforce your message.

Internet marketing includes more than just your Web site. You can also send mini-portfolios or mini-stock submissions in PDF format. The latter can also be delivered on a CD.

Promotional Print Materials

The standard print materials still have use as an adjunct to your electronic marketing. Some print materials to consider are ads, postcards, and public-relations press releases.

A very brief written piece could indicate the special skills, including digital expertise, language fluency, and special logistical experience setting up stock shoots, that you offer through your stock photography company. This can be used as part of a mailing.

You'll see all of these approaches detailed with step-by-step guidance in the recommended marketing-reference book mentioned below.

Promotional Gifts

Sending clients follow-up reminders in the form of a gift to show that you are "still out there" can be very effective in getting and keeping their attention. These items are less of a sales pitch and more just a, "Thank you for past business" or a, "Remember we're here if you need us" to jog the client's memory. You can also send promotional gifts to introduce yourself to a new client. They include a variety of interesting, eye-catching, or charming reminders of you and your services. Use your imagination to come up with your own ideas. Here are a few gimmicks that are reasonably priced and fun:

- Bags of M&M's (with your business name or logo imprinted)
- Post-it notes (with your business name or logo imprinted)
- Mouse pads (with your business name or logo imprinted)
- Snow domes (with your business name or logo imprinted)
- Lens-cleaner fabric. It comes in a tiny, soft bag and has a clip to attach to your camera strap. The bag can be imprinted with your name.

Decide which marketing tools you should (or can afford to) use now and which will be planned for later in your career. Most photographers concentrate on electronic marketing with some reinforcement from traditional print materials.

RESEARCH TOOLS

Help is available. There are a number useful books to give you an in-depth look at how to market photography. If you can only choose one, make it Maria Piscopo's *The Photographer's Guide to Marketing and Self-Promotion,* 3rd edition, from Allworth Press. She also has companion books, which you can find on the Allworth Web site, *www.allworth.com.*

Maria explains in great detail how to build a marketing plan from soup to nuts. The book covers self-promotion, advertising, direct marketing, public relations, and the Internet, as well as promotion pieces, portfolios, researching and winning clients, negotiating rates, and finding and working with reps. It's eminently usable, informative, and full of sage advice.

Also very helpful is the *Photographer's Market,* published by Writers Digest Press, which comes out annually. It lists specific buyers and how to approach them, a glossary of industry terms, and a wealth of other research information.

MARKETING CONSULTANTS

Reading the books on marketing is a great help, but if you are still uneasy about applying the principles to your own work, consider using a consultant. Because of the psychological pitfalls that beset creative people in their marketing efforts, getting marketing consultation might be the best move you ever make. Keep reading. Before you exclaim, "I can barely pay the costs of my stock shoots, and now I'm hearing advice about spending money on consultants!" just consider for a moment that you can't be an expert in everything.

The early stage in your stock photography business might be the best time to get a boost by seeking specific marketing advice tailored to your talents and goals. There are many ways to approach this, and not all of them will break the bank. Look for opportunities for less-expensive marketing advice. For example, if you take a photographic workshop, an added bonus will be access to portfolio reviews from established professionals. There are seminars and workshops conducted across the country by Maria Piscopo and other marketing professionals. You'll find a variety of marketing seminars at industry events such as Photo Expo, held each autumn in New York or on the West Coast. Also, if you develop a mentoring relationship with a working photographer who specializes in stock, he or she can offer tips on developing a marketing plan.

UNDERSTAND THE PHOTO MARKETS

Distinguish between the process of marketing and the markets you are trying to reach. What markets do you want to contact? Based on your analysis of your work (chapter 2), match the style of your stock with the potential markets you've identified in order to decide which ones to approach. Then go after them one at a time.

"Market" in stock photography terms refers to the type of intended use, not the topic or style of photography. What is the intended usage and who is the user? Who pays the reproduction fee and how will the photograph be reproduced? Will it be used to advertise a product or service, to promote a corporation, to illustrate written material in a magazine, or to embellish a calendar?

Travel photography can be used in any of these ways, for example. The same twilight scene of Singapore could advertise an airline, be used in an electronics company's annual report, appear in a magazine article about the Pacific Rim, or represent the month of September in a calendar. Other types of photography have amazingly flexible uses as well. Imagine all the different ways a cozy family scene could be used: in a bank advertisement, in a corporate brochure for a manufacturer of heating units, or in a magazine article about the stability of the family. The list is long.

The following are the major markets for stock photography and their require-ments. In looking at these markets, we'll consider the fee ranges, competition, and releases, as well as mention the likely contact in each market.

Advertising

Advertising is considered the highest-paying market as well as the most demand-ing market for stock photographs.

Fees: High to moderate. Sales will range from many thousands of dollars for an ad on the back cover of a national consumer magazine down to $400 or $500 for a quarter-page ad in a low-circulation trade magazine.

Competition: Fierce.

Releases: Essential. To sell in this market you must have releases for everyone in a photograph and for certain recognizable property. The neighbor's dog you photographed on the steps of a Victorian house provide a charming scene, but the resulting photo needs releases for both the dog and the house. The main reason for this, without worrying about the legal issues here, is that any ad agency buying stock will insist on such a release. (See more on releases in chapter 15.)

Contact: Most often your contact is the photo buyer of an advertising agency acting on behalf of its client. That client is usually a company offering a service or manufacturing a product, but can also be a governmental department or a utility. So the final user, your client's client, may produce dish soap, band aids, kitchen equipment, provide telephone service, or be a branch of the armed forces. That client will make the final decision on what is presented by the ad agency. A few companies have their own in-house advertising departments and might conduct their own photo research.

It is more likely that the person you deal with will be one of the following: the ad agency art director who sets the concept and makes the decision on what to put into layout for approval by the client; the ad-agency art buyer who most often does the photo research under the guidance of the art director and seldom has decision-making power, but translates the concept to the photographer or photo agency; or a photo researcher, usually freelance, hired by the art director or the art buyer for a specific project. A researcher submits photographs to his or her art director (by sending them to a selection on a light box or by use of print outs), but rarely has the ability to make decisions.

Corporate

The corporate market is an interesting and growing market. Clients who formerly assigned most photography are now using stock on a more frequent basis in annual reports, brochures, house organs (company publications for in-house use), or slide shows.

Fees: Medium-high. Annual reports are the highest paying, while PowerPoint slide shows can be extremely low. (It is imperative that slide show use be monitored and that your invoice limit be specific.) Brochures can command a wide range of fees, depending on usage, which is very much open to negotiation.
Competition: Keen.
Releases: Required. It will be especially important to let corporate clients know if the workers or factory scene in your photograph are from a competitor's facility. You may not always have to produce a copy of the release at the time of submission, but a client will want it when they are ready to license a photograph for use.
Contact: The corporate communications department or public relations office of a corporation will most often handle photography needs. You might deal with a designer in corporate communications or the corporate communications director.

Editorial

The editorial market is the broadest market and includes magazines, newspapers, trade books, textbooks, and television. Editorial usage is characterized as being informational or newsworthy. It is generally considered noncommercial usage because the photographs are not used to advertise goods or services or to promote a commercial entity.
Fees: Average to low. A potential for a high volume of sales exists in this market.
Competition: Normal.
Releases: Releases are not usually required for interior editorial use when the photo is shown in an accurate context (i.e., the caption doesn't distort the meaning) and the usage is considered to be newsworthy or to educate or inform. However, clients sometimes consider covers as a commercial use. These clients will require releases.
Contact: Any of the following might be your contact at a magazine, newspaper, or book publisher: the art director, designer, picture editor, photo department staff, or freelance photo researcher.

Advertorial

Advertorial is a hybrid market. Editorial in style and format, it is actually advertising. Most commonly used to advertise a country for tourism or business investment, advertorials are usually published as an insert to a newspaper or magazine. Though it may look like an editorial article, the word "advertisement" at the top of the page is your clue.
Fees: Buyers sometimes offer editorial rates for this usage, but most photographers negotiate for a middle range between editorial and advertising.

Competition: Normal.

Releases: Required. Remember it is advertising in sheep's clothing.

Contact: An advertising or a public relations agency.

To understand the markets for photo sales, a good exercise is to look at the materials published in all these areas. Go back to the clip file concept from chapter 2 and look at advertisements and corporate publications, as well as at magazine articles or book illustrations. Then you'll have an idea of which market to approach.

FINDING BUYERS

Mailing lists are available for sale for virtually all types of photo buyers, or you can build your own list from sources such as the *Photographer's Market*, published by Writer's Digest Books (see bibliography). Besides direct-mail promotion, there are marketing tools such as catalogs and electronic networks, which can be used to reach buyers.

Start your list of buyers to contact by pinpointing organizations and magazines that put out the kind of publications in which you would like to see your work.

Study the buyers' organizations in your area. Groups such as the art directors clubs or the American Institute of Graphic Artists (AIGA), which has chapters in thirty-three cities, often hold seminars, exhibits, and other functions at which you can meet art buyers.

There are catalog and source books, some print and some online, including The Black Book *(www.blackbook.com)* and Workbook *(www.workbook.com)* in which you can buy advertising space. These sources can lead you to buyers as well.

Some photographers market through electronic bulletin systems. As a subscriber to these services, you have access via email to photo requests from a variety of buyers.

Know the company you keep. Ask clients what success they have with these systems and the level of quality and service they receive. Above all, unless you know the client, call before submitting photographs. And do not send out unsolicited material.

REACHING BUYERS

The essence of marketing and promotion is repetition and follow-up. Keep your promotion manageable. It is better to target a small-to-medium size group of buyers and be able to contact them regularly than to hit thousands who never hear from you again.

Once your materials are prepared, contact them through email, send a mailing (800 to 1000 pieces) to carefully selected names. These names should include your assignment clients, the buyers within your area, and a limited mailing list from any of the source books you consult.

From the mailing list, select the other names, based on how well you think your work fits what they do. There are a number of sources for stock photo buyers. Here are a few:

- American Society of Picture Professionals (ASPP) (*www.aspp.com*)
- Photographers Market (*www.photographersmarket.com*)
- The Advertising Red Books (*www.redbooks.com*)

The promotional gifts mentioned earlier are a good way to catch the attention of buyers and perhaps lure them to look at your Web site. If you find a way to cut through the clutter (both electronic and print) that assaults photo buyers on a daily basis, they may pause for a moment, arrested by your ingenuity, and be curious enough to look at the Web site behind your imagination.

Use the announcement of new additions to the file to highlight a second or third mailing. Also, send an announcement of a proposed shooting trip to an unusual locale—it may generate interest in your file. Always include on printed pieces an encouragement to go to your Web site.

DEALING WITH CLIENTS

Make yourself easy to deal with. Your attitude should be as much of an asset as your photographs. Some clients tell me that they avoid contacting individual photographers for their stock because it can be more trouble than it's worth. They prefer to work with photo agencies because they receive professional service and no nonsense.

How do photographers work against themselves? Self-indulgence in some photographers may be the root of the problem. They lose sight of the buyer's requirement for quick, courteous treatment and high-quality photographs.

These days most stock-photo communication is done online. Phone conversations are not the norm, though they still happen, especially when they help clarify stock-photo needs between the photographer and the buyer. On the occasions when you can speak with a client, don't muddy the waters. Aside from being busy, stock buyers may avoid phone conversations because, instead of concentrating on solving the buyer's problem, some photographers use a photo-request call as an opportunity to unburden themselves, behaving in a variety of unappealing ways, ranging from pesky to tiresomely chatty. It sounds impossible that anyone selling a service would be that foolish, but clients assure me that it is distressingly common for photographers to become a nuisance on the phone.

To assure a good reception and repeat requests from buyers, follow these guidelines:

- *Speed.* Respond with your submission as quickly as possible
- *Dependability.* Do what you promise. Follow through with the photographs on the time schedule you discussed
- *Quality.* It's expected that the image on your Web site will be excellent. Make sure that any additional photographs that you post for a submission are equally good. Do a tight edit for quality. Send only the very best. If it's not on the mark, don't send it. I've heard

photographers say, "I'll just send them a lot of stuff and they can weed out what they don't want." Now tell me, why would a buyer want to wade through a messy or mediocre submission? The greatest compliment you can hear from a buyer is, "Well, I know one thing, if you have it, it'll be good. You never send me anything mediocre." A client soon learns to depend on the high level of quality they can expect from you.

- *Variety.* High-quality variations on the original request ideas are almost always welcome. Query the buyer by email or phone. See if your suggestions fit their concept.
- *Organize.* The submission should be organized to match the request as closely as possible. Use the client's spec number or concept name.
- *Courtesy.* In addition to being pleasant, be helpful. If you don't have right photographs to fill a request, email back with a quick note indicating that you cannot fill their list and you hope you can help them with their next request. Then suggest other sources for material you can't offer, such as from the collection of a photographer friend or a catalog you've seen. This doesn't increase the competition—they would fill that request anyway. You emerge as a considerate professional.

Finally, distinguish yourself as a professional. That is the key to good marketing. If your promotional materials are of a high quality, if you make consistent contact, and if you provide courteous, quality service, you will have a greater likelihood of repeat business. In addition, you will build a stronger bargaining position. When it's time to take care of your needs—a good price and respect for your work—the groundwork will have been done.

TIPS FROM THE EXPERTS: MARIA PISCOPO

It's my strongly held belief that someone starting out as a photographer or a picture professional should understand all the marketing tools available to them, even if they aren't in a position to use them yet. For example, I might not recommend buying a two-page spread in a national advertising source book when someone is just starting out—that's their entire marketing budget. But they should know what it is, where it is, and how much it costs. They want to highlight their background, experience, and get their name in front of people through the various marketing tools, such as source books and Web sites.

There is no reason for an entry-level person to avoid the groundwork of mapping out a Web site, even if they have no money. Mapping out a direct-mail campaign can be done without having to design, produce, and print it right now. Just find a concept. What's the "big" idea for your campaign? All of this should be started even while you're in school.

213

On the Basic Divisions in Marketing

I explain to my students that there is a strong division between two types of marketing tools: The first type is the non-personal marketing approach like ads, direct mail, and Web sites, which touch the potential client without your being there. Then there are personal marketing tools, which include phone calls, portfolios, and interviews.

Non-personal is the most visible, but at an early stage in your career, you may not have as much material to show in visual form. So the first thing I do is emphasize personal marketing. At this early stage, you must try any means you can to meet a prospective client. Cold calls can sometime yield results, but I prefer to use really targeted research and work out client-oriented "scripts" of what and when to ask. Another approach is working on pro-bono projects or attending organization meetings where clients are speaking. Use whatever initiative you have to get near a client.

On When to Market

The creative professional is always in a marketing mode. Sometimes it's set on very low because when you are working on a stock project, you can't be out there calling people right in the middle of a shoot. But that would be a good time to have a direct-mail campaign going. Sometimes the flame is turned up. When there's no stock project underway, that's when you turn your marketing up to high. Just don't let the pilot light go out. I've seen photographers in business twenty years who let the pilot light go out. It's very hard to restart.

The idea of marketing mix means it's not about full-out calling people forty hours a week or nothing at all. There is an in-between. If you wait until there is a slow time in your stock business, then you can be tainted by a desperation mode, and clients smell it. If you have something on-going, they see that it's part of the continuum.

On Getting Experience to Show in a Portfolio

In an interesting reversal, the old-fashioned way to get experience seems to be in high gear right now. Entry-level people in all disciplines are doing community service. Pro-bono projects all around the country are actually quite sought after, not just by entry level but by the working professional as well. It's a place to show off your creativity, it's for charity, and the client is paying production costs. You donate services, get great tear sheets, and are making good contacts with high-level people. The invaluable part is that an entry-level person can experience a real job with a real budget, real production specs, and a real

deadline. Finally, you are working with real clients who can give you real testimonials.

The old method of "give it away, to get it back" in today's economy becomes a ten-fold return now because they can make great contacts. Pro-bono can be a great way to show your stuff and prove your worth.

Bio: Maria Piscopo is a photographer's representative, marketing workshop speaker, and author based in Costa Mesa, CA. She is recognized and highly regarded spokesperson on marketing trends.

www.mpiscopo.com

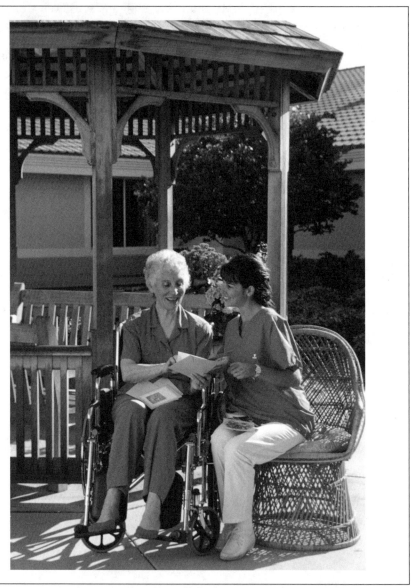

Geriatric health care. Sarasota, Florida

Finding a Stock Agency or Portal

The path to finding an agency is research, research, and more research—plus a large dose of perseverance and luck. There are occasional matches made in heaven when a photographer and the perfect agency for his or her work find each other on the first try, but this is rare. It is currently much more difficult to find agency representation than it was five or ten years ago, a trend that will be discussed later in this chapter. It's not a futile exercise to look into agency representation—after all, as some state lottery ads express the concept: you've got to be in it, to win it! If you're not actively looking for an agency, then, of course, you'll never find one. So don't give up before you start.

And even if finding an agency proves difficult, it is very useful to know how they function and what they have to offer. Then you can make the decision whether or not to pursue that course. It's worth the effort on another count: if you end up handling your own stock marketing, the stock agencies become your competition. You will want to understand the services they offer so you can equal or better them as much as possible. So the more you understand about your competition, the better.

Start by exploring all possibilities: understand the function of a stock agency, assess what you have to offer, and search until you see if there is a good match out there for you. Then, later in this chapter, you can look at the alternative to a traditional stock agency, the portals, for marketing your work.

HOW DOES A STOCK AGENCY WORK?

A stock photo agency is a marketing arm for photographers and a photo source to buyers. An agency provides buyers with quick access to a wide variety of excellent images. For most photographers, agencies can open markets far beyond the scope of what might be achieved by individuals. Agencies license rights to photographs on your behalf, and you provide the photographs that keep them in business. You are partners.

A stock agency functions much as you do when marketing your own work, but on bigger scale. (For a brief overview of an agency, see the box "Stock Agency Functions.")

Photo Requests

An agency maintains a digital archive of photographs on its Web site and fills photo requests from buyers. That is the agency's crucial function. It's done in two basic ways. One approach is a buyer coming to a stock agency Web site: she has the option to search the entire database of photos. This method of searching the files cold by entering keywords for a topic can be useful for an experienced photo researcher who is skillful at using keywords or who wants to see all available images on that topic. But for other clients, it can be a nightmare trying to navigate through the almost impenetrable forest of photos that come up from a simple set of keywords.

On a recent excursion to the Web site of a major photo agency, I searched "snowboarding." In the editorial part of the site, 5,323 photos were offered. Searching the same keyword on the commercial/creative side of the site, there were 2,223 images. You can see that a researcher might need to use more specific keywords ("snowboarding action" or "snowboarding night") to narrow the search for more manageable results. However there are researchers who can skim over that many images and spot a few photos that fit their needs.

The other alternative for a photo buyer or photo researcher is to ask the stock agency to assign one of its in-house researchers to pull a selection based on the buyer's specific project, tailored to the request list. Generally, an agency person will organize the selections according to the list provided and post them on the Web site's light box. At this location, clients can review the images in thumbnail size, click to see an enlarged image, and read full caption information about the picture. They can edit and select certain images to download at low-resolution; they can also email specific images to a colleague or print out certain photographs in preparation for a photo review. This is an enormously helpful tool and service that agencies provide for their clients.

How Are You Paid?

Stock agencies negotiate the fees that accompany photographic usage. The agency will prepare invoices to buyers and provide sales reports and payment to photographers.

The agency charges whatever fee is appropriate to a client's usage—and hopefully as high a fee as they can negotiate. In the past any difference between the amount charged by an agency and what a photographer charged for the same usage was simply a matter of negotiating skills, and agencies usually did a better job. That has changed somewhat. Though in principle agencies charge as high a

fee as they can, in practice they may cut prices by offering buyers volume-discount contracts. An agency may give a price break for the number of photos purchased for one project or for a volume of images used in a calendar year. In addition, there are subscription deals where a client agrees to spend a dollar amount per year with a stock agency in return for deep discounts in photo prices. Naturally the affect on the prices is downward. A number of my photo-buyer clients maintain a list of "preferred vendors;" this list includes photo agencies with which they have negotiated contracts for discounted photo fees. The researchers for those companies are obliged to go to stock agencies that are on the preferred vendor list. Some clients even set a percentage of the number of photos in a project that must come from certain photo agencies. This practice is good for the agencies because it locks buyers in to their collection, but it lowers the per-photo price for the photographer member of that agency. It's an extremely competitive world.

The photographic reproduction fee received by a stock agency from a client is split between agency and photographer. (The exception is royalty-free photography, which was explained in chapter 9.) The percentage paid to a photographer varies with the agency. Traditionally it was 50-50, a percentage that persisted for many years. But then it slid to 60-40 in favor of the agency, and in some cases down to 65-35. Some agencies or portals have different pricing structures, especially when they work with subagencies, so check their contract to see what your percentage would be for all types of sales.

In addition, there can be fees for preparing your photos for file (such as for scanning or keywording). When considering an agency, be sure to learn all the costs associated with supplying photographs for the file. There is a recent change in the relationships at some agencies, whereby they will accept photos on a fee basis—that is, a photographer pays a specified flat amount just to have their images on file at the agency. You need to know what services that covers for the photographer or if there are additional charges for file preparation. That cost needs to be evaluated based on the amount of sales you reasonably expect through the agency. Otherwise it becomes the equivalent of vanity publishing—you've paid to have a few photos on file, but the investment may not be viable in terms of running a business. No aspect of stock is an instant bonanza. If you approach agency representation with realistic expectations, your chance for success will be greater.

Services Stock Agencies Provide the Photographer

Stock agencies provide marketing information to photographers (often via online newsletters), which can give insights into new style trends or topics needed. An agency edits photographers' submissions and prepares photographs for the Web site, conducts worldwide marketing, and develops marketing tools to show a wide range of images to the largest possible number of buyers. Some will help with keywording, but some of these services come with a price tag, as mentioned above.

Who Selects Your Photos for the Files (and How Many Do They Accept)?

A stock agency generally assigns a specific editor to a group of photographers. When you submit a batch of photographs, your editor will select which of your photos will be accepted and posted on the Web site. The criteria for selection, beyond excellent quality (which is always required), is whether the topic is needed—perhaps the agency's files are overcrowded with similar material—and whether the style is suitable to their sense of the current market needs. The editor chooses solely on whether she believes the agency can make money with your image. There are limitations to how many images an agency can display, even on the most powerful Web sites. As a result, you may find that only a few images from your shoot will be chosen. That may mean that many good variations are left in your file, unseen, unsung. What do you do with those excellent variations?

Exclusivity

Many stock agencies in the past insisted on putting photographers under exclusive contracts. The argument for exclusivity from an agency standpoint was simple: it wanted to be free to negotiate deals for you worldwide without conflict. For example, if an advertising agency were offering a high fee for a two-year exclusive usage on one of your pictures and you have that picture with three different stock agencies, no one can guarantee the exclusivity, and you (as well as agencies) are out of luck. It still holds true that for specific individual photos an agency may require exclusivity, but the agency will probably allow you to market additional photos (though not ones substantially similar to the "exclusives") through other means.

Part of the reason an agency maintained exclusivity was that it shared valuable marketing research with photographers. The agency didn't want you giving the fruits of that research to their competitors. Also, having an exclusive contract with a major stock photo agency used to be sought after by many photographers. The thinking was that by having all your work with one agency, it would be possible to streamline your operation by putting all your energy and creativity in the hands of one company. This no longer holds true. Exclusive contracts are less desirable due to the difficulty, mentioned above, of having an agency select a large enough representation of your photographs to do justice to the breadth of your collection. In addition, fewer agencies are offering exclusive contracts.

Today, it's considered wise for a photographer to spread his or her photography to a number of agencies, if possible, by using both major agencies and selected smaller specialty agencies, as well as by using portals and doing in-house marketing. There is a patchwork quilt of ways to present your stock to the buyer. Design one that suits your temperament and style.

FINDING AN AGENCY

There are a number of methods for finding stock agencies. Trade organizations (see Appendix 2), photographer friends or colleagues, assignment clients, and by reading photo credits are a few of your resources for tracking them down.

An excellent source of information on stock agencies is the Picture Archive Council of America (PACA), *www.pacaoffice.org*. It publishes a directory of member agencies on its Web site, including their specialties. A listing of agencies is found also in *Photographer's Market*.

Talk to photographer friends and stock photography colleagues. If you don't have many photographer friends, this is when participation in organizations like ASMP, APA, or ASPP is such a boon. You can get to know members at meetings or seminars, particularly those on the topic of stock. See if you can learn their views on agencies. Ask about how open specific agencies are to new photographers and what their contract provisions are. What are the fees for various services? As marketing practices change, new contractual issues may emerge. It is necessary to know the contractual ramifications of being included in your agency's catalog or electronic marketing tools? Contact with professional organizations will keep you informed about the latest concerns.

Next, speak to your assignment photography clients. Find out how much they use stock photography and what photo agencies they use most often. If they show any hesitation, ask for the first three or four they would think of calling. Then find out why. You should hear "quality, speed of service, dependability," but if the client responds with, "We have a contract for really cheap prices," you have learned something important. It may not mean the agency is ruled out because the discount contracts are ubiquitous. Instead, follow up with questions about quality and service they get from these agencies.

Finally, look at photo credits in editorial usage to see which agencies appear regularly. This will give you a good view of the landscape of photo agencies.

WHERE TO LOOK FOR AN AGENCY

- Source books
- Photographer friends/colleagues
- Assignment clients
- Photo credits

How to Approach an Agency

First, narrow the list. Based on what you've learned visiting Web sites, match yourself with an agency. Be realistic about what you have to offer. Generally you'll need a few years of professional experience under your belt to have value to an agency. But that doesn't mean waiting to organize stock.

Think stock, shoot stock and then when you have an impressive collection, make an approach.

Generally an agency's Web site will list the way the agency wants to be approached and will give specific submission guidelines describing exactly how it wants photographers to make contact and submit work for consideration. Many have stringent technical guidelines for digital files, the level of retouching required, caption and model release requirements, and, in some cases, the brands and models of digital cameras they approve. For example, to see the image submission requirements for Getty Images, go to *www.gettyimages.com.* Once on the Web site, go to "About Us," "Contributors," then go to "Getty Images Contributors" and click on the "Work with us" box. You can do a similar research at Corbis (*www.corbis.com*), or any of the agencies you want to approach.

If you start a relationship in a professional manner, it has a much better chance of success. Follow the agency's guidelines to the letter. Include electronic and printed samples, biographical information, and let the agency know the areas of photography you are interested in pursuing. An agency that has openings for new photographers is as interested in the person, the brain behind the camera, as they are in the photographs they see.

Selling Yourself to an Agency

It may not seem as important as marketing your images, but you have to market yourself when you approach an agency. It's a business and an agency has to know what you can do for them. So, what do you have to offer that's valuable to an agency? Agencies want excellent photographs, a commitment to producing new work, and a wonderful attitude, in that order. You have a hurdle to overcome given the difficulty in gaining representation in an agency. Keep that in mind as you prepare yourself and your materials to give the most impressive presentation you can muster.

SUBMITTING TO AN AGENCY

Show your professionalism to an agency by presenting samples of your work tightly edited but including verticals and horizontals as well as wide and closer viewpoints. Show that you understand the importance of covering a concept in depth to provide broad depth of coverage.

These photos of orthopedic surgeons would have three to four times this many variations in an actual submission. I shot the scene with both doctors working on each of the two children, which gave an ethnic and gender balance in four combinations. The male doctor was a model, the woman doctor was (in a stroke of luck) an actual orthopedic surgeon.

Medical Lightbox

Medical_a06-036

Medical_b06-034

Medical_c06-035

Medical_d06-027

Medical_e06-033

Medical_f06-032

Medical_g06-030

Medical_h06-031

Medical_i06-026

Stock Portfolio

Just as you create a portfolio to present to clients for assignment work or when marketing yourself directly to potential clients, you'll need a portfolio to show to a prospective stock agency. If you plan to market your own work, the same process applies—you will create a portfolio that forms the basis for your Web site. When preparing any type of portfolio, look for a balance: a harmonious relationship between salability and fine photography. Choose the stock concepts that most appeal to you and give them the same care as you would give your portfolio samples or an assignment from your most demanding client. You can prepare a stock portfolio for display on your Web site or prepare a first selection to send in a PDF format or on a DVD to an agency.

When presenting photographs, follow the agency guidelines for submission, but within those guidelines let them see how you think photographically. When organizing a sample submission, arrange the photos to indicate that you have depth of coverage. For each topic or concept, show six to eight variations, including horizontals and verticals, close-ups, and wide shots. This shows an agency that you understand the variety they need. Your presentation to the agency should be a very tight edit. You may prepare PDF presentations of your stock portfolio or arrange a gallery portfolio on your Web site. Whichever method you choose, include only your highest-quality photographs or there won't be a second round of talks.

CONCLUDING A DEAL

Once you've gotten to the deal-making stage and the agency has accepted some of your work, the next step is the contract offer. Read the contract carefully. Decide if there are any provisions you find difficult to live with (consult other photographers). Next, have the contract reviewed by a lawyer who is knowledgeable in photographic matters. If you need a lawyer, organizations such as ASMP, APA, and ASPP may be able to refer you to someone in your region. You and your work may be tied up by this contract for a considerable time. Be aware of what it means. As mentioned above, exclusive contracts are no longer the norm, but scrutinize any contract to see what limitations are placed on your images that are accepted for representation.

PLAN FOR THE LONG TERM

When you are accepted by an agency, commit yourself wholeheartedly. Contribute photographs regularly, listen to agency advice, and shoot what you do best within its requests. It will probably take two to three years to have a clear view of how well you and the agency are doing with your work. Stock is a game

of numbers and time. The more pictures you have on file (that are well-edited by an agency that knows its market), the greater your chances for sales over the long term.

A fruitful agency relationship frees you from some of the marketing burden involved in selling pictures, can increase your income from stock, and, just as importantly, creates a partnership in which professional colleagues share in the excitement and rewards of producing and marketing excellent photographic work. This relationship may exist with a number of stock agencies or portals. Keep the same professional approach with all of them.

FINDING REPRESENTATION

Can you get into an agency? How difficult is it to gain representation? Though it's much more difficult these days to get representation in a traditional stock agency, it is possible. Every agency is on the lookout for the next new talent, the next fresh eye. Familiar styles and images become over-used so fast that an excellent photographer with a fresh approach has a shot at getting into an agency. Just understand the challenges and go armed with perseverance. New faces and new visions will always be needed.

As you go through the process, remember that your search may lead you to believe you'd rather handle the business yourself.

While it's much harder to get into an agency, getting in has considerable value. The good part is that, if they accept you, your chances of making money improve. An agency thinks you can make money or it wouldn't (and couldn't afford to) take you on. The corollary is that agencies want photographers who are constantly producing new work. A successful agency needs a supplier who supplies.

The openings in an agency are few and far between, but if you can demonstrate to an agency that you have and will continue to produce actively and that you can reflect the most current style changes, you may win out over other photographers being considered. Your portfolio may sell them on not just your talent but also your ability to cover topics in depth.

An agency wants you to be producing income for them and that's exactly what you want. You don't want to have pictures lingering in the back of their files, never to see the light of day—or never to see the light of the Web site—any more than they do.

OTHER OPTIONS: THE PORTAL

There is an optimistic glow on the horizon. Just as some opportunities narrow down, along come ingenious photographers and marketing experts to create the portal, a new method for selling stock.

As you saw in chapter 9, portals are Web-based marketing entities. A portal acts as a gateway to image providers, offering access to a large group of individual photographers or sub-agencies in one location. Portals provide photo buyers with an alternative to mega-agency Web sites, giving them the hope of finding fresh photography. Coming just at the time when traditional agencies are less open to new photographers, portals provide a ray of sunshine for individual stock photographers. For them, flexibility is the great asset of portals. You can mix and match one or more portals to fit your work and marketing goals. Because portals differ in the services they offer and the requirements for photographers, you need to understand the functions of portals and research a variety of them before making a decision.

Functions of a Portal

Hands-on or hands-off? That's the spectrum of function control offered by portals. Some portals are so hands-off that they do little more than post your photos and refer a buyer directly so you can manage the rest of the transaction. This is ideal if you are a control maven. Other portals pick up the reins and handle the majority of the tasks in a stock sale, freeing you from the burden of, for example, creating light boxes to display images or negotiating fees.

Match their functions with your needs; that's a simple but necessary first step. Consider the relationship between your own Web marketing plan and what a portal or several portals can offer you. Be scrupulously honest with yourself in assessing your strengths and weaknesses. Are you tech-savvy enough, or willing to make the effort, to provide through your own Web site the functions a portal can offer? For example, if you don't have light-box capability on your Web site and are hesitant to invest the money to build it, you may want to choose a portal that offers the ability to upload your images easily to a light box for a client to view. If you like keeping control, you may want a portal that simply sends buyers to your Web site. Look over all the functions of various portals as part of your selection process.

Acceptance by a Portal

In researching portals, are you back at the starting gate facing the same dilemma as with a stock agency, wondering if you can get into a portal? Requirements for acceptance by a portal vary widely. Some portals accept almost any photographer whose work meets basic image-quality criteria and is willing to pay the fee. Other portals are just as fussy as a traditional stock agency about image content and digital excellence. Consider whether or not you prefer to be in a select group and are therefore willing to go to the extra effort of preparing your digital files for acceptance by the most scrupulous portals. Or, are you interested only in the most basic functions of having a portal refer buyers to you? You have these options and some in between, as you'll find when you go to portal Web sites.

Finding a Portal

You'll need to research portals with the same thoroughnes stock agencies. For a starting point in your research, see Portals" for the names of some current portals. A new crop monthly, so keep in touch with the trade press for Conversations with colleagues and clients may add othe careful to check the track record of a portal: you don't want a company so new it hasn't worked out the bugs or gathered a client base. Search the Web sites of photography organizations such as ASMP, ASPP, or PPA for recent articles about portals which will keep you up to date on the trends in portals and other new marketing methods.

Selecting a Portal

When you have combed the information for a number of portals, analyze their submission requirements. Use the questions posed in the "Queries to Portals" box as a checklist. Any information that's not clear on the portal's Web site should be checked with the portal directly through email or phone. At some point you should speak to a person—that gives you a sense of the portal's customer-service approach to you as a contributor and shows what you might expect once you have a relationship.

Prepare a submission—a sample portfolio—according to the requirements of your first three choices. They will probably be similar, but you'll learn how much is involved with each portal and where your effort is best spent.

With all these options—stock agencies, portals, and your own marketing efforts—work toward the right mix for your photography and experience level. Blend them together to create a rewarding way to put your stock photography in front of buyers. Good sales!

SAMPLING OF PORTALS

To gain an understanding of how portals work, go to some of these Web sites and read the submission guidelines and requirements for photographers. You'll learn the various styles and capabilities of each portal. There are many other portals, but these will give you a good overview.

age fotostock (*agefotostock.com*)
AGPix.com (*agpix.com*)
Alamy (*alamy.com*)
Eureka Images (*eurekaimages.com*)
Independent Photography Network (*ipnstock.com*)

o.com (*istockpro.com*)
connect (*photoconnect.net*)
otoexposure.com (*photoexposure.com*)
PhotoSights (*photosights.net*)
Shutter Point Photography (*shutterpoint.com*)
The PhotoSource BANK (*photosource.com/bank*)
Workbookstock (*workbookstock.com*)

QUERIES TO PORTALS

When you've narrowed the list of portals, use the questions in this box to find out the significant information about each portal. These questions were compiled by photographer and digital marketing expert Ethan Salwen (*www.ethansalwen.com*). Keep your eye out for other interesting and informative articles by Ethan Salwen in the organization and trade press.

Find out the following:
1. What is the portal's pricing structure?
2. What are the portal's image needs?
3. What types of photographers is the portal seeking?
4. Does the portal handle rights-managed or royalty-free images or both?
5. What is the submission process?
6. Can buyers hyperlink to your personal Web site and vice versa?
7. Does the portal provide e-commerce functionality?
8. Does the portal provide lightbox functionality?
9. Does the portal provide keywording? The cost?
10. Does the portal edit submissions?
11. How is keywording handled?
12. Does the portal have a dedicated help line for photographers?
13. Does the portal have strong customer support for buyers?
14. How many individual photographers do they represent? How many agencies?
15. What type of contract does the portal require? Nonexclusive, exclusive?
16. What kind and amount of traffic does the portal get?
17. How long has the portal been in business?

STOCK AGENCY FUNCTIONS

- Maintains a collection of photographs in digital form
- Maintains a Web site of these digital files for access by qualified buyers (sometimes a password is required to access certain parts of the Web site)
- Fills photo requests from buyers by posting images to a light box specifically for clients
- Negotiates fees for usage rights with buyers
- Provides high resolution files to clients for selected images
- Invoices buyers
- Provides sales reports and payment to photographers
- Provides marketing information to photographers
- Seeks a limited number of photographers with new material to complement their files
- Edits photographers' submissions
- Catalogs, assigns keywords (sometimes for a fee) to metadata and prepares photographs for archiving and presentation on the Web site based on the information sent by the photographer with the image
- May offer discount arrangement with digital labs for scanning film in a photographer's collection and for other services
- Conducts domestic and worldwide marketing
- Develops marketing tools (e.g., catalog CDs and Web sites) of photographs representing a cross section of the agency photographers
- Continues to upgrade work on the Web site light box and purchasing capabilities for easier use by buyers

Rice fields. Matsumoto, Japan

Negotiating Prices

Negotiating the price of a stock photograph is one of the most delicate and important tasks you face as a stock photographer. It may be as important as taking good photographs in terms of succeeding at this business. Frankly, most photographers are not very good at negotiating, nor do they enjoy it. This unpleasant chore may account for some of the attraction of photo agencies and some portals—they handle the negotiating and pricing.

PRICING GUIDELINES

Many photographers rely on the useful books and software available for calculating stock fees and usage (see the appendix). However, before using the pricing lists you must understand negotiating in order to make good use of those pricing tools and to understand how and when to adjust these tools. Otherwise, you can be left on thin ice when trying to quote your price. Understanding the principles instead of simply stating a price will build a stronger foundation for your business.

A stock agency and some portals will shield you from the buyer, avoiding uncomfortable or confusing confrontations about money. The agency takes the brunt of any withering remarks, such as, "You're going to charge what? We never pay anything near that amount!"

Getting off the hook on pricing is one reason to work through a portal or an agency. But if that's not an option, you will have to face up to pricing. All is not lost. The balance of this chapter is aimed at increasing your understanding of negotiating strategies for managing this part of your business.

NEGOTIATING IN AN ELECTRONIC WORLD

Negotiating relies on the process of communicating your ideas, whether through speech or in written form. In the past you might have had phone conversations with a client, whereas today the exchanges are most often (though

231

not always) through email. The phone conversations allowed for some subtle maneuvering; you could read the voice tone of a client, and you could have a back and forth discussion ending by concluding a deal. On the down side, some photographers were intimidated by discussing prices directly. Now that virtually all price discussions are in writing, how do you maintain the ability to shift and move, to explain your position, or adjust your posture?

Pricing Paragraphs

A good approach is to create a few written paragraphs to explain your position. See the "negotiating conversations" section later in this chapter. These conversations can be used for the occasional phone call but also to create written scripts to use in email exchanges. This takes the burden from having to cave in and accept a price because it's too much trouble to write down your thoughts in an email.

If you keep these paragraphs handy to insert in an email request for a price, it becomes less of a burden to state your case than if you had to write a tome for each negotiating moment.

Finally, know that there are still phone conversations that will benefit from mastering negotiating strategy. Rare but not unheard of, the personal touch is still possible.

NEGOTIATING ATTITUDES

There is such a thing as a natural negotiator. Like sprinters, they are born, not made. To them, negotiating is an exciting challenge. For the rest of us, it takes time and training to learn the art. But with practice and the right techniques, anyone can become an effective negotiator—the goal is to become the best you can be.

Most photographers dislike negotiating. When it comes to selling our own work, we are often our own worst enemies. Why? Attitudes about ourselves and our work are part of it.

Do you hold the following misconceptions about negotiating a fair price for your photographs?
- You will be perceived as tough, pushy, arrogant, nervy, unseemly, materialistic, greedy.
- You may lose this or future sales by appearing demanding.
- If you lose this sale, the buyer will never call you again.
- It's beneath the dignity of a creative person to talk money.

Fear is the underlying problem here: fear of what the buyer will think of you, what you will think about yourself, and what the buyer will do. Have courage. If you're handling your business properly, it will not founder on the loss of one stock sale. (After all, no one will repossess the refrigerator because of one stock sale lost.)

A handful of brash and unpleasant photographers have made negotiating a dirty word. But equal damage to the climate for negotiating has been done by the scores of pushover photographers who have misled buyers into believing they can dictate stock photo prices, sometimes to a level below what it costs to produce a photo. Now you may think, or a buyer might sputter, "But that's all we can afford on our budget."

I would like to put an end to the notion that it is reasonable or necessary to accept whatever you are offered—especially a bottom-of-the-barrel low price—for the use of a stock photograph. What I am saying is true for a beginner in the field just as much as it is for an established pro.

You do not have to tiptoe. You do not have to take what you get. You can state your price. You may choose to charge what the buyer has quoted. It may be a reasonable price. But you don't *have* to take it. Assess each situation on an individual basis. Everyone recognizes that there is a difference between the price an advertiser can pay for a photograph that will sell a product and what a small trade magazine with a circulation of 1,500 copies can pay. A beginner may *choose* to charge somewhat less for the experience and tear sheets that go with being published, but not because they *must* accept the lesser terms. Your mindset and perspective are determining factors in your power during a negotiation. The reality is: you charge, you don't accept. You can offer a lower price, but you aren't required to take a lower price. Look at the sample negotiating conversations later in this chapter and see how this can be handled in a subtle, diplomatic way.

But the myth persists that to arrive at a price, a photographer must either be a doormat or a hostile, demanding negotiator. To assume that arrogance is a prerequisite for negotiating shows a complete misunderstanding of the negotiating process.

To negotiate means to try to come to an agreement. It doesn't mean to engage in an argument. One dictionary definition is "to try to reach an agreement or arrangement by discussion," and another, "to get over or through (an obstacle or difficulty) successfully." There isn't even a hint of belligerence in either definition. Negotiation is an honorable and civilized method of working things out.

How has the idea of negotiating become tainted? The culprits were those few photographers who were overly aggressive, the many whose timidity made that view acceptable, and those buyers who convinced us that we would not be able to sell our work if we dared to question what they offered.

What are rarely reported are the many successful, amicable negotiations that occur every day in the photography business. These transactions are what the stock photographer should emulate. Before we try to learn the techniques that made those transactions possible, however, a bit of behavior modification is necessary. It's a process of, as the chain gang boss in *Cool Hand Luke* puts it, "getting your minds right."

To achieve a successful attitude about pricing, you need to convince yourself that:

- It is possible to explain, with dignity and courtesy, why you must charge a certain price.
- Charging a fair price for your work is a way of showing respect for your photography.
- It is fair and reasonable to charge enough to earn a living.
- It is possible to turn buyers down courteously and have them call you again.
- Buyers will respect the photographer who values his or her work.
- It is not reasonable for buyers to expect to use photographs for whatever price they have decided to pay, no matter how low.
- You are not personally responsible for the survival of the client's project.
- Perhaps a buyer shouldn't ask to use photographs if he cannot afford to pay a reasonable fee.
- A beginner's photograph isn't reproduced unless it has value to the user, and that value is worth a fair price.
- Dignity and self-confidence are not incompatible with creativity.
- A love of photography doesn't require us to subsidize everyone who asks.

I am taking a strong stand about this subject because I believe fervently that most photographers do themselves in needlessly. If you believe even half of the points above, that's progress. With my clients, I am exceedingly pleasant and accommodating. I will hold firm when they can't meet my bottom price, but in a cordial manner.

Why? Because it's a better negotiating tactic. But an even more important reason to be pleasant is that this is my world, these are my clients, the people I talk to, exchange emails with; this is how I spend many days; dealing with these people. Some have become friends. Why not make that time enjoyable? Being quarrelsome won't add any joy to the day or sell any more photographs.

NEGOTIATING TACTICS

Becoming a good negotiator takes practice, knowledge of the business (so you can educate clients), and faith in yourself. Ignorance of the market and a lack of courage (guts, gumption) is what holds most photographers back.

The goal and measure of a successful negotiation is clarity, a fair price, and a return client. You need clarity so that you avoid the confusion and misunderstanding that breeds conflict, a fair price so you can stay in business, and a return client because that's how you continue to prosper. The ideal is that both you and your client are happy with the outcome of a negotiation.

You may say, "What's to negotiate? The buyer has a price and a budget in mind, that's what they'll pay, and I can simply take it or leave it." Wrong. Every time you touch on price, it is a negotiation. The only question is whether it is successful for you. In addition, so much negotiating is done online that the subtleties of negotiating may seem arcane. But if you become ingrained with the principles of negotiating, then when the opportunity arises, you are ready.

There are four basic steps that take place in every negotiation, whether handled in ten minutes or over a period of days, and they are crucial to the process. These are:

- Establishing rapport
- Gathering information
- Quoting the price
- Closing the deal

Establishing Rapport

This is the first step in any contact with the photo buyers. Start with a friendly, welcoming tone—quite possible even in emails. Find some common ground—the weather, the holidays, events in their area of the country. Next, express your interest in their project. You may think it's obvious that you are pleased to have received their request. Not so. Say it. Make clear that you want to know more about their company, their publication, and their particular request.

If you set the right tone, they will relax, enjoy the exchange, and remember that it is a pleasure to work with you. Learn to read the mood of the client through voice inflection if on the phone or in an email through the use of language. You'll learn quite quickly which clients enjoy casual humor or candid expression and those that maintain a very businesslike decorum. Follow their lead.

Gathering Information

This next step is a critical one. Explain that price depends on usage, size, and many other factors. You must know where, how big, for how long, how many times, and for what purpose the picture will be used. Make clear that you can't quote a price without all of this information. Also, price can depend on which of your photographs they are considering—one produced under normal conditions or one involving high model fees or travel expense. Go to your Stock Request Form (chapter 14) to make sure you've asked all the pertinent questions. Use the negotiating conversations you've written.

Before continuing on this exploration of negotiating prices, be aware of the reality that there are situations where negotiating stock fees is simply not an option. That's a function of the new climate of buyer power—when there is so much competition that the buyer has more strength than ever before.

Be ready to understand that sometimes the buyers have a flat price, often dictated from high up in their corporation, and no negotiating will budge them. Then you simply make your decision on whether you to take the price or walk away (we'll discuss walking away later). But in order to decide, you need to understand the principles underlying pricing.

Occasionally it does happen that you can learn the pricing structure a client has set up. I've worked with clients on large book projects where I shot the assignment

photos but was in their offices watching as they handled the photo research tasks to complete the book. By good fortune, I became privy to their approach to research. I'd see them investigate the major agencies (i.e., the preferred vendors, the suppliers who offered volume discounts) to fill the photo list. Then, about 15 to 20 percent of the time, they'd have to look further. Then they turned to individual photographer's Web sites to see something new and different. Those were opportunities for negotiation. The clients knew that in their budget there would be room for some photos that could not fit their volume-discount parameters. That's the moment to be prepared to negotiate and impress clients with your service as well.

Quoting the Price

Prices are sometimes discussed when buyers are making the initial photo request. Other times, the topic comes up when they actually have your photographs in front of them, either under consideration or actually chosen for use—an ideal time because they are predisposed to use your images!

Buyers may email to ask your price range when they are updating their files or as the result of a promotional mailer you have sent. When this happens, I give a price range (a wide one) rather than a quotation, or I ask about their budget. I try to avoid getting locked into a hypothetical price because different photographs command different prices based on very specific usage and also on their differing production costs. This, of course, is more difficult to pull off in these days of volume-discount contracts with stock agencies because buyers have become used to having their own price list. But the reason they are coming to you may be, as illustrated earlier, that they didn't find what they needed from their volume-discount sources. (You can always point out that you will gladly offer a volume discount, but they need to offer volume!)

Quoting a price in the abstract takes away your flexibility in later negotiations. Don't worry that you are making it difficult for a client to use your work by not giving a firm price in advance. All the buyers I've worked with are confident of their ability to negotiate when they need a photograph. Also, once you have established a base of buyers, only send submissions to those buyers whom you consider to have a satisfactory price range. Weed out those who are too low or too much trouble.

Set a bottom price. It may be tempting to make a deal at all costs. However, saying, "No, thank you" and walking away with your bottom price intact is one form of successful negotiation.

Talking price can be simple and straightforward. Sometimes a buyer will state the normal fee they pay for a usage and it will be well within your own and industry standards—done, finished. Or you may receive a billing-request letter or purchase order stating the buyer's price. Again, if it is reasonable, the transaction becomes merely paperwork.

At other times, the price is less clear and you may have to take the initiative. If, after receiving the photo request, you haven't heard a mention of money, you

should open the subject, writing back that you are working on pulling images for the request, but in the meantime, "Let's talk for a moment about the reproduction fees." This is a good moment to try to reach the buyer by phone, or, failing that, to continue the discussion in writing. Usually, you will need to establish these pricing parameters only once with each new client.

That will usually bring you to one of the two most common approaches to price. The buyer writes, "What do you charge?" or the buyer says, "This is what we pay." Some photographers state a price at this point—not necessary. There is much less time for detailed negotiating at this stage with the tight schedules of many photo buyers. Too often they have their price list and you must decide if this client has enough potential for continuing business to acquiesce. However, there are some buyers who will work with a photographer and entertain a price discussion, so you need to be ready to handle those situations.

You don't always need to rush a price quotation. Are you obliged to give an immediate answer on a price? Not at all! And don't fall for the old line, "Just give me a ballpark figure." That ballpark could become your prison.

If you need time to think, get off the phone or email back that you'll give them a quote shortly. Give it ten minutes while you think, or call a photographer friend. If you don't have a clue about what a specific price should be, it's not necessary to broadcast that fact. See what you can learn about the buyer's budget before you commit yourself. Again, if you can reach him by phone, it's a bonus. Draw him out. Don't ask what he can pay. That puts you in a yes-or-no situation.

Without asking it directly, find out what the buyer has budgeted before you answer the question, "What do you charge?" Float a trial balloon. Quote a price range. (If the buyer gasps, you've learned something useful.) You should quote a wide range so that the price is likely to fall somewhere within it. Also, you need room to maneuver. The buyer may even blurt out his budget at that point. If he hedges, you can ask him to give a price range. Here's how I might answer the buyer's question: "What do you charge?"

Photographer: "Well, I have a range of fees depending on a lot of factors, including usage, which picture we're talking about, and so forth. In my experience, a fee for your use can range from $200 to $750, depending on the size you need, the intended circulation, and the number of pictures you are using from our file." (Note: you don't have to say "I've charged $200 to $750." Your experience can be what you know of industry standards.)

But what if the buyer says, "We never pay more than $150."

Now it's time for the good cop/bad cop technique. It is said that there are always four people in any negotiation: the buyer and his or her boss (the authority who approves the money) and the photographer and his or her boss. If you have a partner (or an accountant or a financial manager), you can use this technique.

You become the good cop: "I wish I could give it to you for that fee, but I may have to check with my partner—we've agreed on a rate schedule. Let me see what I can do." Sometimes you can use your stock agency as the bad cop.

Get off the phone. Make your decision and call back with an answer. If you can't live with the buyer's budget, blame it on the bad cop—your partner or business manager. If you do choose to work within the buyer's limits, take credit for it. Always give a reason and if you lower your price, make sure you get something in return. Don't leave the impression that take-it-or-leave-it intimidation worked.

If you are a one-person operation, remember there are always two parts of you at work: the photographer half, who wants to see the work published, and the business manager half, who must make sure that your economic interests are protected. Make that clear to the caller. State a reason for holding your price or lowering it. See the sample approaches later in this chapter.

Try to educate the client (or show that you are educated about industry practices) as a basis for discussing your price. Until you get right down to a decision, keep the discussion open and fluid. Imply to the client that there is always a possibility for agreement.

All this is useful when you are able to engage a client in a discussion of fees. If the situation is truly a take-it-or-leave-it price structure, all of the thought process above may help you decide if and when you should "leave it."

Closing the Deal

This is an aspect that some photographers ignore. Once you have negotiated your way through the delicate matter of arriving at a price, make sure it is clearly understood by both parties. Ask the buyer if he will be sending a purchase order. If it has been a complex negotiation, send your own follow-up memo confirming the prices quoted and extras, such as additional tear sheets, that were part of the agreement. (Note that the exact license of usage rights must be spelled out in your invoice, and that no rights are granted until full payment is made.)

NEGOTIATING CONVERSATIONS

Having read and thoughtfully considered these principles of negotiation, you must now believe. Believe that you have the right and the ability to negotiate a fair price. Once you are a believer, it's simply a matter of adapting negotiating methods and expressing them in your own style. There are many rhetorical devices that can be used in a negotiating conversation, as you'll see below. Take these conversations and adapt them to written scripts of your own for use on the phone or in email exchanges over pricing.

It may not be common to have the opportunity to interact with a client over prices. But being prepared for the instances when you can makes the preparation well worth it. In picking your approach to negotiating, no matter

what words you choose, remember to communicate the following when you write or speak to a client:

- You want to help them, to work it out, to make a deal.
- You understand their problems.
- You hope they understand your situation.
- You are disappointed when you can't reach agreement.
- You hope that there will be another opportunity to help them out.

Your entire tone is accommodating. Firmness, polite firmness, must be shown when you have reached your bottom line. Regardless of how you really feel about the negotiation (and though you may be tempted to tell the caller to take a walk), you must project an earnest desire to solve their problem. In fact, you do want to conclude a deal, and you are disappointed when you can't meet their needs. Not only is an accommodating attitude a smart negotiation tactic, it usually has the additional merit of being true.

Here are some phrases from hypothetical negotiations. Find the ones that are comfortable for you, that adapt well to your situation, and then translate them into your own language and take them from spoken conversation into written scripts. Also, adapt them according to whether you are dealing with a new client or a repeat customer.

Deserving of special mention is one phrase that I use regularly. It is:

"As I'm sure you understand . . ."

It's especially useful when I'm sure they don't understand at all.

This phrase helps inexperienced buyers to save face. You are attributing to them an education or awareness they may not have. But it prepares them to hear your information in a neutral environment.

The opposite tack, "Look, what you don't understand is . . ." can be dangerous. Nobody likes being lectured. At this point, the buyer is almost required to respond defensively, perhaps with a counter-attack about what you don't understand: that "photographers are a dime a dozen and I can get this picture anywhere at my price." The negotiation is now almost irreparable. You can say: "So fine, get it." You will lose the sale and the client. Or you can backpedal and take the buyer's price. Neither is satisfactory.

The "I'm sure you understand" phrase covers many bases. When the buyer really does understand the business, it serves as a gentle segue into the point you want to reinforce. In this instance, you'll adjust the phrase and your inflection: "Look, Joe, I know you understand the situation as well as I do . . . But this type of photograph is . . . If I go much lower (note that the word much gives you a little room to maneuver), I won't be covering my costs. Let's see how . . ."

That brings us to the next most valuable phrase: "Let's see how we can work this out." Often this is most effective when ended with a pause.

This phrase opens the door for adjustment on both sides. The buyer can enter the pause with an offer: "I could probably get them to go up to $500, but

I'll have to check." Or you can pose some questions that are more suggestions than query.

"Let's see how we can make this work . . . (pause) . . . Are you planning to use more than one picture? Do you have other picture needs on this project? Are we speaking of any volume with these pictures? How about upcoming projects, do you know your needs in the next few months?"

Once the buyer picks up on one of those questions, your negotiation is still alive and you've steered clear of the take-it-or-leave-it waters.

Here are more variations from the photographer's perspective. Whenever possible, refer to that vague entity, "industry standards," or to some experience with a mystery client from the past. Give the buyer some history:

"Well, in the past, I have sometimes given a small break when there was the possibility of extra tear sheets."

"What some other clients of mine have suggested is that they will pay my standard rates for the first ten photos. Above that we start discussing a discount."

"If we had worked together before it might be easier, but . . . Well, let me tell you how I've worked with some of my regular photo buyers. They pay my standard fee for most projects. Then when a special short print-run, lower-budget project comes along, I am able to adjust for them. What other projects do you have coming up? Perhaps we can work out a guarantee of a certain number of pictures to be used between now and your next project.

"I'm sorry, we just can't afford to go that low for usage of one photograph. I'm sure you'll understand—it's one of my expensive underwater shots. But if you decide to use several pictures, maybe we can give you a break on volume."

"Well, that's a bit below my usual fee for this. I'd like to help you out and develop a relationship with you. Let's see . . . If you are able to use a volume of pictures, I might be able to . . ."

"As much as I'd like to help you out, I simply can't go much lower. It's because this particular picture is one of my special collection—you know how expensive that can be—extra model fees, props . . ."

"Because it's going to be tough to come down much further, let's see what else we might work out."

"I'd like to help you out with this one—tell me the usage again—let's see if there's anything we can do..."

When you give a reason for adjusting your price:

"In this one case we're going to bend the rules a bit to help you out. The project sounds interesting and we'd like to work with you, but we'd need to have at least X tear sheets. How do we arrange that?"

Educating the client to the realities:

"I'm sure you're aware that the standard fee in the industry for this usage is $X and can be as high as $X. Now, understanding that you have a low budget, I'll try to accommodate. I can go as low as $X. I'm not sure how much more I could do.

"As you know, most agencies will charge $X for this usage, and we have overhead and expenses to cover also."

When you have to enlighten buyers about your expenses:

"As I'm sure you know, costs for photographic materials have gone up X percent in recent years and photo prices have stayed relatively stagnant. I wish I could do more for you. . . ."

"I'd really like to help you out, but one reason it's tough to go as low as you want is that I need to keep reinvesting in my stock. I hope that each time you come back to me, I'll have fresh new material for you. It's impossible for me to continue investing in new photography if I don't maintain a certain price level. I'm sure you understand."

"I certainly want to sell you rights to this picture. It doesn't do me any good sitting in the file but, as I know you understand, the cost of assistants for labeling, captioning, file preparation, all of it, is getting higher and higher. I'm sure you've got the same problem with your staff. . . ."

"You don't want to hear my business problems, and I wouldn't tire you with them if I could see my way clear to taking your price. As I'm sure you understand, my costs simply aren't covered in that price range. Let's see how we can resolve this."

(These approaches must avoid any hint of whining. References to your high costs must be unemotional and matter-of-fact, not bids for sympathy, from one business person to another.)

When you have to say no:

"I'm afraid that is lower than I can afford to go. Thanks so much for contacting us. Sorry I couldn't help you out this time. Hope I'll be able to provide something for your next project. I'll let you know when I post new material to my Web site."

In order to get a feel for negotiating, some photographers role-play a buyer-seller situation with each other. It is a technique used by some agencies to train their new sales people. The buyer writes down a type of photographic usage, the top price the client's company is willing to pay, and the low price that is their goal. The photographer writes down a bottom price and the highest price that seems even remotely possible for the usage. They begin discussions. When an agreement is reached, the winner is the one who came closest to their goal price. It is a great technique for polishing the rough edges of negotiating.

VALUE OF PHOTOGRAPHS

Photographs have value to users only to the degree that they solve a visual problem for them—whether it's illustrating an article or advertising a product. The amount they will pay to reproduce a photograph depends on what they perceive as the value of that particular photo to their project.

241

The value of a photograph to you is much more complex. There are economic, aesthetic, and emotional components that sometimes cloud the pricing issue. Photographers may hesitate to charge enough for a photograph they especially like, not wanting to risk having their price turned down. They may view a low price offer as a rejection of their photographic worth.

Take a cool-headed look at the value of your photographs. You can and should place greater value on some photographs than on others. Measure your photographs and price them based on their cost to you and their unique quality—not just on the client's intended use or ability to pay.

If you have a clear understanding of their value, you will be much more comfortable charging a price for your photographs and that will keep you in business. The following are some more specific cost factors to consider when measuring the value of a particular picture to your file and calculating individual prices.

Expenses

Normal costs:	shooting time, film, equipment, overhead
Extra costs:	model fees (non-professional)
	model fees (professional)
	location fees
	props
Travel costs:	domestic, foreign, exotic (out-of-the-way)
Extraordinary costs:	helicopter, plane, or balloon rentals
High risk:	extra insurance for shooting from aircraft, bridges, high buildings, or cliffs

Unique Quality

Unable to be repeated

Uncommon

Hard-to-find photographic topics

Freshness

New material, never-before published

I use these factors to decide how to price and mention them in discussions with clients when an explanation seems appropriate.

You can't expect that clients will always understand everything that goes into a good photograph. If you make it look effortless, they may not be ready to pay for the effort unless you make it clear.

You won't want (or find the opportunity) to tell war stories to every client on every stock sale you negotiate. Just keep clear in your mind the cost, effort, and special vision that go into your photographs. An acute awareness of these factors will build your confidence when negotiating, and you'll be well prepared on occasions when it is appropriate to share the information with a client.

Keeping the relative value of different photographs in mind while negotiating is a helpful and valid way to make your case for a fair price.

FINDING PRICES

This is all well and good, but what should you charge? How does one know where to begin? What do other people charge?

Finally, what is a fair price? A fair price is one you are satisfied with—one that will cover costs and bring a profit. What I refer to as a standard price is a commonly quoted price for a particular usage—one that everybody is charging, photographers and agencies alike. Standard prices don't really exist except as a perception. All prices vary, but you can see similarities in ranges. These will emerge as you research past pricing trends in the industry.

The following are some sources for pricing information:

- Published source material
- Your previous experience
- Professional associations
- Photographer colleagues
- Stock agencies

Published Source Material

Reference material on pricing is available from several sources. One resource is the book *Pricing Photography*, co-written by myself and David MacTavish and published by Allworth Press. In addition to comprehensive pricing charts, the book includes guidance on negotiating and calculating your business overhead. Available for the computer is FotoQuote (*www.fotoquote.com*), a program to help calculate prices.

Another source of information is a book published by Jim Pickerell, a photographer based in Washington, D.C., which contains his pricing list for many categories of usage. *Negotiating Stock Photo Prices* is available through Pickerell Marketing, 110A Frederick Avenue, Rockville, MD 20850, or online at *www.pickphoto.com/guide.asp*.

Your Previous Experience

In the process of selling stock you will have learned about pricing in some categories. Compile your own experience in a reference chart. Then add what you have learned from source books and combine this information to create your own price category chart. Date your price chart. Revise it annually. At tax time each year, survey your invoices. Have your prices in each usage changed from previous years? Total the number of sales and divide your total stock income. What is the amount of your average sale? Do your prices reflect changes in the marketplace? Do they cover increased costs in your business and increases in

the cost of living? Are your prices falling behind? If so, your business may do the same.

Professional Associations

Access to industry information is one more excellent reason to belong to ASMP or a similar professional organization. Membership in the organization will provide access to any future surveys on pricing, economic trends, and industry information that the association compiles. No individual can research information to this depth by himself or herself. Membership in a professional organization is as important a tool as your camera.

Stock Agencies

It is unreasonable to expect a stock agency to be a price-answering bureau. They are obliged to sell photos for their member photographers. But certain agents have mentioned their willingness to give (very occasional) guidance on pricing to individual photographers if it doesn't get out of hand. You may meet stock agents at stock seminars at the various photographic conferences or workshops you attend. If you or a colleague have a relationship with an agency, it may be able to help on a complicated quote. Consider this a last-ditch resource. Portals, on the other hand, often make their own pricing structure available to you as a member.

A final thought before embarking on the negotiating trail: There are many photographers who are respected and appreciated by photo buyers as both successful negotiators and nice people. Though limited, there are moments when negotiating is still possible. Be ready for the opportunities when they arise.

Navajo children watching TV. Kayenta, Arizona

Copyright—What Do We Own?

T aking care of the legal formalities is a necessary part of your photographic business which, if handled properly, will allow it to run more smoothly. This, in turn, will give you more time and creative energy for your photography. This chapter presents the basics of copyright law. In the next chapter, we'll follow up with what you need to know about invasion of privacy and the importance of model releases; provide sample releases to clarify your business dealings and help to avoid misunderstandings; and offer some thoughts on where to turn for legal help if things go sour. For further legal information, consult *Legal Guide for the Visual Artist* by Tad Crawford, as well as the legal section in *Starting Your Career as a Freelance Photographer* (both published by Allworth Press).

Understanding copyright is good business, but more important, knowing about copyright is a way of showing respect for your photographs. Your photography is your creation. For most photographers, their photographs are the tangible result of a life's work with economic, artistic, and sometimes historic value. They can be a legacy and an annuity and thus they deserve respect.

It is important to understand that you cannot copyright an idea, only the tangible expression of an idea, which for photographers is the photograph. The copyright is actually composed of a bundle of rights, which can be separated and portioned off for different purposes, and licensed to a variety of clients for a wide range of reproduction fees.

It's good to remember that while we casually refer to the "selling" of pictures on an assignment or to the income from "stock sales," those terms are misleading but convenient and commonly used. The correct terminology is that you "license" rights for specific usage which is then spelled out in your invoice to a client. The same photograph has a virtually unlimited number of uses over its lifetime.

In stock photography, the picture, the actual physical property of the photograph (digital file, transparency, or print) is merely on loan, and the fee paid

is not for the "sale" of anything, it is for usage permission only—that is, reproduction rights.

BACKGROUND OF COPYRIGHT

The Statute of Anne, enacted in 1710 by the British Parliament, is considered the first real copyright law. The drafters of the United States Constitution recognized the importance of protecting "authors"—which means all creators—by giving Congress the power "to promote the Progress of Science and the useful Arts, by securing for limited Times to Authors and Inventors the exclusive Right to their respective Writings and Discoveries." Since 1790, when Congress enacted the first copyright legislation, to the present day, the law has been changed and expanded many times.

The underlying principles of copyright embodied in our Constitution are to encourage and promote the artistic and intellectual life of the society through the fostering of the individual creator. We must continue to cherish and protect those rights so carefully handed down by our enlightened forefathers.

COPYRIGHT OVERVIEW

In general, the following section will center on copyright information applicable to the freelance photographer. It may not apply if you are employed as a photographer by someone else; in most cases your employer will own the copyright to any work done on the job.

You, the photographer, own the copyright to your photograph from the moment of creation (the second the shutter closes). The exceptions are:

- If you are an employee and create the photos within the scope of your employment.
- If you are freelance but have signed a work for hire contract.

This ownership of the copyright from the moment of creation was legislated by Congress in the Copyright Act of 1976 (which took effect January 1, 1978).

The term of copyright for works created on or after January 1, 1978 is the photographer's lifetime plus seventy years. There are also exceptions to the term, such as works published anonymously, under a pseudonym, or as work for hire.

What Are the Rights of the Copyright Holder?

The copyright owner has the exclusive right to control the reproduction of the image; to control the first sale of any copies (such as fine art prints) of the image; to resell that print; to control use of the image in derivative works (such as when an artist uses your photographs as the basis of an illustration); and to control displays of the image (subject to the fact that someone who has purchased a physical copy, such as a fine art print, has the right to display it to people who are present at the location where the display is taking place, as in a home, gallery, or museum). The rights to digital photos are the same as those to traditional images.

As explained by Tad Crawford and Laura Stevens in *Starting Your Career as a Freelance Photographer*:

> A copyright owner may control the distribution of his or her photographs on the Internet in much the same way as would be done with respect to books or magazines. The Digital Millennium Copyright Act, enacted in 1998 extends the copyright protections, which already existed with respect to traditional media (e.g., books, photographs) to their online counterparts (e.g., e-books and photographs made available on the Internet).
>
> Although the DMCA contained some specific limitations on liability for a particular class of parties, it may be generally be assumed that a use that requires permission offline (e.g., to include a photograph in a magazine) would require permission online (e.g., to include a photograph in an e-zine).

What is Work for Hire?

Work for hire means the client, not the photographer, owns the copyright, as if the client had, in fact, shot the photographs because under work for hire, the copyright vests in the client from the moment of creation. There is not even a copyright transfer to the client in a work for hire. This means that in the eyes of the law, the client was the photographer.

Employees, such as most newspaper staff photographers, do work for hire in the traditional employer-employee relationship.

Freelance photographers are never employees. For this discussion, we are concerned with work for hire as it applies to photographs taken on assignment. It can never apply to stock photographs taken on your own time. So if you shoot only for stock, you have no problem. But if you are a stock photographer and do some assignments also, it's good to know the pitfalls and avoid them.

The only way work for hire can come into being for a freelance photographer is if there is a contract that is (1) written; (2) states that the work being done on an assignment is work for hire; (3) is signed by both the photographer and the client; and (4) if the assignment itself falls into one of a limited number of categories, the most likely to apply to photographers being: (a) as a contribution to a collective work such as a magazine, (b) as part of an instructional text, (c) as part of a supplementary work (which is a work intended to supplement a larger work), or (d) as part of an audio-visual work or motion picture.

If the work you do on an assignment does not fall into one of the categories specified in the law, then it is not work for hire, no matter what contract a client may ask you to sign. The best protection is not to sign any work for hire contract, but in the rare instance that you consider doing so, read the contract carefully to make sure that it is binding only on the current job. Also, read the back of a check made in payment for a stock license before depositing the check. Clients have been known to add onerous language not previously agreed upon,

such as the demand that the photograph was made under work for hire. In that case, contact them to get a new check without that language. They do not have permission to use your image until the license is paid for.

Copyright Notice

Copyright notice is the statement of copyright ownership in a photograph. A significant value of copyright notice is symbolic; it warns the public or any potential user not to use the image without permission of the copyright owner. It also has the practical value of letting a potential user know whom they should contact in the event that they want to reproduce the image.

Also, the use of a notice will benefit you in the event of a lawsuit by eliminating the defense that the user was an "innocent infringer" (i.e., he didn't know he couldn't use it).

A proper copyright notice has three elements:
 1. The word "copyright," the abbreviation "copr." or the symbol ©
 2. The year of first publication
 3. The name of the copyright holder (you)

The date may be omitted. Examples of properly worded copyright notices are: "© 2008 Pat Photographer," "Copyright Pat Photographer 2008," or "Copr. 2008 by Pat Photographer."

The date to be used in a copyright notice for unpublished photographs is the year of creation. You may wonder whether using the year of creation may not shorten the term of copyright. However, because the copyright term is measured by the life of the photographer plus seventy years, it will be the same no matter what date appears on the photograph. When a work has been unpublished and is then published, the year of first publication should be put in the copyright notice.

A copyright notice should be on all photographs leaving your studio, whether prints, transparencies, or digital files, and should be required as a part of your photo credit accompanying all publication. Most photographers attach the copyright notice to the digital file of the photograph or embed it in the metadata, and in some cases overlay the photo with a watermark with the copyright notice. (Consult the book *Business and Legal Forms for Photographers*, third edition, by Tad Crawford for more on copyright.)

Copyright Infringement

Infringement occurs when your photograph is used (published) without your permission or that of your authorized agent (such as a stock agency). You will probably only learn that you are being infringed by being alert and if you're lucky. You may notice a usage that you didn't authorize. Often a friend will recognize your photograph and bring it to your attention. But there may very well be infringements that you never see.

If this happens to you, consult a lawyer who is expert in intellectual property law, especially as it pertains to photography. You may not have to go to court; there are sometimes quick, amicable solutions. But knowing about an infringement and doing nothing could jeopardize your right to sue.

Copyright Registration

There is no requirement to register photographs with the Copyright Office, whether photographs are published or unpublished—your copyright ownership is not jeopardized by lack of registration. However, there are enormous benefits to registering photographs. Furthermore, photographs can be registered in groups to make things less complicated and to save fees.

If registration is made within three months after publication of the work or prior to an infringement of the work, statutory damages and attorney's fees will be available to the copyright owner in court actions. Otherwise, only an award of actual damages and profits is available to the copyright owner.

The benefits of registration include certain presumptions in a lawsuit, such as that the copyright is valid and you are the creator of the work.

The U.S. Copyright Office provides "Form VA" for works of visual art. With the form and fee you have to provide copies of the images being registered (generally one copy of unpublished work and two copies of published work). Group application registration can be made using CDs or DVDs. The form, the fee, and the deposit copies of the photographs must all be sent together for the registration to be valid. Registration, by the way, will take effect on the date that these three items are received by the Copyright Office, even if the Copyright Office takes some time to mail the certificate of registration back to you.

For more information about copyright and to download forms, go to the Web site of the Copyright Office, *www.copyright.gov.*

A final piece of advice, don't think copyright infringement is just a fantasy or something that happens only to other people. In fact, there have been a rash of infringements. The typical story is that after the infringement has taken place, the photographer is offered merely the fee that he or she would have gotten in the first place had the infringer come to the photographer for that photograph. This is completely unacceptable. The best way to deter infringement is to use a copyright notice and to register so your threat of a suit will have teeth.

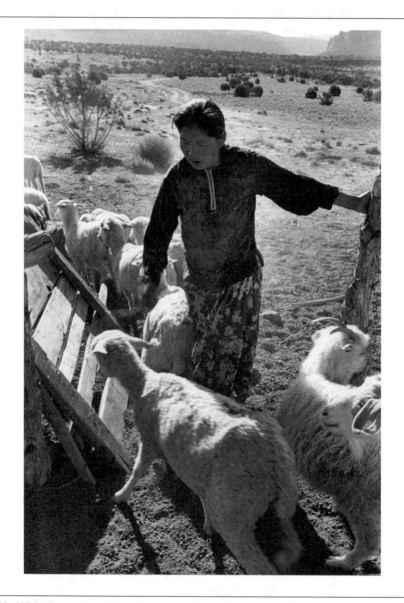
Stella Whitehorse tending sheep. Haskennini Mesa, Arizona

Model Releases and Business Forms

Nuisance though it may seem, paperwork (even when it's generated electronically) is more than just a good idea—it's essential. The most important reason for having a good paper trail is that it protects you with models; with clients over questions of usage, payment, or holding fees; and in disputes over lost transparencies or unauthorized use of a digital file you have submitted in every way imaginable.

Furthermore, you can create an impression of professionalism by using clear, thorough agreements presented on nicely designed forms.

Don't let the concern that you'll alienate a client keep you from using detailed paperwork. Photo buyers are already used to receiving forms from stock photo agencies. Why should they expect less from you? And why should you expect less from yourself? An experienced photo buyer will appreciate the clarity of good paperwork and will take you seriously if that's how you run your business.

You can, and should, make any changes in these sample forms that work well in your business. However, when deciding on the terms and conditions for your forms or the wording for your model releases, be sure to work with a lawyer. This is not the time to be casual.

FORMS

The forms you'll find in this chapter are:

1. Model Release, Adult and Minor
2. Property Release
3. Stock Picture Delivery Memo/Film
4. Stock Picture Delivery Memo/Digital
5. Stock Shoot/Estimate Worksheet
6. Stock Photography Invoice
7. Stock Photo Request

MODEL RELEASES AND INVASION OF PRIVACY

An area in which photographers should exercise the most caution and where they are most likely to put themselves at risk is in the area of the law known as invasion of privacy. Individual citizens have rights of privacy, that is, the right to live free from unwanted publicity. This right to privacy overlaps with another right held by all individuals, but, for this discussion, of particular interest to creators. This is the right to free expression under the First Amendment of the Constitution.

Which rights take precedence and when is complicated and sometimes requires a decision by the courts. Photographers can avoid most of these problems associated with the risks of invasion of privacy by obtaining proper model releases and by observing certain precautions, as we'll see below.

When You Need Releases

From a business standpoint, model releases increase the value of your stock dramatically, so you should make every effort to obtain them. It is also very important to understand your vulnerability in not having releases for stock photographs in terms of the legal protection they can provide. It is not always clear legally when a model release is required or what constitutes an invasion of privacy, but the following guidelines will help.

- If the use of the photograph is commercial for purposes of trade or advertising, a release is needed for any recognizable person (and, in some cases, for property).
- In a non-commercial situation where the use can be considered newsworthy or a matter of public interest, a release may not be needed. In photographic terms, that generally means editorial usage: books, newspapers, or magazines. However, many photographs could have commercial application down the line, and you would be wise to have a release available.

The exception here occurs (even within an otherwise protected use, such as editorial) if the person is portrayed in a false light to the public. This most often takes place when a true photograph (one which has not been altered) is connected with a caption that makes it untrue. For example, a caption describing the family-destroying effects of drug use is connected with the photograph of a mother and child, when, in fact, neither of these actual people has ever had any relationship with drugs. Even though the usage is editorial it is not in the public interest to say false things about particular people. Even a signed model release would not provide protection from this extreme and outrageous usage unless the release specified the models' consent to portrayal as crack users.

Also, know that if the depiction puts the subject of the photograph in a defamatory light, then you may also be open to a claim for libel.

If you plan to shoot a setup photo showing someone in a situation of a sensitive nature, get a release signed with specific wording that spells out the nature of the representation, and have them initial and date the specific wording. For example, I once set up a photo of a young male, his face obscured in shadow, showing a tourniquet tied around his arm

and a needle in his vein. He initialed the notation on his release, which
stand that this photo represents me simulating drug use." Now that languag
wasn't approved by a lawyer, so you might check with your lawyer if you plan to
shooting of this type.

- Physical intrusion, such as trespassing or obtaining entry by fraud to take pho
 graphs, can also be invasion of privacy.
- There is a different set of rules connected with celebrities. A celebrity used in pho-
 tographs for commercial purposes of advertising or trade is protected under the laws
 of privacy as is any other individual, but this leads us into another interesting, and
 somewhat murky, area of the law. What has been termed the right of publicity is the
 right that well-known people have in the value that has come to exist in their names
 and images. While the rights of privacy exist only for living persons, in some states
 the rights of publicity to the persona of a deceased celebrity exist as property rights,
 which descend to the heirs.

Photographers should be aware that the rights to license the images of
certain famous people who are deceased are often held by special agencies set up for
the purpose of controlling the commercial and artistic exploitation of the celebrity's
persona—such as John Wayne, W.C. Fields, Babe Ruth, Albert Einstein, and others.
There are laws in several states that recognize these rights of publicity. It isn't yet known
whether a model release obtained while the celebrity was alive will be valid after death.
This area of the law is in flux. If you specialize in celebrity photography, be sure to
consult your lawyer and watch the developments reported by ASMP closely.

- Property does not have rights of privacy or publicity. However a property owner
 may have the right to prohibit commercial exploitation (use for trade or advertis-
 ing) of his or her identifiable property.

A house, a pet, a piece of jewelry, or sculpture are some items of property that may
require a release for advertising use. A horse running in a field, silhouetted against the
setting sun might not need a release unless that field is on a Kentucky horse farm and
the horse is a famous brood mare. Then a release would be advisable.

A property release may not always be required legally, but such releases are a
necessity if your stock is to have maximum value—which means being available for
advertising users.

Certainly, you should obtain property releases when shooting interiors, especially since
the release can also serve as a contact with the owner. But releases can add value to exte-
rior photographs, especially of buildings, since clients will prefer a photo with a property
release to a photo without one.

In any case, a release should be signed when the property is photographed, and some
payment, even if very small, should be made to the owner.

What is the final word on releases? Simply put, you as a stock photographer
should always obtain a model and/or property release for any subject appearing
in any image that you create. Since advertising is the most lucrative market,
clearly you and your stock agency, will want to have your images available to sell
in that marketplace. Make the effort.

255

this chapter are a model release for both adults and
ease. These releases have been adapted from *Business*
raphers by Tad Crawford (Allworth Press) and appear
uthor.

m 1) that follows is similar to the one I use. Some
l-down release, sometimes called a pocket release,
.... on a 3"×5" card. It is very convenient and not so formidable to a
model, but doesn't offer as much protection as you might want. When possible,
especially if you work with professional models or plan to sell to advertising
clients, use the strongest possible release.

In addition to the language that protects you legally, I add an introductory paragraph to the top of my model release page to soften the harsh tone of the legal language. I find it helps to put nonprofessional models at ease and seems to make the release easier to get signed. Such an introduction might read as follows:

Dear Friend (or Parent):
Thank you for your cooperation in allowing me to photograph you (or your child) for use in my stock photography project. Would you please sign the form below to show that you give me and the user, my stock photo client, permission to use these pictures.

Or, if you are short of space, you can put the friendly introduction on the back of the release along with an explanation of your project and a definition of stock as existing photography. The definition might read, "Stock photographs are existing photography. These photographs may be placed in my stock photography file or that of my agent to be used for publication." Vary the introductory language according to your own prose style and the particular project.

The release shown can be used with either an adult or child model. Or you can make two versions, one for adults and another for the parent (or guardian) of a minor. If you work with children a lot, you might want to have the separate version for minors.

Once you add any introductory words that you may want to this release, have it printed or photocopied on your letterhead. This adds a professional look. Be sure to have your name in the space for the photographer's name so the release will be valid. Also, it is wise to give something of value (even a small amount of money, such as a dollar or complimentary copies of the photographs) to make the release as binding as possible to the model or the property owner. Some releases do not mention giving money, but simply say,

"For valuable consideration received..." Be certain, in fact, that you give something of value to the model and keep a record of what you gave as consideration.

STOCK PICTURE DELIVERY MEMOS

The next forms are used when you deliver photos to a stock photo buyer. There are two variations of the stock picture delivery memos included, one for film (Form 3) and one for digital (Form 4). Even though film is much less used, there are critical stipulations you need to use if film is being shipped. You can send these along with an email submission in a PDF format. Or use this language on your Web site if you are posting images to a light box.

Each has a front with spaces for the photographer to complete, and a back which contains the terms and conditions for the form. The backs of the forms also have a small number of spaces to be filled in. These two forms have been adapted from *Business and Legal Forms for Photographers* by Tad Crawford (Allworth Press) and appear here by permission of the author.

You can design your memo with or without lines. I've tried to use the simplest, cleanest form possible so that I have space to write. You can vary it any way that works well for you. Just be sure to keep the legal protection of the terms and conditions.

FORM # 1

MODEL RELEASE

In consideration of _____ Dollars ($_____), and other valuable consideration, receipt of which is acknowledged, I, _____ (print Model's name) do hereby give _____ (the Photographer), his or her assigns, licensees, successors in interest, legal representatives, and heirs the irrevocable right to use my name (or any fictional name), picture, portrait, or photograph in all forms and in all media and in all manners, without any restriction as to changes or alterations (including but not limited to composite or distorted representations) for advertising, trade, promotion, exhibition, or any other lawful purposes, and I waive any right to inspect or approve the photograph(s) or finished version(s) incorporating the photograph(s), including written copy that may be created and appear in connection therewith. I agree that the Photographer owns the copyright in these photographs and I hereby waive any claims I may have based on any usage of the photographs or works derived therefrom, including but not limited to claims for either invasion of privacy or libel. I am of full age* and competent to sign this release. I agree that this release shall be binding on me, my legal representatives, heirs, and assigns. I have read this release and am fully familiar with its contents.

Witness: _____ Signed: _____

 Model

Address: _____ Address: _____

 Date: _____, 20____

Consent (if applicable)

I am the parent or guardian of the minor named above and have the legal authority to execute the above release. I approve the foregoing and waive any rights in the premises.

Witness: _____ Signed: _____

 Parent or Guardian

Address: _____ Address: _____

 Date: _____, 20____

* Delete this sentence if the subject is a minor. The parent or guardian must then sign the consent.

F O R M # 2
PROPERTY RELEASE

In consideration of the sum of _____Dollars ($_____) and other valuable consideration, receipt of which is hereby acknowledged, I, _____, residing at _____, do, irrevocably authorize _____(the Photographer), his or her assigns, licensees, successors in interest, legal representatives, and heirs to copyright, publish, and use in all forms and media and in all manners for advertising, trade, promotion, exhibition, or any other lawful purpose, images of the following property:

_____,

which I own and have full and sole authority to license for such uses, regardless of whether said use is composite or distorted in character or form, whether said use is made in conjunction with my own name or with a fictitious name, or whether said use is made in color, black-and-white, or otherwise, or other derivative works are made through any medium.

I waive any right that I may have to inspect or approve the photograph(s) or finished version(s) incorporating the photographs, including written copy that may be used in connection therewith.

I am of full age and have every right to contract in my own name with respect to the foregoing matters. I agree that this release shall be binding on me, my legal representatives, heirs, and assigns. I have read the above authorization and release prior to its execution and I am fully cognizant of its contents.

Witness: _____ Signed: _____

Address: _____ Address: _____

Date: _____, 20___

FORM # 3

STOCK PICTURE DELIVERY MEMO (FILM)

Date: _____, 20_____

Client _____ Delivery Memo No. _____
_____ Purchase Order No. _____
Per Request of _____ Email _____
Telephone _____

Photo Return Due_____ Extension Granted_____

Value	Quantity	Format/Size	Original or Dupe	Description/File Number	BW/Color

* Value is in case of loss, theft, or damage. A reproduction fee for specified usage will be negotiated.

Total Color_____ Total Black and White_____

Please count all photographs and confirm that the count is accurate by returning one signed copy of this form. If objection is not immediately made by return mail, the Client shall be considered to accept the count shown on this form as accurate and that the photographs are of a quality suitable for reproduction. If the recipient of the photographs is not the Client, the recipient by accepting this Delivery Memo and the photographs warrants that the recipient has the authority to receive the photographs on behalf of the Client.

Acknowledged and Accepted_____Date:_____

SUBJECT TO ALL TERMS AND CONDITIONS ABOVE AND ON REVERSE SIDE

Terms and Conditions Form # 3

1. Purpose and Definition. Photographer hereby agrees to entrust the Photographs listed on the front of this form to the Client for the purpose of review and examination only and no other purpose. "Photographs" are defined to include transparencies, prints, negatives, digital files, digitized encodations, and any other form in which the images submitted can be stored, incorporated, represented, projected, or perceived, including forms and processes not presently in existence but which may come into being in the future.

2. Ownership and Copyright. Copyright and all reproduction rights in the Photographs, as well as the ownership of the physical Photographs themselves, are the property of and reserved to the Photographer. Client acknowledges that the Photographs shall be held in confidence and agrees not to project, copy, store, or modify directly or indirectly any of the Photographs submitted (whether such modification is of the Photograph itself or involves combining the Photograph with other images or graphic or written elements, including but not limited to comping for clients) without the express permission of the Photographer, nor will Client permit any third party to do any of the foregoing. Reproduction shall be allowed only upon Photographer's written permission specifying usage and fees. In the event of the licensing of any usage rights by Client, payment shall be made within thirty (30) days of the date of the Invoice and time shall be of the essence with respect to payment.

3. Acceptance. Client accepts the listing and values set forth for the Photographs as accurate if not objected to in writing by return mail immediately after receipt of the Photographs. Any terms on this form not objected to in writing within 10 days shall be deemed accepted.

4. Loss, Theft, or Damage. Client agrees to assume full responsibility and be strictly liable as an insurer for loss, theft, or damage to the Photographs and to insure the Photographs fully from the time of shipment from the Photographer to the Client until the time of return receipt by the Photographer. Client further agrees to return all of the Photographs at its own expense by registered mail or bonded courier, which provides proof of receipt. Reimbursement for loss, theft, or damage to any Photograph(s) shall be in the amount of the value entered for that Photograph(s) on the front of this form. Both Client and Photographer agree that the specified values represent the fair and reasonable value of the Photographs. Unless the value for an original transparency is specified otherwise on the front of this form, both parties agree that each original transparency has a fair and reasonable value of $1,500 (Fifteen Hundred Dollars). Client agrees to reimburse Photographer for these fair and reasonable values in the event of loss, theft, or damage.

5. Holding Fees. The Photographs are to be returned to the Photographer within fourteen (14) days after delivery to the Client. Each Photograph held beyond fourteen (14) days from delivery shall incur a weekly holding fee of $5 (Five Dollars) if it is color and $1 (One Dollar) if it is black and white. These holding fees shall be paid to the Photographer when billed.

6. Arbitration. Client and Photographer agree to submit all disputes hereunder in excess of $_____ to arbitration before _____ at the following location_____under the rules of the American Arbitration Association. The arbitrator's award shall be final and judgment may be entered on it in any court having jurisdiction thereof.

7. Copyright Notice. Copyright notice in the name of the Photographer shall be adjacent to the Photograph(s) when reproduced unless otherwise agreed by both parties and stated in the Invoice. If such copyright notice, which also serves as authorship credit, is required hereunder but is omitted, the Client shall pay as liquidated damages triple the usage fee agreed to between the parties instead of the agreed upon usage fee.

8. Tear sheets. Client shall provide Photographer with two (2) copies of tear sheets of any authorized usage.

9. Releases. Client agrees to indemnify and hold harmless the Photographer against any and all claims, costs, and expenses, including attorney's fees, arising when no model or property release has been provided to the Client by the Photographer or when the uses exceed the uses allowed pursuant to such a release.

10. Miscellany. This Agreement shall be binding upon the parties hereto, their heirs, successors, assigns, and personal representatives. This Agreement constitutes the full understanding between the parties hereto. Its terms may only be modified by a written instrument signed by both parties. A waiver of a breach of any of the provisions of this Agreement shall not be construed as a continuing waiver of other breaches of the same or other provisions hereof. This Agreement shall be governed by the laws of the State of _____.

FORM # 4

STOCK PICTURE DELIVERY MEMO (DIGITAL)

Date: _____, 20_____

Client:_____

Delivery Memo No._ _____

Purchase Order No. _____

Per Request of: _____

Email: _____

Telephone: _____

Value	Quantity	Format/Size	Original or Dupe	Description/File Number	BW/Color

The enclosed material, low resolution digital files, are for examination and approval only. Photographs may not be reproduced, copied, projected, televised, digitized or used in any way without (1) express written permission on Photographer's invoice stating rights licensed and the terms thereof and (2) payment of said invoice. The reasonable and stipulated fee for unauthorized use shall be three (3X) times Photographer's normal fee for such usage. Client assumes insurer's liability for all photographs.
Delivery method:

Email _____ CD/DVD _____ PDF _____ FTP_____ Other _____

Acknowledged and Accepted_____

Date _____

SUBJECT TO ALL TERMS AND CONDITIONS ABOVE AND ON REVERSE SIDE

Terms and Conditions Form # 4

1. Purpose and Definition. Photographer hereby agrees to entrust the Photographs listed on the front of this form to the Client for the purpose of review and examination only and no other purpose. "Photographs" are defined to include transparencies, prints, negatives, digital files, digitized encodations, and any other form in which the images submitted can be stored, incorporated, represented, projected, or perceived, including forms and processes not presently in existence but which may come into being in the future.

2. Ownership and Copyright. Copyright and all reproduction rights in the Photographs, as well as the ownership of the physical Photographs themselves, are the property of and reserved to the Photographer. Client acknowledges that the Photographs shall be held in confidence and agrees not to project, copy, store, or modify directly or indirectly any of the Photographs submitted (whether such modification is of the Photograph itself or involves combining the Photograph with other images or graphic or written elements, including but not limited to comping for clients) without the express permission of the Photographer, nor will Client permit any third party to do any of the foregoing. Reproduction shall be allowed only upon Photographer's written permission specifying usage and fees. In the event of the licensing of any usage rights by Client, payment shall be made within thirty (30) days of the date of the Invoice and time shall be of the essence with respect to payment.

3. Acceptance. Client accepts the listing and values set forth for the Photographs as accurate if not objected to in writing by return mail immediately after receipt of the Photographs. Any terms on this form not objected to in writing within 10 days shall be deemed accepted.

4. Loss, Theft, or Damage. Client agrees to assume full responsibility and be strictly liable as an insurer for loss, theft, or damage to the Photographs and to insure the Photographs fully from the time of shipment from the Photographer to the Client until the time of return receipt by the Photographer. Client further agrees to return all of the Photographs at its own expense by registered mail or bonded courier, which provides proof of receipt. Reimbursement for loss, theft, or damage to any Photograph(s) shall be in the amount of the value entered for that Photograph(s) on the front of this form. Both Client and Photographer agree that the specified values represent the fair and reasonable value of the Photographs. Unless the value for an original transparency is specified otherwise on the front of this form, both parties agree that each original transparency has a fair and reasonable value of $1,500 (Fifteen Hundred Dollars). Client agrees to reimburse Photographer for these fair and reasonable values in the event of loss, theft, or damage.

6. Arbitration. Client and Photographer agree to submit all disputes hereunder in excess of $_____ to arbitration before _____ at the following location _____ under the rules of the American Arbitration Association. The arbitrator's award shall be final and judgment may be entered on it in any court having jurisdiction thereof.

7. Copyright Notice. Copyright notice in the name of the Photographer shall be adjacent to the Photograph(s) when reproduced unless otherwise agreed by both parties and stated in the Invoice. If such copyright notice, which also serves as authorship credit, is required hereunder but is omitted, the Client shall pay as liquidated damages triple the usage fee agreed to between the parties instead of the agreed upon usage fee.

8. Tear sheets. Client shall provide Photographer with two (2) copies of tear sheets of any authorized usage.

9. Releases. Client agrees to indemnify and hold harmless the Photographer against any and all claims, costs, and expenses, including attorney's fees, arising when no model or property release has been provided to the Client by the Photographer or when the uses exceed the uses allowed pursuant to such a release.

10. Miscellany. This Agreement shall be binding upon the parties hereto, their heirs, successors, assigns, and personal representatives. This Agreement constitutes the full understanding between the parties hereto. Its terms may only be modified by a written instrument signed by both parties. A waiver of a breach of any of the provisions of this Agreement shall not be construed as a continuing waiver of other breaches of the same or other provisions hereof. This Agreement shall be governed by the laws of the State of _____.

STOCK SHOOT/ESTIMATE WORKSHEET

Assignment photographers know that detailed estimates are virtually always required by clients. And it's essential that they are accurate. A pitfall for the photographer shooting for stock can be spending money on a shoot and not accounting for it. If you create an estimate for each stock project as you begin the planning, you will soon see if the costs add up to a sensible expenditure based on the likely return for the money. You can also see at a glance where the highest price items are and if they can be shaved without damaging quality. Use the Stock Shoot Estimate Worksheet (Form 5) as a basis for designing you own way to budget your shoots.

FORM # 5
STOCK SHOOT ESTIMATE WORKSHEET

Stock Project: _____ Date: _____

Client Contact: _____ Stock Job Number: _____

Shoot Description: _____

Expenses:

Assistants $_____

Casting $_____

Crews/Special Technicians $_____

Equipment Rentals $_____

Film and Processing $_____

Insurance $_____

Location $_____

Messengers $_____

Models $_____

Props/Wardrobe $_____

Sets $_____

Shipping $_____

Styling $_____

Travel/Transportation $_____

Telephone $_____

Other expenses $_____

Total expenses $_____

INVOICE FORM—LICENSING RIGHTS

You can design the front of your invoice (Form 6) any way that is convenient as long as you include all the information needed for a complete invoice. Some photographers use an almost plain letterhead. However you design the face of your forms, be certain to have the terms and conditions on the back. To make your design task easier, electronic versions of forms for photographers are available on the CD that accompanies Tad Crawford's *Business and Legal Forms for Photographers*, published by Allworth Press.

When you write an invoice for the use of one of your stock pictures, you are doing what is termed "granting a license of rights." You grant the user, upon payment of the agreed-upon fee, permission to use your photograph in very specific and limited ways. A well-written license will clearly limit the usage to only what the user needs and has paid for, specifying the limitations of size, time, number of copies, and a number of other factors. It will exclude all other uses.

If you are dealing with governments or governmental institutions, be sure to require that they agree to be sued in the event a dispute arises. This is because sovereign immunity may protect governments and their institutions (such as state-owned universities) from claims under copyright and other laws. However, this immunity can be waived by an agreement to allow lawsuits to be brought. This additional provision should be added to both the stock picture delivery memo and the stock photography invoice.

As mentioned in earlier chapters, you can refer to the *ASMP Professional Business Practices Guide*, Sixth Edition, published by Allworth Press, for a comprehensive listing of the categories of pricing and license of rights specifications for every imaginable stock usage, and to the book *Pricing Photography*, also published by Allworth Press, for comprehensive pricing and negotiating information. Also, remember that the amount paid as the reproduction fee is what determines the extent of the rights granted. So the greater the usage rights required by the client, the higher the fee.

WHEN YOU NEED A LAWYER

In the unlikely and unhappy event that you need to resolve a dispute through the courts or arbitration, by all means get the right lawyer—one who is knowledgeable in the law as it pertains to the photography business.

ASMP maintains a referral list of lawyers in various parts of the country who are experienced in handling legal matters for photographers.

FORM # 6

STOCK PHOTOGRAPHY INVOICE

Client: _____ Date: _____

Address: _____ Invoice No. _____

_____ SS/EIN No. _____

_____ Purchase Order No._____

Per Request of:_____ Telephone: _____

The following nonexclusive rights are granted:

For use in: _____

For the product, project, or publication named:_____

In the following territory:_____

For the following time period or number of uses: _____

Other limitations: _____

Digital File/ Photo ID#	Description	Color/ BW	Size/ Placement	Fee

Total Repro Fee $ _____

Research Fee $ _____

Sales Tax $ _____

TOTAL $ _____

Check should be made payable to: _____

SUBJECT TO ALL TERMS AND CONDITIONS ON REVERSE SIDE

Terms and Conditions

1. Delivery and Definition. Photographer has delivered to the Client those Photographs listed on the front of this form. "Photographs" are defined to include transparencies, prints, negatives, digital files, digitized encodations, and any other form in which the images submitted can be stored, incorporated, represented, projected, or perceived, including forms and processes not presently in existence but which may come into being in the future.

2. Grant of Rights. Upon receipt of full payment, Photographer shall license to the Client the rights set forth on the front of this form for the listed Photographs.

3. Reservation of Rights. All rights not expressly granted are reserved to the Photographer. Without limiting the foregoing, no advertising or promotional usage whatsoever may be made of any Photographs unless such advertising or promotional usage is expressly permitted on the front of this form. Limitations on usage shown on the front of this form include but are not limited to size, placement, and whether usage is in black and white or color.

4. Fee. Client shall pay the fee shown on the front of this form for the usage rights granted. Client shall also pay sales tax, if required.

5. Payment. Payment is due to the Photographer within thirty days of the date of this Invoice. Overdue payments shall be subject to interest charges of _____ percent monthly. Time is of the essence with respect to payment.

6. Copyright Notice. Copyright notice in the name of the Photographer shall be adjacent to the Photograph(s) when reproduced unless otherwise agreed by both parties and stated in this Invoice. If such copyright notice, which also serves as authorship credit, is required hereunder but is omitted, the Client shall pay as liquidated damages triple the usage fee agreed to between the parties instead of the agreed upon usage fee. Copyright credit must be as shown on the Photograph(s) unless specified to the contrary by the Photographer.

7. Alterations. Client shall not make alterations, additions, or deletions to the Photographs, including but not limited to the making of derivative or composite images by the use of computers or other means, without the express, written consent of the Photographer. This prohibition shall include processes not presently in existence but which may come into being in the future.

8. Loss, Theft, or Damage. The ownership of the Photographs shall remain with the Photographer. Client agrees to assume full responsibility and be strictly liable as an insurer for loss, theft, or damage to the Photographs and to insure the Photographs fully from the time of shipment from the Photographer to the Client until the time of return receipt by the Photographer. Client further agrees to return all of the Photographs at its own expense by registered mail or bonded courier which provides proof of receipt. Reimbursement for loss, theft, or damage to any Photograph(s) shall be in the amount of the value entered for that Photograph(s) on the front of this form. Both Client and Photographer agree that the specified values represent the fair and reasonable value of the Photographs. Unless the value for an original transparency is specified otherwise on the front of this form, both parties agree that each original transparency has a fair and reasonable value of $1,500 (Fifteen Hundred Dollars). Client agrees to reimburse Photographer for these fair and reasonable values in the event of loss, theft, or damage.

9. Tear sheets. Client shall provide Photographer with two (2) copies of tear sheets of any authorized usage.

10. Releases. Client agrees to indemnify and hold harmless the Photographer against any and all claims, costs, and expenses, including attorney's fees, arising when no model or property release has been provided to the Client by the Photographer or when the uses exceed the uses allowed pursuant to such a release.

11. Arbitration. All disputes shall be submitted to binding arbitration before _____ in the following location _____ and settled in accordance with the rules of the American Arbitration Association. Judgment upon the arbitration award may be entered in any court having jurisdiction thereof. Disputes in which the amount at issue is less than $_____ shall not be subject to this arbitration provision.

12. Assignment. Neither party shall transfer or assign any rights or obligations hereunder without the consent of the other party, except that the Photographer shall have the right to assign monies due.

13. Miscellany. This Agreement shall be binding upon the parties hereto, their heirs, successors, assigns, and personal representatives. This Agreement constitutes the full understanding between the parties hereto. Its terms may only be modified by a written instrument signed by both parties. A waiver of a breach of any of the provisions of this Agreement shall not be construed as a continuing waiver of other breaches of the same or other provisions hereof. This Agreement shall be governed by the laws of the State of

FORM # 7

STOCK PHOTO REQUEST FORM

Request Date: _____Photos needed by: _____

CLIENT INFO

Company: _____

Address: _____

Contact Name: _____ Title _____

Email address: _____ Telephone: _____

Client Web site: _____ Client FTP site:_____

Photos For (Final Client): _____

PROJECT TITLE: _____

Total number of photos needed: _____ Deadline:_____

Photo subject/concept(s):

USE: **FORMAT:**

Advertising Color

Corporate BW

Editorial Horizontal

Other _____ Vertical

 Final Size:

 Digital Specs: __ dpi __ image size __ MB file

USAGE / RIGHTS: **SHIPPING** (delivery type for photo submissions):

Use in: _____ __Light box __Our Web site __Post on our FTP site

Size: _____ __Post client FTP site __Ship CD/DVD by courier

How many copies: _____ _____ Email contact sheets

Where (U.S.): _____

 Other: _____

English Language: _____ Other Language: _____

Bibliography

PHOTOGRAPHY BOOKS

Eismann, Katrin. *Adobe Photoshop Restoration and Retouching (Voices that Matter),* Third Edition. Berkeley, CA: New Riders Press, 2005.

Doeffinger, Derek. *The Magic of Digital Printing: Great Prints from Shooting to Output.* Asheville, NC: Lark Books, 2005.

Fraser, Bruce. *Real World Camera RAW with Adobe Photoshop CS2.* Berkeley, CA: Peachpit Press, 2005.

Heller, Dan. *Profitable Photography In The Digital Age: Strategies For Success.* New York: Allworth Press, 2005.

Heron, Michal and David **MacTavish.** *Pricing Photography: The Complete Guide to Assignment and Stock Prices,* Third Edition. New York: Allworth Press, 2002.

Kieffer, John. Mastering Nature Photography: Shooting and Selling in the Digital Age. New York: Allworth Press, 2004.

Krogh, Peter. *The DAM Book: Digital Asset Management for Photography.* Sebastopol, CA: O'Reilly Media, 2005.

Monteith, Ann K. *Professional Photographer's Management Handbook.* Norfolk, NE: Marathon Press, 2003.

Peterson, Bryan. *Understanding Digital Photography: Techniques For Getting Great Pictures.* New York: Amphoto Books, 2005.

McCartney, Susan. *Photographic Lighting Simplified.* New York: Allworth Press, 2003.

Poehner, Donna, editor. *Photographer's Market.* Cincinnati, OH: Writer's Digest Books, annual.

Wignall, Jeff. *The Joy of Digital Photography.* Asheville, NC: Lark Books, 2005.

Willmore, Ben. *Adobe Photoshop CS2 Studio Techniques.* Berkeley, CA: Adobe Press, 2005.

MAGAZINES

American Photographer *www.americanphotomag.com*

Aperture *www.aperture.org*

Communication Arts *www.commarts.com*

Outdoor Photographer *www.outdoorphotographer.com*

PC Photo Digital *www.pcphotomag.com*

Photo District News (PDN) *www.pdnonline.com*

PDN Photo Source *www.pdngallery.com*

Photography Review *www.photographyreview.com*

Photoshop User *www.photoshopuser.com*

Popular Photography *www.popphoto.com*

Organizations

Advertising Photographers of America (APA)
www.apanational.com

American Society of Media Photographers (ASMP)
www.asmp.org

The American Society of Picture Professionals (ASPP)
www.aspp.com/index.lasso

The British Association of Picture Libraries and Agencies (BAPLA)
www.pbf.org.uk

National Association of Photoshop Professionals (NAPP)
www.photoshopuser.com

National Press Photographers Association (NPPA)
www.nppa.org

North American Nature Photography Association (NANPA)
www.nanpa.org

Photo Marketing Association International (PMA)
www.pmai.org

Picture Archive Council of America (PACA)
www.pacaoffice.org

Professional Photographers of America (PPA)
www.ppa.com

Society for Photographic Education (SPE)
www.spenational.org

Workshops

The Great American Photography Workshops
www.gapweb.com

Midwest Photo Workshops
www.mpw.com

Boyd Norton's Wilderness Photography Workshops
www.nscspro.com/workshops

The Palm Beach Photographic Centre
www.workshop.org

Santa Fe Photographic Workshops
www.sfworkshops.com

The Workshops (Formerly: The Maine Photographic Workshops)
www.theworkshops.com

Promotion/Source Books

Workbook (corporate office)
www.workbook.com

The Black Book
www.blackbook.com

Manufacturers

Adobe Systems (software) *www.adobe.com*

Apple Computer, Inc. *www.apple.com*

Bogen Imaging (photo equipment, tripods, lighting) *www.bogenimaging.us*

Canon USA (cameras, lenses, accessories) *www.usa.canon.com*

Delkin Devices (storage media) *www.delkin.com*

Eastman Kodak Company (digital cameras, film) *www.kodak.com*

Epson America (printers, inks, cameras) *www.epson.com*

Fuji Photo Film USA (cameras, printers, film) *www.fujifilm.com*

Hewlett-Packard Development Co. (digital cameras, printers, computers) *www.hp.com*

Leica Camera AG (cameras) *www.leica-camera.com*

Lexar Media (storage media) *www.lexarmedia.com*

LumiQuest (flash accessories) *www.lumiquest.com*

Nikon USA (cameras, lenses, accessories) *www.nikonusa.com*

Sony Electronics (cameras, storage media) *www.sonystyle.com/digitalimaging*

A

Adobe Bridge, 150, 151, 158, 160, 161, 162, 165, 167, 168
Adobe Camera Raw, 150, 159, 164, 167–168
Adobe Photoshop. *See* Photoshop
Adobe Photoshop CS2 Studio Techniques (Willmore), 270
Adobe Photoshop Lightroom, 43, 46, 161, 165
Adobe Photoshop Restoration & Retouching (Voices that Matter) (Eismann), 269
Adobe Systems, 274
Adorama, 33
advertising, 14–15, 22
 agencies, 4
 diversity and, 62
 headlines, 19
 lenses and, 39
 markets, 6, 13–14, 64, 75, 175, 209
 photography, 24
Advertising Photographers of America (APA), 152, 189, 271
Advertising Red Books, 212
advertorial market, 210–211
age fotostock, 227
agencies. *See* assignment agencies; stock agencies
agents, stock, 104
AGPix.com, 227
Alamy, 227
American Institute of Graphic Artists (AIGA), 211
American Photographer, 270
American Society of Media Photographers (ASMP), 5, 152, 188, 189, 205, 221, 224, 227, 244, 255, 265, 271
American Society of Picture Professionals (ASPP), 47, 152, 188, 212, 221, 224, 227, 271
animals, 73, 90, 144
APA, 221, 224
aperture, 44

Aperture, 165
Aperture, 270
Apple Aperture, 161
Apple Computer, Inc., 274
archiving. *See* storing/protecting/archiving images
art directors clubs, 211
ASMP Bulletin, 205
ASMP Professional Business Practices Guide, 265
ASPP magazine, 199
assignment agencies, 5
assignment photography, 3, 6, 7, 9, 58, 150, 172, 221
assignments, stock, 59–60, 71–100
 animals, 90
 commerce (downtown/central business district), 78
 emotions (pride), 84
 family, 82
 health care, 85, 98
 housing/houses, 83, 91
 in-depth coverage and, 71–72
 International Business Communications, 96
 people, 77, 81, 86, 87, 88, 89, 92, 93, 94, 97, 99
 sensitive issues, 100
 sports (gymnastics), 76
 still life (healthy food), 95
 travel, 79, 80
 why these, 72–75

B

B&H, 33
backgrounds, 22–24
backups, 53, 156, 157, 164, 168, 192
 See also storing/protecting/archiving
Black Book, The, 211, 273
blogs, 201–205
body language. *See* gestures
Bogen Imaging, 274
bookkeeping system, 185
books, 152, 269, 273
Boyd Norton's Wilderness Photography Workshops, 272

British Association of Picture Libraries and Agencies (BAPLA), 4, 271
Business and Legal Forms for Photographers, 3rd edition (Crawford), 250, 257, 265
business identity/name, 196–198
business of digital stock photography, vi, 1–10, 171–192
 business strategy, 179–180
 changing perceptions of stock photography, 6–7
 confusion over word "stock," 2
 current trends, 7–8
 definition of stock photographs, 2
 expectations and, 9–10, 189
 history of, 5–6
 new economics of stock, 179
 psychology of stock and, 174
 running the business, 180–186
 sources of stock photography, 2–3, 8
 stages of a stock sale, 191
 success and, 10
 tips from the experts, 191–192
 training staff, 186–189
 See also licensing rights; marketing; markets; portals; stock agencies
buyers, finding/reaching, 211–221

C

Camera Raw with Adobe Photoshop CS (Fraser), 152
cameras, 38–39, 44–45, 55, 166–167, 222
Canon USA, 274
capabilities, 198–199
captions, 146, 150, 153, 160–161, 162, 164, 168, 183, 199, 222, 254
card readers, 41, 156
Cartier-Bresson, Henri, 22
cataloging software, 151, 162
celebrities, 255
children, photographing, 110, 112, 113, 119, 121, 133–134, 137, 142, 147, 256

clients, 212–213
clip art, 3, 175
clip files, 17–18, 19, 27, 28, 39, 105
CMYK, 50–51
color, 19, 24–25, 30–31, 34, 50–51
Color Management for Photographers: Hands on Techniques for Photoshop Users (Rodney), 50
Color Marketing Group (CMG), 25
commerce assignment, 74, 78
Communication Arts, 270
composite imaging, 75
composition, 20–22
computers, 51–52, 55, 109
 See also e-mail; Internet; software; Web sites
concepts, 26–31, 63–66, 213, 224
 clip files and, 19
 color and, 30–31
 decoding photographs and, 27
 fine art and, 28–29
 illustrating, 27–28
 planning stock projects and, 61, 62
 symbols and, 30–31
consistency, 153–154
contracts, 9, 224
controlled vocabulary, 162
"Controlled Vocabulary Keyword Catalog, The" (Rieck), 162
Cook, James, 53
copyright, 2, 5, 160, 176, 183, 247–251, 265
 background of, 248
 clip files and, 18
 decoding photographs and, 27
 infringement, 250–251
 models and, 114
 notice, 250
 overview, 248
 registration, 251
 rights of holder of, 248–249
 Web sites and, 205
 work for hire and, 249–250
 See also licensing rights
Copyright Act of 1976, 248
copywriting, 198–199
Corbis, 8, 68, 174–175, 176, 177–178, 222
corporate markets, 4, 13, 64, 75, 209–210
Crawford, Tad, 247, 249, 250, 257, 265
cropping, 22
crowd-sourcing, 14

D
DAM. *See* digital asset management (DAM)
DAM Book: Digital Asset Management for Photographers, The (Krogh), 46, 53, 152, 160, 269
decisive moments, 22
delivery memos, 183–184, 257, 260–263
delivery methods, 184
Delkin Devices, 274
de Maria, Catherine, 107
Department of the Interior, 118
descriptions, 130–131
design, of marketing materials, 199–200
detailed corrections, 159
digital asset management (DAM), 45–46, 53, 106, 108, 152
Digital Camera Resource, 34
digital composites, 68
digital language, 47
digital manipulation, 75, 100
Digital Millennium Copyright Act (DMCA), 249
digital negative format (DNG), 159
Digital Photography Review, 34
digital technicians, 108, 109
disk drives, 55
diversity, 62–63, 71, 72
DNG (image file format), 167
Doeffinger, Derek, 269
Doritos Company, 14
downloading, 156, 164, 191

E
Eastman Kodak Company, 274
editing, 157–158, 159–160, 164
editorial markets, 4, 13, 39, 64, 75, 175, 210
education, digital, 151–153
Eismann, Katrin, 269
electronic bulletin systems, 211
e-mail, 55, 231–232
emotions assignment, 72–73, 84
Epson America, 274
equipment, 33–55, 51–52, 180, 192
 cameras, 38–39, 44–45, 55, 166–167, 222
 color and, 50–51
 computers/workstations, 51–52

digital language and, 47
exposure and, 49–50
finding, 33–34
ISO setting and, 49
lenses, 39–40
lighting, 34–37
list of, 55
memory cards, 40–42
resolution/sharpness and, 47–49
scanners, 53–54
shooting raw and, 42–47
storing/protecting/archiving images, 52–53
technical excellence and, 54
what's needed, 34
estimates, 263–264
Eureka Images, 227
Excel, 105
exclusivity, 220
exposure, 49–50
Extensis Portfolio 8, 165
Eye One Match 3, 50

F
family assignment, 72, 73, 82
Farace, Joe, 47
fashion markets, 13, 24
Feingersh, Jon, 66–68
Ferrari, Maria, 16, 52, 152, 157, 166–168
file formats, 40–41, 159
fine art, 28–29
FireLite, 52
FireWire card reader, 41, 51, 52, 156
FireWire portable storage device, 52
flash meters, 37
folders, 155
forms, 60, 253–268
 blank assignment form, 75
 for delivery memos, 257, 260–263
 invoicing, 185, 265–267
 for model releases, 258
 for property releases, 259
 Stock Request Form, 235, 268
 for stock shoot/estimate worksheet, 263–264
 U.S. Copyright Office "Form VA," 251
FotoBiz 2.0, 166
FotoQuote, 166, 243
framing, 24
Fraser, Bruce, 42, 43, 50, 152, 158, 269
FTP sites, 180, 184, 185, 189, 198
Fuji Photo Film USA, 274

G

gaps in stock supply, 57–59, 72, 73
Genuine Fractals, 38, 166
gestures, 19, 24, 25–26
Getty Images, 8, 39, 54, 68, 168, 174–175, 176, 177–178, 222
gifts, promotional, 207, 212
global corrections, 159
grain, in film, 48, 49
Great American Photography Workshops, The, 272
guerilla marketing, 14–15

H

hard drives, 55, 157, 192
health assignments, 74, 85, 98
Heisler, Greg, 66
Heller, Dan, 269
Heron, Michal, 269
Hewlett-Packard Development Co, 274
high-resolution files, 184–185, 186
Hindsight Ltd., 150, 165
Hispanics, 59, 63, 66, 97
History of Magazines on a Timeline, The (Kleiner), 5
housing/houses assignment, 73–74, 83, 91

I

icons, 26, 27, 29, 196, 197
illustration, 68
Image Bank, The, 5–6
Image Pond, 227
Independent Photography Network, 227
in-depth coverage, 61, 71–72
in-house photographers, 8
InStock, 161
International Business Communications assignment, 96
Internet, 57, 197–198
Internet Service Providers (ISPs), 55
invasion of privacy, 254–255
InView, 150, 165
invoicing, 184, 185, 247, 265–267
ISO settings, 44, 45, 49
ISPs. *See* Internet Service Providers (ISPs)
iStockpro.com, 228
iView, 165, 191

J

Jackson, Craig, 191–192
Joy of Digital Photography, The (Wignall), 269

JPEG, 40, 41, 42, 43, 44, 168, 191
Jupitermedia, 174, 176–177

K

keywords, 162, 178, 191, 218, 219
Kieffer, John, 269
Kleiner, Art, 5
Krogh, Peter, 46, 53, 155, 160, 162, 269

L

laptop computers, 52, 55
lawyers, 224, 251, 265
Legal Guide for the Visual Artist (Crawford), 247
Leica Camera AG, 274
lenses, 39–40
letters, 104, 112, 126–127, 130–138, 145–146
Lexar Media, 274
libel, 254
licensing rights, 3, 5, 6, 175–176, 185, 265
See also copyright; rights-managed photography; royalty-free (R-F) photography
light boxes, 182–183, 189–190, 198, 218, 223, 226, 257
lighting, 34–37, 39
location files, 105, 146
location photography, 105–106, 111–112, 115–118, 132–135
logos, 197, 199
LumiQuest, 274

M

MacBook Pro, 55
Mack-Jackson, Tracy, 192
MacTavish, David, 243, 269
magazines, 270
Magic of Digital Printing: Great Prints from Shooting to Output, The (Doeffinger), 269
Magnum Photos, 5
manufacturers, 274
marketing, 171, 172–173, 174–175, 195–215
agencies and, 9
alternative, 14–15
in the blogosphere, 202–205
clients and, 212–213
consultants, 208
developing a strategy, 196–200
developing marketing materials, 200–201, 205–207

electronic, 10
finding/reaching buyers, 211–212
portals and, 8, 177–178
promotion/source books, 273
research tools, 207–208
stock agencies and, 219, 220, 222, 225
tips from the experts, 213–215
Web sites and, 58, 226
See also markets
markets, 4, 13, 15–16, 57–59, 75, 208–211
advertising, 6, 13–14, 64, 75, 175, 209
advertorial, 210–211
corporate, 13, 64, 75, 209–210
editorial, 4, 13, 39, 64, 75, 175, 210
fashion, 13, 24
Mastering Nature Photography Shooting—Selling in the Digital Age (Kieffer), 269
match prints, 50
McCartney, Susan, 35, 269
memory cards (media cards), 40–42, 146, 155, 156, 164
metadata, 159, 160–162, 164, 168, 183
Midwest Photo Workshops, 272
model files, 105
model releases, 23, 64, 74, 110, 112, 121, 160, 253–257
advertising market and, 209
advertorial market and, 211
corporate market and, 210
editorial market and, 210
file for, 105
forms for, 256–257, 258
getting them signed, 144–146
invasion of privacy and, 254–255
stock agencies and, 168, 222
stock assignments and, 72, 73, 92
See also children, photographing
models, 109–115, 136–138, 142–143, 147
modems, 55
monitors, 50, 55
monolights, 36
Monteith, Ann K., 269
multiculturalism. *See* diversity

N

name, business, 197–198
naming files, 161
National Association of Photoshop Professionals (NAPP), 151, 189, 271

national parks, 117–118
National Press Photographers
 Association (NPPA), 271
negative space, 19, 20–21
negotiating prices, 231–244, 265
 attitudes for, 232–234
 conversations for, 238–241
 e-mail and, 231–232
 pricing guidelines, 231
 pricing information for,
 243–244
 tactics for, 234–238
 value of photographs and,
 241–243
 written paragraphs for, 232
 See also negotiation
Negotiating Stock Photo Prices
 (Pickerell), 243
negotiation, 5, 10, 178, 181,
 185, 218
 See also negotiating prices
New Yorker magazine, 25
niches, 58, 66
Nikon USA, 274
NikonView, 191
noise, 48, 49
Noise Ninja, 166
North American Nature
 Photography Association
 (NANPA), 189, 271

O
Outdoor Photographer, 270

P
Palm Beach Photographic
 Centre, The, 272
payment, receipt of, 185
PC Photo Digital, 270
PDN (Photo District News),
 199, 270
PDN Photo Source, 270
people assignments, 72, 73, 74,
 77, 81, 86, 87, 88, 89, 92,
 93, 94, 97, 99
permits, 117–118
Peterson, Bryan, 269
Photoconnect, 228
photo coordinators. See pro-
 duction coordinators
Photo Expo, 208
Photoexposure.com, 228
Photographer's Guide to Marketing
 and Self-Promotion, The,
 (Piscopo), 207
Photographer's Market, 208,
 211, 212, 221
Photographic Lighting Simplified
 (McCartney), 35, 269

Photography Review, 270
Photo Marketing Association
 International (PMA), 271
Photo Price Guide, 166
photo researchers, 5
Photoshop, 51, 60, 122, 150,
 151, 159, 165, 166, 167
 backgrounds and, 23
 cameras and, 38
 ISO settings and, 49
 shooting raw and, 43–44
Photoshop User, 270
PhotoSights, 228
PhotoSource Bank, The, 228
Pickerell, Jim, 177, 178, 243
Picture Agency Council of
 America (PACA), 4
Picture Archive Council of
 America (PACA), 221, 271
Picture Professional, The, 47
Piscopo, Maria, 207, 208,
 213–215
planning stock projects, 61–62,
 103–104, 126
platforms, 52
Polonius, 13, 15
Popular Photographer, 270
portals, 8, 159, 171, 173,
 177–179, 220, 225–228
 cameras and, 39
 negotiating prices and, 244
 pricing and, 231
portfolios, 206
post-production, 66, 153, 164, 184
PowerBook, 55
power packs, 35–36
preparing the shoot, 103–138
 digital technicians and,
 108–109
 locations and, 115–118
 models and, 109–115
 planning projects, 103–104
 preparing the computer, 109
 pre-production, 109, 126
 production coordinators and,
 107–108, 121–122
 prohibitions and, 123–124,
 127–128
 props and, 119–120,
 122–123, 128–129
 sample letters/forms and,
 126–127, 130–138
 setting up location photo-
 graphy, 105–106
 setting up systems, 104–105
 storyboards and, 124–126
 wardrobe and, 118–119
pre-production, 109, 126
pricing, 185, 219, 265
 See also negotiating prices

Pricing Photography: The
 Complete Guide to
 Assignment and Stock Prices
 (Heron and MacTavish),
 243, 265, 269
printers, 55
pro-bono projects, 214–215
processing, 159
producers. See production coor-
 dinators
production, 105
 See also post-production; pre-
 production
production coordinators, 106,
 107–108, 121–122, 179,
 187
professional organizations,
 188–189, 244, 271
Professional Photographer's
 Management Handbook
 (Monteith), 269
Professional Photographers of
 America (PPA), 189, 227,
 271
Profitable Photography In The
 Digital Age: Strategies For
 Success (Heller), 269
prohibitions, 123–124,
 127–128
property releases, 73, 74,
 255–256
 advertising market and, 209
 advertorial market and, 211
 corporate market and, 210
 editorial market and, 210
 forms for, 256–257, 259
 housing/houses assignment
 and, 83
 stock agencies and, 168
props, 119–120, 121, 122–123,
 128–129, 142
purchase orders (POs), 185

R
racing images, 66–67
ratings, 159–160, 164
raw. See shooting raw
"Raw Power—Buenos Aires
 Style" (Salwen), 47
Real World Camera Raw with
 Adobe Photoshop CS2
 (Fraser), 42, 43, 158, 269
Real World Color Management
 (Fraser), 50
reference photos, 113
releases. See model releases;
 property releases
research fees, 184
research tools, 207–208
residual fees, 114

resolution/sharpness, 47–49
retouching, 159
RGB, 50–51
Rieck, David, 162
rights-managed photography,
 175–176, 179
Roark, Betty, 48
Rodney, Andrew, 50
royalty-free (R-F) photography,
 3, 174, 175–177, 179, 219

S
Salwen, Ethan G., 42, 43–47,
 158, 202–205, 228
Santa Fe Photographic
 Workshops, 272
scanning, 53–54, 55, 149, 183,
 184, 219
searchLynx, 166
"Selling Stock," 177
semiotics, 27
 See also symbols
sensitive issues assignment, 100
sensitivity setting, 49
set, decorating, 141–142
sharpness. See resolution/
 sharpness
shooting raw, 41, 42–47, 55,
 149, 150, 152, 158, 164,
 167, 168
shooting schedules, 62–63
shooting tethered, 42
Shutter Point Photography, 228
shutter speeds, 44
SmartDisk, 52
Society for Photographic
 Education (SPE), 271
software, vi, 55, 150–153, 154,
 161, 162, 167–168, 191
 cameras and, 38
 digital asset management
 (DAM) and, 45
 digital technicians and, 108
 negotiating prices and, 231
 overview, 165–166
 setting up systems and, 105
Sony Electronics, 274
sovereign immunity, 265
space, 20–21
sports assignment, 72, 76
staff training, 186–189
stages of a stock sale, 180, 191
*Starting Your Career as a
 Freelance Photographer,*
 247, 249
Statute of Anne, 248
Steedman, Richard, 27

Stevens, Laura, 249
still life (healthy food)
 assignment, 95
stock agencies, vii, 4, 5–6, 7,
 10, 171, 173, 217–225,
 229
 business of, 174–175
 cameras and, 38–39, 55, 167
 clients and, 212
 finding, 221–222, 224–225
 functions of, 229
 how they work, 217–220
 image requirements and, 168
 keywords and, 162
 knowledge and, 67
 mergers of, 8–9
 negotiating prices and, 244
 portals and, 177–178
 pricing and, 231
 research fees and, 184
 scanning and, 54, 55
 sharpness and, 47–48
 sources of stock photography
 and, 3
Stock Connection, 178–179
Stock Request Form, 235, 268
StockView, 150, 166
storing/protecting/archiving
 images, 52–53, 152, 159,
 162–163, 164
 See also backups
storyboards, 124–126
strobe lighting, 34–37, 39
style, vi, 1–2, 7, 9, 13–16
 alternative marketing and,
 14–15
 analyzing, 16–17, 19
 changes in, 67, 68
 clip files and, 17–18, 19
 color and, 24–25
 elements of, 18, 20–26
 fine art and, 28–29
 gaps in stock supply and, 58
 gestures, 25–26
 markets and, 64
 stock assignments and,
 72, 75
 tips for stock, 23
 trends and, 14–15
 X-style, 14, 24, 28–29, 34
submissions, 182–183, 184,
 189–190, 224, 227
symbols, 26–27, 28, 29–30,
 64, 75
sync capability, 39
systems, setting up, 104–105,
 191–192

T
tear sheets, 185
themes, 103–104
Tiff files, 41
time management, 52
trademarks, 124
travel assignments, 75, 79, 80
trends, 15–16, 24–25

U
*Understanding Digital
 Photography: Techniques
 For Getting Great Pictures*
 (Peterson), 269
upsampling, 38
U.S. Copyright Office, 251

V
vendor list, preferred, 219
vertical photographs, 20, 73,
 224
viewer-created content, 14

W
wardrobe, 118–119, 121, 122,
 136–137
wasabi green, 25
watermarks, 183
watt seconds, 36
Web galleries, 57
Web sites, 181, 182, 196, 198,
 199, 205, 212, 213, 257
 blogs and, 201–205
 clients and, 212
 design and, 199–200,
 200–201
 negotiating prices and, 236
 portals and, 226–227
 portfolios and, 206, 222, 224
 stock agencies and, 218, 219,
 220, 222
Wignall, Jeff, 269
Willmore, Ben, 270
Workbook, 211, 273
Workbook East, 273
Workbook Midwest, 273
Workbookstock, 228
workflow, vi, 152, 153–154,
 164, 166, 192
work for hire, 249–250
workshops, 272
workstations, 51–52

X
X-style, 14, 24, 28–29, 34

Y
YouTube™, 14, 29

Books from Allworth Press

Allworth Press is an imprint of Allworth Communications, Inc. Selected titles are listed below.

Pricing Photography: The Complete Guide to Assignment Stock Prices, Third Edition
by Michal Heron and David MacTavish (paperback, 11 × 8 ½, 160 pages, $24.95)

Photographing Children and Babies: How to Take Great Pictures
by Michal Heron (paperback, 8 ½ × 11, 144 pages, $24.95)

Starting Your Career as a Freelance Photographer
by Tad Crawford (paperback, 6 × 9, 256 pages, $19.95)

The Professional Photographer's Legal Handbook
by Nancy E. Wolff (paperback, 6 × 9, 272 pages, $24.95)

Licensing Photography
by Richard Weisgrau and Victor S. Perlman (paperback, 6 × 9, 208 pages, $19.95)

Profitable Photography in the Digital Age: Strategies for Success
by Dan Heller (paperback, 6 × 9, 240 pages, $24.95)

How to Succeed in Commercial Photography: Insights from a Leading Consultant
by Selina Maitreya (paperback, 6 × 9, 240 pages, $19.95)

The Photographer's Guide to Marketing and Self-Promotion, Third Edition
by Maria Piscopo (paperback, 6 ¾ × 10, 208 pages, $19.95)

Business and Legal Forms for Photographers, Third Edition with CD-ROM
by Tad Crawford (paperback, 8 ½ × 11, 192 pages, $29.95)

ASMP Professional Business Practices in Photography, Sixth Edition
by ASMP (paperback, 6 ¾ × 9 ⅞, 432 pages, $29.95)

Photo Styling: How to Build Your Career and Succeed
by Susan Linnet Cox (paperback, 6 × 9, 288 pages, $21.95)

The Photographer's Guide to the Digital Darkroom with CD-ROM
by Bill Kennedy (paperback, 6 ¾ × 10, 224 pages, $29.95)

How to Grow as a Photographer: Reinventing Your Career
by Tony Luna (paperback, 6 × 9, 224 pages, $19.95)

Creative Careers in Photography: Making a Living With or Without a Camera
by Michal Heron (paperback, 6 × 9, 272 pages, $19.95)

To request a free catalog or order books by credit card, call 1-800-491-2808. To see our complete catalog on the World Wide Web, or to order online for a 20 percent discount, you can find us at **www.allworth.com**.